BULLETIN OF THE JOHN RYLANDS LIBRARY

VOLUME 98 NUMBER 2, AUTUMN 2022

BULLETIN OF THE JOHN RYLANDS LIBRARY

ISSN 2054-9318 (Print)
ISSN 2054-9326 (Online)

Established in 1903

Members of the Editorial Board 2022

Chair: Andrew Morrison
Editors: Stephen Mossman and Cordelia Warr
Editorial Assistant: Emma Nelson

Editorial Board
Hannah Barker
Joseph Bergin
Paul Fouracre
Roy Gibson
John Hodgson
David Law
Phyllis Mack
David Matthews
John Morgan
Walter Pohl
Lynda Pratt
Julianne Simpson
Carsten Timmermann

Subscriptions

To subscribe please contact: Manchester University Press Journals Subscriptions, 176 Waterloo Place, University of Manchester, Oxford Road, Manchester, M13 9GP, UK
Tel: +44 (0)161 275 2310
manchesterhive@manchester.ac.uk
https://www.manchesterhive.com/view/journals/bjrl/bjrl-overview.xml

The *Bulletin* is published twice a year. The subscription prices for 2022 are:
Institutions (print and online) £215/$325/€255
Institutions (online only) £179/$265/€205
Individual (print only) £73/$110/€83

The complete archive of the *Bulletin of the John Rylands Library*, from its first issue in 1903 to Volume 80 (1998) is now available to purchase from Manchester University Press. The archive complements the current subscription product (1999 to date), and can be purchased on a one-time basis or as an annual subscription. To obtain pricing information, please contact Shelly Turner at shelly.turner@manchester.ac.uk.

BULLETIN OF THE JOHN RYLANDS LIBRARY

VOLUME 98 NUMBER 2, AUTUMN 2022

CONTENTS

Articles

Twenty-Three Ur III Texts from Detroit Institute of Arts *Changyu Liu*	1
Lorenzo Opimo of Bologna, Teaching Doctor of the Servites during the Reformation, and His *Sentences* Lectures at the University of Paris in 1370–71 (Part I) *Chris Schabel*	49
Littifredi Corbizzi, Johann Anton Ramboux and an Album of Manuscript Cuttings at the John Rylands Library *Fergus Bovill*	87
Incunabula at the Manchester Grammar School *R. M. Cleminson*	111
David Lloyd Roberts (1834–1920), Physician and Gynaecologist: His Collection of Rare Books and Art Treasures *Peter Mohr*	117
Review Article: 'Manchester Men?' *Emily Jones*	139
The Mammal Thing: Jeff Nuttall and Visceral Intelligence *Timothy Emlyn Jones*	149

Twenty-Three Ur III Texts from Detroit Institute of Arts

CHANGYU LIU, ZHEJIANG NORMAL UNIVERSITY

Abstract

The twenty-three Ur III cuneiform texts presented in this article are housed in the collections of the Detroit Institute of Arts. This article publishes thirteen Neo-Sumerian tablets from Puzriš-Dagan which primarily deal with animals, and a further ten texts from Umma, including five messenger texts. The aim of the article is to offer an edition and an updated catalogue of these texts, with a special focus on the Neo-Sumerian administration.

Keywords: administrative tablets; Neo-Sumerian; Puzriš-Dagan; Umma; Ur III period

This article is concerned with twenty-three cuneiform clay tablets kept in the Detroit Institute of Arts (DIA), Detroit, Michigan.[1] These administrative documents date to the Third Dynasty of Ur (Ur III, c.2112–2004 BC) of Mesopotamian history and are from Puzriš-Dagan (modern Drehem) and Umma (modern Tell Jokha) in southern Iraq.[2] They were formerly in the collection of Professor Albert T. Clay, Yale University, and were subsequently donated to the DIA by Henry Glover Stevens in 1919. While one text (no. 1) has been published by Piotr Michalowski,[3] twenty-two texts (nos 2–23) have not been published to date. Their photographs are available at the Cuneiform Digital Library Initiative (CDLI), thanks to the research project 'Creating a Sustainable Digital Cuneiform Library (CSDCL)' managed by Lina Meerchyad, DIA Collection Research Associate.[4] In the CDLI, five texts (nos 9, 11, 13, 17, 23) have been transliterated by Robert K. Englund, one text (no. 14) by Daniel A. Foxvog, and seven texts (nos 1, 5, 6, 7, 8, 10, 12) by the author. In this article, based on the photographs provided by CDLI[5] and Database of Neo-Sumerian Texts (BDTNS),[6] I (re-)transliterate, (re-)translate and comment on all the texts, as well as attaching hand copies.

The Ur III dynasty is considered one of the best-documented periods in the history of the ancient Near East. At least 120,000 cuneiform tablets have been unearthed from the southern Iraq and collected in various museums, libraries and private collections in the world.[7] One of the largest collections in the United Kingdom is held at the John Rylands Library in Manchester, where there are more than 1,100 items in Sumerian and Akkadian cuneiform scripts.[8] These cuneiform

objects mostly date to the Ur III period from two southern Iraqi sites, Puzriš-Dagan and Umma. They have been published by previous scholars, digitised, and are available from the CDLI. Among them, 54 texts were published by Charles L. Bedele in 1915,[9] 843 texts by Thomas Fish in 1932,[10] one text by Trevor Donald in 1962,[11] 86 texts by Tohru Gomi in 1981–82,[12] 30 texts by Farouk N. H. Al-Rawi in 2000,[13] as well as three unpublished texts, JRL 1088d (P430886), JRL 1088e (P430887), JRL 1088f (P430888). Cataloguing and publishing cuneiform texts is fundamental and indispensable for the reconstruction of the administration and daily life of the ancient Near-Eastern society, and the editing of unpublished cuneiform tablets is always crucial in this task.

The twenty-three cuneiform texts from the Detroit Institute of Arts are classified according to the place of their supposed origin, then arranged in chronological order. **Table 1** and **Table 2** provide the essential details of these texts.

TABLE I
Cuneiform texts in the Detroit Institute of Arts.

No.	Museum number	Provenience	Date	Sealing	CDLI	BDTNS
1	DIA 19.024.11	Puzriš-Dagan	Š 30 ix	–	P461504	194517
2	DIA 65.369	Puzriš-Dagan	Š 34 x	–	P461533	194851
3	DIA 19.024.28	Puzriš-Dagan	Š 39 iv	Sealed	P461527	194850
4	DIA 19.024.27	Puzriš-Dagan	Š 44 xi	Sealed	P461525	194849
5	DIA 19.024.07	Puzriš-Dagan	Š 46 vi 30	–	P461501	194837
6	DIA 19.024.13	Puzriš-Dagan	Š 47 viii 3	–	P461506	194841
7	DIA 78.064	Puzriš-Dagan	AS 1 vi 30	–	P461534	194852
8	DIA 19.024.09	Puzriš-Dagan	AS 4 x 7	–	P461503	194839
9	DIA 19.024.15	Puzriš-Dagan	AS 6 ix 22	–	P461508	194843
10	DIA 19.024.06	Puzriš-Dagan	AS 7 xii 25	–	P461500	194836
11	DIA 19.024.05	Puzriš-Dagan	AS	Sealed	P461499	194835
12	DIA 19.024.08	Puzriš-Dagan	ŠS 9 ii	–	P461502	194838
13	DIA 19.024.04	Puzriš-Dagan	IS 1 ii	–	P461498	194834
14	DIA 19.024.14	Umma	Š 30 v	–	P461507	194842
15	DIA 19.024.02	Umma	Š 43	–	P461496	194832
16	DIA 19.024.01	Umma	Š 47	–	P461495	194831
17	DIA 19.024.12	Umma	AS 2 xii	–	P461505	194840
18	DIA 19.024.16a	Umma	ŠS 3 i 16	–	P461509	194844
19	DIA 19.024.16b	Umma	ŠS 3 iv 18	–	P461510	194845
20	DIA 19.024.16d	Umma	ŠS 5 viii	–	P461512	194847
21	DIA 19.024.16c	Umma	– x 30	–	P461511	194846
22	DIA 19.024.16e	Umma	Undated	–	P461513	194848
23	DIA 19.024.03	Umma	Undated	–	P461497	194833

TABLE II
Concordance of museum numbers.

Museum number	No.	Museum number	No.
DIA 19.024.01	16	DIA 19.024.14	14
DIA 19.024.02	15	DIA 19.024.15	9
DIA 19.024.03	23	DIA 19.024.16a	18
DIA 19.024.04	13	DIA 19.024.16b	19
DIA 19.024.05	11	DIA 19.024.16c	21
DIA 19.024.06	10	DIA 19.024.16d	20
DIA 19.024.07	5	DIA 19.024.16e	22
DIA 19.024.08	12	DIA 19.024.27	4
DIA 19.024.09	8	DIA 19.024.28	3
DIA 19.024.11	1	DIA 78.064	7
DIA 19.024.12	17	DIA 65.369	2
DIA 19.024.13	6		

No. 1 – Archive of Šulgi-simti

Museum number: DIA 19.024.11
Provenience: Puzriš-Dagan
Date: Š 30 ix

obv.

1) 1 gu$_4$ niga 5 udu gu$_4$-e-us$_2$-<sa> *1 barley-fed ox, 5 barley-fed sheep following the oxen, 4*
2) 4 udu u$_2$ 1 maš$_2$ *grass-fed sheep, 1 kid*
3) Nin-kal-la *of Ninkalla;*
4) 1 gu$_4$ u$_2$ 4 udu u$_2$ 1 maš$_2$ *1 grass-fed ox, 4 grass-fed sheep, 1 kid*
5) SI.A-tum *of SI.A-tum;*
6) 1 gu$_4$ u$_2$ 2 udu niga <sig$_5$>-us$_2$ *1 grass-fed ox, 2 barley-fed sheep top quality next grade,*
7) 2 udu u$_2$ 1 maš$_2$ *2 grass-fed sheep, 1 kid*
8) Simat-E$_2$-a *of Simat-Ea;*
9) 1 gu$_4$ u$_2$ 2 udu niga <sig$_5$>-us$_2$ *1 grass-fed ox, 2 barley-fed sheep top quality next grade,*
10) 2 udu u$_2$ 1 maš$_2$ *2 grass-fed sheep, 1 kid*
11) E$_2$-a-ni-ša *of Eaniša;*
12) 1 gu$_4$ u$_2$ 10-la$_2$-1 udu 1 maš$_2$ *1 grass-fed ox, 9 sheep, 1 kid*
13) Hal-hal-la *of Halhalla;*

rev.

1) 1 gu$_4$ u$_2$ 10-la$_2$-1 udu u$_2$ *1 grass-fed ox, 9 grass-fed sheep,*
2) 1 maš$_2$ *1 kid*
3) Te-și-in-Ma-ma *of Teșin-Mama;*
4) 10 udu u$_2$ 1 maš$_2$ *10 grass-fed sheep, 1 kid*
5) Bu$_3$-ga-a šabra *of Buga'a, the chief household administrator*
6) Te-și-in-Ma-ma *of Teșin-Mama;*
7) mu-ku$_x$(DU) *delivery.*
8) u$_4$ nin-ĝu$_{10}$ a ur$_3$-ra/in-tu$_{17}$-a *When my lady wiped clean the water in the lustration rite, Šukubum received.*

9) Šu-ku$_8$-bu-um i$_3$-dab$_5$	Month: 'Great Festival'.
10) iti ezem mah	Year: 'The ensi of Anšan married the
11) mu dumu-munus lugal ensi$_2$/ An-ša-an-naki-ke$_4$/ba-an-tuku	daughter of the king.'

1a. Obv. 3) Presumably, the PN Nin-kal-la is a scribal error for Nin$_9$-kal-la.

1b. Obv. 8) For the role of Simat-Ea as the wife of Shulgi, see F. Weiershäuser, *Die königlichen Frauen der III. Dynastie von Ur* (Göttingen: Universitätsverlag Göttingen, 2008), p. 209.

1c. Rev. 5) The PN Bu$_3$-ga-a, otherwise unattested, is presumably a variant of Bu-ga-a. See *AUCT* 1 964, *CST* 263, *CUSAS* 3 309, *Nisaba* 3/1 178, *Nisaba* 15 554, *Nisaba* 24 15, *Princeton* 2 141, *SAT* 3 2035 and *TRU* 59.

1d. Rev. 8) For the phrase in-tu$_{17}$-a, see P. Michalowski, 'Sumerian Royal Women in Motown', in P. Corò et al. (eds), *Libiamo ne'lieti calici: Ancient Near Eastern Studies Presented to Lucio Milano on the Occasion of his 65th Birthday by Pupils, Colleagues and Friends* (Münster: Ugarit-Verlag, 2016), pp. 397–9. The term ur$_3$-ra, whose exact meaning is not yet determined, qualifies the water (a) and designs the instrument of the bathing. See M. Civil, 'Prescriptions Médicales Sumériennes', *Revue d'Assyriologie et d'Archéologie Orientale*, 54 (1960), 60 (a-bi an-tu$_x$-tu$_x$ 'avec cette eau tu laveras').

No. 2 – Withdrawal of livestock

Museum number: DIA 65.369
Provenience: Puzriš-Dagan
Date: Š 34 *x*
obv.

1) 4 ab$_2$ amar nu$_2$-a	*4 pregnant cows,*
2) 14 u$_8$ sila$_4$ nu$_2$-a	*14 pregnant ewes,*
3) 10 ud$_5$ maš$_2$ nu$_2$-a	*10 nanny goats,*
4) e$_2$ dBe-la-at-suh-ner	*for the temple of Belat-suhner*
5) u$_3$ dBe-la-at-dar-ra-ba-an	*and Belat-daraban;*
6) 10 udu niga sa$_2$-du$_{11}$	*10 barley-fed sheep, regular offering*
7) Unugki-še$_3$	*to Uruk,*
8) ĝiri$_3$ Ma-šum	*conveyor: Mašum,*
9) ša$_3$ Uri$_5^{ki}$-ma	*in Ur.*
10) 1 gu$_4$ niga 1 udu niga	*1 barley-fed ox, 1 barley-fed sheep*
11) ka Ĝi$_6$-par$_4$-ra	*at the front side of Ĝiparu;*
12) 1 gu$_4$ niga 2 udu niga	*1 barley-fed ox, 2 barley-fed sheep,*
13) 4 udu u$_2$	*4 grass-fed sheep*

rev.

1) eš$_3$-še$_3$ ezem e$_3$-gi-še$_3$	*to the shrine for the festival of egi;*
2) 1 udu 1 maš$_2$	*1 sheep, 1 goat*
3) Nin-eb$_2$-gu-ul	*for Ninebgul;*

4) 1 udu Li-bur-si₂-im-ti	*1 barley-fed sheep for Libur-simti;*
5) 1 maš₂ ka₂ ᵈMuš-a-igi-ĝal₂	*1 goat for the gate of Mušaigigal,*
6) ša₃ Unu^ki-ga	*in Uruk.*
7) 1 gu₄ niga kaš-de₂-a/ᵈAl-la-gu-la	*1 barley-fed ox for the banquet of Allagula.*
8) zi-ga Be-li₂-DU₁₀	*(They were) withdrawals of Beli-tab.*
9) iti ezem An-na	*Month: 'Festival of An'.*
10) mu An-ša-an^ki ba-hul	*Year: 'Anšan was destroyed.'*

2a. Obv. 4–5) For DNs, both ᵈBe-la-at-suh-ner and ᵈBe-la-at-dar-ra-ba-an, originated from Eshnuna, see W. Sallaberger, *Der kultische Kalender der Ur III-Zeit* (Berlin: Walter de Gruyter, 1993), p. 19; M. Such-Gutiérrez, *Beiträge zum Pantheon von Nippur im 3. Jahrtausend* (Rome: Università degli Studi di Roma 'La Sapienza', 2003), pp. 322–3.

2b. Obv. 11) For the sign ka, probably meaning 'front side', see T. E. Balke, 'Die sumerischen Dimensionaladjektive nim und sig. Anmerkungen zur Polysemie und Grammatikalisierung dimensionaler Ausdrücke im Sumerischen', in O. Loretz, K. A. Metzler and H. Schaudig (eds), *Ex Mesopotamia et Syria Lux: Festschrift für Manfried Dietrich zu seinem 65. Geburtstag* (Münster: Ugarit-Verlag, 2002), p. 33.

2c. Rev. 1) The meaning of eš₃-še₃ ezem e₃-gi-še₃ remains obscure.

2d. Rev. 3) For the PN Nin-eb₂-gu-ul, occurring frequently from the Umma texts, see *AAICAB* 1/1 pl. 038–039 1911–229, *BPOA* 6 202, *CUSAS* 39 126, *MVN* 18 535, *MVN* 21 238, *Nisaba* 6 27, *Nisaba* 24 28, *SAT* 2 1047, *SET* 277, *SNAT* 487, and from the Ĝirsu texts, see *MVN* 2 176, *MVN* 22 43, *STA* 10.

2e. Rev. 4) For Li-bur-si₂-im-ti, see Weiershäuser, *Die königlichen Frauen der III. Dynastie von Ur*, p. 66.

2f. Rev. 5) For the DN ᵈMuš-a-igi-ĝal₂, see Sallaberger, *Der kultische Kalender der Ur III-Zeit*, p. 221.

2g. Rev. 8) For the reading of Be-li₂-DU₁₀ as Beli-tab 'Mein Herr ist gut, schön', see M. Hilgert, *Akkadisch in der Ur III-Zeit* (Münster: Rhema-Verlag, 2002), p. 401.

No. 3 – Receipt of sickle

Museum number: DIA 19.024.28
Provenience: Puzriš-Dagan
Date: Š 39 iv

Tablet:
obv.

1) 8 ^uruda kin	*8 sickles*
2) ki Nu-ur₂-ni-a-/ta	*from Nurnia,*
3) Ur-Bil₃	*Ur-Bil*
4) šu ba-ti	*received.*

rev.

 1) 'iti ki'-siki dNin-a-zu Month: 'Kisiki of Ninazu'.

 2) mu PU$_3$.ŠA-iš-/Da-gan ba-du$_3$ Year: 'Puzriš-Dagan was built.'

Envelope:
obv.

 1) 8 urudakin 8 sickles
 2) kišib Ur-Bil$_3$ under seal of Ur-Bil.
 (seal)
 3) iti ki-siki dNin-a-zu Month: 'Kisiki of Ninazu'.
 4) mu e$_2$ PU$_3$.ŠA-iš-dDa-gan/ba-du$_3$ Year: 'The House of Puzriš-Dagan was
 built.'

rev.

 seal
 1) Ur-dBil$_3$ Ur-Bil
 2) dumu Lugal-a$_2$-[zi-da] son of Lugal-a[zida]
 3) šabra the chief temple administrator.

3a. Obv. 1) For the term urudakin, see A. Salonen, *Agricultura Mesopotamica: Nach Sumerisch-Akkadischen Quellen* (Helsinki: Suomalaisen Kirjallisuuden Kirjapaino Oy Helsinki, 1968), p. 164 (urudakin 'Sichel'); J. Bauer, 'Altsumerische Wirtschaftsurkunden in Leningrad', *Archiv für Orientforschung*, 36–7 (1989–90), 85 (urudugur$_{10}$ 'Sichel'); D. I. Owen, *Cuneiform Texts Primarily from Iri-Saĝrig/Āl-Šarrākī and the History of the Ur III Period, Volume 1: Commentary and Indexes* (Bethesda: CDL Press, 2013), p. 388 (urudakiĝ 'bronze plow').

3b. Obv. 2) The PN Nu-ur$_2$-ni-a is not otherwise attested.

3c. Obv. 3, seal 1) For the DN dBil$_3$ which is presumably a variant or abbreviation of dBil$_3$-ga-mes '(deified) Gilgamesh', see Such-Gutiérrez, *Beiträge zum Pantheon von Nippur im 3. Jahrtausend*, pp. 323–4.

3d. seal 2) For the restoration, see *ASJ* 19 209 27, *AUCT* 1 45, *BIN* 3 546, *BPOA* 7 2650, *MVN* 3 253, *Ontario* 1 128, *PDT* 1 420, *SAT* 3 1354, *ZA* 93 55 no. 4.

No. 4 – Receipt of barley

Museum number: DIA 19.024.27
Provenience: Puzriš-Dagan
Date: Š 44 xi

Tablet:
obv.

 1) 100.3.0 še gur lugal *100 gur 3 barig royal barley*
 2) ša$_3$ na-kab-tum Uri$_5$/ki-ma-ta *from the nakabtum of Ur,*

3) 19.2.0 gur	*19 gur 2 barig (barley)*
4) e$_2$ Pe-ru-ru-ta	*from the House of Peruruti;*
5) ki La-ni-mu-ta	*from Lanimu,*
6) DI.KU$_5$-i$_3$-li$_2$	*Dajjanum-ili,*
7) lu$_2$ ensi$_2$ Ka-zal/-luki-ka-ke$_4$	*the man of the governor of Kazallu,*

rev.

1) šu ba-an-ti	*received.*
2) ša$_3$ na-kab-tum EN./LIL$_2^{ki}$-ka ku$_4$-ku$_4$-dam	*They are to be brought to the nakabtum of Nippur.*
3) iti ezem Me-ki-ĝal$_2$	*Month: 'Festival of Mekiĝal'.*
4) mu a-ra$_2$ 10-la$_2$-1-kam-aš Si-mu-/ru-umki Lu-lu-bu-/umki ba-hul	*Year: 'Simurum and Lulubum were destroyed for the ninth time.'*

Envelope:
obv.

1) 100.3.0 še gur lugal	*100 gur, 3 barig royal barley*
2) ša$_3$ na-kab-tum Uri$_5^{ki}$-ma-ta	*from the nakabtum of Ur,*
3) 19.2.0 gur e$_2$ Pe-ru-ru-ta	*19 gur, 2 barig (barley) from the House of*
4) ki La-ni-mu-ta	*Peruruti; from Lanimu,*
5) DI.KU$_5$-i$_3$-li$_2$ lu$_2$ ensi$_2$ Ka-zal-lu/ki-ka-ke$_4$	*Dajjanum-ili, the man of the governor of Kazallu,*
6) šu ba-an-ti	*received,*
7) [š]a$_3$ na-kab-tum Nibruki-ka	*they are to be brought to the nakabtum of*
8) ku$_4$-ku$_4$-dam	*Nippur.*
9) [it]i ezem Me-ki-ĝal$_2$	*Month: 'Festival of Mekiĝal.'*

rev.

1) [mu a-ra$_2$ 10-la$_2$-1-kam-aš Si-mu-ru-umki Lu-lu-bu-umki ba-hul]	*Year: 'Simurum and Lulubum were destroyed for the ninth time.'*
(seal)	
seal	
1) DI.KU$_5$-i$_3$-[li$_2$]	*Dajjanum-ili*
2) dumu Im-me-[er]	*son of Immer.*

4a. Obv. 2, Rev. 2) For the na-kab-tum organisation, see, recently, H. Brunke, 'The nakabtum – An Administrative Superstructure for the Storage and Distribution of Agricultural Products', *Kaskal*, 5 (2008), 111–26.

4b. Obv. 7) Presumably, the name of the governor is Kallamu; see L. Allred, 'The Tenure of Provincial Governors: Some Observations', in S. Garfinkle and M. Molina (eds), *From the 21st Century BC to the 21st Century AD: Proceedings of the International Conference on Sumerian Studies Held in Madrid 22–24 July 2020* (Winona Lake: Eisenbrauns, 2013), p. 122.

No. 5 – Withdrawal of livestock

Museum number: DIA 19.024.07
Provenience: Puzriš-Dagan
Date: Š 46 vi 30
obv.

1) 1 sila$_4$ dEn-lil$_2$	1 lamb for Enlil,
2) 1 sila$_4$ dNin-lil$_2$	1 lamb for Ninlil,
3) mu-ku$_x$(DU) Ur-dEN.ZU	delivery of Ur-Suen,
4) 1 sila$_4$ dEn-lil$_2$	1 lamb for Enlil,
5) 1 maš$_2$ dNin-lil$_2$	1 kid for Ninlil,
6) mu-ku$_x$(DU) en dInana	delivery of the en-priest of Inana,

rev.

1) zabar-dab$_5$ maškim	the zabardab-official is a bailiff,
2) zi-ga u$_4$ 30-kam	withdrawal. On the 30th day.
3) iti a$_2$-ki-ti	Month: 'Akiti'.
4) mu Ki-maški u$_3$ Hu-/ur$_5$-tiki ba-hul	Year: 'Kimaš and Hurti were destroyed.'

5a. Obv. 3) For the role of Ur-Suen as the general of Uruk and Der dealing primarily with bear cubs, see P. Michalowski, 'Of Bears and Men: Thoughts on the End of Šulgi's Reign and on the Ensuing Succession', in D. S. Vanderhooft and A. Winitzer (eds), *Literature as Politics, Politics as Literature: Essays on the Ancient Near East in Honor of Peter Machinist* (Winona Lake: Eisenbrauns, 2013), pp. 285–320.

5b. Rev. 1) For the title zabar-dab$_5$, referring to the highest cultic official, comparable to sukkal-mah, the highest political official, see W. Sallaberger and A. Westenholz, *Mesopotamien: Akkade-Zeit und Ur III-Zeit* (Freiburg: Universitätsverlag Freiburg Schweiz/Göttingen: Vandenhoeck & Ruprecht, 1999), pp. 186–90. For maškim as 'bailiff/lurker' in the texts from Drehem, see C. Tsouparopoulou, *The Ur III Seals Impressed on Documents from Puzriš-Dagan (Drehem)* (Heidelberg: Heidelberger Orientverlag, 2015), p. 72.

No. 6 – Withdrawal of livestock

Museum number: DIA 19.024.13
Provenience: Puzriš-Dagan
Date: Š 47 viii 3
obv.

1) 1 gu$_4$	1 ox
2) e$_2$-muhaldim	for the kitchen,
3) u$_4$ 3-kam	on the 3rd day,
4) zi-ga	(was) withdrawal
5) ki dEn-lil$_2$-la$_2$	(of) Enlila.

rev.

1) iti šu-eš-ša Month: 'Šueša'.
2) mu us$_2$-sa Ki-maški/ba-hul Year after: 'Kimaš was destroyed.'

6a. Obv. 2) For the term e$_2$-muhaldim, 'kitchen', used in the Ur III administrative documents, see L. Allred, 'Cooks and Kitchens: Centralized Food Production in Late Third Millennium Mesopotamia' (PhD dissertation, Johns Hopkins University, 2006).

No. 7 – Livestock withdrawn

Museum number: DIA 78.064
Provenience: Puzriš-Dagan
Date: AS 1 vi 30
obv.

1) [2 g]u$_4$ niga saĝ-gu$_4$ 2 barley-fed 'head-ox' oxen,
2) [4] gu$_4$ niga 4 barley-fed oxen
3) eš$_3$-eš$_3$ e$_2$-u$_4$-7 for the Festival of 7-Day-House,
4) [iti] u$_4$ 5 ba-zal the 5th day of the month passed;
5) 2 gu$_4$ niga dInana 2 barley-fed oxen for Inana,
6) iti u$_4$ 12 ba-zal the 12th day of the month passed;
7) 2 gu$_4$ niga saĝ-gu$_4$ 2 barley-fed 'head-ox' oxen,
8) 10-la$_2$-1 gu$_4$ niga 9 barley-fed oxen
9) eš$_3$-eš$_3$ e$_2$-u$_4$-15 for the Festival of 15-Day-House,
10) iti u$_4$ 13 ba-zal the 13th day of the month passed;
11) ša$_3$ Nibruki in Nippur.
12) 2 gu$_4$ niga dInana 2 barley-fed oxen for Inana,
13) iti u$_4$ 14 ba-zal the 14th day of the month passed;
14) 2 gu$_4$ niga dInana 2 barley-fed oxen for Inana,
15) iti u$_4$ 15 ba-zal the 15th day of the month passed;
16) 2 gu$_4$ niga dInana 2 barley-fed oxen for Inana,
17) iti u$_4$ 17 ba-zal the 17th day of the month passed;
18) 4 gu$_4$ niga ezem ma$_2$-an-na 4 barley-fed oxen for Festival of Heaven-Boat,
19) zabar-dab$_5$ maškim the zabardab-official is a bailiff,

rev.

1) iti u$_4$ 23 ba-zal the 23rd day of the month passed;
2) ša$_3$ Unuki-ga in Uruk.
3) 1 gu$_4$ niga dNin-hur-saĝ Nu-tur 1 barley-fed ox for Ninhursag of Nutur,
4) 1 gu$_4$ niga An-nu-ni-tum 1 barley-fed ox for Annunitum,
5) 1 gu$_4$ niga dUl-ma-ši-tum 1 barley-fed ox for Ulmašitum,
6) dNanše-ul$_4$-gal maškim Nanše-ulgal was responsible for that,
7) iti u$_4$ 30 ba-zal the 30th day of the month passed,
8) ša$_3$ Uri$_5^{ki}$-ma in Ur.
9) 32 (Total:) 32 (oxen).
10) šu-niĝin$_2$ 4 gu$_4$ niga saĝ-gu$_4$ Sum: 4 barley-fed 'head-ox' oxen,

11) šu-niĝin$_2$ 28 gu$_4$ niga	*sum: 28 barley-fed oxen.*
12) šu-la$_2$-a bala Nam-zi-tar-ra/ ensi$_2$ Gu$_2$-du$_8$-aki	*entrusted for the bala-tax of Namzitara, ensi of Gudua.*
13) Be-li$_2$-A.ZU i$_3$-dab$_5$	*Beli-asum received,*
14) ki A-hu-ni-ta	*from Ahuni,*
15) ba-zi	*were withdrawn.*
16) iti a$_2$-ki-ti	*Month: 'Akiti.'*
17) [mu d]Amar-dEN.ZU lugal	*Year: 'Amar-Suen was the king'.*

7a. Obv. 1–2) The restored numbers of cattle in two lines are based on summary statistics in the lines rev. 10–11.

7b. Obv. 3, 9) For two festivals, both eš$_3$-eš$_3$ e$_2$-u$_4$-7 and eš$_3$-eš$_3$ e$_2$-u$_4$-15, see Sallaberger, *Der kultische Kalender der Ur III-Zeit*, p. 40.

7c. Obv. 18) For the festival ezem ma$_2$-an-na, see Sallaberger, *Der kultische Kalender der Ur III-Zeit*, pp. 216–19.

7d. Rev. 4–5) For DNs, both An-nu-ni-tum and dUl-ma-ši-tum, see Sallaberger, *Der kultische Kalender der Ur III-Zeit*, pp. 198–201; Such-Gutiérrez, *Beiträge zum Pantheon von Nippur im 3. Jahrtausend*, p. 319; M. Krebernik, 'Ulmašitum', *Reallexikon der Assyriologie und vorderasiatischen Archäologie*, 14 (2014), 309–10.

7e. Rev. 12) For the Gudua's governors, see D. I. Owen, 'The Ensis of Gudua', *Acta Sumerologica*, 15 (1993), 131–52.

No. 8 – Livestock withdrawn

Museum number: DIA 19.024.09
Provenience: Puzriš-Dagan
Date: AS 4 x 7

obv.

1) 1 sila$_4$ ga	*1 suckling lamb*
2) ne-mur-ta ba-še$_6$	*cooked in the ashes,*
3) ki lugal-še$_3$ ba-an-ku$_4$	*brought to the royal place,*
4) ĝiri$_3$ dŠul-gi-/a-a-ĝu$_{10}$	*conveyor: Šulgi-a'aĝu,*
5) ša$_3$ Uri$_5^{ki}$-ma	*in Ur;*
6) iti u$_4$ 7 ba-zal	*the 7th day of the month passed,*

rev.

1) ki dŠul-gi-a-a-/ĝu$_{10}$-ta	*from Šulgi-a'aĝu,*
2) ba-zi	*was withdrawn.*
3) iti ezem An-na	*Month: 'Festival of An.'*
4) mu En-mah-gal-an-na/en dNanna ba-huĝ	*Year: 'Enmahgalanna the en-priestess of Nanna was installed.'*

left

1) 1	*(Sum:) 1*

8a. Obv. 2–3) For the terms ne-mur-ta ba-še$_6$ 'wird in der Asche gekocht' and gir$_4$-ta ba-še$_6$ 'wird im Ofen gekocht', see H. Brunke, *Essen in Sumer: Metrologie,*

Herstellung und Terminologie nach Zeugnis der Ur III-zeitlichen Wirtschaftsurkunden (München: Herbert Utz Verlag, 2011), pp. 171–2; P. Steinkeller, 'Joys of Cooking in Ur III Babylonia', in P. Michalowski (ed.), *On the Third Dynasty of Ur: Studies in Honor of Marcel Sigrist* (Boston: American Schools of Oriental Research, 2008), p. 186 ('Like its Akkadian correspondent *bašālu*, šag$_6$ seems to denote any type of food preparation involving heating, such as boiling, frying, roasting, and baking. Accordingly, its best translation is "to cook" ').

No. 9 – Transfer of animals

Museum number: DIA 19.024.15
Provenience: Puzriš-Dagan
Date: AS 6 ix 22
obv.

1) 3 lulim nita$_2$	*3 male deer,*
2) 3 lulim munus	*3 female deer,*
3) 1 ha-bu-um	*1 habum-animal,*
4) u$_4$ 22-kam	*on the 22nd day,*
5) ki Ab-ba-sa$_6$-/ga-ta	*from Abba-saga,*

rev.

1) Lu$_2$-diĝir-ra	*Lu-diĝira*
2) i$_3$-dab$_5$	*received.*
3) iti ezem mah	*Month: 'Great Festiva'.*
4) mu Ša-aš-ru/ki ba-hul	*Year: 'Šašrum was destroyed.'*
left	
1) 7	*(Sum:) 7.*

9a. Obv. 1–2) For the term lulim, 'a type of deer', see P. Steinkeller, 'Sheep and goat terminology in Ur III sources from Drehem', *Bulletin on Sumerian Agriculture*, 8 (1995), 50.

9b. Obv. 3) For the term ha-bu-um, see M. Stępień, *Animal Husbandry in the Ancient Near East: A Prosopographic Study of Third-Millennium Umma* (Bethesda: CDL Press, 1996), p. 212; M. Hilgert, *Cuneiform Texts from the Ur III Period in the Oriental Institute, Volume 2: Drehem Administrative Documents from the Reign of Amar-Suena* (Chicago: The Oriental Institute of the University of Chicago, 2003), p. 62.

No. 10 – Receipt of livestock delivered

Museum number: DIA 19.024.06
Provenience: Puzriš-Dagan
Date: AS 7 xii 25

obv.

1) 1 sila$_4$	1 lamb
2) Sig$_4$-te-li	of Sigteli,
3) 1 maš$_2$ Du-uk-ra	1 kid of Dukra,
4) 1 sila$_4$ Ur-dEn-gal-/du-du	1 lamb of Ur-Engaldudu,
5) 1 sila$_4$ Za-zi	1 lamb of Zazi,
6) 1 sila$_4$ Ĝiri$_3$-ni-i$_3$-sa$_6$	1 lamb Ĝirini-isa,

rev.

1) 1 amar maš-da$_3$ nita$_2$	1 young male gazelle
2) Ur-niĝarĝar	of Ur-niĝar,
3) 1 sila$_4$ dUTU-ba-ni	1 lamb of Šamaš-bani,
4) u$_4$ 25-kam	on the 25th day,
5) mu-ku$_x$(DU)	delivery,
6) Ab-ba-sa$_6$-ga i$_3$-dab$_5$	Abba-saga received.
7) iti še-KIN-ku$_5$	Month: 'Barley-Harvest'.
8) mu Hu-uh$_2$-nu-riki/ba-hul	Year: 'Huhnuri was destroyed.'

left

1) 7	(Sum:) 7.

10a. Obv. 2) For the PN Sigteli, see I. J. Gelb, *Glossary of Old Akkadian* (Chicago: University of Chicago Press, 1957), pp. 290–1. For the alternative reading Murteli, see W. Röllig, 'Murteli', *Reallexikon der Assyriologie und vorderasiatischen Archäologie*, 8 (1993–1996), 441.

10b. Obv. 3) For the PN Du-uk-ra, see A. Goetze, 'Šakkanakkus of the Ur III Empire', *Journal of Cuneiform Studies*, 17 (1963), 16.

10c. Obv. 4) For the PN Ur-dEn-gal-du-du, see Goetze, 'Šakkanakkus of the Ur III Empire', 20–1.

10d. Obv. 5) For the PN Za-zi read as Sa$_3$-si$_2$ from Akkadian *sâsum* 'moth', see Gelb, *Glossary of Old Akkadian*, p. 237.

No. 11 – Receipt of dead animals

Museum number: DIA 19.024.05
Provenience: Puzriš-Dagan
Date: AS

bulla

1) 1 udu hur-saĝ	1 wild sheep,
2) 6 maš-da$_3$	6 gazelles,
3) ba-ug$_7$	dead,
4) ki Tu-ra-am-/dDa-gan-ta	from Turam-Dagan,
5) [dŠul-gi-iri-ĝu$_{10}$]	Šulgi-iriĝu
6) [šu ba-ti]	received.
7) [kišib Ba-ba-ti]	Under seal of Babati.
8) [iti ...]	Month: [...].
9) [mu ...]	Year: [...].

seal

i 1) dAmar-dEN.ZU *Amar-Suen,*
 2) [ni]ta kala-ga *strong man,*
 3) [lu]gal Uri$_5$/ki-ma *king of Ur,*
 4) [lugal an ub-da limmu$_2$-ba] *king of the four quarters:*
ii 5) Ba-b[a-ti] *Babati,*
 6) dub-[sar] *scribe,*
 7) arad$_2$-[zu] *(is) your servant.*

11a. 6–9) For the restoration of the damaged lines, see *NYPL* 354, *PDT* 1 398, *PPAC* 4 121. For Babati, see lately P. Michalowski, *The Correspondence of the Kings of Ur: An Epistolary History of an Ancient Mesopotamian Kingdom* (Winona Lake: Eisenbrauns, 2011), pp. 147–9.

No. 12 – Withdrawal of livestock

Museum number: DIA 19.024.08
Provenience: Puzriš-Dagan
Date: ŠS 9 ii
obv.

1) 1 gu$_4$ e$_2$ dNanna *1 ox for the temple of Nanna,*
2) ĝiri$_3$ Ku$_3$-dNanna *conveyor: Ku-Nanna,*
3) 1 udu 1 maš$_2$ gal *1 sheep, 1 goat,*
4) zi-ga *withdrawal,*
5) ĝiri$_3$ Ur-šu-ga-lam-ma *conveyor: Ur-šugalama,*
6) 2 udu mu kin!(TUK)-na-še$_3$ *2 sheep on behalf of working*
7) SIPA-ṣi-in *for Re'usin,*

rev.

1) 1 maš$_2$ gal u$_2$ *1 grass-fed goat*
2) mu kin!(TUK)-na-še$_3$ *on behalf of working*
3) Ur-niĝarĝar *for Ur-niĝar.*

4) iti maš-da$_3$-gu$_7$ *Month: 'Eating-gazelle'.*
5) mu e$_2$ dŠara$_2$/ba-du$_3$ *Year: 'The temple of Šara was built.'*

12a. Obv. 6, Rev. 2) The sign TUK is presumably a scribal error for kin 'to work' (see Salonen, *Agricultura Mesopotamica: Nach Sumerisch-Akkadischen Quellen*, p. 147). For the expression mu kin-na-še$_3$, see *MVN* 13 464, *TCL* 2 5506, *YOS* 15 162.

12b. Obv. 7) For SIPA-ṣi-in, see Gelb, *Glossary of Old Akkadian*, p. 228, Hilgert, *Akkadisch in der Ur III-Zeit*, p. 475.

No. 13 – Receipt of reeds delivered

Museum number: DIA 19.024.04
Provenience: Puzriš-Dagan
Date: IS 1 ii

obv.

1) 3595 ⁵/₆ /gu₂ gi-zi	3595 ⁵/₆ loads of gizi-reeds
2) ša₃ PU₃.ŠA-iš-ᵈDa-gan	in Puzriš-Dagan,
3) 1426 gu₂ gi-zi	1426 loads of gizi-reeds
4) ša₃ Nibru^ki	in Nippur,
5) 5021 ⁵/₆ gu₂	5021 ⁵/₆ loads of (gizi-reeds),

rev.

1) ša₃-gal udu niga-še₃	fodder for the barley-fed sheep,
2) a₂ erin₂ Ĝir₂-su^ki	labor of the troops of Ĝirsu,
3) ki sukkal-mah-ta	from the chief secretary,
4) mu-ku_x(DU)	delivery,
5) ᵈŠul-gi-i₃-li₂	Šulgi-ili
6) šu ba-ti	received.
7) ĝiri₃ Lu₂-giri₁₇-zal	Conveyor: Lu-girizal.
8) iti maš-da₃-gu₇	Month: 'Eating-gazelle'.
9) mu ᵈI-bi₂-ᵈEN.ZU/lugal	Year: 'Ibbi-Suen was the king.'

13a. Obv. 1) For the term gu₂, a unit of weight 'Traglast', see H. Waetzoldt, 'Rohr und dessen Verwendungsweisen', *Bulletin on Sumerian Agriculture*, 6 (1992), 126. For gi-zi, a sort of reed, see W. Heimpel, *Workers and Construction Work at Garšana* (Bethesda: CDL Press, 2009), p. 210.

13b. Rev. 3) For the profession sukkal-mah, 'chief secretary' or 'secretary of state', see T. M. Sharlach, 'Diplomacy and the Rituals of Politics at the Ur III Court', *Journal of Cuneiform Studies*, 57 (2005), 18; Michalowski, *The Correspondence of the Kings of Ur: An Epistolary History of an Ancient Mesopotamian Kingdom*, p. 65.

No. 14 – Record on barley

Museum number: DIA 19.024.14
Provenience: Umma
Date: Š 30 v
obv.

1) 2.0.0 še gur lugal	2 royal gur barley
2) še-ba za₃-mu	as the barley-ration of New Year
3) Lugal-^ĝiš gigir-re	Festival,
4) dumu Igi-ᵈŠara₂-še₃/muhaldim	for Lugal-gigire son of Igi-Šaraše the cook,

rev.

1) a-ša₃ sipa-ne-/ta	from the field of shepherds.
2) iti dal	Month: 'dal'.
3) mu dumu lugal PA.TE./SI An-ša-na^ki-/ke₄ ba-tuku-a	Year: 'The ensi of Anšan married the daughter of the king.'

14a. Obv. 2) For the term za₃-mu 'New Year', see M. E. Cohen, *The Cultic Calendars of the Ancient Near East* (Bethesda: CDL Press, 1993), pp. 14–16; Sallaberger, *Der kultische Kalender der Ur III-Zeit*, p. 142.

14b. Obv. 3–4) For the father-and-son relationship between Igi-dŠara$_2$-še$_3$ and Lugal-ĝišgigir-re, see *CUSAS* 39 135, *TCNU* 706. For the personal name Igi-dŠara$_2$-še$_3$ 'in the presence of (the deity) Šara', see Igi-dEn-lil$_2$-še$_3$ 'in the presence of (the deity) Enlil', a well-known name from Puzriš-Dagan texts.

No. 15 – List of barley

Museum number: DIA 19.024.02
Provenience: Umma
Date: <Š 43>
obv.

1) [7.3.4 3]+2 sila$_3$ še gur	7 gur 3 barig 4 ban 5 sila barley
2) Lugal-im-ri-a	by Lugal-imria,
3) 3.4.0 gur Niĝ$_2$-tuku	3 gur 4 barig by Nigtuku,
4) 7.0.3 7½ sila$_3$ gur	7 gur 3 ban 7½ sila
5) U$_2$-u$_2$-mu	by U'umu,
6) 7.2.3 gur La-qi$_3$-ip	7 gur 2 barig 3 ban by Laqip,
7) 8.0.0 gur A$_2$-bi$_2$-li$_2$	8 gur by Abili,
8) 6.2.3 Zu$_2$-la-a	6 gur 2 barig 3 ban by Zula'a,
9) 3.3.4 5 sila$_3$ Ur-niĝarĝar	3 gur 3 barig 4 ban 5 sila by Ur-niĝar,
10) 9.4.2 2½ sila$_3$ gur	9 gur 4 barig 2 ban 2½ sila
11) Ad-il$_2$-at	by Adilat,
12) 3.0.2 7½ sila$_3$ gur A-kal-l[a]	3 gur 2 ban 7½ sila by Akalla,
13) 3.0.0 gur Lu$_2$-dNin-ĝir$_2$-su	3 gur by Lu-Ninĝirsu,
14) 1.0.0 gur ki Lugal-ku$_3$-zu-ta	1 gur from Lugal-kuzu,
15) 8.0.0 gur Ur-dBa-ba$_6$	8 gur by Ur-Baba,
16) 30+[7.1.1] gur {sila$_3$} Šu-zu	37 gur 1 barig 1 ban by Šuzu,

rev.

1) 8.1.5 2½ sila$_3$ [gur]	8 gur 1 barig 5 ban 2½ sila
2) I-di$_3$-na-[dI]ŠKUR	by Iddin-Adad,
3) [4]+3.0.0 gur Ur-niĝarĝar	7 gur by Ur-niĝar,
4) [1.3.0] gur E-mu$_5$(NI)-ul	1 gur 3 barig by Emul,
5) [2.3.0] gur A-hu-ni	2 gur 3 barig by Ahuni.

This text is a duplicate of *AAICAB* 1/2 pl. 148 1971–377 (Š 43). It is not clear why the lines rev. 6–11 of *AAICAB* 1/2 pl. 148 1971–377 are omitted or missing in the present text (presumably one line lost after blank space of the reverse). A possible reason is that this text is an incomplete copy or exercise work of its original text *AAICAB* 1/2 pl. 148 1971–377. This text records the barley delivered by numerous persons. For instance, 7.3.4 5 sila$_3$ še gur (in obv. 1) refers to the capacity of barley, meaning 7 gur, 3 barig (ba-ri-ga), 4 ban$_2$, 5 sila$_3$. Note the ancient Mesopotamian units of capacity: 1 gur = 5 barig, 1 barig = 6 ban$_2$, 1 ban$_2$ = 10 sila$_3$, and 1 sila$_3$ is approximately equal to 1 litre.

15a. Obv. 2) The name is read as Lugal-lim$_4$(NE)-ri-a in *AAICAB* 1/2 pl. 148 1971–377.

15b. Obv. 8) This line is 6.2.3 gur Zu-la-a in *AAICAB* 1/2 pl. 148 1971–377.

15c. Obv. 11) The name is Ad-il$_3$-at in *AAICAB* 1/2 pl. 148 1971–377. For the variants of this name, see *UMTBM* 3 21 (Ad-il-at), *Nisaba* 3 191 (Ad-il$_3$-at). Other variants of this name are: Ad-i$_3$-la-at, Ad-il$_6$-lat, Ad-illat. The variants and reading of this PN have been discussed by M. Molina and P. Notizia, 'Five Cuneiform Tablets from Private Collections', *Annali dell'Istituto Universitario Orientale di Napoli. Sezione linguistica*, 72 (2012), p. 56.

15d. Rev. 4) The name E-mu$_5$(NI)-ul is written as E-mul (e-AN.AN.AN) in *AAICAB* 1/2 pl. 148 1971–377.

No. 16 – List of trees producing dates

Museum number: DIA 19.024.01
Provenience: Umma
Date: Š 47
obv.

col. i
1) [x] ĝiš 3 sila$_3$ [x] trees (each producing) 3 sila (dates),
2) [x] ĝiš 0.0.5 [x] trees (each producing) 5 ban (dates),
3) [x]+6 ĝiš 5 6+ trees (each producing) 5 sila (dates),
4) [x]+8 ĝiš 0.0.1 8+ trees (each producing) 1 ban (dates),
5) [x]+2 ĝiš 2 sila$_3$ 2+ trees (each producing) 2 sila (dates),
6) [x]+3 ĝiš 0.0.2 3+ trees (each producing) 2 ban (dates),
7) [x]+6 ĝiš 0.0.1 5 6+ trees (each producing) 1 ban 5 sila
8) [x]+3 ĝiš 0.0.4 (dates),
9) 1 ĝiš 0.0.2 5 3+trees (each producing) 4 ban (dates),
10) zu$_2$-lum-bi 2.1.0 3 sila$_3$/gur 1 tree (producing) 2 ban 5 sila (dates).
11) šu-niĝin$_2$ 64 ĝiš hi-a Their dates: 2 gur 1 barig 3 sila,
12) Lugal-iti-da SIG$_7$-a total: 64 assorted trees,
13) 2 ĝiš 0.1.0 Lugal-itida, the blind person.
14) 13 ĝiš 0.0.1 2 trees (each producing) 1 barig (dates),
15) 10-la$_2$-1 ĝiš 0.0.2 13 trees (each producing) 1 ban (dates),
16) 10-la$_2$-1 ĝiš 3 sila$_3$ 9 trees (each producing) 2 ban (dates),
17) 4 ĝiš 0.0.2 5 9 trees (each producing) 3 sila (dates),
18) 2 ĝiš 0.0.5 4 trees (each producing) 2 ban 5 sila
19) 1 ĝiš 0.0.4 (dates),
20) 2 ĝiš 0.0.1 5 2 trees (each producing) 5 ban (dates),
21) 10 ĝiš 0.0.3 1 tree (producing) 4 ban (dates),
22) 15 ĝiš 5 2 trees (each producing) 1 ban 5 sila
23) 7 ĝiš 2 sila$_3$ (dates),
24) zu$_2$-lum-bi 3.3.3/6 sila$_3$ gur 10 trees (each producing) 3 ban (dates),
25) šu-niĝin$_2$ 74 ĝiš hi-a 15 trees (each producing) 5 sila (dates),
26) Ur-dEn-gal-du-du 7 trees (each producing) 2 sila (dates).
27) 5 ĝiš 0.0.3 5 Their dates: 3 gur 3 barig 3 ban 6 sila,
28) 19 ĝiš 0.0.3 total: 74 assorted trees,
29) 67 ĝiš ša$_3$-su$_3$ Ur-Engaldudu.
30) 10 ĝiš 0.0.4 5 trees (each producing) 3 ban 5 sila

31) 14 ĝiš 0.0.2 5
32) 30-la₂-1 ĝiš 5
33) 22 ĝiš 0.0.2
34) 8 ĝiš 3 sila₃
35) 30-la₂-1 ĝiš 0.0.1
36) 6 ĝiš 0.0.1 5
37) 10-la₂-1 ĝiš 2 sila₃
38) 1 ĝiš 0.1.0 [5]
col. ii
1) zu₂-lum-bi 8.2.5/7 sila₃
2) šu-niĝin₂ 220-la₂-1 ĝiš hi-a
3) Lu₂-ᵈNin-šubur/šandana
4) 15 ĝiš 0.0.3
5) 45 ĝiš ša₃-su₃
6) 8 ĝiš 5
7) 3 ĝiš 0.0.4
8) 20 ĝiš 0.0.1
9) 15 ĝiš 0.0.2
10) 3 ĝiš 0.0.2 5
11) 5 ĝiš 0.0.1 5
12) 1 ĝiš 3 sila₃
13) 2 ĝiš 2 sila₃
14) zu₂-lum-bi 4.1.0 7 sila₃ gur
15) šu-niĝin₂ 117 ĝiš hi-a
16) U₃-ma-ni
17) 30-la₂-1 ĝiš 0.0.1
18) 10-la₂-1 ĝiš 0.0.1 5
19) 25 ĝiš 5 sila₃
20) 10 ĝiš 0.0.2
21) 22 ĝiš ša₃-su₃
22) 6 ĝiš 0.0.2 5
23) 12 ĝiš 0.0.3
24) 32 ĝiš 3 sila₃
25) 2 ĝiš 0.0.3 5
26) 12 ĝiš 2 sila₃
27) zu₂-lum-bi 4.3.4 5/sila₃ gur
28) šu-niĝin₂ 160-la₂-1 ĝiš hi-a
29) a-ša₃ gibil
30) Ur-ᵈA-šar₂
31) 5 ĝiš 0.0.3
32) 7 ĝiš 5
33) 3+[x] ĝiš 0.0.1
34) [x] ĝiš 0.0.4
destroyed below
col. iii
1) zu₂-lum-bi 1.2.0 6 sila₃ gur
2) šu-niĝin₂ 41 ĝiš hi-a
3) Ma₂-gur₈-re
4) 18 ĝiš 5
5) 5 ĝiš 3 sila₃
6) 4 ĝiš 2 sila₃

(dates),
19 trees (each producing) 3 ban (dates),
67 unproductive trees,
10 trees (each producing) 4 ban (dates),
14 trees (each producing) 2 ban 5 sila
(dates),
29 trees (each producing) 5 sila (dates),
22 trees (each producing) 2 ban (dates),
8 trees (each producing) 3 sila (dates),
29 trees (each producing) 1 ban (dates),
6 trees (each producing) 1 ban 5 sila
(dates),
9 trees (each producing) 2 sila (dates),
1 tree (producing) 1 barig 5 sila (dates).

Their dates: 8 gur 2 barig 5 ban 7 sila,
total: 219 assorted trees,
Lu-Ninšubur, the garden administrator.
15 trees (each producing) 3 ban (dates),
45 unproductive trees,
8 trees (each producing) 5 sila (dates),
3 trees (each producing) 4 ban (dates),
20 trees (each producing) 1 ban (dates),
15 trees (each producing) 2 ban (dates),
3 trees (each producing) 2 ban 5 sila
(dates),
5 trees (each producing) 1 ban 5 sila
(dates),
1 tree (producing) 3 sila (dates),
2 trees (each producing) 2 sila (dates).
Their dates: 4 gur 1 barig 7 sila,
total: 117 assorted trees,
Umani.
29 trees (each producing) 1 ban (dates),
9 trees (each producing) 1 ban 5 sila
(dates),
25 trees (each producing) 5 sila (dates),
10 trees (each producing) 2 ban (dates),
22 unproductive trees,
6 trees (each producing) 2 ban 5 sila
(dates),
12 trees (each producing) 3 ban (dates),
32 trees (each producing) 3 sila (dates),
2 trees (each producing) 3 ban 5 sila
(dates),
12 trees (each producing) 2 sila (dates).
Their dates: 4 gur 3 barig 4 ban 5 sila,
total: 159 assorted trees,
in the new field,
Ur-Ašar.
5 trees (each producing) 3 ban (dates),

7) 25 ĝiš 0.0.1
8) 2 ĝiš 0.0.1 5
9) 3 ĝiš 0.0.3
10) 10-la₂₋1 ĝiš [0.0.2]

11) 2 ĝiš 0.0.2 [5]
12) zu₂-lum-bi 2.1.5 3 sila₃ gur
13) šu-niĝin₂ 68 ĝiš hi-a
14) An-dul₃
rev.

col. iv

1) e₂ ᵈNin-ur₄-ra
2) 20-la₂₋1 ĝiš 5
3) 27 ĝiš 2 sila₃
4) 7 ĝiš 3 sila₃
5) 105 ĝiš ša₃-su₃
6) 14 ĝiš 0.0.1
7) 20-la₂₋1 ĝiš 0.0.2
8) 7 ĝiš 0.0.1 5
9) 1 ĝiš 0.0.4
10) 6 ĝiš 0.0.3
11) 2 ĝiš 1 sila₃
12) 5 ĝiš 0.0.2 5
13) zu₂-lum-bi 3.4.0 2 sila₃/ gur
14) šu-niĝin₂ 212 ĝiš hi-a
15) Lu₂-ᵈAb-U₂
16) 35 ĝiš 5
17) 157 ĝiš ša₃-su₃
18) 13 ĝiš 2 sila₃
19) 38 ĝiš 3 sila₃
20) 33 ĝiš 0.0.2
21) 55 ĝiš 0.0.1
22) 10 ĝiš 0.0.3
23) 15 ĝiš 0.0.1 5
col. v
beginning destroyed
1') šu-niĝin₂ [x] ĝiš hi-a
2') Lugal-ku₃-zu
3') 14 ĝiš 0.0.1
4') 10 ĝiš 0.0.2
5') 12 ĝiš 5
6') 20 ĝiš ša₃-su₃
7') 4 ĝiš 0.0.3
8') 3 ĝiš 0.0.2 5
9') 3 ĝiš 0.0.1 5
10') 7 ĝiš 3 sila₃
11') 2 ĝiš 0.0.4
12') zu₂-lum-bi 2.2.2 1 sila₃/ gur
13') šu-niĝin₂ 75 ĝiš hi-a
14') Lugal-e-i₃-zu

7 trees (each producing) 5 sila (dates),
3+trees (each producing) 1 ban (dates),
[x] trees (each producing) 4 ban (dates),
[…].

Their dates: 1 gur 2 barig 6 sila,
total: 41 assorted trees,
Magure.
18 trees (each producing) 5 sila (dates),
5 trees (each producing) 3 sila (dates),

4 trees (each producing) 2 sila (dates),
25 trees (each producing) 1 ban (dates),
2 trees (each producing) 1 ban 5 sila
(dates),
3 trees (each producing) 3 ban (dates),
9 trees (each producing) 2 ban (dates),
2 trees (each producing) 2 ban 5 sila
(dates).
Their dates: 2 gur 1 barig 5 ban 3 sila,
total: 68 assorted trees,
Andul,

for the temple of Ninurra.
19 trees (each producing) 5 sila (dates),
27 trees (each producing) 2 sila (dates),
7 trees (each producing) 3 sila (dates),
105 unproductive trees,
14 trees (each producing) 1 ban (dates),
19 trees (each producing) 2 ban (dates),
7 trees (each producing) 1 ban 5 sila
(dates),
1 tree (producing) 4 ban (dates),
6 trees (each producing) 3 ban (dates),
2 trees (each producing) 1 sila (dates),
5 trees (each producing) 2 ban 5 sila
(dates).
Their dates: 3 gur 4 barig 2 sila,
total: 212 assorted trees,
Lu-AbU.
35 trees (each producing) 5 sila (dates),
157 unproductive trees,
13 trees (each producing) 2 sila (dates),
38 trees (each producing) 3 sila (dates),
33 trees (each producing) 2 ban (dates),
55 trees (each producing) 1 ban (dates),
10 trees (each producing) 3 ban (dates),
15 trees (each producing) 1 ban 5 sila
(dates),
[…Their dates: xxx],
total: [x] assorted trees,
Lugal-kuzu.

col. vi

1) e₂ ᵈŠara₂
2) [mu] us₂-sa Ki-maški/ba-hul

14 trees (each producing) 1 ban (dates),
10 trees (each producing) 2 ban (dates),
12 trees (each producing) 5 sila (dates),
20 unproductive trees,
4 trees (each producing) 3 ban (dates),
3 trees (each producing) 2 ban 5 sila
(dates),
3 trees (each producing) 1 ban 5 sila
(dates),
7 trees (each producing) 3 sila (dates),
2 trees (each producing) 4 ban (dates).
Their dates: 2 gur 2 barig 2 ban 1 sila,
total: 75 assorted trees,
Lugale-izu,
for the temple of Šara.
Year after: 'Kimaš was destroyed.'

This large text lists the date palms along with their produce, see D. C. Snell, 'The Lager Texts: Transliterations, Translations and Notes', *Acta Sumerologica*, 11 (1989), 155–224. The date harvest may have stretched from the sixth month to the twelfth month of the year (see R. W. Schery, *Plants for Man* (Englewood Cliffs: Prentice-Hall, 1972), p. 567), perhaps peaking in the tenth month of the year (see D. Cocquerillat, *Palmeraies et Cultures de l'Eanna d'Uruk (559–520)* (Berlin: Gebr. Mann Verlag, 1968), p. 34).

16a. Obv. col. i 12) For the term SIG₇-a 'blind person', see W. Heimpel, 'Blind Workers in Ur III Texts', *Kaskal*, 6 (2009), 43; A. Greco, *Garden Administration in the Ĝirsu Province during the Neo-Sumerian Period* (Madrid: Consejo Superior de Investigaciones Científicas, 2015), p. 304.

16b. Obv. col. ii 3) For the term šandana 'garden administrator', see Greco, *Garden Administration in the Ĝirsu Province during the Neo-Sumerian Period*, p. 305.

16c. Rev. col. iv 15) The PN Lu₂-ᵈAb-U₂ (see Sallaberger, *Der kultische Kalender der Ur III-Zeit*, p. 190) is probably read as Lu₂-ᵈAb-ba₆ (see Owen, *Cuneiform Texts Primarily from Iri-Saĝrig/Āl-Šarrākī and the History of the Ur III Period, Volume 1: Commentary and Indexes*, p. 503) or Lu₂-ᵈAb-bu₁₁ (lately, see I. Schrakamp, 'Die Lesungen der Götternamen ᵈba-U₂ und ᵈab-U₂. Bemerkungen zu J. Keetman, Revue d'assyriologie et d'archéologie orientale 112, 2018, 15–22', *Nouvelles Assyriologiques Brèves et Utilitaires*, 1 (2019), 6–8).

No. 17 – Receipt of barley

Museum number: DIA 19.024.12
Provenience: Umma
Date: AS 2 xii

obv.

 1) 0.2.0 še-ba za$_3$-mu *2 barig barley-ration of New Year*
 2) e$_2$-kikken-ta *Festival, from the millhouse,*
 3) dNin-ur$_4$-ra-/da *Ninurrada*
 4) šu ba-ti *received.*

rev.

 1) iti dDumu-zi *Month: 'Dumuzi'.*
 2) mu Ur-bi$_2$-/i$_3$-lumki ba-/hul *Year: 'Urbilum was destroyed.'*

17a. Obv. 2) For the term e$_2$-kikken, 'millhouse', in the Ur III period, see L. Milano, 'Mühle. A. I. In Mesopotamien', *Reallexikon der Assyriologie und vorderasiatischen Archäologie*, 8 (1993–97), 393–400.

17b. Obv. 3) This PN is exclusively attested in Umma texts, see *AnOr* 1 88, *BCT* 2 224, *BPOA* 2 2656, *BPOA* 6 1535, *MCS* 7 23 BM 106075, *Nisaba* 23 41, *Tavolette* 295, *TCL* 5 6038.

No. 18 – Messenger text

Museum number: DIA 19.024.16a
Provenience: Umma
Date: ŠS 3 i 16

obv.

 1) 5 sila$_3$ kaš 3 sila$_3$ ninda 5 gin$_2$ šum$_2$ 3 gin$_2$ i$_3$ 2 [gin$_2$ naga] *5 sila beer, 3 sila bread, 5 gin onions, 3 gin oil, 2 gin herb-naga*
 2) Al-la-mu *for Allamu;*
 3) 5 sila$_3$ kaš 3 sila$_3$ ninda 5 gin$_2$ šum$_2$ 3 gin$_2$ i$_3$ [2 gin$_2$ naga] *5 sila beer, 3 sila bread, 5 gin onions, 3 gin oil, 2 gin herb-naga*
 4) PU$_3$.ŠA-Eš$_{18}$-tar$_2$ *for Puzur-Eštar;*
 5) 5 sila$_3$ kaš 3 sila$_3$ ninda 5 gin$_2$ <šum$_2$>3 gin$_2$ i$_3$ 2 [gin$_2$ naga] *5 sila beer, 3 sila bread, 5 gin onions, 3 gin oil, 2 gin herb-naga*
 6) Ad-da *for Adda;*
 7) 5 sila$_3$ kaš 3 sila$_3$ ninda 5 gin$_2$ šum$_2$ 3 gin$_2$ i$_3$/ 2 gin$_2$ [naga] *5 sila beer, 3 sila bread, 5 gin onions, 3 gin oil, 2 gin herb-naga*
 8) Lu$_2$-dBa-ba$_6$ *for Lu-Baba;*
 9) 5 sila$_3$ kaš 3 sila$_3$ ninda 5 gin$_2$ šum$_2$ 3 gin$_2$ i$_3$/ 2 gin$_2$ naga *5 sila beer, 3 sila bread, 5 gin onions, 3 gin oil, 2 gin herb-naga*
 10) Tu-ga *for Tuga;*
 11) 5 sila$_3$ kaš 3 sila$_3$ ninda 5 gin$_2$ šum$_2$ 3 gin$_2$ i$_3$ [2]/gin$_2$ [naga] *5 sila beer, 3 sila bread, 5 gin onions, 3 gin oil, 2 gin herb-naga*
 12) Lu$_2$-bala-sa$_6$-ga *for Lu-balasaga;*
 13) 5 sila$_3$ kaš 3 sila$_3$ ninda 5 gin$_2$ šum$_2$ 3 gin$_2$ i$_3$ 2 [gin$_2$ naga] *5 sila beer, 3 sila bread, 5 gin onions, 3 gin oil, 2 gin herb-naga*

 14) Ša$_3$-ku$_3$-ge *for Šakuge;*
 15) 3 sila$_3$ kaš 2 sila$_3$ ninda 5 gin$_2$ šum$_2$ 3/ gin$_2$ i$_3$ 2 gin$_2$ naga *3 sila beer, 2 sila bread, 5 gin onions, 3 gin oil, 2 gin herb-naga*

rev.

1) La-qi₃-ip *for Laqip;*
2) 3 sila₃ kaš 2 sila₃ ninda 5 gin₂ šum₂ [3 gin₂]/i₃ 2 gin₂ naga Ba-a-[x] *3 sila beer, 2 sila bread, 5 gin onions, 3 gin oil, 2 gin herb-naga for Ba'a-[x];*
3) 3 sila₃ kaš 2 sila₃ ninda 5 gin₂ šum₂ 3 [gin₂]/i₃ 2 gin₂ naga Ur-E₂-babbar₂ *3 sila beer, 2 sila bread, 5 gin onions, 3 gin oil, 2 gin herb-naga for Ur-Ebabbar;*
4) 3 sila₃ kaš 2 sila₃ ninda 5 gin₂ šum₂ 3 [gin₂ i₃ 2 gin₂ naga] *3 sila beer, 2 sila bread, 5 gin onions, 3 gin oil, 2 gin herb-naga*
5) Ha-la-l[a] *for Halala;*
6) 3 sila₃ kaš 2 sila₃ ninda 5 gin₂ šum₂ [3 gin₂ i₃ 2 gin₂ naga] *3 sila beer, 2 sila bread, 5 gin onions, 3 gin oil, 2 gin herb-naga*
7) Ur-ᵈŠul-pa-e₃ *for Ur-Šulpae;*
8) 3 sila₃ kaš 2 sila₃ ninda 5 gin₂ šum₂ 3 [gin₂ i₃ 2 gin₂ naga] *3 sila beer, 2 sila bread, 5 gin onions, 3 gin oil, 2 gin herb-naga*
9) Šu-Eš₁₈-[tar₂] *for Šu-Eštar;*
10) 0.0.1 kaš 1 dida sig₅/0.0.2 dabin Šu-ᵈNin-šubur *1 ban beer, 1 top quality sweet wort, 2 ban semolina for Šu-Ninšubur;*
11) šu-niĝin₂ 0.1.0 3 sila₃ kaš 1 KAŠ.[U₂.SA sig₅]/0.0.3 3 sila₃ ninda 0.0.2 [dabin] *sum: 1 barig 3 sila beer, 1 top quality sweet wort, 3 ban 3 sila bread, 2 ban semolina;*
12) šu-niĝin₂ 1 sila₃ 5 gin₂ šum₂ [½ sila₃ 9]/ gin₂ i₃ šu-niĝin₂ ⅓ sila₃ 6 gin₂/naga *sum: 1 sila 5 gin onions, ½ sila 9 gin oil; sum: ⅓ sila 6 gin herb-naga.*

left

1) u₄ 16-kam iti še-KIN-ku₅ *On the 16th day. Month: 'Barley-Harvest.' Year*
2) mu us₂-sa ma₂ ᵈEn-ki ba-ab-du₈ *after: 'The boat of Enki was caulked.'*

This text is one of the 'messenger texts' from Umma (Group B based on R. C. McNeil, 'The "Messenger Texts" of the Third of Ur Dynasty' (PhD dissertation, University of Pennsylvania, 1971)). The content of these texts is represented by the assignment of six types of goods (beer, bread, onions, oil, herb-naga and fish) in quite regular quantities that normally vary. The receivers of these food allotments are mostly single persons mentioned either only with the name or also with the name of their profession or office, such as sukkal, gaba-aš, gaba-ta or KA-us₂-sa₂. For the previous study of the 'messenger texts', see McNeil, 'The "Messenger Texts" of the Third of Ur Dynasty'; F. D'Agostino and F. Pomponio, *Umma Messenger Texts in the British Museum, Part One (UMTBM 1)* (Messina: Dipartimento di Scienze dell'Antichita dell'Universita degli Studi di Messina, 2002).

No. 19 – Messenger text

Museum number: DIA 19.024.16b
Provenience: Umma
Date: ŠS 3 iv 18

obv.

1) 5 sila$_3$ kaš 3 sila$_3$ ninda 5 gin$_2$ šum$_2$ 3 gin$_2$ i$_3$ 2 gin$_2$ naga
2) Lu$_2$-giri$_{17}$-zal
3) 5 sila$_3$ kaš 3 sila$_3$ ninda 5 gin$_2$ šum$_2$ 3 gin$_2$ i$_3$ 2 gin$_2$ naga
4) PU$_3$.ŠA-dšakkan$_2$
5) 5 sila$_3$ kaš 5 sila$_3$ ninda 5 gin$_2$ šum$_2$ 3 gin$_2$ i$_3$ 2 gin$_2$ naga
6) A-a-kal-la sukkal
7) 5 sila$_3$ kaš 3 sila$_3$ ninda 5 gin$_2$ šum$_2$ 3 gin$_2$ i$_3$ 2 gin$_2$/naga
8) Li-bur-dŠul-gi
9) [5] sila$_3$ kaš 3 sila$_3$ ninda 5 gin$_2$ šum$_2$ 3 gin$_2$ i$_3$ 2 gin$_2$ naga
10) [A]-da-lal$_3$
11) [5 sila$_3$] kaš 3 sila$_3$ ninda 5 gin$_2$ šum$_2$ 3 gin$_2$ i$_3$ 2 gin$_2$ naga
12) [Ip]-qu$_2$-ša
13) [5 sila$_3$ kaš] 3 sila$_3$ ninda 5 gin$_2$ šum$_2$ 3 gin$_2$ i$_3$ 2 gin$_2$ naga
14) An-ne$_2$
15) 3 sila$_3$ kaš 2 sila$_3$ ninda 5 gin$_2$ šum$_2$ 3 gin$_2$ i$_3$/ 2 gin$_2$ naga
16) [L]u$_2$-kal-la
17) [3 sila$_3$ kaš] 2 sila$_3$ ninda 5 gin$_2$ šum$_2$ 3 gin$_2$ i$_3$/2 gin$_2$ naga

5 sila beer, 3 sila bread, 5 gin onions, 3 gin oil, 2 gin herb-naga
for Lu-girizal;
5 sila beer, 3 sila bread, 5 gin onions, 3 gin oil, 2 gin herb-naga
for Puzur-Šakkan;
5 sila beer, 5 sila bread, 5 gin onions, 3 gin oil, 2 gin herb-naga
for A'a-kala the diplomatic secretary;
5 sila beer, 3 sila bread, 5 gin onions, 3 gin oil, 2 gin herb-naga
for Libur-Šulgi;
5 sila beer, 3 sila bread, 5 gin onions, 3 gin oil, 2 gin herb-naga
for Adalal;
5 sila beer, 3 sila bread, 5 gin onions, 3 gin oil, 2 gin herb-naga
for Ipquša;
5 sila beer, 3 sila bread, 5 gin onions, 3 gin oil, 2 gin herb-naga
for Anne;
3 sila beer, 2 sila bread, 5 gin onions, 3 gin oil, 2 gin herb-naga
for Lu-kala;
3 sila beer, 2 sila bread, 5 gin onions, 3 gin oil, 2 gin herb-naga

rev.

1) Ur-dBa-ba$_6$
2) [3 sila$_3$ kaš] 2 sila$_3$ ninda 5 gin$_2$ šum$_2$ 3 gin$_2$ i$_3$/2 gin$_2$ naga
3) Ur-ur
4) [3 sila$_3$] kaš 2 sila$_3$ ninda 5 gin$_2$ šum$_2$ 3 gin$_2$ i$_3$ 2 gin$_2$ naga
5) Im-ti-dam
6) 3 sila$_3$ kaš 2 sila$_3$ ninda 5 gin$_2$ šum$_2$ 3 gin$_2$ i$_3$ 2 gin$_2$ naga Ur-PA
7) 0.0.2 kaš 2 dida du 0.0.2 1 dida sig$_5$/0.0.2 zi$_3$-gu sig$_5$ 0.1.3 dabin 2 sila$_3$ i$_3$/0.0.2 zu$_2$-lum 2 maš$_2$
8) elam Hu-li$_2$-bar-[ra-ke$_4$ šu ba-ti]
9) šu-nigin$_2$ 0.1.1 kaš 2 dida du 0.0.2 1 dida sig$_5$
10) šu-nigin$_2$ 0.0.3 3 sila$_3$ ninda 0.0.2 zi$_3$-gu sig$_5$ 0.1.3 dabin/0.0.2 zu$_2$-lum [...] 2 maš$_2$
11) šu-nigin$_2$ 1 sila$_3$ šum$_2$ šu-nigin$_2$ 2 ½ sila$_3$ 6 gin$_2$ i$_3$
12) šu-nigin$_2$ ⅓ sila$_3$ 4 gin$_2$ naga left
1) u$_4$ 18-kam iti ne[sag mu]/Si-ma-num$_2^{[ki]}$ ba-[hul]

for Ur-Baba;
3 sila beer, 2 sila bread, 5 gin onions, 3 gin oil, 2 gin herb-naga
for Urur;
3 sila beer, 2 sila bread, 5 gin onions, 3 gin oil, 2 gin herb-naga
for Imtidam;
3 sila beer, 2 sila bread, 5 gin onions, 3 gin oil, 2 gin herb-naga for Ur-PA;
2 ban beer, 2 normal sweet wort, 2 ban 1 top-quality sweet wort, 2 ban top-quality sigu, 1 barig 3 ban semolina, 2 sila oil, 2 ban dates, 2 goats; the Elamites of Hulibar received;
sum: 1 barig 1 ban beer, 2 normal sweet wort, 2 ban 1 top-quality sweet wort;
sum: 3 ban 3 sila bread, 2 ban top-quality sigu, 1 barig 3 ban semolina, 2 ban dates, 2 goats; sum: 1 sila onions; sum: 2 ½ sila 6 gin oil;
sum: ⅓ sila 4 gin herb-naga.
On the 18th day. Month: 'The first-fruit offering'. Year: 'Simanum was destroyed.'

This text belongs to the so-called Umma 'messenger texts', a variant of Group B, based on McNeil, 'The "Messenger Texts" of the Third of Ur Dynasty'.

19a. Rev. 8) For the phrase elam Hu-li$_2$-bar-ra-ke$_4$ šu ba-ti, see *Nisaba* 16 58.

No. 20 – Messenger text

Museum number: DIA 19.024.16d
Provenience: Umma
Date: ŠS 5 viii
obv.

1) 2 dida du {PA}/0.1.0 dabin ½ sila$_3$ i$_3$	*2 normal sweet wort, 1 barig semolina, ½ sila oil*
2) Ba-ga u$_3$ DIĜIR-ba-qar	*for Baga and Ilum-baqar;*
3) 0.0.1 5 sila$_3$ kaš 0.0.1 5 sila$_3$ ninda/10 gin$_2$ i$_3$	*1 ban 5 sila beer, 1 ban 5 sila bread, 10 gin oil*
4) Šeš-šeš-mu u$_3$/Nam-ha-ni	*for Šeššešmu and Namhani;*
5) 0.0.1 5 sila$_3$ kaš 0.0.1 5 sila$_3$ ninda/10 gin$_2$ i$_3$	*1 ban 5 sila beer, 1 ban 5 sila bread, 10 gin oil*

rev.

1) Lu$_2$-dNanna/u$_3$ Šeš-kal-la	*for Lu-Nanna and Šeškalla;*
2) šu-niĝin$_2$ 0.0.3 kaš 2 dida du	*sum: 3 ban beer, 2 normal sweet wort;*
3) šu-niĝin$_2$ 0.0.3 ninda 1 dabin 5/6 sila$_3$/ i$_3$	*sum: 3 ban bread, 1 barig semolina, 5/6 sila oil;*
4) ša$_3$-gal a-ša$_3$ ZU.LUM-e-ne	*(they were) fodders of ZU.LUM.*
5) iti e$_2$-iti-6	*Month: 'Six-Month-House'.*
6) mu us$_2$-sa d[Šu-dEN.ZU]/lugal Uri$_5$[ki-ma-ke$_4$]/bad$_3$ mar-tu [Mu]-/ri-iq-Ti-id-ni-/im mu-du$_3$	*Year after: 'Šu-Suen, king of Ur, built the Amorite wall Muriq-Tidnim.'*

20a. Rev. 4) The meaning of ZU.LUM remains obscure.

No. 21 – Messenger text

Museum number: DIA 19.024.16c
Provenience: Umma
Date: – x 30
obv.

1) 5 sila$_3$ kaš sig$_5$ 3 sila$_3$ ninda 5 gin$_2$ šum$_2$	*5 sila top-quality beer, 3 sila bread, 5 gin onions,*
2) 3 gin$_2$ i$_3$ 2 gin$_2$ naga	*3 gin oil, 2 gin herb-naga*
3) Lugal-KA-gi-na	*for Lugal-KAgina;*
4) 5 sila$_3$ kaš sig$_5$ 3 sila$_3$ ninda 5 gin$_2$ šum$_2$	*5 sila top-quality beer, 3 sila bread, 5 gin onions,*
5) 3 gin$_2$ i$_3$ 2 gin$_2$ naga	*3 gin oil, 2 gin herb-naga*
6) Ur-dNin-sun$_2$-ka	*for Ur-Ninsun;*

7) 5 sila₃ kaš 3 sila₃ ninda 5 gin₂ šum₂ *5 sila beer, 3 sila bread, 5 gin onions,*
8) 3 gin₂ i₃ 2 gin₂ naga *3 gin oil, 2 gin herb-naga*
9) Ša₃-ku₃-ge *for Šakuge;*
10) 3 sila₃ kaš 2 [sila₃ ninda 5 gin₂ šum₂] *3 sila beer, 2 sila bread, 5 gin onions,*

rev.

1) 3 gin₂ i₃ 2 gin₂ naga *3 gin oil, 2 gin herb-naga*
2) Lugal-[ku₃]-zu *for Lugal-kuzu;*
3) 3 sila₃ kaš 2 sila₃ ninda 5 [gin₂ šum₂] *3 sila beer, 2 sila bread, 5 gin onions,*
4) 3 gin₂ i₃ 2 gin₂ naga *3 gin oil, 2 gin herb-naga*
5) Da-da-mu *for Dadamu;*
6) šu-niĝin₂ 0.0.1 kaš <sig₅>0.0.1 1 sila₃ kaš *sum: 1 ban top-quality beer, 1 ban 1 sila beer,*
7) 0.0.1 3 sila₃ ninda 1/3 sila₃ 5 gin₂ šum₂ *1 ban 3 sila bread, 1/3 sila 5 gin onions,*
8) 15 gin₂ i₃ 10 gin₂ naga *15 gin oil, 10 gin herb-naga.*
9) u₄ 30-kam iti ezem/ᵈŠul-gi *On the 30th day. Month: 'Festival of Šulgi.'*

This text belongs to the Umma 'messenger texts', Group J, based on McNeil, 'The "Messenger Texts" of the Third of Ur Dynasty'.

No. 22 – Messenger text

Museum number: DIA 19.024.16e
Provenience: Umma
Date: undated
obv.

1) 5 sila₃ kaš 5 sila₃ ninda 5 gin₂ šum₂ *5 sila beer, 5 sila bread, 5 gin onions, 3 gin oil, 2*
2) 3 gin₂ i₃ 2 gin₂ naga *gin herb-naga*
3) PU₃.ŠA-Eš₁₈-tar₂ *for Puzur-Eštar;*
4) 5 sila₃ kaš 5 sila₃ ninda 5 gin₂ šum₂ *5 sila beer, 5 sila bread, 5 gin onions, 3 gin oil, 2*
5) 3 gin₂ i₃ 2 gin₂ naga *gin herb-naga*
6) Hal-li₂-a *for Hallia;*
7) 5 sila₃ kaš 5 sila₃ ninda 5 gin₂ <šum₂> *5 sila beer, 5 sila bread, 5 gin onions,*
8) 3 gin₂ i₃ 2 gin₂ naga *3 gin oil, 2 gin herb-naga*
9) Šu-ᵈNisaba *for Šu-Nisaba;*
10) 5 sila₃ kaš 5 sila₃ ninda 5 gin₂ <šum₂> *5 sila beer, 5 sila bread, 5 gin onions,*
11) 3 gin₂ i₃ 2 gin₂ naga *3 gin oil, 2 gin herb-naga*
12) A-hu-DU₁₀ *for Ahu-tab;*

rev.

1) 5 sila₃ kaš 5 sila₃ ninda 5 gin₂ <šum₂> *5 sila beer, 5 sila bread, 5 gin onions,*
2) 3 gin₂ i₃ 2 gin₂ naga *3 gin oil, 2 gin herb-naga*
3) Ur-ᵈLamma *for Ur-Lamma;*
4) 5 sila₃ kaš 5 sila₃ ninda 5 gin₂ <šum₂> *5 sila beer, 5 sila bread, 5 gin onions,*

5) 3 gin$_2$ i$_3$ 2 gin$_2$ naga	3 gin oil, 2 gin herb-naga
6) Šu-dEN.ZU	for Šu-Suen;
7) 3 sila$_3$ kaš 2 sila$_3$ ninda 5 gin$_2$ <šum$_2$>	3 sila beer, 2 sila bread, 5 gin onions,
8) 3 gin$_2$ i$_3$ 2 gin$_2$ naga	3 gin oil, 2 gin herb-naga
9) Ba-ba-a	for Baba'a;
10) šu-niĝin$_2$ 0.0.3 3 sila$_3$ kaš 0.0.3 2 sila$_3$ ninda/½ sila$_3$ 5 gin$_2$ šum$_2$	sum: 3 ban 3 sila beer, 3 ban 2 sila bread, ½ sila 5 gin onions;
11) šu-niĝin$_2$ ⅓ sila$_3$ 1 gin$_2$ i$_3$/14 gin$_2$ naga	sum: ⅓ sila 1 gin oil, 14 gin herb-naga.

This text belongs to the Umma 'messenger texts', Group D. The date of this text remains obscure.

No. 23 – List of various objects

Museum number: DIA 19.024.03
Provenience: Umma
Date: undated
obv.

1) la$_2$-ia$_3$ 3 ⅚ ma-na erin$_x$(KWU896)	Arrears 3 ⅚ minas cedar,
2) la$_2$-ia$_3$ 1 ⅔ ma-na za-ba-lum	arrears 1 ⅔ minas juniper,
3) la$_2$-ia$_3$ 1 ⅔ ma-na šu-ur$_2$-me	arrears 1 ⅔ minas cypress;
4) diri 2 ⅔ ma-na gi	surplus 2 ⅔ minas reed,
5) 2 ⅔ ma-na šim-IM	2 ⅔ minas šimIM-aromatics,
6) 6 ma-na dam-še-lum	6 minas damšelum-aromatics,
7) 1 ½ ma-na 5 gin$_2$ šim	1 ½ minas 5 gin aroma,
8) 4 ⅚ ma-na ar-ga-num$_2$	4 ⅚ minas arganum-aromatics,
9) 2 ⅚ ma-na NI-gi$_4$-ib$_2$	2 ⅚ minas NIgib-aromatics,
10) 5 ⅓ ma-na 2 ½ gin$_2$ en-HAR	5 ⅓ minas 2 ½ gin enHAR-aromatics,
11) 3 ⅚ ma-na šim-hi	3 ⅓ minas šimhi-aromatics,
12) 4 ½ sila$_3$ šim-gana$_2$	4 ½ sila šimgana-aromatics,
13) 4 ½ sila$_3$ še li	4 ½ sila juniper berries,
14) diri-ga-am$_3$	(they) are the surpluses.
15) la$_2$-ia$_3$ 2 sila$_3$ šim GAM.GAM-ma	Arrears 2 sila terebinth,
16) diri 4 ½ sila$_3$ gu$_4$-ku-ru	surplus 4 ½ sila gukuru-aromatics,

rev.

1) diri la$_2$-ia$_3$ šim i$_3$-du$_{10}$ gi	(these are) surpluses and arrears of aroma, flavored oil, and reed; for 3 festivals: 3 minas cedar
2) ezem 3-a-ba	
3) 3 ma-na erin$_x$(KWU896) ezem še-KIN-ku$_5$	for Festival of Barley-Harvest,
4) 3 ma-na erin$_x$(KWU896) ezem sig$_4$ i$_3$-šub-/ba-ĝa$_2$-ra	3 minas cedar for the festival of 'laying the bricks in the brick molds',
erased line	
5) 6 ma-na za-ba-lum	6 minas juniper for the lustration rite of the deity Šara,
6) a-tu$_5$-a dŠara$_2$	
7) 3 ma-na erin$_x$(KWU896) ezem šu-numun	3 minas cedar for the festival of seed grain, from the person working on oil-cream.
8) ki lu$_2$ i$_3$-gara$_2$-ta	6 minas cedar from the person working on water,

9) 6 ma-na erin$_x$(KWU896) ki lu$_2$ a gub-ba-ta	*1 mina cedar from the person of the fire place,*
10) 1 ma-na erin$_x$(KWU896) ki lu$_2$-gu$_2$-NE-ta	*3 minas cedar from the betrothal gift of the deity Dumuzida,*
11) 3 ma-na erin$_x$(KWU896) niĝ$_2$-mu$_{10}$-us$_2$-sa$_2$ d/ Dumu-zi-da-ta	*these aromatics (were) the regular offerings of Šara remaining in place.*
12) šim sa$_2$-du$_{11}$ dŠara$_2$-ka/ki-a tak$_4$-a	

The text is a list of various aromatics as the regular offerings of Šara remaining in place. For the readings and translations of these aromatics, see H. Brunke and W. Sallaberger, 'Aromata für Duftöl', in A. Kleinerman and J. M. Sasson (eds), *Why Should Someone Who Knows Something Conceal It? Cuneiform Studies in Honor of David I. Owen on His 70th Birthday* (Bethesda: CDL Press, 2010), pp. 41–74.

Text 1

Obv.

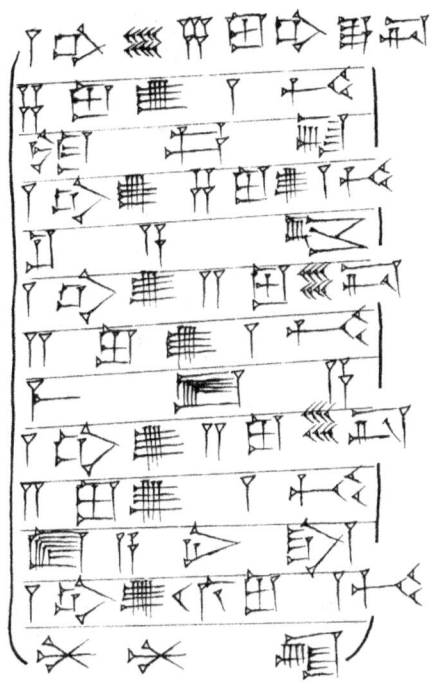

Rev.

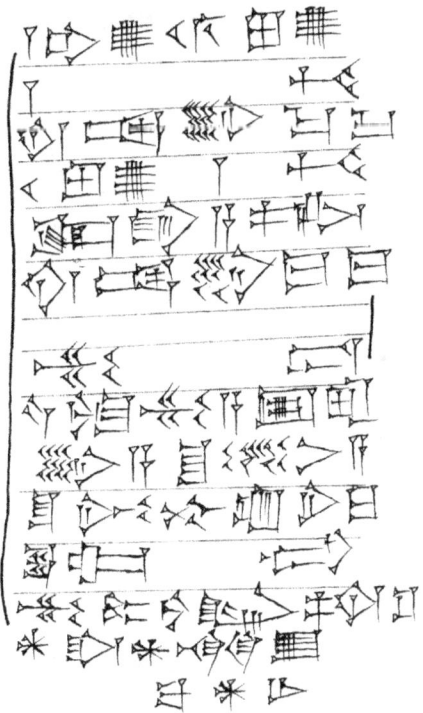

Text 2

Obv.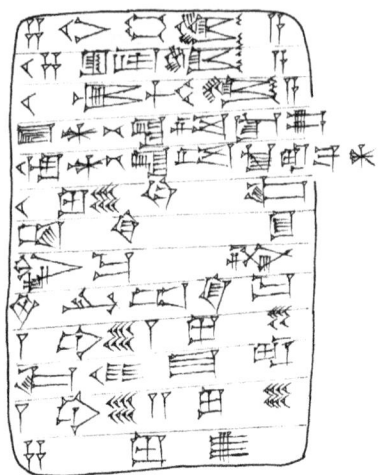

Rev.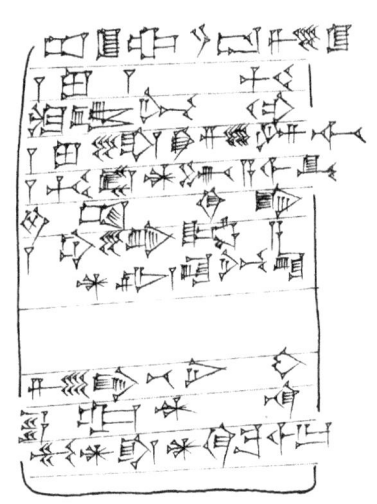

Text 3 Tablet

Obv.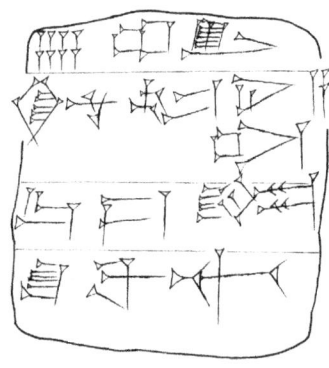

Rev.

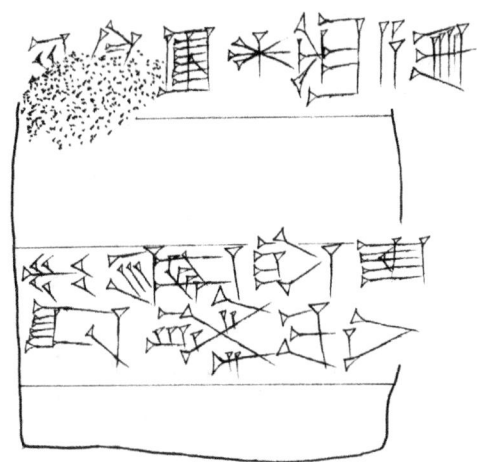

Envelope

Obv.

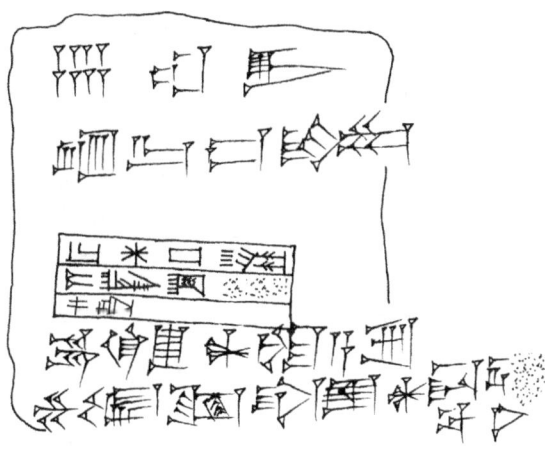

Rev.

Text 4 **Tablet**

Obv.

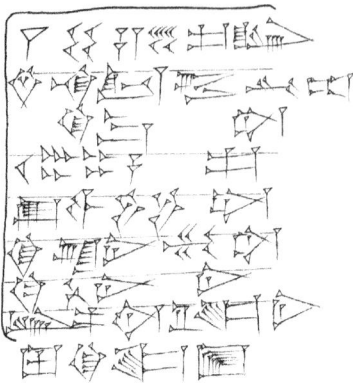

Rev.

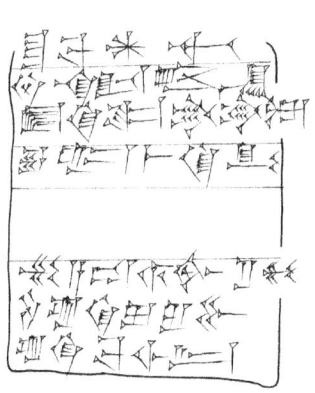

Envelope

Obv.

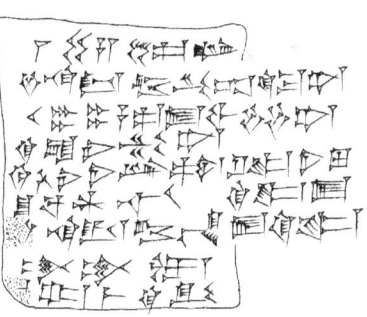

Rev.

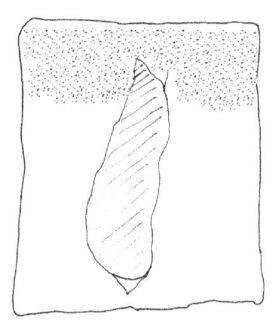

Text 5

Obv.

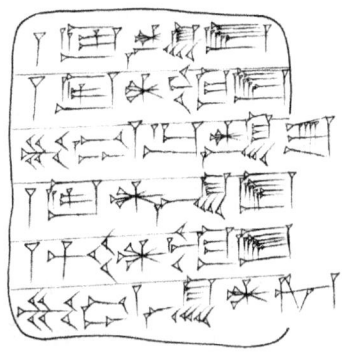

Rev.

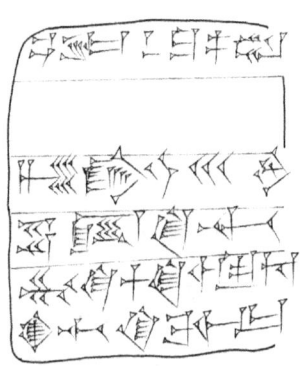

Text 6

Obv.

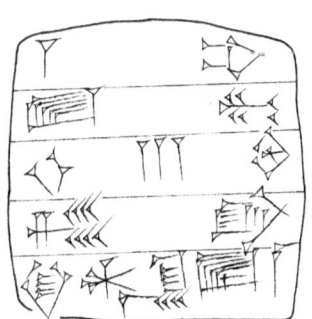

Rev.

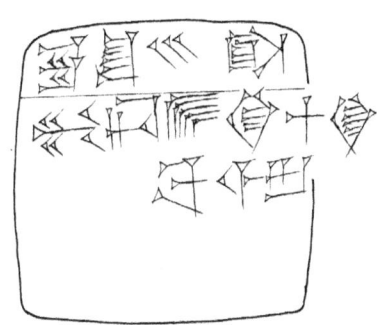

Text 7

Obv.
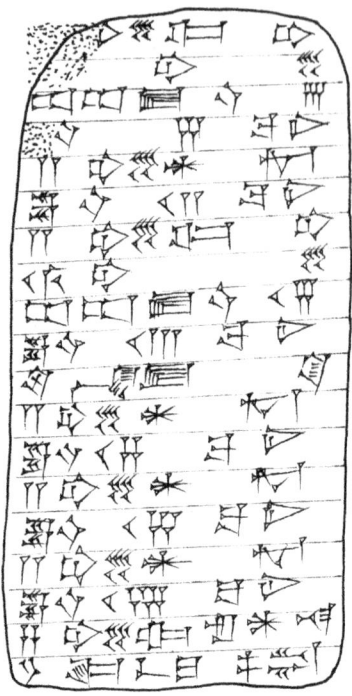

Rev.
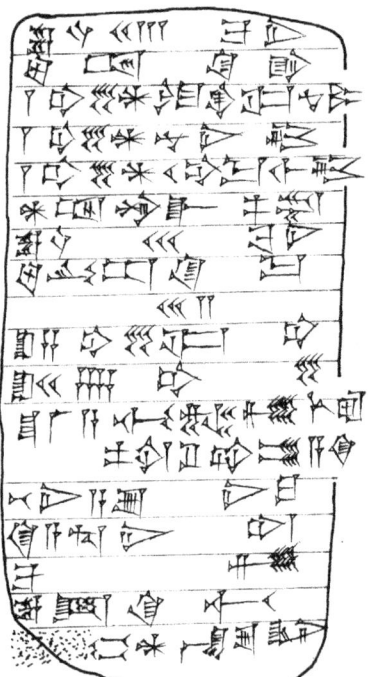

Text 8

Obv.
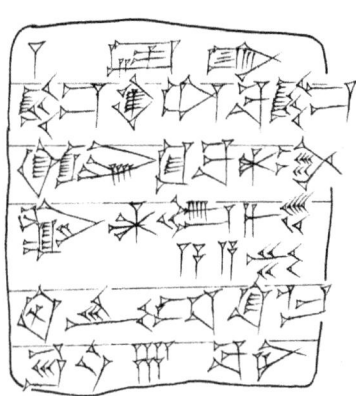

Rev.
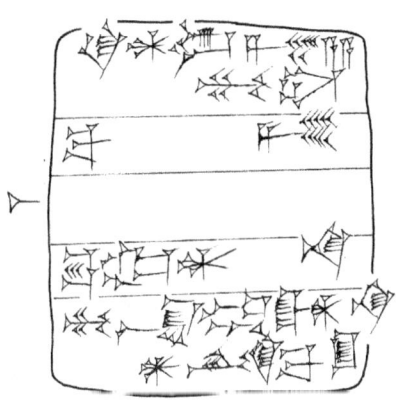

Text 9

Obv.
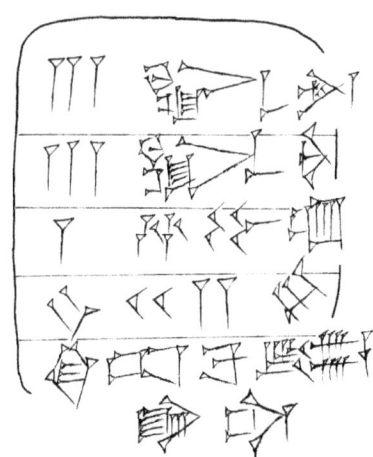

Rev.

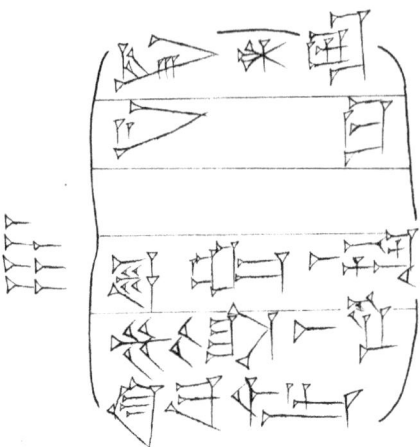

Text 10

Obv.

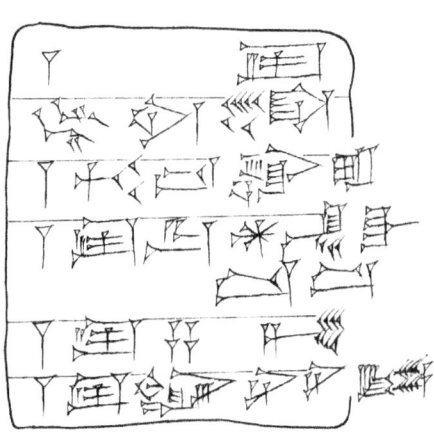

Rev.

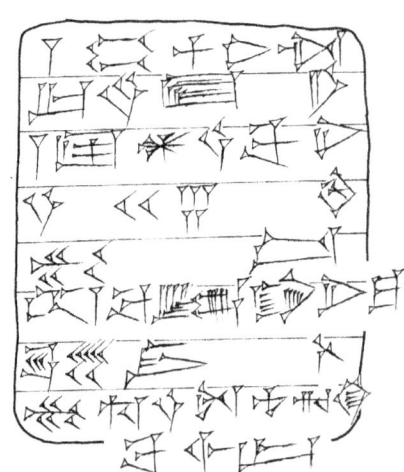

Text 11

Bulla

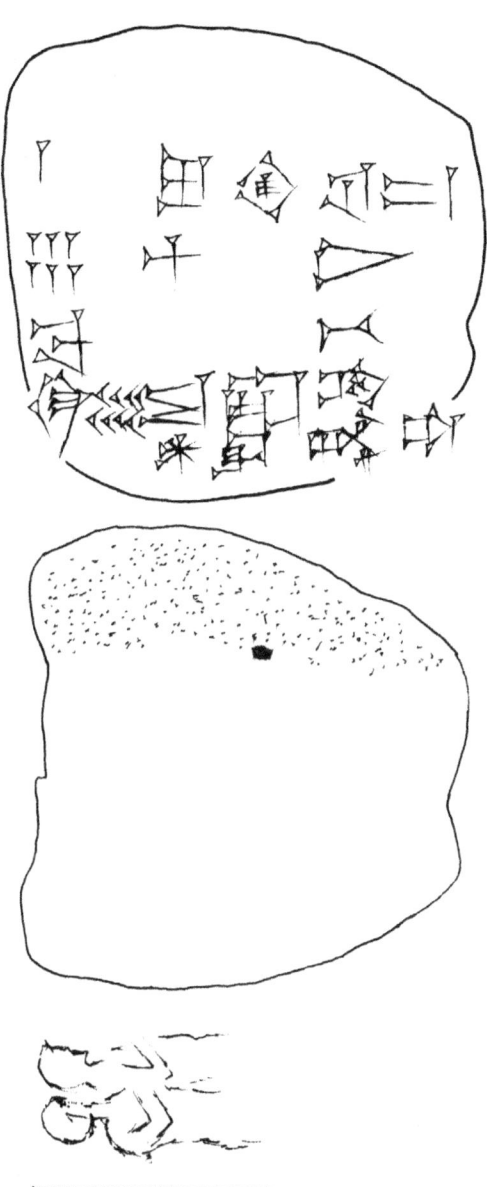

Seal

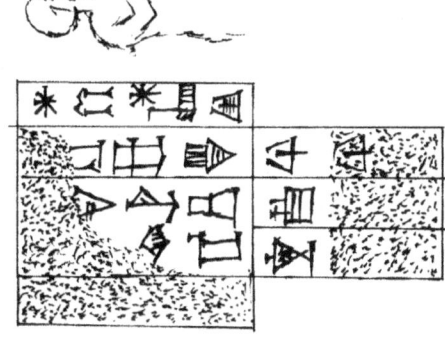

Text 12

Obv.

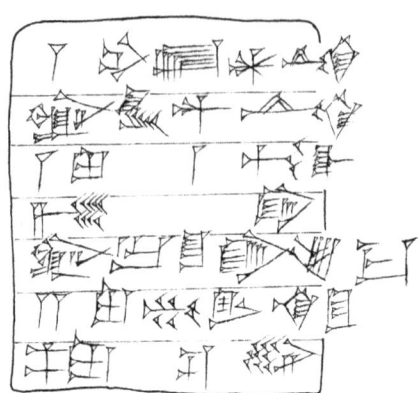

Rev.

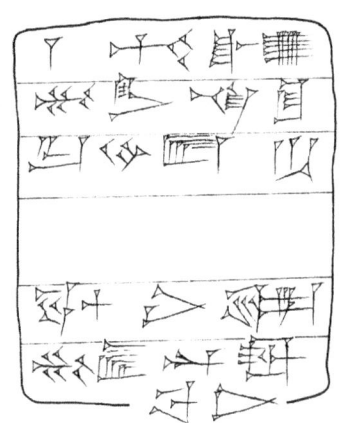

Text 13

Obv.

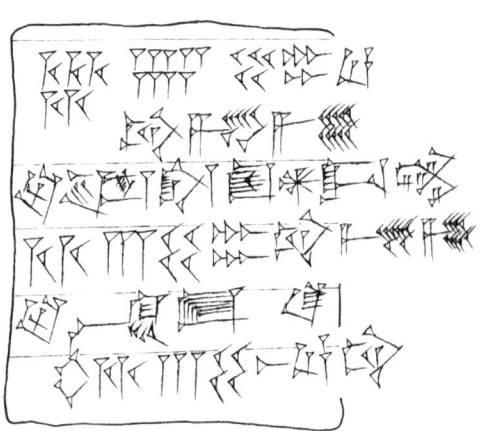

Rev.

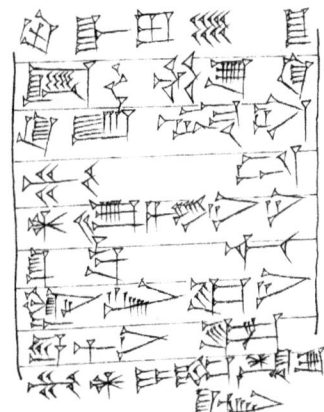

Text 14

Obv.

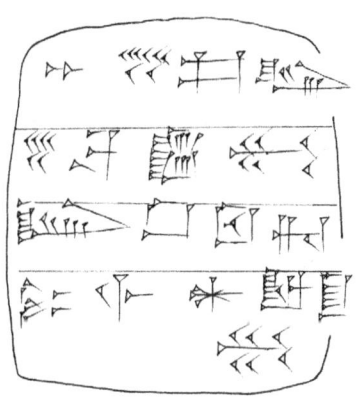

Rev.

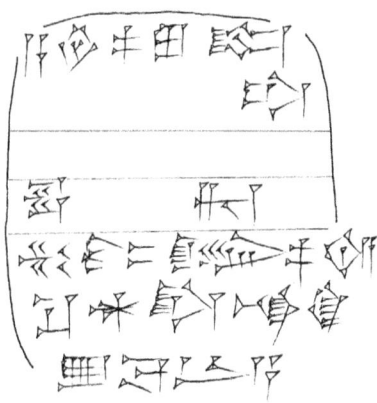

Text 15

Obv.

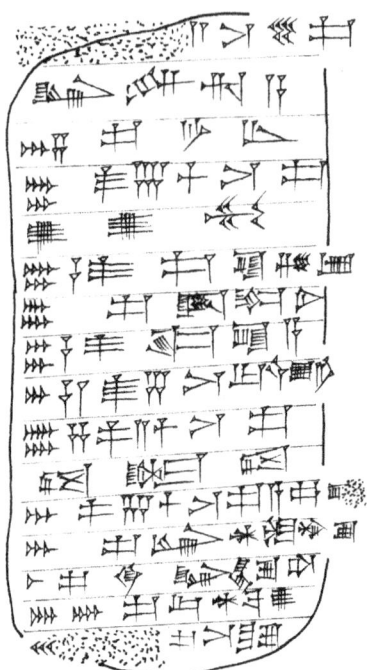

Rev.

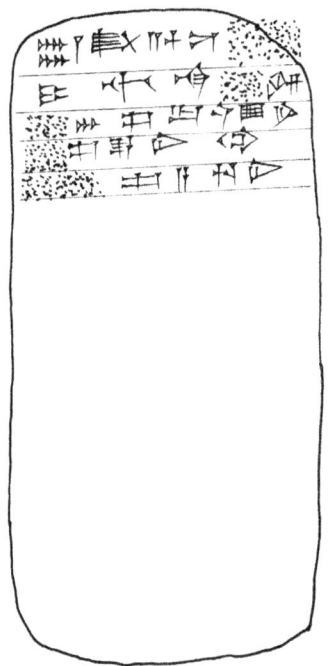

Text 16

Obv.

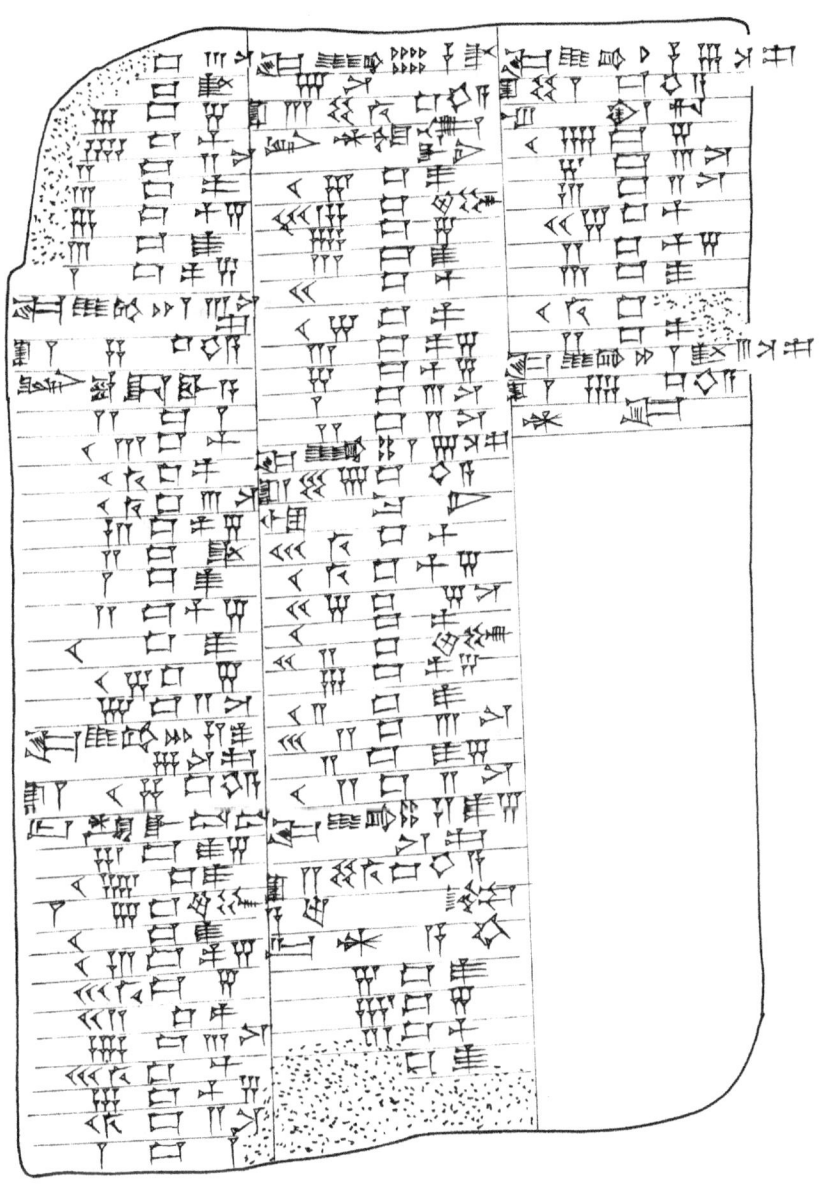

Rev.

Text 17

Obv.
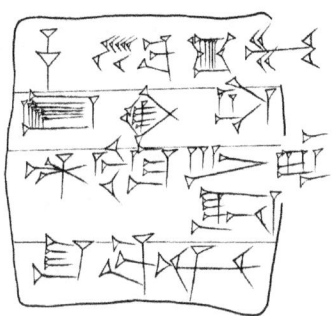

Rev.
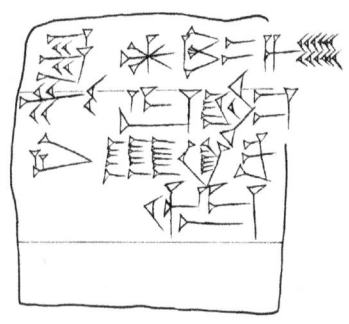

Text 18

Obv.
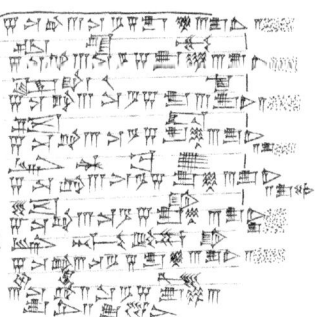

Rev.
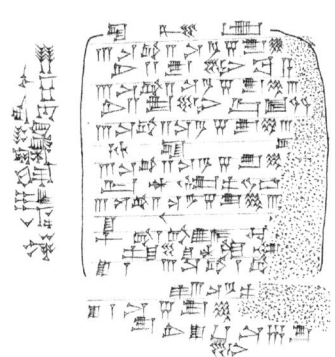

Text 19

Obv.

Rev.

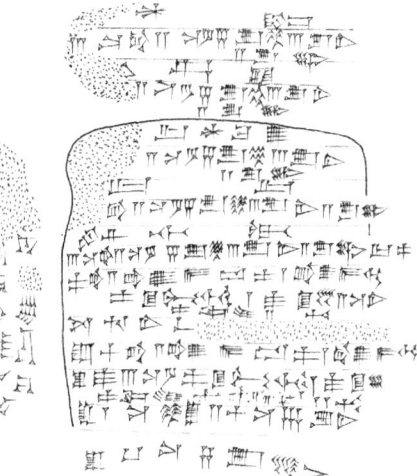

Text 20

Obv.

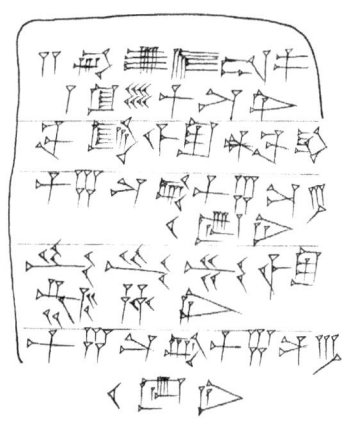

Rev.

Text 21

Obv.

Rev.

Text 22

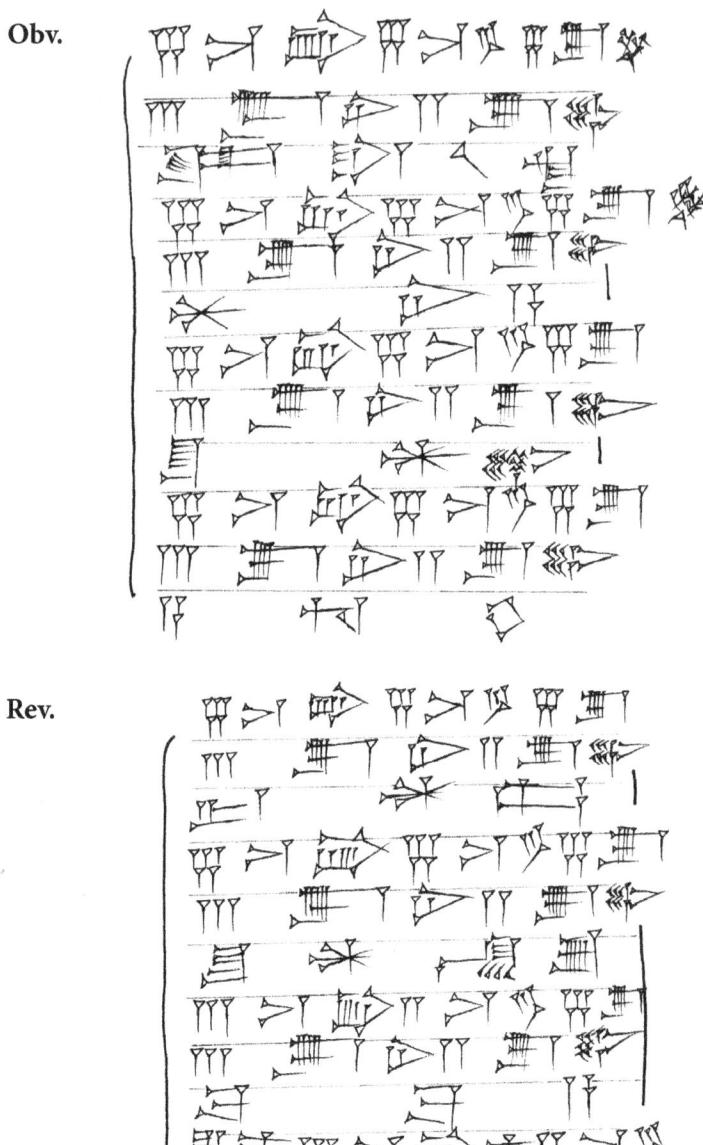

Text 23

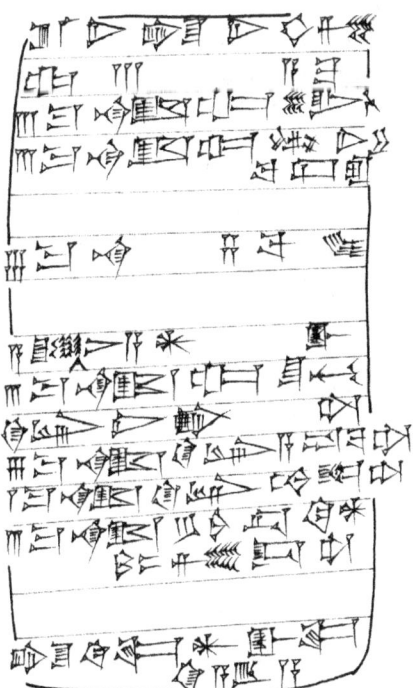

Notes

1 The author would like to thank Nii O. Quarcoopome, Co-Chief Curator of the DIA, and Birgitta Augustin, Associate Curator of Asian Art, Acting Head, Department of the Arts of Asia and the Islamic World of the DIA, for permission to publish these texts here and for providing me with great support. The abbreviations in this study are listed on the Cuneiform Digital Library Initiative (http://cdli.ox.ac.uk/wiki/abbreviations_for_assyriology, accessed 26 March 2022). Add AS = Amar-Suen, DN = Divine Name, GN = Geographical Name, IS = Ibbi-Suen, PN = Personal Name, Š = Šulgi, ŠS = Šu-Suen.

2 For Puzriš-Dagan, see T. B. Jone and J. W. Snyder, *Sumerian Economic Texts from the Third Ur Dynasty: A Catalogue and Discussion of Documents from Various Collections* (Minneapolis: University of Minnesota Press, 1961); T. Maeda, 'Bringing (mu-túm) livestock and the Puzurish-Dagan organization in the Ur III dynasty', *Acta Sumerologica*, 11 (1989), 69–111; M. Sigrist, *Drehem* (Bethesda: CDL Press, 1992); M. Hilgert, *Cuneiform Texts from the Ur III Period in the Oriental Institute, Volume 1: Drehem Administrative Documents from the Reign of Šulgi* (Chicago: The Oriental Institute of the University of Chicago, 1998); Hilgert, *Cuneiform Texts from the Ur III Period in the Oriental Institute, Volume 2: Drehem Administrative Documents from the Reign of Amar-Suena*; Sallaberger and Westenholz, *Mesopotamien: Akkade-Zeit und Ur III-Zeit*, pp. 238–73; C. Tsouparopoulou, 'A Reconstruction of the Puzriš-Dagan Central Livestock Agency', *Cuneiform Digital Library Journal*, 2 (2013), 1–15; C. Liu, *Organization, Administrative Practices and Written Documentation in Mesopotamia during the Ur III Period (c.2112–2004 BC): A Case Study of Puzriš-Dagan in the Reign of Amar-Suen* (Münster: Ugarit-Verlag, 2017). For the scientific excavations at Drehem undertaken in 2007, see N. Al-Mutawalli and W. Sallaberger, 'The Cuneiform Documents from the Iraqi Excavation at Drhem', *Zeitschrift für Assyriologie und Vorderasiatische Archäologie*, 107 (2017), 151–217. For Umma during the Ur III period, see H. Sauren, 'Topographie der Provinz Umma nach den Urkunden der Zeit der III. Dynastie von Ur, Teil I: Kanäle und Bewässerungsanlagen' (PhD dissertation, Ruprecht-Karl-Universität Heidelberg, 1966); Stępień, *Animal Husbandry in the Ancient Near East: A Prosopographic Study of Third-Millennium Umma*; Sallaberger and Westenholz, *Mesopotamien: Akkade-Zeit und Ur III-Zeit*, pp. 315–29; J. L. Dahl, *The Ruling Family of Ur III Umma: A Prosopographical Analysis of an Elite Family in Southern Iraq 4000 Years Ago* (Leiden: Nederlands Instituut voor het Nabije Oosten, 2007); N. Vanderroost, 'Organisation administrative du bureau de l'agriculture d'Umma à l'époque de la Troisième Dynastie d'Ur' (PhD dissertation, Université libre de Bruxelles, 2012); X. Ouyang, *Monetary Role of Silver and Its Administration in Mesopotamia during the Ur III Period (c.2112–2004 bce): A Case Study of the Umma Province* (Madrid: Consejo Superior de Investigaciones Científicas, 2013); H. Waetzoldt, 'Umma. A. Philologisch', *Reallexikon der Assyriologie und vorderasiatischen Archäologie*, 14 (2014), 318–27; S. Rost, 'Water Course Management and Political Centralization in 3rd Millennium BC Southern Mesopotamia. A Case Study of the Umma Province During the Ur III Period (2112–2004 BC)' (PhD dissertation, Stony Brook University, 2015). For the scientific

excavations at Umma, see S. Salman Fahad and R. Abdul-Qadir Abbas, 'Cuneiform Tablets from Shmet from the Excavation Season of 2001', *Zeitschrift für Assyriologie und Vorderasiatische Archäologie*, 110 (2020), 1–13.

3 Michalowski, 'Sumerian Royal Women in Motown', in P. Corò *et al.* (eds), *Libiamo ne'lieti calici: Ancient Near Eastern Studies Presented to Lucio Milano on the Occasion of his 65th Birthday by Pupils, Colleagues and Friends*, p. 402.

4 https://cdli.ucla.edu/?q=news/detroit-institute-arts%E2%80%94cuneiform-too (accessed 26 March 2022).

5 https://cdli.ucla.edu/ (accessed 26 March 2022).

6 http://bdtns.filol.csic.es/ (accessed 26 March 2022).

7 M. Molina, 'The Corpus of Neo-Sumerian Tablets: An Overview', in S. J. Garfinkle and J. C. Johnson (eds), *The Growth of an Early State in Mesopotamia: Studies in Ur III Administration. Proceedings of the First and Second Ur III Workshops at the 49th and 51st Rencontre Assyriologique Internationale, London July 10, 2003 and Chicago July 19, 2005* (Madrid: Consejo Superior de Investigaciones Científicas, 2008), pp. 19–54; M. Molina, 'Archives and Bookkeeping in Southern Mesopotamia During the Ur III Period', *Revue d' Histoire des Comptabiliteis*, 8 (2016), 2–19.

8 www.library.manchester.ac.uk/rylands/special-collections/exploring/a-to-z/detail/ ?mms_id= 992983876609801631 (accessed 26 March 2022).

9 C. L. Bedale, *Sumerian Tablets from Umma in the John Rylands Library, Manchester* (Manchester: Manchester University Press, 1915).

10 T. Fish, *Catalogue of Sumerian Tablets in the John Rylands Library* (Manchester: Manchester University Press, 1932).

11 T. Donald, 'A Sumerian Plan in the John Rylands Library', *Journal of the Semitic Studies*, 7 (1962), 184–90.

12 T. Gomi, 'Ur III Texts in the John Rylands University Library of Manchester', *Bulletin of the John Rylands Library*, 64 (1981–82), 87–116.

13 F. N. H. Al-Rawi, 'Cuneiform Inscriptions in the Collections of the John Rylands Library, University of Manchester', *Iraq*, 62 (2000), 21–63.

Lorenzo Opimo of Bologna, Teaching Doctor of the Servites during the Reformation, and His *Sentences* Lectures at the University of Paris in 1370–71 (Part I)

CHRIS SCHABEL, IRHT/CNRS, PARIS

Abstract

The beautiful Latin MS 198 of the John Rylands Library preserves one of two currently known manuscript copies of the Servite Lorenzo Opimo of Bologna's *Scriptum* on the *Sentences*, the only such text by a Servite that survives. In 1494, the Chapter General of the Servite Order made Lorenzo the order's teaching doctor, since the representatives declared that his work, primarily his questions on the *Sentences*, would be required reading for Servite students and masters of theology. No doubt as a result, Lorenzo's *Scriptum* was printed in Venice in 1532. To most medieval intellectual historians, the printing, the author, and even the religious order are virtually unknown. This two-part article puts this unique text in its doctrinal and institutional context. Part I argues that Lorenzo delivered his *Sentences* lectures at the University of Paris in 1370–71, presents and analyses the tradition of the three textual witnesses, and offers a question list.

Keywords: Lorenzo Opimo of Bologna; Servite Order; University of Paris; Peter Lombard's *Sentences*; Immaculate Conception

Two decades ago, Steven J. Livesey pointed to confusion in Friedrich Stegmüller's 1947 repertory of questions on the *Sentences* – probably led astray by Victorin Doucet – in which a 'phantom author' named *Laurentius Anglicus* was invented for the text preserved in Manchester, John Rylands Library, Latin MS 198.[1] Livesey remarked that the incipit in the Manchester codex is identical to what Stegmüller recorded for a text in Florence, Biblioteca nazionale centrale, Cod. Conv. soppr. G.5.1348, which Stegmüller attributed to *Laurentius de Bononia*, the only Servite mentioned in his repertory. In fact, as Livesey found, even the Manchester manuscript attributes the text to *Laurentius Opimus de Bononia*. What neither Stegmüller nor Livesey noted is that this text was printed in Venice in 1532, and thus survives in at least thirty more copies. Moreover, Stegmüller did not even venture a location or approximate date for the questions in the two manuscripts, since no firm and dated link between this *Laurentius* and Paris was established in the mainstream among historians of ideas until 2004.[2] Not knowing that *Laurentius* was active before 1500, I failed to include the early printing of his work in my own recent attempt at an exhaustive list of the medieval sets of questions on the *Sentences* printed before 1600.[3] Clearly, the until-recently inaccessible specialist literature on Servite scholastics and on Lorenzo Opimo of Bologna, mostly in

Italian, has not succeeded in raising awareness of the unique fact that he is, as far as I know, the only Servite theologian with a surviving set of questions on the *Sentences*, and perhaps the only medieval Servite with a major theological work that has come down to us.[4]

According to his cover letter for the 1532 printing on the reverse of the title page, dated Padua, 1 August 1530, and addressed to Jerónimo de Lucca, general of the Servite Order (1523–35), when Friar Domenico Dotti di Castrofranco, master of theology, was shown Lorenzo Opimo of Bologna's work on the *Sentences* it had long remained in darkness, hidden in the dust. Despite Friar Domenico's efforts, Lorenzo's work once again lies forgotten, and the simple purpose of this article is to draw attention again to Lorenzo's questions on the *Sentences*, to put them in their spatial and temporal context, to determine the relationship between the witnesses, and – in part II – to formulate a general characterisation of the doctrine espoused by a Servite whose major work was required reading in the Reformation period. A *tabula quaestionum* is included in the Appendix.

The Servites at Paris and the Date of Lorenzo's Lectures on the *Sentences*

The Order of the Servants of the Blessed Virgin Mary, or the Servites, was never very large, but it still exists today. The Servites are said to have originated near Florence in the early 1230s, first appear in the records in the 1240s, chose to follow the Rule of St Augustine, and received Pope Alexander IV's blessings in 1256. The Servites survived an attempt to suppress the order in the context of the Second Council of Lyon in 1274, and only obtained final papal approval from Pope Benedict XI in 1304. Under mendicant influence they originally adopted a strict attitude toward poverty, but this had been relaxed by 1304. In the fourteenth century they remained primarily an Italian order.[5]

It is hard to separate myth from reality in the Servite chronicles concerning their presence in Paris, so it is best to stick to contemporary documentation.[6] Although individual Servites were already studying theology at the University of Paris just before 1304, perhaps even with a prior, Heinrich Denifle noted that there were doubts about the nature of the order's presence,[7] and it was not until the Chapter General meeting in Siena in May 1328 that the Servite Order decided to establish a *studium* for theology in Paris.[8] Along with Nicholas of Autrecourt and several others, a Servite bachelor of theology named *Iohannes Teutonicus* was summoned to Avignon to answer charges of doctrinal irregularities on the basis of a letter of Pope Benedict XII to the bishop of Paris, dated 21 November 1340.[9] Pope Clement VI encouraged the *studium* with a constitution reforming the order, dated 23 March 1346,[10] and we have evidence of more named Servite students in theology soon afterwards, Servite bachelors of the *Sentences* in the mid-1350s, and Servite masters of theology by 1363, when at least three Servite formed bachelors were waiting to be promoted to the *magisterium*.[11]

Just like Lorenzo, the other known Servites at Paris were Italians, especially from Bologna. When the faculty of theology was established at Bologna in 1364, with

other faculties elsewhere on the peninsula, the possibility arose that the Servites would leave Paris for the new Italian universities. This did not happen before the Great Schism, for two Servites were licensed in theology at Paris in 1381, first Andrea of Forlì and then Giovanni of Florence, who was called master in the summer of 1385.[12] In late 1387, however, when he allowed Giovanni to join the Benedictines, the Avignon Pope Clement VII remarked that he had no Servite convents left in his obedience, and the next and last medieval Servite master at Paris was not licensed until 1470.[13] Before the Schism, the Paris *studium* produced the Servites' most famous medieval theologian, Lorenzo Opimo of Bologna. In 1494, the Servite Chapter General stipulated 'that students in every faculty shall use the doctors of our order; similarly regent [masters] shall read their doctrine, namely, in theology, master Lorenzo of Bologna',[14] which accounts for the 1532 printing of his questions on the *Sentences*, although he penned two other brief works that have not been identified: *Placita theologica* and *Abbreviata*.[15]

In two obscure publications from the 1930s, the only real studies on Lorenzo Opimo of Bologna, the Servites Sostegno M. Berardo and Corrado Berti found that the testaments of the Bolognese cloth merchant Tommaso Dall'Olio, son of the late Pietro, husband of Cola Zanelli, and resident of the parish of Sant'Agata in the centre of the city, dated 26 March 1378 and 28 September 1379, name the Servite master of theology Lorenzo as their son, the brother of Pietro and Agnese.[16] Lorenzo was thus a member of the well-known Dall'Olio family, the sobriquet *Opimus* only appearing in the fifteenth century.[17] Lorenzo de Oleo or Olleo is mentioned in Servite acts dated Bologna, 26 January 1360 and 3 February 1362, and Lorenzo of Bologna is referred to in a Servite act dated Bologna, 5 December 1366. Berardo estimated that Lorenzo was born about 1325–30, entered the Servite Order around 1357–59, and went to Paris around 1367.[18] Corrado Berti claimed that Lorenzo is explicitly called 'lettore' already in the 1360 act, which Berardo quoted with ellipses.[19] Berti did not provide the Latin, but if he is correct, then Lorenzo must have been born before 1335, probably joined the order earlier than Berardo thought, but likely did go to Paris in 1367 or 1368, as we shall see, and not 'verso il 1370 o 1371', as Berti calculated.[20]

The Servite Francesco of Milan was licensed in 1377 and was labelled a master in May 1379,[21] so it is likely that Francesco succeeded Lorenzo as Servite regent master in Paris either for the 1377–78 academic year or for 1378–79, when Lorenzo was probably already teaching at the Servite convent in Bologna. Lorenzo was accepted as a master in the Faculty of Theology of Bologna on 2 June 1379, and remained at the University of Bologna into the mid-1380s.[22] Some Servite and Bolognese histories mistakenly have Lorenzo as bishop of Trent in 1376, an error originating in 1500. Others correctly have him as bishop of Trogir in today's Croatia. Bishop Chrysogonus of Trogir was in place from 1372 to 1403, but on 23 August 1387, during the Schism, a certain *Laurentius* obliged himself to pay the common services for Trogir to the Roman Pope Urban VI. A document of Bishop Ugolino of Reggio Emilia (1387–94), dated at the monastery of St Prosper outside Reggio on 1 September 1387, refers to 'Fratrem Laurentium de Bononia Ordinis

Sanctae Mariae Servorum Traguriensem' as being in his presence. Lorenzo's appointment was surely the result of the rivalry of the Schism, and it is doubtful that Lorenzo ever resided in Trogir: 'Laurentius episcopus Traguriensis' was in Bologna on 24 August 1389, had not yet paid his common services on 24 December 1390, and is noted in Bolognese documents again on 23 February, 20 May, and 23 September 1391, and 7 March 1392, probably dying not long afterwards.[23] Claims that he passed away in 1400 are no doubt based on confusion with the Servite Lorenzo di Budrio, whose father was Ugolino, not Tommaso.[24]

The first issue concerning Lorenzo's questions on the *Sentences* involves the date of the lectures from which those questions stem, which Berti placed 'fra il 1372 e il 1374'.[25] The only specific information we have is that Lorenzo was licensed in theology at Paris in 1374 after Easter, ranked last out of eight.[26] It is hard to know what these rankings meant at this point, since detailed records only begin in 1373, and we lack an explanation.[27] William J. Courtenay has suggested that they may be linked to the bachelors' performance in their principial debates, held in the year when they read the *Sentences*.[28] The problem with this hypothesis is that the principial debates took place years before licensing, and the groups of theologians licensed at the same time do not correspond to the groups of theologians who participated in principial debates. Ranking according to performance in principial debates would thus entail comparing bachelors who did not debate with each other. In any case, one of the fastest to be licensed after lecturing on the *Sentences*, the Dominican Simon Bardelli, was ranked ninth out of ten, so rank and date seem unrelated.[29]

According to the statutes, bachelors who had read the *Sentences* normally had to wait four years before licensing, but this number included the year in which they were licensed and the year of their *Sentences* lectures. Ordinarily this would mean that Lorenzo finished his *Sentences* lectures in the spring of 1371, but delays occurred and the period could be shortened by papal bull or concession of the faculty of theology.[30] Using the data compiled by Thomas Sullivan for the dates of the licensing of Parisian theologians from 1373 to 1377 and comparing them with the dates of the *Sentences* lectures of those theologians whose dates are known from other sources, we can guess the most likely date for Lorenzo's own Parisian lectures on the *Sentences*. Here is what we know about the groups of licensees and the dates of their *Sentences* lectures:[31]

Those licensed in 1374 before Easter:
 1368–69: perhaps one bachelor
 1369–70: two bachelors
 1370–71: one bachelor

Those licensed in 1374 after Easter (along with Lorenzo):
 1369–70: two bachelors
 1370–71: one bachelor
 1371–72: one bachelor

Summer 1372: one bachelor
 Others unknown: two bachelors (three including Lorenzo)

Those licensed between 25 December 1374 and 2 February 1375:
 1369–70: one bachelor
 1370–71: one bachelor
 1371–72: two bachelors
 Others unknown: four bachelors

Those licensed later in 1375:
 1371–72: four bachelors
 Summer 1372 or 1373: one bachelor
 1372–73: one bachelor
 Others unknown: four bachelors

Those licensed in 1377:
 1373–74: ten bachelors
 1374–75: one bachelor
 Others unknown: five bachelors

Thus, for the theologians for whom we have good information in these years, almost all were licensed from two to four years after the *Sentences* lectures and none within a shorter amount of time. There are only three exceptions. The Franciscan Iohannes Regis experienced a delay of 4.5 years – from June 1370, when he finished, to late 1374 or early 1375, when he was licensed – but this delay could be due to a backlog of Franciscan candidates. It is possible that the Dominican Petrus Barroni lectured in 1368–69 and, perhaps for the same reason, was not licensed until 5.5 years later, along with Regis. Barroni's confrère Michael Perdigach perhaps lectured as far back as 1366–67, but he appears to have left Paris and returned later for licensing between 25 December 1374 and 2 February 1375.[32] Lorenzo himself did not face such long delays, however. In two questions (numbers 28 and 30 in the Appendix) he criticises the Franciscan Francis of Perugia, citing him as regent master and twice making a point of saying that his remarks are meant 'cum reverentia'. Since Francis was not regent master until 1369–70 at the earliest, Lorenzo could not have been lecturing on the *Sentences* before then.[33]

Aside from the three exceptions, four were licensed a mere two years after completing their *Sentences* lectures, in five cases the bachelor had to wait four years, and in no fewer than nineteen cases the bachelor was licensed three years after reading the *Sentences*, in line with the statutes. This makes 1370–71, three years before his licensing, statistically most likely as Lorenzo's year as *sententiarius* by a ratio of more than 2:1 over 1369–70 and 1371–72 combined.

There is even more support for this hypothesis if we take into consideration what we know about the two other possibilities, 1369–70 and 1371–72. There is no evidence regarding Lorenzo in surviving *principia* materials from the debates among the bachelors of theology that occurred throughout the academic year in which they read the *Sentences*, in which materials the bachelors often cited

their fellow bachelors – called *socii* – by name, religious order, or secular college. Lorenzo's questions on the *Sentences* do not include *principia*, and no known *principia* contain references to Lorenzo. Nevertheless, primarily on the basis of surviving *principia*, we do know the names of ten bachelors of the *Sentences* who participated in the principial debates in each of the years 1369–70 and 1371–72, and Lorenzo is not among them.[34] Admittedly, we are not completely certain whether only ten bachelors took part or whether any others lectured on the *Sentences* without playing a role in the principial debates, but the number ten does seem to have been typical.

In sum, when we take into account the fact that Lorenzo is not among the ten bachelors known to have lectured in 1369–70, nor among the ten who definitely read the *Sentences* in 1371–72, we can be almost certain that he lectured in 1370–71. Indeed, the next Servite master, Francesco of Milano, was licensed in 1377, three years after his *Sentences* lectures of 1373–74, as I surmise happened with Lorenzo.[35] According to the Parisian statutes, Lorenzo had to wait two years after the start of his Bible lectures to begin reading the *Sentences*,[36] so the latest he began his Bible lectures was in the fall of 1368, the earliest the fall of 1367, to take into consideration his presence in Bologna on 5 December 1366.

We know the names of four bachelors of theology who lectured on the *Sentences* in 1370–71 along with Lorenzo: the Dominican *Guillelmus de Marreja*, the Carmelite *Iohannes de Cruone*, the secular *Hugo Lenvoisie* of the Collège de Navarre, and the Franciscan *Guillelmus de Cremona*.[37] Based on their date of licensing and our knowledge of the 1369–70 and 1371–72 academic years, it is quite likely that the Augustinian *Alanus de Lambalia*, the Benedictine *Michael Stoch*, either *Galterus de Voto* or *Nicasius Jossiaume* of the Cistercian Order, and the secular *Iohannes Mercerii* of the Collège de la Sorbonne were other *socii* from the 1370–71 academic year. In addition to these nine bachelors (including Lorenzo and only one of the Cistercians), a tenth *sententiarius* probably left Paris or died before licensing, and his name has not come down to us.

Unfortunately, no surviving Parisian texts have been attributed to any of these other theologians.[38] All that we have from the bachelors of the *Sentences* from the 1370–71 academic year are the two manuscripts and the copies of the early print of Lorenzo's questions on the *Sentences*.

The Manuscripts and Early Print of Lorenzo's Questions on the *Sentences*

As mentioned, there are three known witnesses to Lorenzo Opimo of Bologna's questions on the *Sentences*, the printed edition and two manuscripts, although a third manuscript is probably somewhere in private hands.[39]

F = Florence, Biblioteca nazionale centrale, Cod. Conv. Soppr. G.5.1348[40]

First half of fifteenth century, Italy, parchment, 303 × 215 mm (text 211/215 × 151 mm), fos i + 82 + i (1–79 + 19bis, 47bis, and 60bis), two columns, c.53–61 lines per column. The manuscript consists of ten quires, all quaternions

except for the first, which is a quinion (1–10, 11–18, 19–25 + 19bis, 26–33, 34–41, 42–48 + 47bis, 49–56, 57–63 + 60bis, 64–71, 72–79). The manuscript is from Santissima Annunziata in Florence, the headquarters of the Servite Order. Colophon on fo. 1ra: 'Incipit novella Lectura supra totum lib<r>um *Sententiarum* secundum magistrum Laurentium de Bononia Fratrum Servorum Sancte Marie Ordinis Sancti Augustini.'

M = Manchester, John Rylands Library, Latin MS 198[41]

Northeast Italy, c.1430–c.1445, parchment and paper, 288 × 217 mm (text c.179 × 117 mm), ff. 171, two columns, 46/47 lines per column. The manuscript consists of fourteen quires (with *reclamantes*), all sexternions except for the first and last quires, which are septernions (1–14, 15–26, 27–38, 39–50, 51–62, 63–74, 75–86, 87–98, 99–110, 111–22, 123–34, 135–46, 147–58, 159–72). The outer and central bifolios of the quires are parchment, and the remainder are paper. The original northern Italian binding is of oak boards covered with brown sheepskin leather over wood, which Sotheby's described as having 'blind tooled scroll borders, enclosing panels of Arabic knots'.

The main text and marginal references to numbered conclusions and *nota* are in a northern Italian bookhand that Sotheby's called 'semi-gothic', that is 'semi-textualis', with titles and rubrics in rotunda; note the consistent use of the straight 'r' and round 's'. Occasional marginal notations with manicules are made by a second scribe (with occasional references to Francis of Meyronnes and others). Large initials for question titles alternate between blue and red. Each of the four books begins with an even larger, decorated initial; the first one, a 14-line 'C' in gold and colour on fo. 1ra, surrounds a miniature of the author at the lectern in his Servite habit and has *putti* in the floral decoration in the right margin, perhaps suggesting the inspiration of the workshop of Cristoforo Cortese, active c.1409–45 in Venice, although it seems to have been left unfinished and/or was completed or retouched later. According to Adinel Dincă, to whom I owe most of the above, the script and decoration point to a date late in the first half of the fifteenth century, perhaps the 1440s. This is in general agreement with Stephen Mossman's analysis of the watermarks, which points to paper dating to c.1420–c.1445, probably the early 1430s.

A note on fo. 1r *infra* in a hand other than that of the text reads: 'Magister Laurerentius [sic] de Bononia Ordinis Servorum composuit hoc opus' (**Figure 1**). In the upper right of the rear pastedown one reads 'pretii FR vi', probably six *Floreni Renenses* (Rhenish guilders), according to Cappelli and Du Cange. The manuscript was purchased on 10 June 1918 at Sotheby's from the library at Sudbury Hall, Derbyshire, of the renowned Dante scholar Lord Vernon (George John Warren Venables-Vernon, fifth Baron Vernon, 1803–66), who had collected manuscripts in London, Paris and Italy (see also the pencil note on the front pastedown; digital images are online at: https://luna.manchester.ac.uk/luna/servlet/s/yj8rqd).

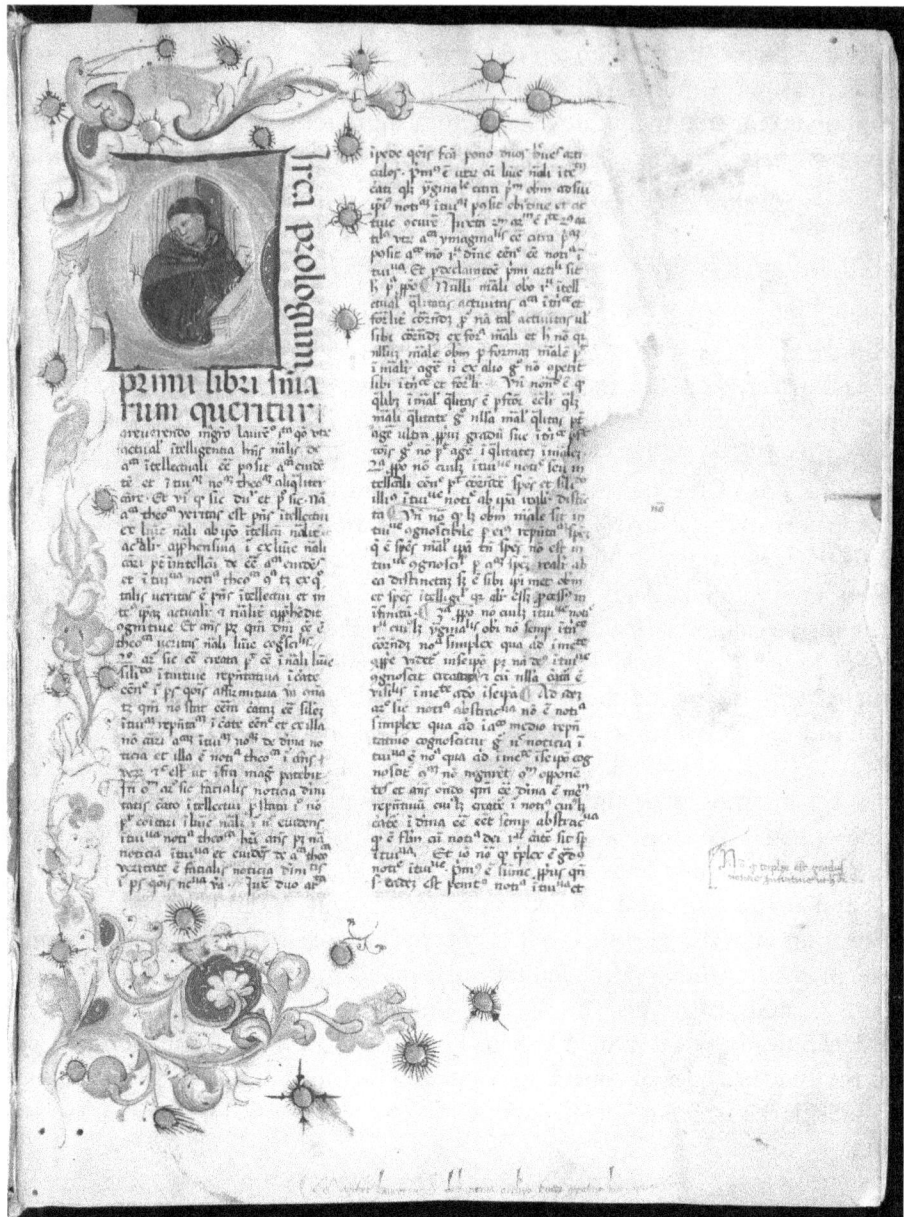

Figure 1 Manchester, John Rylands Library, Latin MS 198, fo. 1r. Photo © The University of Manchester.

U = Untraced

Another manuscript copy was for sale at Ludwig Rosenthal's Antiquariat, Munich, which lists a parchment and paper copy from the fifteenth century in their catalogues from 1900 to 1914. Since it supposedly consisted of only fifty-two folios,

it cannot be identified with M.[42] This is surely the same manuscript described in a catalogue of 1921, which gives the explicit on fo. 45ra: 'Explicit Scriptum super primo libro *Sententiarum* secundum eximium doctorem magistrum Laurentium de Bononia Ordinis Servorum'. This explicit matches that of M for book I, but it contained only book I, since it is described as being folio sized and consisting of 53 folios, 22 of parchment and 31 of paper, again similar to M (perhaps five quinternions of two parchment and three paper bifolia with an extra bifolium of parchment surrounding a sheet of paper), in two columns of fifty lines each. A *tabula quaestionum* must have occupied the last few folios. A space for the large initial on fo. 1ra was left blank. It was from the collection of Alfred Heales (1827–98).[43] It is probable that this manuscript and M came from the same workshop, and it is possible that U employed the book I in M as its exemplar.

V = Venice 1532 printing

The full title is as follows: 'Ordinatissimi ac ingeniosi doctoris Laurentii Opimi Bononiensis Ordinis Servorum egregia super quatuor libros *Sententiarum* Lectura Parisiis habita'. According to the colophon on the final folio, the edition was printed in Venice in the month of April by Giovanni Antonio de Sabbio and his brothers, all sons of Nicolino. What is unusual is that the foliation restarts for each book, such that it is numbered (incorrectly for the first six folios) 1–51 (prologue and book I); 1–51 (II); 1–24 (III); and 1–18 (IV).

Over thirty copies survive, perhaps many more. The Universal Short Title Catalogue (USTC) lists twenty-five copies, twenty of which are in Italy. The French SUDOC (système universitaire de documentation) adds a copy in the Bibliothèque Mazarine in Paris, WorldCat lists one in UCLA in the United States, and there are at least four others, including the copy in the Biblioteca de Castilla-La Mancha in Toledo, which has been digitised:

http://bidicam.castillalamancha.es/bibdigital/bidicam/es/consulta/busqueda_referencia.cmd?campo=idautor&idValor=88333.

For the *tabula* I have employed the Toledo copy, except that I have inspected the Mazarine copy *in situ* for book III, folios 8–11, which are missing in the Toledo copy.

The Nature and the Structure of the *Scriptum* and the Manuscript Tradition

The explicits for books I, II and III in M identify the text as a *Scriptum*, as does the explicit for book I in U and the explicit for book II in V. The colophon in F describes the text as a *Lectura*, and V also employs the term *Lectura* in the explicits for books III and IV, specifying that this *Lectura* was *Parisius habita* and, in the case of the last explicit, applying it to all four books. The term *Lectura* is rather generic, however, and the fact that all four witnesses (including U) refer to Lorenzo as a *magister* or even a *doctor* supports the characterisation of the work as a *Scriptum*

edited by Lorenzo based on an earlier *Lectura* delivered at Paris, perhaps put into final form after Lorenzo was made master, maybe even in Bologna.

Nevertheless, for a *Scriptum*, there are few cross-references to other books or even distinctions within the same book, the most telling being a reference to book III in book IV (question 113), 'ut patuit in 3°', hinting that Lorenzo may have read the four books in the sequence I–II–III–IV and not I–IV–II–III, which had been prevalent earlier in the fourteenth century. Lorenzo even expresses his uncertainty in question 67, 'De hoc tamen latius dicetur inferius, Deo concedente.' If Lorenzo began with a *reportatio*, the extent of his revisions was perhaps limited. Numerous traces of the original lectures remain, with references to 'the present lecture' in question 3 ('pro praesenti lectione'), to 'the other lecture' in question 117 ('in alia lectione'), and to what happened 'yesterday' in questions 14 ('tertia propositio hesterna'), 16 ('quaestione hesterna'), 18 ('ut heri dictum fuit'), 59 ('Prima pars fuit probata heri in alia lectione'), and at the end of question 98 ('ut probatum fuit heri'). That these lectures were delivered at Paris is confirmed by a reference in question 92 to 'unus doctor huius universitatis Parisiensis'.[44]

The *Scriptum* is remarkably consistent in structure, notably in the uniform length of the questions, and perhaps for this reason the early modern editor called Lorenzo the 'Doctor Ordinatissimus'. Early in book I, a question in MV (no. 7 overall) is missing in F, which has instead three other questions lacking in MV (after no. 8). Thus F contains 121 questions and MV 119 (four for the prologue, 43/41 for book I, forty for book II, nineteen for book III, and fifteen for book IV).[45] A decade later, the Victorine Pierre Leduc, lecturing at Paris in 1382–83, informs us that his reading the *Sentences* was done in 122 lectures over thirty-four weeks,[46] precisely the total number of combined questions in FMV, almost exactly the number of Lorenzo's questions in F, 121, and very close to the 119 in MV. Given their uniformity, therefore, each question probably corresponds to one lecture, as implied by the references to 'yesterday' and proven in the case of the citation of 'tertia propositio hesterna'. Question 3's remark concerning 'the present lecture' demonstrates that question 4 was the next lecture: 'Iuxta duo argumenta duo erunt articuli. Primo enim pro praesenti lectione videbitur utrum theologicus habitus sit cognitivus, adhaesivus, vel scientificus. Secundus est iuxta materiam secundi argumenti utrum habitus fidei infusus vel acquisitus possit esse aliqualiter scientificus.' The topic of the second article is not covered in question 3, but in question 4.

The structural homogeneity is also present within the questions.[47] Lorenzo divides almost every question into three 'conclusiones' or theses, which are usually preceded by three propositions, to the extent that in question 21 he states that 'more solito ponam tres propositiones et tres conclusiones'. Each thesis typically faces one or more objections that are in turn answered with propositions. At the end of most questions, having responded to the opening arguments, often with propositions, Lorenzo adds three tiny questions with his own brief responses, with the exception of questions 32–3 and 37–45 at the end of book I (perhaps he was

running out of time) and question 117 near the end of the lecture series. By comparison, questions 93 and 106 add a fourth small question, although question 93 is suspiciously missing in FM. Altogether, then, there are 122 main questions and 332 small ones for which we have Lorenzo's doctrinal opinion.

To print this material in a modern edition of typical pages, the entire text would require about 1,200 pages, best distributed into three volumes: prologue and book I; book II; books III–IV. This may seem like a lot, but in fact each main question is roughly equivalent to a brief twenty-minute conference paper. If we assume that Lorenzo lectured for 75 or 90 minutes, perhaps the tiny questions were originally given as much attention as the others, but Lorenzo decided not to redact them.

Because of their relative chronology, M and F are independent from V. Critically editing questions 36, 68, 80 and 93, which represent different sections of the text, revealed four omissions *per homoeoteleuton* in M (of twenty words in Q.36 and of fifteen, twelve and four words in Q.93) that are not shared by F or V and an omission *per homoeoteleuton* in F (of seven words in Q.93) that is not shared by F or V, such that F cannot derive (exclusively) from M nor vice versa, and V cannot derive (exclusively) from M or F.[48] For its part, V seems to have an omission *per homoeoteleuton* of four words in question 68.

The question then becomes whether any two of these witnesses derive from a common exemplar below the exemplar that is shared by all three. MV share an omission *per homoeoteleuton* of ten words in question 68, an indication that MV may form a family. It is hard to verify this with an analysis of more minor errors, however, for two reasons. First, it was common for early modern printers to intervene with corrections and other improvements to the text, for example where V modifies what turns out to be a quotation from Gregory of Rimini in question 80. Second, because M is by far the most corrupt witness, one would expect occasional common errors shared with both F and V. For the four questions, the chart of minor errors is as shown in **Table 1**.

It seems clear, at least, that F and V do not form a family. The number of minor errors shared with M by F and V is roughly the same, yet they could be due in part to easy corrections in F and V or their exemplars, or perhaps because of unclear

TABLE I
Chart of minor errors.

Sigla	Q.36	Q.68	Q.80	Q.93	Total	Shared	Grand Total
F	4	6	11	5	26	13	39
M	23	18	21	32	94	21	115
V	6	14	13	6	39	10	49
FM	4	3	3	2	12		
FV	0	0	0	1	1		
MV	3	0	4	2	9		

readings in the archetype. Based solely on the errors in these four questions, it is not yet clear whether M belongs in a family with V (or F) or stems independently from the common archetype. While F and V are roughly equal in quality, M is much worse, which is perhaps not surprising for such a pretty manuscript in which beauty may have taken precedence over accuracy.

How do these results fit with the structural differences between the three witnesses? In question 62, M omits the first tiny question at the end, but this could be an unfortunate omission *per homoeoteleuton*, jumping from one 'Utrum' to the next, which, given the general corruption in M, was perhaps bound to happen with hundreds of tiny questions. Tiny question 2 for question 83 differs in FM and V, but probably the editor of V simply decided to clarify the title.

As mentioned, the three witnesses disagree early in book I. Questions 7 and 8 in V, labelled distinctions 2 and 3 respectively, are in reverse order in M, which accordingly assigns question 7 to distinction 3 and question 8 to distinction 2. F shows that M probably has the correct sequence: first, it also labels question 8 as distinction 2; second, F omits number 7 and adds three questions after question 8 that are lacking in MV, and the first additional question in F (8F1) is clearly a substitute for the missing question 7, not question 8. One could imagine that F contains the original arrangement, 6–8–8F1–8F2–8F3, and that Lorenzo later removed the three questions and inserted on a cedula replacement question 7, which was copied correctly in M in the sequence 6–8–7 and incorrectly in the tradition of V as 6–7–8. This would accord with the term 'Scriptum' being used in MV but not in F. More likely, however, given that the other two added questions in F, 8F2 and 8F3, differ suspiciously in structure from most of the rest in that they lack the typical three theses, F replaced the one question with the three new ones and, separately, the tradition of V reversed the sequence of 7 and 8. It could simply be instead that the archetype was unbound and chaotic. Whatever the case, F and MV are de facto separated here.

The confusion at the beginning of book III is the result of early chaos. Book III begins with a series of questions about the incarnation of the Word, covering distinctions 1–2, and then moves to the immaculate conception of the Virgin Mary in distinction 3. There are supposed to be seven questions on the incarnation followed by two on the immaculate conception, but early on something went wrong and the two questions on the immaculate conception were inserted in the middle of the incarnation questions, and the third question on the incarnation, number 88 in V, was positioned after the immaculate conception questions and before the last two incarnation questions, making it de facto the fifth question on the incarnation. One exemplar must have had a marginal note for this misplaced question saying that it is supposed to follow the second question on the incarnation, number 87 in V, which title must have been written in the note. The scribe of the common exemplar of FM must have merely copied the questions as he found them and when he saw the marginal note he simply inserted it into the text, and it was duly copied into FM. Besides the confused order, the numbering in these manuscripts also became confused.

The editor of V, or less likely the scribe of a manuscript from which it ultimately stems, saw the note and moved the third question on the incarnation back into the correct position. He also moved the two immaculate conception questions to their correct position after the seven incarnation questions, but in doing so he reversed the two immaculate conception questions, 93 and 94 in V, not seeing that the opening 'quaero secundo et ultimo circa materiam de peccato originali' in V's question 93 referred back to 'Circa distinctionem 3, in qua Magister agit de virginali conceptu beatae Virginis', which is the first question on original sin, although now it is number 94 in V. Here is a chart of what happened at the start of book III:

Correct sequence: 1 2 3 4 5 6 7 8 9 10
Sequence in FM: 1 2 4 5 8 9 3 5 6 10
Sequence in V: 1 2 3 4 5 6 7 9 8 10

Unfortunately, not only does this chaos not inform us about whether or not V belongs with F or M, but it indicates that FMV all stem from a common exemplar that is not the archetype. Perhaps, however, it explains another anomaly. As mentioned, question 93 in V is one of two cases where a fourth tiny question is added to the normal three at the end of the main question. In this case it is present only in V, not in the two manuscripts. In fact, at the end of tiny question 3, V adds the unnecessary phrase 'ideo fomes non fuit in ea', which repeats the start of the sentence: 'Respondetur quod in ea non fuit fomes …'. Having argued strongly in favour of the immaculate conception of the Virgin, the text in V continues with the oddly and awkwardly worded tiny question 4, charitably translated thus: 'Whether, if the Blessed Virgin had been (*fuisset*) born without original sin, because of this it would equal the conception of Christ.' This is odd because Lorenzo has already argued that de facto she was born without original sin, so the pluperfect subjunctive 'fuisset' is jarring. On the one hand, the awkward Latin does not seem to be what a Venetian printer in the humanist age would have added, but, on the other, it does not appear to be original either, hence its absence in FM. Since the Ordo Servorum Beatae Virginis Mariae was and is especially devoted to the Virgin, could the tiny question 4 be a clumsy addition in V's tradition by a later follower of Lorenzo in the order? The reversal of the two questions on the immaculate conception in V may have encouraged this, for the first question, which has become the second, number 94 in V, is prefaced with 'concesso quod Beata Virgo fuerit concepta cum peccato originali', which in V follows smoothly after 'si Beata Virgo fuisset sine peccato originali genita …'. Whatever the explanation, the extra tiny question in V sets it apart from FM.

Further editing work may clarify the relationship between the three witnesses, but even if it does not, we already have a sensible *ratio edendi* where there is disagreement and there is no obvious error: wherever F and V disagree, we should generally use M to break the tie, all else being equal. The following question list uses this method.

In the *tabula quaestionum*, questions are numbered according to the sequence in V. The witnesses do not always agree on the distinction numbers, and there is also overlap in distinctions covered. If yes/no responses are given, they are provided in parentheses after the question; otherwise a simple (-) indicates that the response is more complicated. Generally, Lorenzo will argue for the opposite response for the main questions, but the initial responses to the tiny questions are his own.

Acknowledgements

I thank Ziang Chen for photographing the Florence manuscript; Anne Anderton for her gracious assistance with the Manchester manuscript; Laura Light, William Duba, Monica Brînzei, and especially Adinel Dincă for their expert opinions on the script and illustration in the Manchester manuscript and Stephen Mossman for the analysis of the watermarks; Russell Friedman and Steven Spileers for information retrieval; the two anonymous readers for their comments and corrections; and the extremely efficient editors of this journal. This article has received funding from the European Research Council (ERC) under the European Union's Horizon 2020 research and innovation programme (grant agreement No. 771589 – DEBATE).

Appendix: Tabula Quaestionum

Prologus

[1] Prologus, q. 1 [F 1ra–va; M 1ra–2va; V 2ra–3rb (IIra–IIIrb)] Circa prologum... quaeritur [a reverendo magistro Laurentio *add.* M] utrum actualis intelligentia luminis naturalis de aliqua intellectuali essentia possit aliquam evidentem et intuitivam notitiam theologicam aliqualiter causare. (*sic*) 1. Utrum divina essentia sub quacumque ratione essentiali intrinseca menti obiectiva sit de immensa sui natura cuiuslibet veri sufficiens notitia. (*sic*) 2. Utrum divina essentia tam intense respectu veri contingentis sit species vel idea sicut respectu sui veri absolute necessarii. (*sic*) 3. Utrum sit possibile intellectum creatum respectu divinae essentiae omniumque creaturarum intelligibilium in ipsa relucentium habere intuitivam notitiam. (*sic*)

[2] Prologus, q. 2 [F 1va–2ra; M 2va–3vb; V 3rb–4rb (IIIrb–IIIIrb)] Utrum aliqua imaginabilis essentia citra primam possit aliquo modo esse respectu divinae essentiae notitia intuitiva. (non) 1. Utrum divina essentia, sicut respectu quorum qualitercumque sciri possunt est ratio cognitiva, ita respectu quorum qualitercumque fieri possunt sit idealis notitia. (non) 2. Utrum sola essentia divina possit esse menti beatae notitia obiectiva in esse intuitivae notitiae facialis sic quod possit esse eiusdem formale praemium beatificum. (*sic*) 3. Utrum divina essentia sit lumen formale gloriae aeternae supernaturaliter elevans intellectum creatum in patria ad Deum clare videndum. (*sic*) [*F moves the three tiny questions to after question 3*]

[3] Prologus, q. 3 [F 2ra–va; M 3vb–5va; V 4rb–5rb (IIIIrb–vb, then folio numbered IIIra–b)] Utrum creatura rationalis possit de veritatibus theologicis habere aliquam habitualem notitiam proprie scientificam. (*sic*) 1. Utrum ad habendum seu eliciendum assensum theologicae veritatis sola libertas sufficiat viatoris. (non) 2. Utrum quanta est certitudo fidei tanta sit certitudo habitus theologici. (*sic*) 3. Utrum ex discursu mere probabili theologicus habitus concludatur. (non)

[4] Prologus, q. 4 [F 2va–3ra; M 5va–6ra; V 5rb–6rb (folio numbered IIIrb–vb, then folio numbered 5ra–b)] Utrum habitus fidei infusus vel acquisitus possit esse proprie scientificus. (*sic*) 1. Utrum habitus theologicus sit proprie practicus. (non) 2. Utrum autem sit proprie speculativus. (non) 3. Utrum sit simul practicus et speculativus. (non)

Primus liber

[5] D. 1, q. 1 [F 3ra–va; M 6ra–7va; V 6rb–7rb (folio numbered 5rb–vb, then folio correctly numbered 7ra–b, number 6 having been skipped)] Utrum cuiuslibet creaturae rationalis activitas perceptiva praecise in aliquo incommutabili bono possit ultimo beatifice quietari. (non) 1. Utrum frui sit actus proprius voluntatis.

(*sic*) 2. Utrum voluntas possit beatifice frui sine omni actu. (non) 3. Utrum fruitio in se ipsa sit realiter vel essentialiter beatitudo. (*sic*)

[6] D. 1, q. 2 [F 3va–4rb; M 7va–9ra; V 7rb–8vb] Utrum volitiva potentia per suae libertatis propriam efficaciam possit non frui obiecto beatifico clare viso. (*sic*) 1. Utrum beatus fruatur tribus personis una fruitione necessario. (*sic*) 2. Utrum aliqua creatura sit ordinate fruendum. (non) 3. Utrum visio beatifica sit immediatum obiectum ordinatae fruitionis in patria. (non)

[7] D. 2 (3 M), q. un. [F *deest*; M 10rb–11rb (*reversing QQ. 7–8*); V 8vb–9vb] Utrum prima denominatio perfectionis simpliciter ipsius divini esse naturae divinae intrinseca sit communis Deo et creaturae. (non) 1. Utrum necesse sit ponere unum Deum. (*sic*) 2. Utrum aliquis ordo sit in perfectionibus divinis. (non) 3. Utrum prima perfectio in divinis includat alias unitive. (-)

[8] D. 3 (2 FM), q. un. [F 4rb–vb; M 9ra–10rb; V 9vb–10va] Utrum partes imaginis creatae in anima rationali ad invicem sint aequales. (non) 1. Utrum unica sit potentia arbitrativa et per se ipsam deliberativa. (*sic*) 2. Utrum partes imaginis coaequentur quoad facile operari. (non) 3. Utrum coaequentur quoad faciliter operari in patria. (*sic*)

[8F1] [F 4vb–5vb] Utrum creatura mundi per ea quae a Deo facta sunt invisibilia Dei valeat cognoscere. (non) 1. Utrum Deus cognoscatur a nobis hic in via. (-) 2. Utrum Deum esse sit per se notum. (-) 3. Utrum Deum esse possit demonstrari. (-)

[8F2] [F 5vb–6rb] Utrum per naturalem rationem Trinitas possit cognosci. (*sic*) 1. Quaeritur respectu cuius sumitur vestigium. (-) 2. Quaeritur an aequaliter in omnibus reperiatur vestigium. (-) 3. Quaeritur quot sunt partes vestigii. (-)

[8F3] [F 6va–b] Utrum potentiae animae, scilicet memoria, intelligentia, et voluntas, sint aequales. (non) 1. Utrum memoria, intelligentia, et voluntas sint tres potentiae. (-) 2. Utrum una potentia oriatur ab alia. (-) 3. Quaeritur secundum quid magis repraesentatur Trinitas. (-)

[9] D. 4, q. un. [F 7ra–va; M 11rb–12vb; V 10vb–11va] Utrum in summa, aeterna, et incommutabili natura sit possibilis aliqua distinctio, productio, vel origo. (-) 1. Utrum quanta necessitate Pater est Deus tanta necessitate Pater generet Verbum. (*sic*) 2. Utrum tanta simplicitate Pater sit Deus et Pater quanta et qua est essentia vel paternitas. (*sic*) 3. Utrum, sicut Filius est a Patre Filius in esse personali, sic ab eo accipiat esse sapientiam in essentiali. (*sic*)

[10] D. 5, q. un. [F 7va–8ra; M 12va–14ra; V 11va–12va] Utrum tanta possit esse activa causalitas alicuius imaginabilis essentiae intrinseca quod ex se ipsa possit se ipsam gignere vel in esse producere. (*sic*) 1. Utrum essentia aliquam activitatem habeat in divinis in esse agendi. (-) 2. Utrum aeque proprie dicatur quod divinitas generat *sic*ut quod Pater generat. (non) 3. Utrum aliqua perfectio in Filio possit esse terminus generationis. (non)

[11] D. 6, q. un. [F 8ra–vb; M 14rb–15va; V 12va–14ra] Utrum proprium productivum principium Verbi divini sit formaliter voluntas paterna. (sic) 1. Utrum Verbum essentiale sit prius quolibet Verbo suppositali. (non) 2. Utrum quodlibet essentiale in divinis sit prius quolibet notionali. (-) 3. Utrum Filius genitus habeat a se aliquam perfectionem. (-)

[12] D. 7, q. 1 [F 8vb–9rb; M 15va–17ra; V 14ra–15rb] Utrum increatum Verbum natura et necessitate vel spontanee liberaque voluntate aeternaliter sit productum. (sic) 1. Utrum posse in actum et in eius oppositum sit de intrinseca et formali ratione libertatis. (-) 2. Utrum eadem praecise libertate Pater gignat Verbum et creaturam producat. (-) 3. Utrum percipere notitiam de sui natura sit notitiam de se gignere. (non)

[13] D. 7, q. 2 [F 9rb–10ra; M 17ra–18va; V 15rb–16va] Utrum posse active generare Verbum sit immensum posse activum et causale. (sic) 1. Utrum quodlibet posse in Patre sit communicabile. (non) 2. Utrum quodlibet divinum suppositum formaliter sit immensum. (non) 3. Utrum producere suppositum divinum ad intra sit proprium *sic*ut agere. (*sic*)

[14] D. 7, q. 3 [F 10ra–vb; M 18va–20ra; V 16va–17vb] Utrum suppositale Verbum per suam immensam et aeternalem potentiam possit aliam personam a se per modum generationis in esse producere. (sic) 1. Utrum in divinis generatio et generare sint idem formaliter. (non) 2. Utrum dicere in divinis sit perfectionis simpliciter. (-) 3. Utrum posse producere amorem seu donum infinitum essentialiter sit infinitae perfectionis simpliciter. (-)

[15] D. 8, q. un. [F 10vb–11va; M 20ra–21vb; V 17vb–19ra] Utrum immutabilis, supersimplex, et immensa essentia possit esse in aliquo genere praedicamentali, non obstante eius immensa simplicitate graduali. (sic) 1. Utrum maiorem simplicitatem includat separata intelligentia quam anima humana. (sic) 2. Utrum cuiuslibet rei ideatae sit aequalis idea in divina essentia. (sic) 3. Utrum non obstante finitate ideatorum sint infinitae ideae in intellectu divino. (sic)

[16] D. 9, q. un. [F 11va–12rb; M 21vb–23rb; V 19ra–20rb] Utrum generatio Verbi divini in instanti aeternitatis proprie valeat mensurari. (non) 1. Utrum in aeterna essentia aeternitas et instans aeternitatis sint aliquo modo differentia. (non) 2. Utrum plura possint esse instantia aeternitatis. (non) 3. Utrum in divinis sint plures producti, ita quod possit concedi quod ibi sint plures aeterni. (-)

[17] Dd. 10–11, q. un. [F 12rb–13ra; M 23rb–25ra; V 20va–21vb] Utrum Spiritus Sanctus ut amor infinitus a Patre et Filio liberrime producatur ut ab uno formali principio productivo. (-) 1. Utrum, si Filius non spiraret, esset a Patre genitus. (non) 2. Utrum Spiritus Sanctus spiretur totaliter a Patre et totaliter a Filio. (sic) 3. Utrum, *sic*ut sunt duae personae distinctae spirantes, possit aliqualiter dici quod sint duae spirationes distinctae. (non)

[18] D. 12, q. un. [F 13ra–va; M 25rb–26vb; V 21vb–23ra] Utrum Spiritus Sanctus a Patre et Filio aliqua prioritate vel ordine omnimode uniformiter producatur.

(non) 1. Utrum Spiritus Sanctus plenius procedat a Patre quam a Filio. (non) 2. Utrum Spiritus Sanctus immediatius procedat a Patre quam a Filio vel e converso. (non) 3. Utrum Spiritui Sancto sit vis spirativa. (-)

[19] D. 13, q. un. [F 13va–14rb; M 26vb–28rb; V 23ra–24rb] Utrum generatio et spiratio ex varietate principiorum in divinis suppositis ad invicem formaliter distinguantur. (non) 1. Utrum eadem sit activa virtus intellectus et voluntatis divinae. (-) 2. Utrum, si Spiritus Sanctus non procederet a Filio, distingueretur ab eo. (non) 3. Utrum, si Spiritus Sanctus non procederet a Filio, procederet tamen a Patre tanquam ab uno principio productivo. (non)

[20] Dd. 14–15, q. un. [F 14rb–15ra; M 28rb–29vb; V 24rb–25va] Utrum invisibilis Spiritus Sancti missio in mente viatoris sit solum a Patre et Filio vel illa tota incommutabilis Trinitas inseparabiliter operetur. (-) 1. Utrum processio aeternalis Spiritus Sancti et temporalis eodem termino terminetur. (-) 2. Utrum missio Filii in mentem sit similis missioni Spiritus Sancti consimiliter missi ad ipsam mentem. (-) 3. Utrum Spiritus Sancti temporalis missio sit intrinsece aliqua mutatio. (-)

[21] D. 16, q. un. [F 15ra–va; M 29vb–31rb; V 25va–27ra] Utrum solum increatum donum ad creaturam sanctificandam temporaliter mittatur et solum per ipsum sine creato dono creatura rationalis intrinsece gratificetur. (non) 1. Utrum Spiritus Sancti dona dentur sine eo quod detur ipsa persona Spiritus Sancti. (*sic*) 2. Utrum omnibus quibus datur Spiritus Sancti persona dentur eis gratissima dona. (non) 3. Utrum creata mens per Spiritum Sanctum actuata sit ad vitam aeternam aeternaliter praeordinata. (*sic*)

[22] D. 17, q. 1 [F 15va–16rb; M 31rb–32vb; V 27ra–28rb] Utrum caritas vel dilectio qua meritorie diligimus Deum et proximum sit ipse Spiritus Sanctus increatum donum. (*sic*) 1. Utrum aliquis actus ex puris naturalibus elicitus possit acceptari a Deo ad praemium beatificum. (-) 2. Utrum possibile sit animam existentem in caritate non esse Deo dilectam. (-) 3. Utrum aliquis actus ex caritate factus possit non esse Deo placitus. (non)

[23] D. 17, q. 2 [F 16rb–17rb; M 32vb–34va; V 28rb–29vb] Utrum actus bonus ex genere extra caritatem factus illius qui remanet in culpa mortali possit de potentia Dei absoluta ad esse gratuitum aliqualiter acceptari. (*sic*) 1. Utrum fugibilior sit poena damni quam sensus. (-) 2. Utrum, *sic*ut quilibet actus meritorius est meritorius ex sola acceptatione divina, ita quilibet demeritorius sit demeritorius ex sola divina non-acceptatione. (non) 3. Utrum quilibet actus a caritate elicitus sit ita bonus *sic*ut alius extra caritatem est malus. (non)

[24] D. 17, q. 3 [F 17rb–18ra; M 34va–36va; V 29vb–31ra] Utrum caritas vel aliqua imaginabilis forma divisibilis intensissime possit intendi per additionem novi gradus ad aliquem priorem realiter condistincti. (non) 1. Utrum voluntas ex aliquo actu meritorio possit in se caritatem aliqualiter augmentare. (non) 2. Utrum caritas in tempore vel in instanti a Deo realiter augmentetur. (*sic*) 3. Utrum caritas unico actu vel pluribus augmentetur. (-)

[25] D. 17, q. 4 [F 18ra–vb; M 36va–38rb; V 31ra–32vb] Utrum ad quodlibet meritorie agere imputabiliter se habens ad praemium gloriae [et *add. codd.*] creata caritas totaliter vel partialiter active concurrat. (non) 1. Utrum aliqua caritate informatus possit ex se cognoscere quod sit Deo gratus. (non) 2. Utrum intellectus activitas possit definitive cognoscere quid sit creata caritas. (*sic*) 3. Utrum voluntas non iuta speciali auxilio possit exire in actum meritoriae actionis sola caritate informata. (non)

[26] D. 17, q. 5 [F 18vb–19va; M 38rb–40ra; V 32vb–34ra] Utrum per aliquam culpam mortalem vel venialem alicuius pravitatis possit diminui substantia vel esse alicuius infusae vel acquisitae caritatis. (*sic*) 1. Utrum quaelibet minima latitudo gratiae quantumlibet parva sit melior quam aliqua venialis culpa quantumlibet magna sit mala. (*sic*) 2. Utrum peccatum veniale sit tantae activitatis in agendo quantae activitatis est gratia in resistendo. (non) 3. Utrum caritas sit diligenda ex caritate ab ipsa realiter condistincta. (-)

[27] Dd. 19–24, q. 1 [F 19va–19bisrb; M 40ra–41va; V 34ra–35rb] Utrum personae divinae, non obstante quacumque distinctione personali, sint perfectissime aequales in omni perfectione essentiali. (non) 1. Utrum, *sicut* una persona dicitur aequalis alteri, ita dicatur alteri adaequari. (non) 2. Utrum aliqua creatura possit per aliquam potentiam tam perfecte alteri coaequari *sicut* una persona divina est alteri coaequalis. (non) 3. Utrum, non obstante distinctione personali, una persona possit esse in aliqua aliarum. (*sic*)

[28] Dd. 19–24, q. 2 [F 19bisrb–vb; M 41va–42vb; V 35rb–36rb] Utrum tanta sit aequalitas divinarum personarum quoad potentiam quanta est identitas earum quoad essentiam. (*sic*) 1. Utrum posse perceptivum includatur in ratione omnipotentiae. (*sic*) 2. Utrum quodlibet posse factivum sit posse productivum. (*sic*) 3. Utrum quaelibet persona divina sit alteri aequalis in quolibet effectivo posse. (*sic*)

[29] D. 24, q. un. [F 19bisvb–20va; M 42vb–44rb; V 36va–37va] Utrum ex aliqua replicatione unitatis divinae aliquis formalis numerus sit aliqualiter ponendus in divina essentia. (non) 1. Utrum numerus perfectionum in divinis aliqua unitate essentiali proprie mensuretur. (-) 2. Utrum unitas personalis in divina essentia sit intrinseca unitas. (*sic*) 3. Utrum unitas vel numerus dicat aliam rem superadditam a tribus rebus numeratis. (non)

[30] Dd. 25–34, q. 1 [F 20va–21ra; M 44rb–45vb; V 37va–38vb] Utrum personae divinae per aliquam positivam proprietatem complexe vel incomplexe sumptam ad invicem distinguantur. (*sic*) 1. Utrum personae divinae se ipsis vel suis proprietatibus distinguantur. (-) 2. Utrum, subductis proprietatibus, personae divinae possint ad invicem distingui. (non) 3. Utrum paternitas sit in Patre intrinseca proprietas, et filiatio in Filio, et spiratio passiva in Spiritu Sancto. (-)

[31] Dd. 25–34, q. 2 [F 21ra–vb; M 45vb–47rb; V 38vb–40ra] Utrum notionale Verbum ex Verbo essentiali et proprietate personali constituatur in esse suppositali. (*sic*) 1. Utrum unicum sit esse essentiale et suppositale. (*sic*) 2. Utrum esse

suppositale sit aliquod positivum esse. (-) 3. Utrum persona possit per aliquam proprietatem ab esse\<ntia\> distingui. (non)

[32] Dd. 27–33, q. 1 [F 21vb–22rb; M 47rb–48rb; V 40rb–41rb] Utrum quaelibet viatoris voluntas possit quemlibet gradum caritatis amittere secundum quem Deum super omnia potest meritorie diligere. (non)

[33] Dd. 27–33, q. 2 [F 22rb–va; M 48rb–vb; V 41rb–va] Utrum, posito quod aliquis amittat caritatem, deleatur per hoc de libro vitae. (-)

[34] D. 29, q. un. [F 22va–23rb; M 48vb–50ra; V 41va–42va] Utrum ratio principiandi respectu cuiuslibet rei creabilis vel creatae cuilibet divino supposito aequaliter correspondeat. (non) 1. Utrum persona Patris per prius sit principium causandi ad extra quam Filius. (sic) 2. Utrum una persona sit alterius principiativa. (-) 3. Utrum, si creaturae fuissent ab aeterno, hoc nomen 'principium' per prius diceretur de Deo respectu personarum quam respectu creaturarum. (sic)

[35] D. 30, q. un. [F 23rb–24ra; M 50ra–51vb; V 42va–43va] Utrum relatio Dei ad creaturam possit esse temporalis similiter et aeterna. (-) 1. Utrum omnia nomina quae dicuntur de Deo ex tempore dicantur de qualibet persona. (non) 2. Utrum aliquis ex nova denominatione relationis possit intrinsece transmutari. (sic) 3. Utrum idem possit ad se referri. (sic)

[36] D. 41, q. 1 [F 24ra–vb; M 51vb–53rb; V 44ra–45rb] Utrum futurum temporale demeritum creaturae sit aliquo modo causa reprobationis aeternae. (sic) 1. Utrum numerus electorum sit contingens aequaliter. (sic) 2. Utrum numerus electorum vel reprobatorum sit certus et immutabilis. (sic) 3. Utrum Deus sit causa obdurationis in praescito. (-)

[37] D. 41, q. 2 [F 24vb–25ra; M 53rb–vb; V 45rb–vb] Utrum praedestinationis electi causa et reprobationis praesciti sit eorum aliquid meritorie vel demeritorie operari. (sic)

[38] D. 42, q. 1 [F 25ra–b; M 53vb–54va; V 45vb–46rb] Utrum omne possibile fieri Deus ex sua potentia facere possit. (non)

[39] D. 42, q. 2 [F 25rb–va; M 54va–55rb; V 46rb–vb] Utrum Deus per suam potentiam posset dicere falsum. (sic)

[40] D. 45, q. un. [F 25va–26ra; M 55rb–56ra; V 46vb–47rb] Utrum voluntas Dei omnium quae fiunt sit prima causa efficiens. (non)

[41] D. 47, q. un. [F 26ra–b; M 56ra–vb; V 47rb–vb] Utrum voluntas Dei semper impleatur. (non)

[42] D. 48, q. 1 [F 26rb–vb; M 56vb–57rb; V 47vb–48rb] Utrum quilibet viator utens libero arbitrio teneatur voluntatem suam voluntati divinae conformare in volito. (non)

[43] D. 48, q. 2 [F 26vb–27ra; M 57rb–58rb; V 48rb–49ra] Utrum voluntas creata gratia et caritate praeventa respectu cuiuslibet sui actus sit simpliciter libera. (-)

[44] D. 48, q. 3 [F 27ra–b; M 58rb–vb; V 49ra–va] Utrum in radio luminis aeterni possit creatum quodlibet deformiter discerni. (-)

[45] D. 48, q. 4 [F 27rb–va; M 58vb–59ra; V 49va–b] Utrum Patris potentia generandi ad intra possit communicari Filio. (*sic*)

Explicits

F: Explicit super primo Sententiarum.
M: Explicit scriptum super primo libro Sententiarum secundum exim<i>um doctorem magistrum Laurentium de Bononia Ordinis Servorum.
V: Ordinatissimi theologi et Sacrae Scripturae scientissimi Laurentii Opimi Bononiensis super primo Sententiarum explicit impressum per Jo. Antonium et fratres de Sabio MDXXXII. *Tabula quaestionum Prologi*: 50ra; *Tabula quaestionum libri primi*: 50ra–51rb; *Errata*: 51v

Secundus liber

[46] D. 1, q. 1 [F 27va–28rb; M 59rb–61ra; V 1ra–2rb] Utrum immensum unicum principium ex sua propria causalitate possit aliud universum in esse producere ab isto specie vel numero distinctum. (-) 1. Utrum ab unico principio possit aliquod malum aliquo modo derivari in esse. (-) 2. Utrum, *sic*ut ex quolibet contingenti esse inferatur simpliciter aliquod necesse esse, ita ex primo necesse esse sequatur aliquod contingens esse. (non) 3. Utrum ex quantalibet remissa factione independente alicuius viventis arguatur immensa activitas primi agentis. (*sic*)

[47] D. 1, q. 2 [F 28rb–29ra; M 61ra–62rb; V 2rb–3va] Utrum primi principii entitas vel essentia in esse causalitatis et activae potentiae infinitae formaliter sit immensa. (non) 1. Utrum divina causalitas respectu inaequalium effectuum inaequaliter sit activa. (non) 2. Utrum, *sic*ut divina causalitas respectu cuiuslibet effectus aequaliter se habet active, ita in quolibet tali aeque reluceat perfective. (non) 3. Utrum cuilibet causalitati divinae extrinsece creata causalitas possit cooperari. (non)

[48] D. 1, q. 3 [F 29ra–va; M 62rb–63va; V 3va–4va] Utrum praecise eodem modo quo Deus principiat ad intra aeternaliter principiaverit ad extra temporaliter. (*sic*) 1. Utrum aeque immense Deus principiet ad extra *sic*ut ad intra. (*sic*) 2. Utrum Deus aeque uniformiter producat ad extra *sic*ut uniformiter producit ad intra. (non) 3. Utrum Deus possit esse aliquo modo ad extra necessario activus. (-)

[49] D. 1, q. 4 [F 29va–30ra; M 63va–64vb; V 4va–5vb] Utrum ex activitate primi entis simpliciter ex nihilo possit aliquis effectus in esse produci in latitudine entis creati. (non) 1. Utrum, si forma substantialis vel accidentalis essent separatae per aliquam divinam potentiam, aliquod agens naturale posset ipsas corrumpere per

aliquam violentiam. (non) 2. Utrum aliqua creatura posset Deo cooperari in opere creationis. (-) 3. Utrum, etsi agentia <naturalia> non cooperentur proprie Deo in creatione, tamen eidem in aliqua rerum productione. (-)

[50] D. 1, q. 5 [F 30ra–va; M 64vb–65vb; V 5vb–6vb] Utrum quilibet effectus ad extra productus temporaliter a prima causa sit derivabilis contingenter. (non) 1. Utrum aliqua causa inferior essentialiter possit determinare suam causam sibi superiorem realiter. (non) 2. Utrum Deus aliqualiter producat ad extra qualiter producit ad intra. (-) 3. Utrum causa naturalis ita necessario producat suum effectum quod non possit non producere ipsum. (-)

[51] D. 1, q. 6 [F 30va–31ra; M 65vb–67rb; V 6vb–7vb] Utrum cuiuslibet effectus producibilis vel producti divina causalitas sit prima et immediata causa. (non) 1. Utrum prima causa ad quemlibet effectum generando vel potius creando concurrat. (-) 2. Utrum solus Deus possit esse libera causa ut aliqua res sit causa partialis efficiens essentiam aliquam. (*sic*) 3. Utrum prima causa possit supplere causalitatem cuiuslibet creabilis vel creatae rei. (non)

[52] D. 1, q. 7 [F 31ra–vb; M 67rb–68va; V 7vb–9ra] Utrum ad quemlibet actum elicitum voluntatis creatae necessario exigatur divinus concursus aliqua prioritate. (non) 1. Utrum in aliquo peccato culpae mortalis aliquo modo requiratur auxilium vel coefficientia specialis Dei. (-) 2. Utrum respectu omnis partialis agere voluntatis concursus Dei specialem actum habeat activitatis. (*sic*) 3. Utrum actus meritorie elicitus voluntatis creatae dicatur esse libere ex habitu caritatis. (non)

[53] D. 1, q. 8 [F 31vb–32rb; M 68va–69vb; V 9ra–10rb] Utrum quodlibet divinum suppositum praecise secundum eundem causalitatis modum sit cuiuslibet effectus productivum ad extra in latitudine entitatis. (non) 1. Utrum causalitas respectu creaturae per prius competat Patri quam Verbo. (*sic*) 2. Utrum, etsi causalitas respectu creaturae prius competat Patri quam Verbo, per hoc Pater per prius actualiter concurrat ad effectum quam Verbum. (non) 3. Utrum, si non esset nisi unum suppositum in divinis vel una persona, illa plene posset quodlibet possibile ponere in esse. (*sic*)

[54] D. 1, q. 9 [F 32rb–33ra; M 69vb–71ra; V 10rb–11rb] Utrum ex immensa activitate primi principii aliqua res ad extra ab aeterno potuit in esse produci. (non) 1. Utrum quodlibet quod potuit vel potest habere contingenter esse necessario potuerit incipere esse. (non) 2. Utrum aliquid quod nunc est potuerit non incipere esse. (*sic*) 3. Utrum alius mundus ab isto sit aeternus et in infinitum perfectior isto. (*sic*)

[55] D. 1, q. 10 [F 33ra–vb; M 71ra–72rb; V 11va–12va] Utrum ad deformiter agere voluntatis creatae divina voluntas possit aliquo modo immediate causaliter et active concurrere. (*sic*) 1. Utrum respectu alicuius peccati sit aliqua potentia. (-) 2. Utrum potentia peccandi sit a Deo. (-) 3. Utrum aliquis actus voluntatis sit ita deformis quod nullo modo possit esse conformis. (*sic*)

[56] D. 1, q. 11 [F 33vb–34rb; M 72rb–73va; V 12va–13va] Utrum in causis essentialiter ordinatis causa superior aliis inferioribus causis in esse causalis perfectionis supremae causae sit propinquior. (sic) 1. Utrum sicut causa inferior exigit sibi superiorem in causari, ita exigat in suo conservari. (sic) 2. Utrum causa inferior dependeat in causando a prima superiori. (sic) 3. Utrum causa superior prius influat in effectum quam causa inferior. (sic)

[57] Dd. 2–12, q. 1 [F 34rb–35ra; M 73va–75ra; V 13va–14vb] Utrum probabiliter possit teneri angelos omnes specifice diversificari. (non) 1. Utrum unus angelus ad unum effectum sufficiat vel plures concurrant ad eundem effectum. (non) 2. [*this question was left unanswered*: Utrum quanto entia sunt simpliciora dicantur esse saltem secundum speciem numerosiora] tertio (!) utrum angeli individualiter dicantur personae realiter. (sic) 3. Utrum angelorum non parvus sed maximus credatur esse numerus. (sic)

[58] Dd. 2–12, q. 2 [F 35ra–vb; M 75ra–76rb; V 14vb–15vb] Utrum angelus intelligat suam essentiam clarissime et formaliter per se ipsam. (non) 1. Utrum angelus bonus sua naturali notitia cognoscat homines esse in gratia. (sic) 2. Utrum angelus ad custodiam alicuius deputatus habeat plenam cognitionem illius. (non) 3. Utrum angelus bonus noverit hominem ad sui custodiam deputatum esse praescitum vel praedestinatum. (-)

[59] Dd. 2–12, q. 3 [F 35vb–36va; M 76rb–78ra; V 15vb–16vb] Utrum spiritus angelici in primo suo instanti quo fuerunt creati habitu supernae caritatis fuerint decorati. (non) 1. Utrum omnes angeli in caritate differentes fuerint creati. (sic) 2. Utrum aliquis de his qui ceciderunt habuerit in primo instanti intensiorem habitum caritatis quam aliquis illorum qui permanserunt. (sic) 3. Utrum angeli suam beatitudinem potuerint meruisse in primo instanti sui esse. (sic)

[60] Dd. 2–12, q. 4 [F 36va–37ra; M 78ra–79rb; V 16vb–17vb] Utrum possibile fuerit potentiam volitivam angeli primi appetere essentiam suae entitatis converti in supersimplicissimum gradum immensae deitatis. (sic) 1. Utrum praecise Dei similitudinem appetere sit semper culpabile delinquere. (-) 2. Utrum angeli mali ita appetierint aequalitatem Dei, saltem indirecte, ut dicitur primum angelum appetisse. (-) 3. Utrum angelus malus adhuc concipiat formaliter quod sibi debeatur gloria et beatitudo non ex gratia, sed ex debito realiter. (sic)

[61] Dd. 2–12, q. 5 [F 37ra–vb; M 79rb–80va; V 17vb–19ra] Utrum essentia cuiuslibet angeli ex sua propria ratione intrinseca essendi possit alicubi coexistere praesentialiter et definitive. (non) 1. Utrum angelus sit vel possit esse in loco indivisibili vel in loco punctali. (non) 2. Utrum angelus, licet possit esse successive in pluribus locis, sit tamen determinatus ad maximum locum cui potest coexistere sic quod non in maiori. (-) 3. Utrum angelus determinet sibi naturaliter unum locum sic quod in minori non possit esse. (non)

[62] Dd. 2–12, q. 6 [F 37vb–38va; M 80va–82ra; V 19ra–20ra] Utrum alicuius angeli damnati voluntas per aliquod suum velle vel nolle possit moraliter vel iuste

bene velle. (-) 1. Utrum, sicut angelus malus continue peccat mortaliter, sic continue de novo demereatur actualiter. (non) [*M omits tiny question 1*] 2. Utrum, quia Deus non vult iuvare speciali iuvamento daemonem, sit necessitas antecedens ad ipsum culpabiliter agere. (non) 3. Utrum pravus angelus qui continue peccat dicat aliquando verum. (-)

[63] Dd. 2–12, q. 7 [F 38va–39rb; M 82ra–83va; V 20ra–21rb] Utrum unus angelus suae mentis conceptum per locutionem alteri valeat manifestare vel superior inferiorem valeat illuminare. (-) 1. Utrum, si per imaginationem poneretur vacuum inter tres angelos, posset unus angelus alteri loqui. (non) 2. Utrum unus angelus sic possit loqui uni quod non alteri. (*sic*) 3. Utrum sit differentia inter locutionem et illuminationem. (*sic*)

[64] Dd. 2–12, q. 8 [F 39rb–vb; M 83va–85ra; V 21va–22vb] Utrum sit possibile aliquem angelum malum posse illabi in aliquam animam rationalem intrinsece per quantumlibet suum immensum activum agere. (*sic*) 1. Utrum sit licitum in artibus magicis uti auxilio daemonum. (non) 2. Utrum sit aliquo modo licitum invocare daemonem ut inveniatur aliquod perditum. (*sic*) 3. Utrum per revelationes daemonum possit haberi veritas divinationum. (non)

[65] D. 11, q. un. [F 39vb–40va; M 85ra–86va; V 22vb–24ra] Utrum angeli confirmati propter ipsorum ministerium habere possint aliquam meritoriam imputabilitatem ad aliquod beatificum praemium. (*sic*) 1. Utrum infidelibus qui nihil de fide catholica scire dicuntur angeli pro custodia deputentur. (-) 2. Utrum angelus bonus aliquando deserat illum ad cuius custodiam scit se esse deputatum. (-) 3. Utrum homo Christus fuerit ab angelo custoditus. (-)

[66] Dd. 12–16, q. 1 [F 40va–41va; M 86va–88rb; V 24ra–25va] Utrum materia cuiuslibet supercaelestis orbis sit alterius rationis a materia corporis existentis infra latitudinem elementaris regionis. (non) 1. Utrum cuiuslibet formae substantialis sola materia sit primum et immediatum subiectum. (*sic*) 2. Utrum compositum sit formae accidentalis subiectum ratione materiae praecise vel ratione formae substantialis dissimilis. (-) 3. Utrum sit possibile per divinam potentiam materiam existere et nullam in se formam substantialem vel accidentalem habere. (*sic*)

[67] Dd. 12–16, q. 2 [F 41va–42ra; M 88rb–89va; V 25va–26vb] Utrum cuiuslibet corporis supercaelestis naturalis essentia intrinsece et proprie sit incorruptibilis et ingenita. (non) 1. Utrum caelum moveatur a principio intrinseco. (-) 2. Utrum corpora caelestia aliquo modo sint complexionata. (non) 3. Utrum corpora caelestia super liberum arbitrium habeant causalitatem vel influentiam. (-)

[68] Dd. 12–16, q. 3 [F 42ra–43ra; M 89va–91ra; V 26vb–28ra] Utrum astrologus per aliquam contemplationem scientificam motus vel coniunctionis elementaris possit verissime praenosticari aliquod futurum contingens esse verum. (non) 1. Utrum in rebus omnibus licitum sit contemplari dies, menses, et horas et electo tempore aliquid operari. (-) 2. Utrum ex coniunctionibus siderum

producantur interdum monstra vel variae species animalium. (*sic*) 3. Utrum in caelorum essentia sit materia quae sit pura potentia. (-)

[69] Dd. 16–22, q. 1 [F 43ra–vb; M 91ra–92va; V 28ra–29va] Utrum sit possibile Deum producere speciem perfectissimam quae possit existere. (*sic*) 1. Utrum in Deo sit aliqua exemplaris idea supremae species repraesentativa. (non) 2. Utrum sit possibilis productio effectus tam minimi quin ex illa possit argui independentia in primo principio. (non) 3. Utrum, ex quo datur infimum in latitudine specierum, etiam detur supremum. (non)

[70] Dd. 16–22, q. 2 [F 43vb–44vb; M 92va–94rb; V 29va–31ra] Utrum possit evidenter probari vel sola fide teneri quod anima secundum quam homo est ad imaginem Dei factus sit eius substantialis forma et intrinsecus actus. (-) 1. Utrum equus generando equum generet in ipso formam sensitivam. (non) 2. Utrum, si Deus animam non infunderet, illud quod est in ventre matris esset animal. (non) 3. Utrum eadem sit rationalis anima intellectiva et sensitiva. (*sic*)

[71] Dd. 21–23, q. un. [F 44vb–45va; M 94rb–95vb; V 31ra–32rb] Utrum primum peccatum ipsius primi hominis actuale potuit fuisse peccatum veniale. (*sic*) 1. Utrum omnia peccata primorum parentum fuerint aequalia vel unum fuerit alio gravius. (-) 2. Utrum peccato transgressionis iuste fuerit poena tanta inflicta. (-) 3. Utrum, in anima Adae et Evae existente iustitia originali, fuisset aliqua virium inferiorum respectu superiorum repugnantia. (-)

[72] Dd. 22–24, q. un. [F 45va–46rb; M 95vb–97va; V 32rb–33vb] Utrum simpliciter pura omissio sit culpabilis praecepti transgressio. (non) 1. Utrum quodlibet purum simpliciter omittere per respectum ad praecepta evangelica sit meritorium. (non) 2. Utrum aliqua pura omissio simpliciter ex impedimento contra usum rationis assumpta sit actio meritoria. (*sic*) 3. Utrum omittere furari sine actu volendi non furari possit tanquam servator illius praecepti iuste praemiari. (*sic*)

[73] D. 24, q. un. [F 46rb–47ra; M 97va–98vb; V 33vb–35ra] Utrum quaelibet viatoris operatio contra rectam rationem scienter elicita sit formaliter culpa mortalis. (*sic*) 1. Utrum pro culpa veniali debeatur poena aeterna. (non) 2. Utrum, si per possibile quis decederet sine gratia et cum solo peccato veniali, deberet in aeterno exilio perpetuo cruciari. (-) 3. Utrum decedens cum gratia, sed cum veniali, deberet ex hoc a gloria aliqualiter retardari. (non)

[74] D. 25, q. 1 [F 47ra–vb; M 98vb–100rb; V 35ra–36rb] Utrum primus homo per liberum arbitrium acceperit sufficienter posse quodlibet vitare peccatum. (*sic*) 1. Utrum Adam et Eva habuerint velle meritorium vitae aeternae ante peccatum. (non) 2. Utrum carnis temptatio sit fortior quam daemonis incitatio. (*sic*) 3. Utrum ut plus mereamur debeamus appetere ut temptemur. (-)

[75] D. 25, q. 2 [F 47vb–47[bis]va; M 100rb–102ra; V 36rb–37va] Utrum libertas creata ex peccato primi hominis sit in aliquo minorata. (*sic*) 1. Utrum in brutis sit liberum arbitrium. (non) 2. Utrum voluntas possit ad aliquem actum necessitari. (*sic*) 3. Utrum voluntas in aliquo suo libero actu possit difficultari. (*sic*)

[76] D. 25, q. 3 [F 47bisvb–48vb; M 102ra–104ra; V 37va–39rb] Utrum divina voluntas per suum determinatum velle vel nolle ad extra possit necessitare voluntatem creatam ad suum velle vel nolle vel aliquem effectum ad esse vel non esse. (*sic*) 1. Utrum voluntas creata sit suorum actuum necessitas antecedens. (non) 2. Utrum cum naturali activitate secundae causae stet contingentia in effectu. (*sic*) 3. Utrum voluntas creata possit respectu alicuius effectus se habere ut causa naturalis et non ut libera. (*sic*)

[77] D. 25, q. 4 [F 48vb–49va; M 104ra–105va; V 39rb–40va] Utrum creata voluntas respectu cuiuslibet sui actus ab ea eliciti sit immediata causa libere productiva. (non) 1. Utrum in aliquibus actibus voluntas creata per prius causaliter eliciat actum quam divina voluntas concurrat. (-) 2. Utrum liberum arbitrium quoad aliquam eius potentiam possit cogi. (-) 3. Utrum omnes actus humani sint ab ipso libero arbitrio. (*sic*)

[78] D. 25, q. 5 [F 49va–50rb; M 105va–107ra; V 40va–41va] Utrum creatura rationalis per liberum arbitrium sufficiat operari tam bene quam per illud idem sufficit operari male. (*sic*) 1. Utrum homo per sui arbitrii efficaciam possit mereri primam gratiam. (non) 2. Utrum aliquis actus sit tam bonus quam malus est Dei contemptus. (*sic*) 3. Utrum purus viator possit dilectione [delectatione *codd.*] finita ex puris naturalibus Deum diligere super omnia. (non)

[79] D. 25, q. 6 [F 50rb–51ra; M 107ra–108va; V 41va–42vb] Utrum quaelibet creata voluntas per suum velle vel nolle quantumcumque intensum ex sua intrinseca activitate possit aliquem effectum in instanti producere. (non) 1. Utrum, *sicut* datur alicuius temporis instans primum, ita possit dari ultimum. (non) 2. Utrum voluntas hominis aliquem actum necessario per tempus continuet. (*sic*) 3. Utrum quaelibet creata voluntas se iudicio intellectus valeat conformare. (non)

[80] Dd. 26–28, q. un. [F 51ra–52ra; M 108va–110ra; V 42vb–44ra] Utrum aliquis homo pro statu praesenti, stante Dei influentia generali, possit agere aliquem actum moraliter bonum sine Dei gratia et auxilio speciali. (*sic*) 1. Utrum ad quemlibet bonum actum cadentem sub praecepto, non solum ad melius et facilius agendum, sed simpliciter ad agendum, indigeat homo speciali Dei auxilio. (*sic*) 2. Utrum aliquis, etsi non de condigno, saltem de congruo possit mereri primam gratiam. (non) 3. Utrum Deus tanta prioritate concurrat generaliter quanta concurrit per suam gratiam specialiter et econtra. (*sic*)

[81] Dd. 29–34, q. un. [F 52ra–vb; M 110ra–111vb; V 44rb–45va] Utrum magis mala fuerit vel sit originalis culpa quam fuerit bona originalis iustitia. (non) 1. Utrum originale peccatum, quod est generalius, aliqua actuali culpa sit gravius. (-) 2. Utrum culpa originalis ex diuturnitate fiat maior quam culpa mortalis actualis. (non) 3. Utrum si Deus per prius mundaret foetum ab omni indispositione et macula, et animam postea infunderet, non concernendo gratiam, anima illa esset cum originali iustitia. (non)

[82] Dd. 34–36, q. un. [F 52vb–53va; M 111vb–113rb; V 45va–46va] Utrum actualis peccati deformitas vel malitia possit esse aliqua entitas vel essentia. (*sic*) 1. Utrum omne peccatum consistat in aliquo actu. (-) 2. Utrum aliqua culpa actualis ab intellectu divino sit immediate per se et proprie scibilis. (non) 3. Utrum aliqua actualis culpa sit per se vera. (non)

[83] Dd. 38–43, q. 1 [F 53va–54va; M 113rb–114vb; V 46va–48ra] Utrum quaelibet culpa mortalis sit in se infinita malitia vel infinita iniustitia actualis. (*sic*) 1. Utrum semper peior sit prima culpa mortalis, qua quis cadit a quantalibet iustitia vel gratia, quam secunda vel tertia. (non semper) 2. Utrum semper aliquo bono contingat mentem privari se avertendo a Deo [V] || Utrum summo bono privari contingat mentem averti a Deo [FM]. [*Both versions are corrupt*] (-) 3. Utrum deformitas infectiva possit dici esse in parte intellectiva. (non)

[84] Dd. 38–43, q. 2 [F 54va–55rb; M 114vb–116rb; V 48ra–49ra] Utrum divinum beneficium ab aliquo scienter receptum habeat aggravare peccatum. (non) 1. Utrum praedestinationis beneficium, quod est maius simpliciter, dicatur aggravare peccatum aliqualiter. (non) 2. Utrum quodlibet beneficium quo aliquis plus indiget magis proportionaliter aggravet peccatum. (-) 3. Utrum prima gratia sit absolute maius beneficium homini quam secunda. (-)

[85] D. 43, q. un. [F 55rb–56ra; M 116rb–118ra; V 49ra–50rb] Utrum ex actu exteriori fiat aliqua additio in esse meriti vel demeriti ad actum interiorem. (*sic*) 1. Utrum aliquis actus sit ita indifferens quod non sit bonus nec malus. (-) 2. Utrum ad commutabile bonum conversio sit tam peccatum quam sit ab incommutabili bono aversio. (*sic*) 3. Utrum cessante actu peccati anima remaneat obligata peccati reatu. (-)

Explicits

F: Explicit super secundo Sententiarum.
M: Explicit Scriptum super secundo Sententiarum secundum reverendum magistrum Laurentium de Bononia Ordinis Fratrum Servorum Sanctae Mariae.
V: Explicit Scriptum super secundo Sententiarum editum a Laurentio Opimo Bononiensi Ordinis Servorum Beatae Mariae Virginis. *Tabula quaestionum libri secundi*: 50va–51vb; *Errata*: [52r]

Liber tertius

[86] Dd. 1–2, q. 1 [F 56ra–vb; M 118ra–119vb; V 1ra–2ra] Utrum in Christo, qui est incarnatus, dum venit plenitudo temporis, perfecte fuerit gratiarum plenitudo et numerus. (non) 1. Utrum, si Pater et Filius incarnarentur, plus honoris esset humanae naturae quam si solus Filius incarnatus dicatur. (non) 2. Utrum Christus, qui tantae fuit excellentiae, debeat dici caput Ecclesiae. (*sic*) 3. Utrum Christus ex gratia quam recepit debeat dici angelorum caput. (*sic*)

[87] Dd. 1-2, q. 2 [F 56vb-57va; M 119vb-121rb; V 2ra-3rb] Utrum pro redemptione generis humani Verbum potuerit humanari. (non) 1. Utrum, *sicut* persona divina potest esse suppositum naturae humanae, ita persona humana possit esse suppositum naturae divinae. (non) 2. Utrum congruum fuerit Deum incarnari. (-) 3. Utrum congruentius fuerit Filium incarnari quam Patrem et Spiritum Sanctum. (*sic*)

[88] Dd. 1-2, q. 3 [F 60vb-60bisvb; M 127va-129rb (FM *different order until* Q.95); V 3rb-5ra] Utrum creaturae rationali ex vi temporalis unionis ad personam Verbi possit sibi intrinsece correspondere abstractive denominatio in esse divinitatis. (*sic*) 1. Quaeritur qualis differentia sit inter unionem et assumptionem. (-) 2. Utrum unio divinae et humanae naturae in persona divina post unionem Trinitatis sit maxima unio. (*sic*) 3. Utrum Verbum assumpserit animam mediante gratia creata. (*sic*)

[89] Dd. 1-2, q. 4 [F 57va-58rb; M 121rb-122vb; V 5ra-6ra] Utrum idem Filius sit Dei Filius et Virginis Filius. (non) 1. Utrum Christi conceptio in Virgine fuerit facta subito vel successive. (-) 2. Utrum una persona creata possit hypostatice substantificare aliquam creatam naturam. (-) 3. Utrum haec *sic* concedenda: 'Christus potest non esse Christus'. (non)

[90] Dd. 1-2, q. 5 [F 58rb-59rb; M 122vb-124rb; V 6ra-7va] Utrum ex personali unione Verbi ad naturam humanam aliquod tertium per se existens sit constitutum in esse. (*sic*) 1. Utrum, *sicut* anima rationalis et caro unus est homo, ita Deus et homo unus sit Christus. (-) 2. Utrum divina natura assumpserit humanam. (-) 3. Quaeritur tertio quid sit assumptum. (-)

[91] Dd. 1-2, q. 6 [F 60bisvb-61rb; M 129rb-130rb; V 7va-8va] Utrum Deus possit naturam irrationalem assumere in unitate suppositi vel personae. (non) 1. Utrum mediante gratia creata fuerit Verbo divino natura humana unita. (-) 2. Utrum Deus posset naturam malam assumere in unitatem suppositi vel personae. (-) 3. Utrum Dei Filius mediante anima assumpserit corpus. (-)

[92] Dd. 1-2, q. 7 [F 61rb-62ra; M 130rb-131va; V 8va-9vb] Utrum, *sicut* Christus assumpsit humanitatem ad redimendum humanam naturam, ita posset assumere spiritualem substantiam ad redimendum angelicam ruinam. (non) 1. Utrum quaecumque habent formam eiusdem speciei sint formaliter eiusdem speciei. (-) 2. Utrum corpus Christi in triduo fuerit Deus vel econtra. (non) 3. Utrum Deus potuerit naturam humanam assumere pro reparatione angelicae ruinae. (*sic*)

[93] Dd. 3-7, q. 2 [F 59vb-60vb; M 125vb-127va; V 9vb-11rb] Utrum de facto Virginis caro a parentibus genita fuerit concepta in aliqua deformitate vel originali culpa. (*sic*) 1. Utrum peccatum originale magis inficiat vim generativam quam alias vires. (*sic*) 2. Utrum peccatum originale remittatur in baptismo quantum ad culpam. (*sic*) 3. Utrum, etsi Beata Virgo sine peccato originali fuerit genita, remanserit tamen in ea fomes peccati vel non a fomite fuerit purgata. (-) 4. Utrum, si Beata

Virgo fuisset sine peccato originali genita, [si *add. V*] propter hoc adaequaverit conceptioni Christi. (non) [*FM omit tiny question 4*]

[94] Dd. 3–7, q. 1 [F 59rb–vb; M 124rb–125vb; V 11rb–12rb] Utrum, concesso quod Beata Virgo fuerit concepta cum peccato originali, Christus potuerit de ipsa incarnari. (non) 1. Utrum Virgo Dei advocatrix rei fieri meruerit Mater Dei. (-) 2. Utrum, quando Filius ex Virgine debuit incarnari, debuit talis incarnatio Virginis annuntiari. (*sic*) 3. Utrum Christi corpus unicum fuerit solum ex puris sanguinibus Virginis formatum. (*sic*)

[95] Dd. 8–12, q. un. [F 62ra–vb; M 131va–132vb; V 12rb–13rb] Utrum natura humana a Verbo imaginarie dimissa et in suis naturalibus posita possit ex suo libero agere quoquo modo deformiter velle. (*sic*) 1. Utrum, *sicut* Verbum divinum dicitur vere homo, ita humanitas verissime nuncupetur. (non) 2. Utrum, *sicut* ista est vera: 'Deus factus est homo', ita et ista: 'Deus homo factus est'. (non) 3. Utrum Verbum divinum sit factus homo. (-)

[96] D. 13, q. un. [F 62vb–63va; M 132vb–134rb; V 13va–14va] Utrum ex suppositali unione ad Verbum anima Christi essentialiter et intrinsece sit perfectior quam sit aliqua imaginabilis creatura citra Deum. (non) 1. Utrum in Christo fuerit gratiae plenitudo. (*sic*) 2. Utrum gratia Christi creata fuerit finita. (*sic*) 3. Utrum gratia Christi potuerit augmentari. (non)

[97] D. 13–17, q. un. [F 63va–64rb; M 134rb–135vb; V 14va–15vb] Utrum in anima Christi per lumen creatum vel increatum beatifice supernaturaliter elevata ex passione sensibili corporis aliquis dolor vel aliqua tristitia fuerit generata. (non) 1. Utrum in Christo cum gaudio fruitionis fuerit vere dolor acerbissimae passionis. (*sic*) 2. Utrum Christus per actum suae passionis fuerit sufficiens causa effectiva peccati delectationis. (*sic*) 3. Utrum Christi passio ex parte patientis in infinitum fuerit maius bonum quam fuerit malum ex parte inferentis. (*sic*)

[98] Dd. 18 et 21, q. un. [F 64rb–vb; M 135vb–137rb; V 16ra–17ra] Utrum divina persona communicet homini Christo divinum quodlibet idioma. (*sic*) 1. Utrum ita perfecte idiomata aliqua naturae humanae contulerit sibi Mater *sicut* divina idiomata aeternaliter contulit sibi Pater. (-) 2. Utrum, si Pater nunc suppositaret humanitatem beati Petri, sortiretur nomen vicarii Filii Dei, ita quod Pater vere diceretur vicarius Christi *sicut* beatus Petrus. (-) 3. Utrum, si Filius dimitteret humanitatem illam, cum illa esset homo, quaeritur utrum ille homo esset filius Virginis. (non)

[99] Dd. 18–22, q. 1 [F 64vb–65va; M 137rb–138va; V 17ra–18rb] Utrum aliqua pura rationalis creatura pro peccato Adae potuerit satisfacere vel pro aliqua mortali culpa. (-) 1. Utrum post Adae peccatum omne bonum cadat sub Christi meritum homini a Deo collatum. (*sic*) 2. Utrum Dei Filius per satisfactionem debuerit humanam naturam reducere ad statum beatificae perfectionis. (-) 3. Utrum per Christi passionem et satisfactionem habeamus effectuum praedestinationis multiplicationem et quot sunt. (-)

[100] Dd. 18–22, q. 2 [F 65va–66rb; M 138va–140rb; V 18rb–19va] Utrum anima Christi ex vi unionis ad Verbum electum meruerit de condigno aeternum praemium. (non) 1. Utrum, si per possibile anima Christi potuerit recipere in duplo intensiores creatas volitiones, et si recepisset, fuisset in eo in duplo maior iustitia actualis. (non) 2. Utrum Christus de facto meruerit in instanti suae conceptionis. (*sic*) 3. Utrum Christus tunc meruerit impassibilitatem. (*sic*)

[101] Dd. 23–26, q. un. [F 66rb–67ra; M 140rb–141vb; V 19va–20vb] Utrum cum certitudine credendorum per creatum assensum possit fidei falsum subesse. (*sic*) 1. Utrum quaelibet theologica virtus ex sui natura propria in divinam essentiam tanquam in proprium et immediatum obiectum immediate et proprie terminetur. (*sic*) 2. Utrum quaelibet virtus theologica sit ab alia proprie et formaliter condistincta. (*sic*) 3. Utrum virtutes theologicae in sola portione superiori animae informative consistant. (*sic*)

[102] Dd. 27–32, q. un. [F 67ra–vb; M 141vb–143ra; V 20vb–21vb] Utrum diligere inimicum timore poenae sit meritorium vitae aeternae. (*sic*) 1. Utrum quilibet ex beneficio liberationis a morte magis obligetur ad illius liberatorem quam ad patris salutem corporalem. (*sic*) 2. Utrum homo debeat se magis diligere quam proximum. (*sic*) 3. Utrum recipiens ab inimico offensam possit ab eo licite petere emendam. (*sic*)

[103] Dd. 33–36, q. un. [F 67vb–68va; M 143ra–144rb; V 21vb–22vb] Utrum virtutes morales et dona Spiritus Sancti se habeant in comprehensorum mentibus informative. (non) 1. Utrum vita contemplativa sit excellentior seu maioris meriti quam activa. (*sic*) 2. Utrum virtutes cardinales infusae vel acquisitae sint nobis connaturales. (non) 3. Utrum virtutes gratuitae sint ita connexae quod qui habet unam habeat omnes. (*sic*)

[104] Dd. 37–40, q. un. [F 68va–69rb; M 144rb–145vb; V 22vb–23vb] Utrum aliquod divina lege prohibitum possit in casu esse homini licitum. (*sic*) 1. Utrum status evangelicae legis sit levioris observantiae quam status antiquae legis. (*sic*) 2. Utrum aliqua rationalis creatura possit obligative se disponere ad aliquod iuramentum. (*sic*) 3. Utrum quodlibet iuramentum a voluntate creata elicitum secundum ordinem legis evangelicae sit obligativum. (-)

Explicits

F: Explicit super tertio *Sententiarum*.
M: Explicit scriptum super 3° *Sententiarum* secundum magistrum Laurentium de Bononia Ordinis Servorum Sanctae Mariae
V: Explicit lectura resolutissimi theologi magistri Laurentii Opimi Bononiensis Ordinis Servorum super tertio *Sententiarum* Parisius habita. *Tabula quaestionum tertii libri*: 24ra–vb

Liber quartus

[105] D. 1, q. un. [F 69rb–70ra; M 146ra–147rb; V 1ra–2ra] Utrum sacramenta novae legis ex vi sanctissimae passionis Christi sint causa effectiva gratiae in mente viatoris. (*sic*) 1. Utrum omnia sacramenta fuerint a Christo ordinata. (*sic*) 2. Utrum gratia a Deo per sacramenta creata sit subito vel successive data. (-) 3. Utrum, *sicut* ex peccato incurrimus in ignorantiam, in impotentiam, et concupiscentiam, *sic* ex sacramentis contra illa recipiamus efficaciam. (*sic*)

[106] Dd. 2–8, q. 1 [F 70ra–vb; M 147rb–148vb; V 2ra–3rb] Utrum baptizatus baptismo flaminis teneatur recipere baptismum fluminis de necessitate salutis. (non) 1. Utrum esset baptismus si diceretur 'baptizo vos'. (*sic*) 2. Utrum esset baptismus si diceretur 'in nomine Trinitatis'. (non) 3. Utrum sit baptismus si fiat verborum transpositio, ut si diceretur 'in nomine Filii, et Patris, et Spiritus Sancti'. (*sic*) 4. Utrum esset baptismus dicendo 'in nomine genitoris, et geniti, et procedentis'. (non)

[107] Dd. 2–8, q. 2 [F 70vb–71va; M 148vb–150ra; V 3rb–4ra] Utrum sacramentum baptismi in adultis viatoribus ipsum rite recipientibus respectu effectus gratuiti sit aequaliter causativum. (*sic*) 1. Utrum Iudaeorum parvuli sint invitis parentibus baptizandi. (-) 2. Utrum adulti et perpetuo furiosi possint veraciter baptizari. (*sic*) 3. Utrum baptismus tollat omnem satisfactoriam poenam etiam in adultis. (*sic*)

[108] Dd. 2–8, q. 3 [F 71va–72ra; M 150ra–151rb; V 4ra–5ra] Utrum baptismi sacramentum respectu cuiuslibet ipsum suscipientis sit characteris impressivum. (non) 1. Utrum fictio seu mentis humanae dispositio non recta impediat effectum baptismi. (-) 2. Utrum baptizatus recedente fictione habeat effectum vel non. (*sic*) 3. Utrum character confirmationis necessario praesupponat characterem baptismi. (*sic*)

[109] Dd. 8–13, q. 1 [F 72ra–vb; M 151rb–152vb; V 5ra–6va (says '2')] Utrum substantia panis quae a presbytero consecratur in substantiam carnis Christi verissime convertatur. (non) 1. Utrum sub utraque specie sit totus Christus. (*sic*) 2. Utrum Christus quantum ad animam sub utraque specie sit contentus. (*sic*) 3. Utrum, si corpus Christi in triduo fuisset consecratum sub specie panis, quantum ad animam fuisset contentum. (non)

[110] Dd. 8–13, q. 2 [F 72vb–73va; M 152vb–154rb; V 6va (says '2')-7vb] Utrum corpus Christi existens in eucharistia possit in altari sacramentaliter contineri sub aliqua visibili natura specifica. (non) 1. Utrum corpus Christi definitive sit in altari. (non) 2. Utrum Christi corpus sub speciebus panis subito vel successive incipiat esse. (subito) 3. Utrum illa mutatio sit maior seu mirabilior creatione. (non)

[111] Dd. 8–13, q. 3 [F 73va–74rb; M 154rb–155vb; V 7vb–9ra] Utrum Deus faciat de facto quod omne accidens panis in sacramento sit carens subiecto. (non) 1. Utrum oculus corporalis etiam glorificatus possit videre corpus Christi sub speciebus. (non) 2. Utrum accidentia illa sive species possint nutrire. (*sic*) 3.

Utrum, si corpus Christi fuisset reservatum in die cenae in pyxide moreretur ibi in die Veneris. (*sic*)

[112] Dd. 14–22, q. 1 [F 74rb–75ra; M 155vb–157va; V 9ra–10rb] Utrum in iustificatione impii gratiae infusio et culpae expulsio sit unica, instantanea, et simplex mutatio. (-) 1. Utrum ceteris paribus maior ingratitudo committatur cadendo ab innocentia quam cadendo a vera paenitentia. (*sic*) 2. Utrum de quocumque minimo peccato mortali debeat paenitens plus dolere quam de amissione cuiuscumque imaginabilis rei temporalis. (*sic*) 3. Quid est vera contritio. (-)

[113] Dd. 14–22, q. 2 [F 75ra–vb; M 157va–159ra; V 10rb–11rb] Utrum sit absolute possibile voluntatem creatam ex intrinseca actuatione alicuius gratuiti doni sine merito passionis Christi pro quacumque mortali culpa posse Deo plene satisfacere. (non) 1. Utrum paenitentia perfecta virtutes restituat. (*sic*) 2. Utrum quis aliquo casu possit satisfacere de uno peccato absque offensam tollere et amicitiam restituere. (non) 3. Utrum opera facta extra caritatem sint meritoria alicuius boni. (-)

[114] Dd. 14–22, q. 3 [F 75vb–76va; M 159ra–160va; V 11va–12va] Utrum venialis culpa in mente cum aliqua actuali deformitate coniuncta transire possit in naturam actualis seu mortalis culpae, ea remanente sub proprio specifico esse. (*sic*) 1. Utrum qualiscumque proportio fuerit inter merita talis sit inter eorum praemia. (*sic*) 2. Utrum indulgentiae tantum valeant quantum sonant. (*sic*) 3. Utrum perdenti gratiam sit necessarium proprio sacerdoti confiteri. (*sic*)

[115] Dd. 23–42, q. un. [F 76va–77rb; M 160va–162ra; V 12va–13va] Utrum voluntas creata ex istis tribus sacramentis <extremae unctionis, ordinis, et matrimonii> rite requisitis actuetur intrinsece et meritorie ex aliqua gratia noviter data. (non) 1. Utrum mutuus consensus qui fuit inter Virginem Gloriosam et Ioseph fuerit vera obligatio in esse matrimonii. (*sic*) 2. Utrum consensus faciat matrimonium. (*sic*) 3. Utrum alter coniugum possit intrare religionem ante carnalem copulam altero invito. (*sic*)

[116] Dd. 43–46, q. 1 [F 77rb–vb; M 162ra–163va; V 13va–14vb] Utrum evidenti ratione in lumine naturali sit probabile hominum generalem resurrectionem ad esse vel fore esse possibilem. (*sic*) 1. Utrum resurrectio quoad suum totale esse sit aliqualiter naturalis vel praecise miraculosa. (-) 2. Utrum talis resurrectio fiet in instanti. (*sic*) 3. Utrum resurrectio Christi specialis sit causa resurrectionis ultimae generalis. (-)

[117] Dd. 43–46, q. 2 [F 78ra–va; M 163va–164vb; V 14vb–15vb] Utrum agens naturale possit idem numero reparare. (*sic*)

[118] Dd. 48–50, q. 1 [F 78va–79rb; M 164vb–166rb; V 15vb–16vb] Utrum voluntas divina per suum dignum iudicium semper puniat peccatores citra condignum. (non) 1. Utrum de divina iustitia homo debeat in aeternum puniri pro actuali culpa. (*sic*) 2. Utrum ignis infernalis sit eiusdem speciei cum nostro igne materiali.

(*sic*) 3. Utrum talis ignis possit agere in animam separatam a corpore, cum sit corporeus. (*sic*)

[119] Dd. 48–50, q. 2 [F 79rb–vb; M 166rb–167va; V 16vb–17vb] Utrum per aliquod activum posse divinae voluntatis anima damnati pro sua aliqua actuali culpa possit ad condignum aeternaliter puniri. (*sic*) 1. Utrum aliqui homines cum Christo iudicabunt. (*sic*) 2. Utrum angeli tunc iudicabunt. (non) 3. Utrum angeli a Christo iudicabuntur. (-)

Explicits

F: Explicit super 4°. Deo gratias, amen.
M: Amen. Explicit. *Tabula quaestionum quattuor librorum*: 167va–171vb.
V: Explicit lectura super quattuor libros Sententiarum ingeniosi doctoris Laurentii Opimi Bononiensis Ordinis Servorum Deiparae Virginis Parisiis habita in singulare praeconium sanctae et individuae Trinitatis totiusque caelestis curiae laudem. *Tabula quaestionum quarti libri*: 18ra–b (unnumbered).

Notes

1 S. J. Livesey, '*Lombardus Electronicus*: A Biographical Database of Medieval Commentators on Peter Lombard's *Sentences*', in G. R. Evans (with R. L. Friedman) (ed.), *Mediaeval Commentaries on the Sentences of Peter Lombard* I (Leiden: Brill, 2002), pp. 1–23 (at p. 3), correcting F. Stegmüller, *Repertorium commentariorum in Sententias Petri Lombardi*, vol. I (Würzburg: Schöningh, 1947), p. 254, and V. Doucet's review of another work, in *Archivum Franciscanum Historicum* 26 (1933), pp. 206–14 (at p. 213).
2 In a general work based on an unpublished late seventeenth-century list of Parisian licentiates in theology: T. Sullivan, *Parisian Licentiates in Theology, AD 1373–1500. A Biographical Register. Vol. 1. The Religious Orders* (Leiden: Brill, 2004), pp. 92–3. The explicits to books III and IV of the early print mention Paris as the location of Lorenzo's lectures, but since the text is followed by a *tabula quaestionum* the last explicit is less conspicuous.
3 C. Schabel, 'Were there *Sentences* Commentaries?', in P. Bermon and I. Moulin (eds), *Commenter au Moyen Âge* (Paris: Vrin, 2019), pp. 243–66, listing 40 in notes on pp. 243–5.
4 There are a half dozen later Servites mentioned in F. Stegmüller, *Repertorium biblicum medii aevi* (Madrid: Consejo superior de investigaciónes científicas, Instituto Francisco Suárez), but none with an extant biblical commentary, as far as the compiler knew: Alexander Bolanus and Andreas Venetus (*Tomus II: Commentaria. Auctores A-G*, 1950, pp. 66 and 107), Hieronymus de Franciscis and Johannes Saxonius (*Tomus III: Commentaria. Auctores H-M*, 1951), pp. 87 and 423), and Raimundus Hermannus and Theodorus Beneventanus (*Tomus V: Commentaria. Auctores R-Z*, 1955, pp. 55 and 315).

5 R. Taucci, 'Servites (ordre de)', *Dictionnaire de Théologie Catholique* 14/2 (1941), cols 1982–7; T. M. Izbicki, 'Servites', in W. M. Johnston (ed.), *Encyclopedia of Monasticism*, 2 vols (Chicago: Fitzroy Dearborn, 2000), vol. 2, pp. 1153b–4b. See also the limited documentary evidence collected in *Fonti storico-spirituali dei Servi di Santa Maria I: dal 1245 al 1348* (Vicenza: Associazione Emmaeus Servitium, 1998) and, more substantially, in *II: dal 1349 al 1495* (Vicenza: Servitium, 2002), and the studies in *Monumenta ordinis Servorum Sanctae Maria*, 20 vols (Brussels: Société Belge de Librairie, 1897–1930), continued in the journal *Studi storici sull'Ordine dei Servi di Maria* (1933–).

6 See P. M. Soulier, 'De Collegio Parisiensi Ordinis Servorum sanctae Mariae', *Monumenta ordinis Servorum Sanctae Mariae*, vol. 1 (1897), pp. 150–210, especially pp. 158–70, and also the general remarks in L. M. Di Girolamo, 'L'insegnamento universitario nell'Ordine dei Servi di Maria dalle origini ai giorni d'oggi', *Angelicum* 94 (2017), 551–82 (at 554–8).

7 *Chartularium Universitatis Parisiensis* (*CUP*), ed. H. Denifle and E. Chatelain, vol. 2 (Paris: Delalain, 1891) (= *CUP* II), no. 697, pp. 141–2, from 10 February 1310, which document has Clemente Brunacci as 'Prior Servorum Sancte Marie Parisiensis' and 'Frater Accursius, ejusdem loci'. According to p. 142, n. 4, Clemente had been sent to Paris in 1303, but the two names may have been added later to the document as it has come down to us. For the doubts, see p. 142, n. 4, and the note to the document cited in the following note.

8 *CUP* II, no. 877, pp. 312–13.

9 *Ibid.*, no. 1041, p. 505.

10 *Ibid.*, no. 1122, pp. 575–6.

11 *Chartularium Universitatis Parisiensis*, ed. H. Denifle and E. Chatelain, vol. 3 (Paris: Delalain, 1894) (= *CUP* III), no. 1249, p. 70, from 4 November 1359 (also in AAV, Reg. Vat. 234, fo. 275v, no. 166) (Pope Innocent VI to the chancellor on Paolo of Bologna, who had read the *Sentences* probably in 1355–56 and was ready to be made master); no. 1278, pp. 103–4, from the Florence Chapter General, 28 April 1363 (with rules on studies at Paris); and no. 1281, p. 106, a supplication from the Order dated 5 July 1363 (on Antonio Mannucii of Florence, who had studied at Paris since *c.*1347, read the *Sentences* around the same time as Paolo, but was still third in line for the *magisterium*, which the Servites asked Urban V to have the chancellor grant). In n. 1 on p. 106, we are informed that Vitale of Bologna was master by 1362.

12 Sullivan, *Parisian Licentiates in Theology*, I, pp. 175 and 180.

13 *CUP* III, no. 1554, p. 466, from 21 November 1387. The documents from the *CUP* cited list the scholars Antonio, Matteo, Paolo, Urbano and Vitale of Bologna in addition to about ten others, almost all identified as Italians. Denifle's notes and these documents, many of which are also found in Soulier, 'De Collegio Parisiensi', pp. 178–205, provide the starting point for a secure history of the Servites at Paris.

14 Taucci, 'Servites', col. 1985: 'Item quod studentes in qualibet facultate utantur doctoribus ordinis nostri; similiter regentes eorum doctrinam legant, scil., in theologia magistrum Laurentium de Bolognia.'

15 These other writings are listed in various repertories and texts from the seventeenth century onward, but see the thorough (for the time) biography of S. M. Berardo, 'Il dottore ordinatissimo ven. Lorenzo Opimo', *Il Comune di Bologna*, 19 (1932), 77a–84b (at 81b and n. 15).

16 Berardo, 'Il dottore ordinatissimo', 77b and nn. 12–13; C. Berti, *La santificazione dell'anima e il merito secondo maestro Lorenzo da Bologna dell'Ordine dei Servi di Maria* (Gembloux: J. Duculot, 1939), p. 5 and n. 2.

17 Taucci, 'Servites', col. 1985.

18 Berardo, 'Il dottore ordinatissimo', 78a and nn. 1–3, 80b and 81b.

19 Berti, *La santificazione*, p. 6.

20 *Ibid.*, p. 6.

21 Sullivan, *Parisian Licentiates in Theology*, I, p. 249.

22 Berardo, 'Il dottore ordinatissimo', 81a–b; Berti, *La santificazione*, p. 6 and n. 8.

23 Berardo, 'Il dottore ordinatissimo', 82b–4b and notes; Berti, *La santificazione*, p. 6 and n. 9; C. Eubel, *Hierarchia Catholica Medii Aevi* (Münster: Regensberg, 1913), pp. 490 and 498; H. Hoberg, *Taxae pro communibus serviciis ex libris Obligationum ab anno 1295 usque ad annum 1455 confectis* (Vatican City: Biblioteca Apostolica Vaticana, 1949), pp. xvi, 121 and 124.

24 Berardo, 'Il dottore ordinatissimo', 78a–b; Berti, *La santificazione*, p. 6, n. 9.

25 Berti, *La santificazione*, p. 8.

26 Sullivan, *Parisian Licentiates in Theology*, I, p. 92.

27 *Ibid.*, pp. 13–14 and passim.

28 W. J. Courtenay, *Changing Approaches to Fourteenth-Century Thought* (Toronto: Pontifical Institute of Mediaeval Studies, 2007), p. 33.

29 Sullivan, *Parisian Licentiates in Theology*, I, pp. 76–7.

30 *CUP* II, pp. 692, §13, and 695, n. 10.

31 For the licensees, *see* Sullivan, *Parisian Licentiates in Theology*, I, pp. 14–15, slightly corrected in T. Sullivan, *Parisian Licentiates in Theology, A.D. 1373–1500. A Biographical Register. Vol. 2. The Secular Clergy* (Leiden: Brill, 2004), pp. 10–11. For the *Sentences* lectures, see primarily M. Brînzei, 'When Theologians Play Philosopher: A Lost Confrontation in the *Principia* of James of Eltville and his *Socii* on the Perfection of Species and its Infinite Latitude', in M. Brînzei and C. Schabel (eds), *The Cistercian James of Eltville († 1393): Author at Paris and Authority at Vienna* (Turnhout: Brepols, 2018), pp. 43–78, and W. J. Courtenay, 'James of Eltville, O.Cist., his Fellow *Sententiarii* in 1369–70, and his Influence on Contemporaries', in the same volume, pp. 21–42; M. Brînzei and C. Schabel, 'Henry of Langenstein's *Principium* on the *Sentences*, his Fellow Parisian Bachelors, and the Academic Year 1371–1372', *Vivarium* 58 (2020), 335–46; W. J. Courtenay, 'Theological Bachelors at Paris on the Eve of the Papal Schism. The Academic Environment of Peter of Candia', in K. Emery, Jr, R. L. Friedman and A. Speer (eds), *Philosophy and Theology in the Long Middle Ages. A Tribute to Stephen F. Brown* (Leiden: Brill, 2011), pp. 921–52 (at pp. 929–34).

32 Sullivan, *Parisian Licentiates in Theology*, I, pp. 277–8.

33 This is an updated interpretation of the evidence supplied in J. Lechner, 'Franz von Perugia O. F. M. und die Quästionen seines Sentenzenkommentars', *Franziskanische*

Studien 25 (1938), 28–64 (at 29–35): Francis was promoted under Chancellor Grimier Boniface, who died on 12 October 1370; the explicit in Munich, Bayerische Staatsbibliothek, Clm 8718, fo. 80va, says that he was regent in 1370: 'Explicit liber primus Sententiarum editus a Magistro Francisco de Perusio regente Parisius in scolis Fratrum Minorum anno M°CCC°LXX'; Dionigi of Modena, whom Lechner wrongly thought to be a Cistercian and whom we now know to have lectured on the *Sentences* in 1371–72 (*see* Brînzei and Schabel, 'Henry of Langenstein's *Principium* on the *Sentences*'), refers early in his *Sentences* questions to 'Magister Franciscus de Parisio regens in domo Minorum'. If the Munich explicit is accurate, then Francis was Franciscan regent master in both 1370–71 and 1371–72, which is already unusual. Prima facie it seems very implausible that he was promoted in early 1369 and also reigned in 1369–70, giving him a three-year tenure, but 1368–69 has to be excluded, although Lechner and others were led astray by a confused passage in the early sixteenth-century chronicle of the Franciscan Nikolaus Glassberger, who has Francis 'regens' in 1368 under Master John of Ripa while he 'subtiliter super Sententias scripsit et continuavit post duos annos'. In his introduction to Iohannes de Basilea OESA, *Lectura super quattuor libros Sententiarum*, vol. I, ed. V. Marcolino, with M. Brînzei and C. Oser-Grote (Würzburg: Augustinus bei echter, 2016), p. 26, n. 74, Marcolino confirms the above by quoting the vesperies of Étienne Gaudet to the effect that Francis held his vesperies first that year ('positio cuiusdam reverendi patris qui primo loco vesperiavit hoc anno, scilicet contra Franciscum de Perusio'), which could not have happened before December 1368 or after January 1370, with Marcolino arguing for the end of 1369/beginning of 1370.

34 For 1369–70, *see* Brînzei, 'When Theologians Play Philosopher', and Courtenay, 'James of Eltville, O.Cist.'. For 1371–72, *see* Brînzei and Schabel, 'Henry of Langenstein's *Principium* on the *Sentences*'.

35 Sullivan, *Parisian Licentiates in Theology*, I, p. 249; Courtenay, 'Theological Bachelors at Paris', pp. 929–30.

36 *CUP* II, p. 692, §§11 and 16: Lorenzo either read one book of the Old Testament and then one book of the New Testament or, as was required of the members of the four mendicant orders and Cistercians, he read the Bible for two years continuously. See also *CUP* III, pp. 441–2, no. 1534, from 1387, where the option is either the Bible or two *cursus*.

37 *Acta Capitulorum Generalium Ordinis Praedicatorum, vol. II. Ab anno 1304 usque ad annum 1378*, ed. B. M. Reichert (Rome: In domo generalitia, 1899), p. 417 (= *CUP* III, p. 190, no. 1359); *Acta Capitulorum Generalium Ordinis Fratrum B. V. Mariae de Monte Carmelo. Vol. I. Ab anno 1318 usque ad annum 1593*, ed. G. Wessels (Rome: Curia generalitia, 1912), p. 66; *Rotuli Parisienses. Supplications to the Pope from the University of Paris. Volume II: 1352–1378*, ed. W. J. Courtenay and E. D. Goddard (Leiden: Brill, 2004), p. 369; C. Schabel, 'The Franciscan Guglielmo Centueri of Cremona's Bologna *Principium* of 1368, with an Appendix on Whether God Can Make the Past Not to Have Been', in M. Brînzei and W. O. Duba (eds), *Principia on the Sentences* (Turnhout: Brepols: forthcoming).

38 *See* the bio-bibliographical entries in Sullivan, *Parisian Licentiates in Theology*, I–II and, for *Stoch*, T. Sullivan, *Benedictine Monks at the University of Paris AD 1229–1500* (Leiden: Brill, 1995), pp. 321–2. Keep in mind that those licensed before Easter 1373 were licensed before Easter 1374 new style. *Guillelmus de Cremona's* earlier Bologna Sentences questions survive, as well as some much later works: Schabel, 'The Franciscan Guglielmo Centueri'.

39 There are also brief descriptions in Berti, *La santificazione*, p. 7, n. 10, which do not always accord with mine.

40 G. Pomaro, *Catalogo di manoscritti filosofici nelle biblioteche italiane. Vol. 9. Firenze. Fondo SS. Annunziata depositato presso la Biblioteca Medicea-Laurenziana e la Biblioteca Nazionale Centrale di Firenze* (Florence: SISMEL – Galluzzo, 1999), pp. 163–4, no. 73, with more details and noting that an earlier catalogue gave the date of 1466 without explanation. The manuscript was already in the Florence convent on 28 February 1473: Berardo, 'Il dottore ordinatissimo', 82, n. 1.

41 See the Sotheby's sales record, no. Jun101918-373, on Rare Book Hub (I thank Laura Light for this information); 'Hand-list of Additions to the Collection of Latin Manuscripts in the John Rylands Library, 1908–1920', pp. 187 and 193; https://armorial.library.utoronto.ca/stamp-owners/VER003.

42 *Fine Manuscripts and Miniatures from Europe, Asia and Africa VIIIth–XIXth Century*. Katalog 155 (1914), Ludwig Rosenthal's Antiquariat, Munich, p. 44, no. 239: 'Laurentius de Bononia. Libri sententiarum. Manuscrit du XV. siècle sur vélin et papier. 52 fos, 2 coll. Pet.-in.fol. D.-maroquin. Laurent de Bologne, théologien italien, frère servite, docteur de Paris, mort vers 1390.' Katalog 135 (1900), p. 234, no. 1305: 'Laurentius de Bononia. Libri sententiarum. Mscr. sur vélin et papier du XV. siècle. 52 fos, 2 coll. Pet.-in.fol. D.-maroq. Mscr. entièrement écrit de la même main en bon état. Laurent de Bologne, théologien italien, frère servite, docteur de Paris, mort vers 1390.'

43 Of the firm Karl W. Hiersemann, *Manuscripte vom Mittelalter bis zum XVI. Jahrhundert. Einzel-Miniaturen, orientalische Manuscripte und Malereien* (Leipzig: Hiersemann, 1921), p. 32.

44 Berti, *La santificazione*, p. 8, n. 11, has noted two of these remarks.

45 Berti, *La santificazione*, p. 7, seems to count 114.

46 C. Schabel, 'The Victorine Pierre Leduc's *Collationes*, *Sermo finalis*, and *Principia* on the *Sentences*, Paris 1382–1383', *Archives d'histoire doctrinale et littéraire du Moyen Age* 87 (2020), pp. 237–334 (at pp. 241 and 262).

47 As Berti, *La santificazione*, pp. 7–8, has noted.

48 As Berti, *La santificazione*, p. 7, n. 10, has observed.

Littifredi Corbizzi, Johann Anton Ramboux and an Album of Manuscript Cuttings at the John Rylands Library

FERGUS BOVILL, UNIVERSITY OF YORK

Abstract
This article examines cuttings from a now-lost manuscript decorated by the little-known Florentine illuminator Littifredi Corbizzi (1465–c.1515) at the turn of the sixteenth century. This manuscript, a choirbook produced for the monks at San Benedetto in Gubbio in 1499–1503, was dismembered in the nineteenth century. Until now, all but one of its cuttings were believed to be lost. Through the emergence of several key pieces of evidence, most notably the identification of tracings of the manuscript made by the German artist Johann Anton Ramboux in the mid-1830s before its dismemberment, I have been able to link definitively three initials to this largely unresearched commission. Two of these are in a previously unstudied manuscript album at the John Rylands Library, recently digitised. Considering the cuttings stylistically and, critically, interrogating their provenance, I propose that a further ten cuttings can also be linked to Littifredi's work for the monastery, and argue that Ramboux played a significant role in their initial collection.

Keywords: Manuscript illumination; fragmentology; albums of manuscript cuttings; Italian Renaissance; Littifredi Corbizzi; Johann Anton Ramboux; John Rylands Library

In the first half of the nineteenth century, the German Nazarene artist and collector Johann Anton Ramboux (1790–1866) travelled extensively around Italy. During two or three extended stays, he produced an enormous series of sketches and tracings reproducing a vast quantity and range of art and architecture from the Middle Ages, including fresco and panel paintings, mosaics, stained glass, illuminated manuscripts and sculpture.[1] Many of these are now preserved at the Städel Museum in Frankfurt.[2] These meticulously executed copies were dedicated to 'serving the history of the visual arts of the middle ages in Italy'.[3] They were intended to both aid and expand the scholarship of art historians such as Carl Friedrich von Rumohr (1785–1843), also working in Italy at the time, while functioning as a kind of model-book for contemporary artists.[4] Particular notice was paid to the recording of place names and signatures; and less explored regions, such as Umbria, were given greater attention than the already well-trodden Florence and Rome.[5] The project was motivated by a desire to preserve and promote the 'venerable' art of Italy's past for its artistic, historical and pedagogic value.[6] Ramboux did not explicitly state the criteria for selecting works to reproduce, but

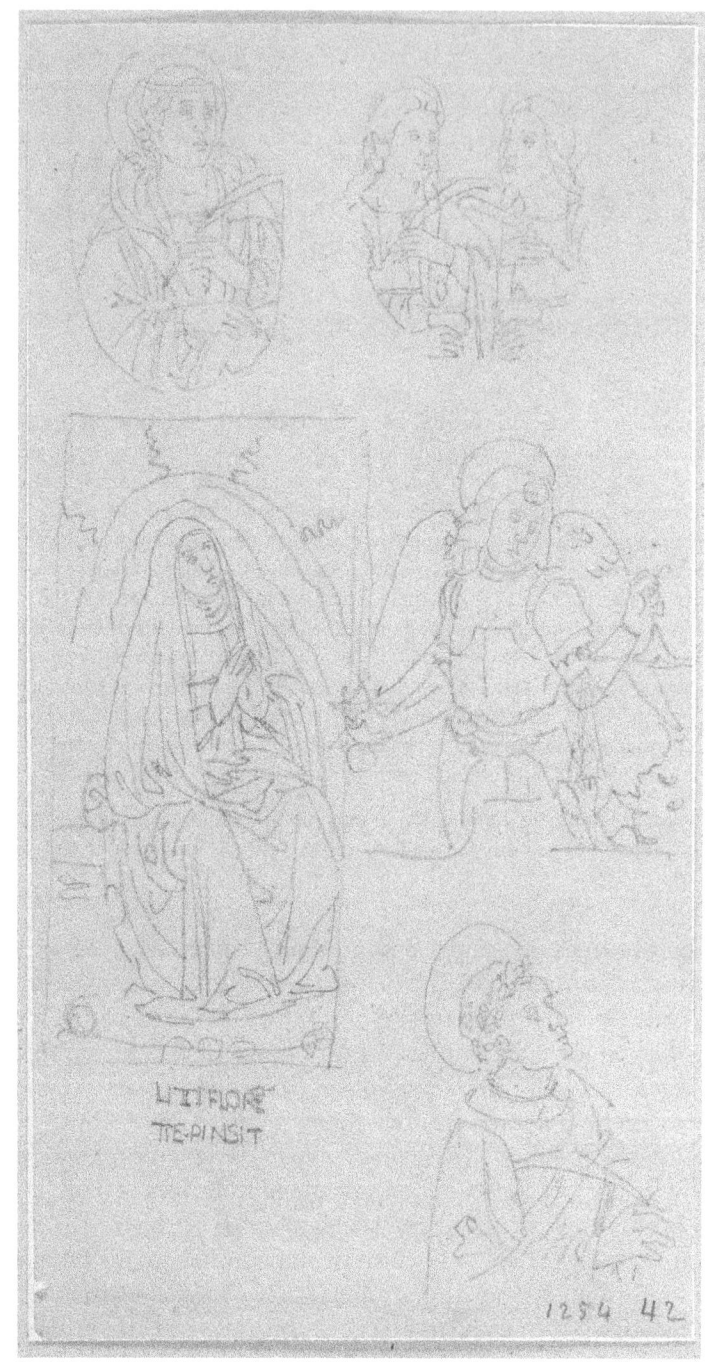

Figure 1 Johann Anton Ramboux, *Aus den Choralbüchern in San Pietro in Gubbio*, c.1834–35, 233 × 123 mm; see top right and bottom right tracings. Frankfurt, Städel Museum, object no. Bib. 2472 II 115C (photo: Städel Museum, Frankfurt am Main).

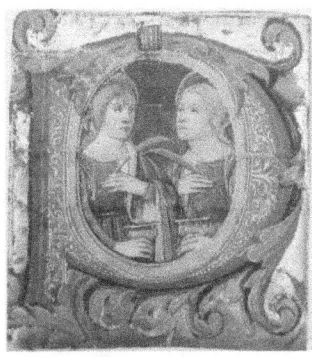

Figure 2 Littifredi Corbizzi, initial 'P' with Saints Flora and Lucilla, 1499–1503, 85 × 79 mm. UK private collection (photo: author).

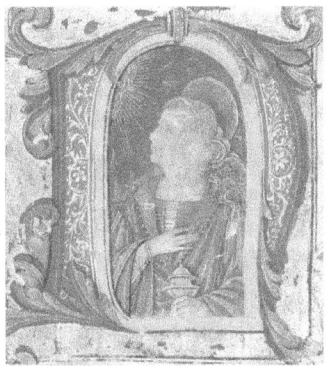

Figure 3 Littifredi Corbizzi, initial 'N' with the Penitent Magdalene, 1499–1503, 97 × 86 mm. Manchester, John Rylands Library, Latin MS 14, no. 28, fo. 24 (photo: © the University of Manchester).

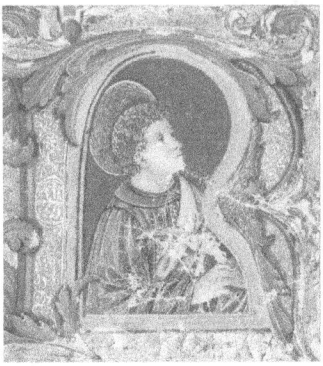

Figure 4 Littifredi Corbizzi, initial 'R' with a male martyr Saint, 1499–1503, 98 × 91 mm. Manchester, John Rylands Library, Latin MS 14, no. 31, fo. 27 (photo: © the University of Manchester).

Christina Schulze and Dóra Sallay have convincingly argued that it was based on the objects' perceived art-historical significance as well as his own iconographic interests.[7] Ramboux attempted to offer a 'History of Art in Copies', representing what he considered to be the *best*, most instructive art of the period.[8]

Among the sheets at the Städel Museum are four with tracings made during a stay in Gubbio, c.1834–35. These tracings, which include the inscription 'LITTI FLORETIE PINSIT' (see **Figure 1**), almost certainly reproduce select initials and miniatures (and what appears to be a section of border) from a lost manuscript decorated by the little-known Florentine illuminator Littifredi Corbizzi (1465–c.1515)[9] for the Monastero di San Benedetto in Gubbio.[10] Payment records from the monastery published by Giuseppe Mazzatinti in 1884 reveal that Littifredi – referred to here as *Maestro Litti* – worked in Siena on 'miniatures' between 1499 and 1503.[11] This commission, representing his last known datable period of work, was part of a larger series of liturgical books produced for the Olivetan monks at San Benedetto between 1494 and 1504. A further eleven scribes and illuminators, also mentioned by Mazzatinti, were involved in the production of these books, including fellow Florentine Boccardino 'il Vecchio' (1460–1542).[12]

At the beginning of the sixteenth century, these codices were transferred to the nearby Convento di San Pietro (also in Gubbio), where they were studied by Ramboux in the mid-1830s. By 1860 at the latest, many had been extensively dismembered.[13] In the following years, knowledge of the cuttings' whereabouts was lost. While scholars such as Annarosa Garzelli were working profitably on Littifredi's earlier career, his work at the turn of the Cinquecento was largely left behind.[14] It was only after the emergence of Ramboux's tracings from San Pietro and, critically, their linking by Irene Hueck in 1980 and Ada Labriola in 2016 to the San Benedetto commission revealed by Mazzatinti, that a miniature with the *Coronation of Christ* (Berlin, Kupferstichkabinett, Min. 3342) was finally placed within this period of work.[15] This cutting, the subject of a recent study by Beatrice Alai, is the only one matched to Ramboux's tracings from San Pietro. It has stood until now as the sole representative of this important yet almost entirely uncharted period of Littifredi's career.

Through further examination of Ramboux's tracings and the rediscovery of an album of manuscript cuttings now at the John Rylands Library, Latin MS 14, I have been able to link an additional three cuttings – all historiated initials – to the San Benedetto commission.[16] These cuttings, published here for the first time, all correspond directly to a single tracing on Ramboux's sheets. They mark the first initials attributable definitively to this commission. The first, an initial 'P' with Saints Flora and Lucilla (**Figures 1** and **2**), was sold at Christie's in July 2020 where it was attributed to Littifredi by Gaudenz Freuler, but not linked to his work for San Benedetto.[17] The second and third, an initial 'N' with the Penitent Magdalene (**Figure 3**), and an initial 'R' with a male Martyr Saint (**Figures 1** and **4**) are contained within the Rylands album and have not before been attributed to Littifredi nor linked to Ramboux or San Benedetto.[18]

In this article, focusing primarily on these three initials, my inquiry will be threefold. First, I will consider how these cuttings can be understood stylistically – in particular, how they compare to one another, to the *Coronation* miniature, and to Littifredi's earlier work. I am concerned especially with the characteristics that distinguish his work from that of contemporary illuminators, and the extent to which his style suggests the influence of monumental painting. Second, delving deep into the provenance of Latin MS 14, I will examine its significance for perhaps the most pressing issue surrounding these cuttings – the question of when and by whom they were excised, as well as their movements thereafter. Finally, building on these conclusions, I will consider the implications of the initials' identification for further study of Littifredi. I will argue that through these three, a further ten initials – some of which have already been attributed to Littifredi – can also be linked to the San Benedetto commission. While many questions cannot yet be answered, I hope that by laying the foundations for an understanding of this commission and its nineteenth-century context, this article will encourage the emergence of more cuttings which inevitably lie hidden in public and private collections. These cuttings have significant implications for our understanding of Littifredi, for Florentine illumination more generally, and for the reception of Italian Renaissance illumination in the nineteenth century, an area which still awaits further research.[19] Containing forty-nine historiated initials, eleven sections of border (ten from the same manuscript arranged on a single page) and three miniatures, Latin MS 14 also offers particularly fertile ground for both provenance research and for the study of the manuscript album, a significant and yet largely overlooked phenomenon in the history of collecting and of the book.[20]

This research comes at a time of increasingly critical study of the rich, complex and sometimes problematic histories of medieval and Renaissance manuscripts. These histories have often been neglected in scholarship, particularly in collections' catalogues. Prefaced with useful histories of the collecting of single leaves and cuttings, volumes dedicated to collections of illuminations such as *Le miniature della Fondazione Giorgio Cini* (2016) and *The Burke Collection of Italian Manuscript Paintings* (2021) have begun to address this. Similarly, the launch of the digital 'laboratory for medieval manuscript fragments', Fragmentarium, and its journal *Fragmentology*, dedicated to research in the field of that name, offers powerful new possibilities for provenance research and virtual manuscript reconstructions.[21] A recent exhibition held at the Victoria and Albert Museum has helped extend the study of the many and varied ways that individuals engaged with illuminations in the nineteenth century beyond the specialist academic or collector.[22]

The Three Traced Initials

Why Ramboux chose to reproduce these three initials, or indeed the other twelve illuminations, out of what was certainly a wider corpus will probably always remain a mystery. Perhaps the most likely explanation is that he considered these

to be a 'representative selection' of the codices then at San Pietro.[23] What is intriguing is that although numerous illuminators were known to have worked on the San Benedetto books, Ramboux appears to have been drawn to the work of a single illuminator, Littifredi. This becomes clear when looking at the fifteen tracings, which reveal a compelling stylistic unity and on two pages are accompanied by a transcription of Littifredi's signature (see **Figure 1**).[24] Although half a century removed from Ramboux's study, it is interesting to note the comments made by the manuscript scholar J. W. Bradley in his 1887 *Dictionary of Miniaturists*. Here he praises Littifredi for 'combining all the highest qualities which are expected in a miniaturist', indicating a clearly aesthetic and connoisseurial interest in his work.[25]

That Ramboux's tracings reproduce the work of a single illuminator and, as is likely, a single manuscript, is further confirmed by the three traced initials whose striking similarities – in terms not only of style and composition, but critically in size – leaves little doubt of their shared origin. While the fleshy, almost sculpted, foliate-entwined initial is a trope of Quattrocento Florentine illumination, its realisation here, the subtleties of its form, are almost identical across the three and find compelling precedents in Littifredi's earlier work.[26] The soft use of tone around the outer edge of the initial, the distinctive acanthus-like filigree motif within the letter stroke, and the pronounced black double line of the left-hand side of the initial window, together differentiate the initials – albeit subtly – from those of his contemporaries, such as an initial 'D' also in Latin MS 14, perhaps painted by Boccardino 'il Vecchio' (**Figure 5**).[27] This way of painting the initial can be seen in two manuscripts now at the Vatican Library, on the incipit page to the Office of the Virgin in a Book of Hours from the mid-1490s (MS Ross. 177, fo. 1r) (**Figure 6**), and in three historiated initials in a previously unattributed choirbook (MS Ross. 607, fos 1r, 4v and 14v) which I believe can be assigned to Littifredi; as well as in two initials in an antiphonary decorated in part by him for the Ospedale degli Innocenti in Florence in 1493 (Istituto degli Innocenti, MS 161, fos 13r, 137r).[28]

It is the figural components of the three initials, however, that offer the most compelling proof of Littifredi's hand. The figures all appear in half-bust, in front of a dark grey ground. Their physiognomies, the fleshy nose, heavy eyes and almost soporific gaze, are almost identical to one another and find precedents in a lavish Book of Hours decorated and signed by Littifredi in 1494 (Siena, Biblioteca comunale degli Intronati, MS X.V.3).[29] Particularly noticeable is the closeness of the poses of Saints Flora, Lucilla and Mary Magdalene. One distinctive feature of these figures and of those from across Littifredi's corpus is the way in which the hands are painted. Unlike Attavante degli Attavanti (1452–1525), whose figures' hands can have a certain woodenness and rigidity, Littifredi's in this period are delicate and unfussy with fine, elongated fingers modelled in only a few strokes.[30]

Another telling motif is the halo. It appears here as just a trace, a glow emanating from a single delineating band of gold. While not unique to Littifredi, this halo type is unusual and has relatively few precedents in contemporaneous illumination.[31] More common was the circular or floating disk form. There is

Figure 5 Boccardino 'il Vecchio' (?), initial 'D' with King David in prayer, c.1490–1500, 96 × 102 mm. Manchester, John Rylands Library, Latin MS 14, no. 36, fo. 31 (photo: © the University of Manchester).

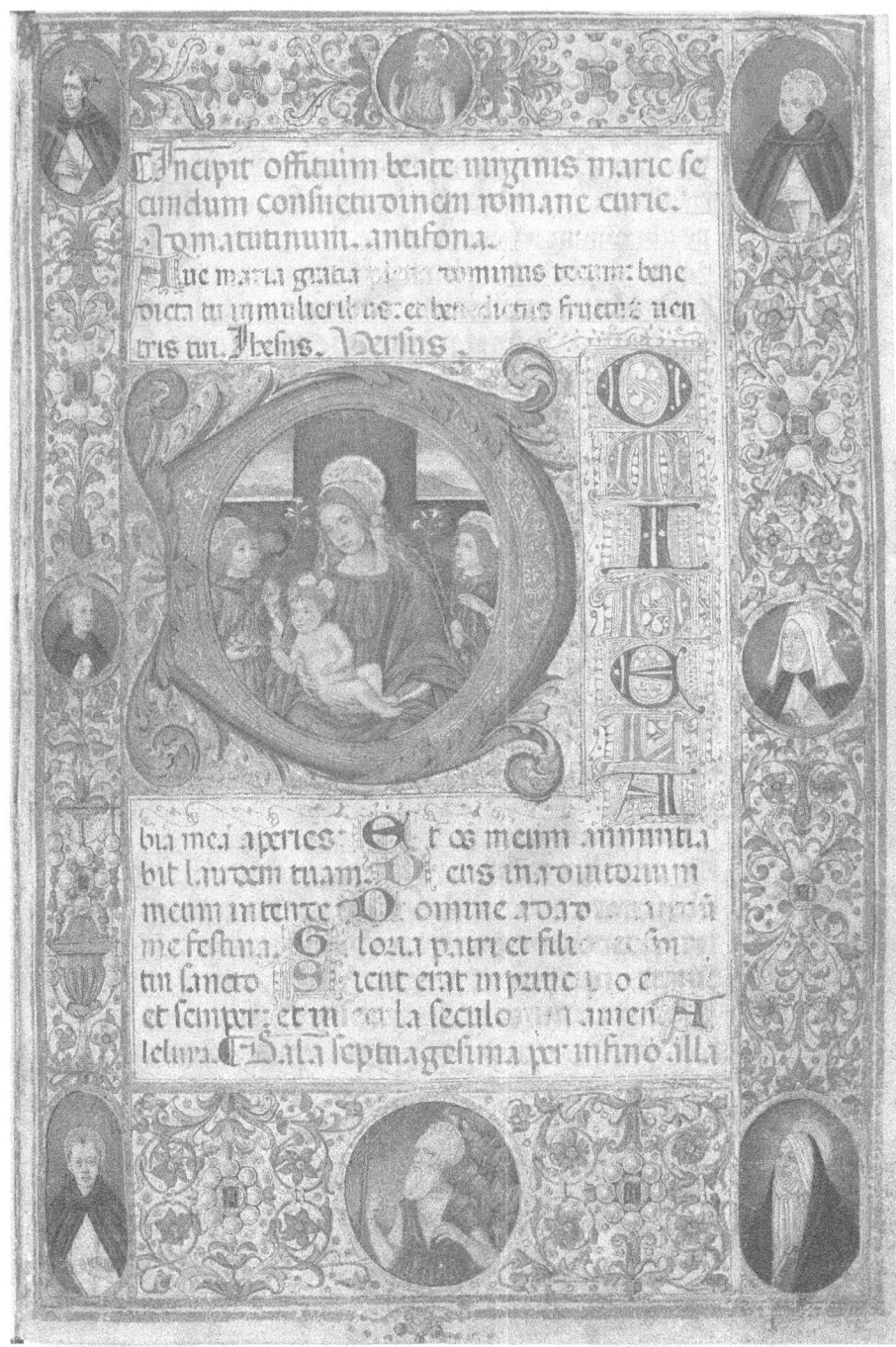

Figure 6 Littifredi Corbizzi, incipit page to the Hours of the Virgin from a *Horae canonicae* of Dominican use, mid-1490s. Vatican City, Biblioteca Apostolica Vatican, MS Ross. 177, fo. 1r (photo: © 2022 Biblioteca Apostolica Vaticana).

some evidence of a similar form in the work of the older Monte di Giovanni (1448–1532/33), active in Florence at the same time as Littifredi, as for example in a miniature of David in prayer in a psalter (Florence, Biblioteca Medicea Laurenziana, MS Plut. 15.7, fo. 2v). But this is not common, as far as I am aware, in the work of Attavante, whom scholars have agreed was key to the development of Littifredi's style.[32] While it is of course possible that he could have adopted this way of painting the halo from a fellow illuminator, it seems more likely that it was learnt from monumental painting, where it was far more common. Indeed, this influence on Littifredi's work has been previously observed by both Garzelli and Freuler.[33] There is known to have been interchange between the two media. Fra Angelico, for example, worked on the painted page (see Florence, Museo di San Marco, MS 558, fo. 86v); likewise, Monte worked with Domenico Ghirlandaio on a commission for Santa Maria del Fiore in Florence.[34] Even if not working across media, illuminators, especially in Florence, worked within the same artistic milieu as their contemporaries and, thus, a diffusion of motif and technique was inevitable.

This halo form is not deployed universally across Littifredi's corpus. Its first known appearance is in 1493 in an initial in the Innocenti antiphonary (fo. 137r). It appears again a year later in the Siena Book of Hours. However, it is used here in tandem with the more conventional solid form. For example, in the initial 'D' with the *Nativity* opening the Office of the Virgin (fo. 51r), both forms appear simultaneously: the 'trace' for the Virgin and Joseph, the solid cruciform halo for the Christ Child.[35] Similarly, the only other identified tracing from Ramboux's sheets of Littifredi's San Benedetto commission, the Berlin *Coronation*, features the solid halo and not the 'trace'. It is not clear whether this variation was just experimentation or a response to iconography. However, a similar repetition of the halo forms seen in the initial 'D' in another (lost) *Nativity* scene reproduced by Ramboux strengthens the second theory.[36] It is a further indication of an illuminator who was not slavishly bound to a single stylistic repertory but was, as Dillon Bussi argues, increasingly innovative.[37]

The discovery of these cuttings also brings to the fore another issue touched on by Alai in 2019 which requires further resolution: the case of a large choirbook initial 'M' with Isaac and Esau also in the album (**Figure 7**). This cutting is accompanied by the inscription 'LITTI FLORETIE PINSIT'. Since M. R. James's 1921 *Descriptive Catalogue*, the initial has been attributed to Littifredi.[38] This was upheld by both Garzelli in 1985 and Alexander in 1992, both of whom saw its stylistic closeness to Attavante as evidence of Littifredi's training in his workshop.[39] It was thus ascribed to the earliest years of his career. Recently, however, both Labriola and Alai have raised doubts about the accuracy of this attribution. Alai argues that it *is* in fact a work by Attavante, and that the inscription is a nineteenth-century pastiche.[40] Given the initial's stylistic incompatibility with Littifredi's known work – especially the San Benedetto initials – and the similarities to Attavante's, this updated attribution is convincing. As for the inscription, it seems unlikely that an individual in the nineteenth century would forge Littifredi's signature as it is hard to imagine any credible motivations to do this, whether art-historical or monetary,

Figure 7 Attavante degli Attavante, initial 'M' with Isaac and Esau, late fifteenth century, 157 × 130 mm. Manchester, John Rylands Library, Latin MS 14, no. 11, fo. 10 (photo: © the University of Manchester).

given Littifredi's relative anonymity.[41] Furthermore, the similarity of this signature to one reproduced in Ramboux's tracings (see **Figure 1**) is too great to ignore. A look at the reverse of the cutting reveals that the inscription is on a separate triangular piece of parchment, which has been taped to the initial. Adding modern inscriptions to cuttings is known to have occurred in the nineteenth century; it was particularly favoured by the infamous abbot-turned-dealer Luigi Celotti (1759–1843), for example in montages offered at the important sale at Christie's in London in 1825, the first auction dedicated solely to detached illuminations.[42] However, these usually recorded the names of famous individuals, such as popes or particularly well-known artists, in order to enhance the provenance, and thus value, of the objects.[43] In the case of the Isaac and Esau cutting, a more plausible explanation is that the inscription was actually cut from another initial, perhaps one with significant damage, and then added to this cutting, which the person responsible may reasonably have considered also to be a work by Littifredi.

Dismemberment, Dispersal and Collection in the Nineteenth and Twentieth Centuries

After the completion of Littifredi's work for San Benedetto in 1503, and the whole series of liturgical books by 1504, they remained in situ for less than two decades. According to Oderigi Lucarelli in his *Memorie e guida storica di Gubbio* (1888),

on the orders of Pope Leo X the Olivetan monks were transferred in 1521 to the nearby Convento di San Pietro within the city walls of Gubbio; the manuscripts followed.[44] In 1860, the codices, by this time with many illuminations excised, entered the state archive in Gubbio, where twenty are now preserved.[45] This includes one choirbook from which a staggering fifty-eight illuminations, mostly historiated initials, have been removed, as well as several folios.[46] The circumstances surrounding the dismemberment of these codices remain murky.

A theory addressing the question as to when and by whom the illuminations were removed was proposed by Mazzatinti and reproduced more recently by Luisa Morozzi.[47] Writing in 1890, Mazzatinti claimed that 'the best miniatures' ('le migliori miniature') from the books at San Pietro were excised by the monks there and sold to Marchese Francesco Ranghiasci Brancaleoni (1800–77), a prominent Gubbian collector, in the mid-nineteenth century.[48] Moreover, he claimed that these same cuttings were in fact among the ones listed incorrectly as work of 'Oderisi [da Gubbio], Franco Bolognese and Attavante' in the catalogue of a sale of Ranghiasci's collection at Luigi Bonfatti in Gubbio in 1882.[49] Labriola also suggests that the mention of '65 miniatures by Attavante' in an inventory of Ranghiasci's collection from 1877 may also be a reference to the miniatures from the dismembered codices.[50]

While this theory is superficially plausible – after all, there has been, and still is, known confusion between the work of Attavante and the illuminators in his circle – parts of it are problematic. For example, a section of the inventory not cited by Labriola indicates that one miniature included the signature *Ata pinxit* ('At[t]a[vante] painted this').[51] There is no evidence that Attavante was involved in the decoration of the San Benedetto books, so this cutting must be from another commission. Furthermore, given that the cataloguer appears to be noting inscriptions, it seems bizarre that Littifredi's signature – which Ramboux's tracings indicate was attached to at least two initials (see **Figure 1**) – was not detailed. The strongest evidence against this hypothesis is a document brought to my attention by John Hodgson which proves that the cuttings now held in the album now known as Latin MS 14 – including, of course, the two traced initials from San Benedetto – were in Britain nearly two decades before the inventory and sale in Gubbio. This critical piece of evidence offers an alternative, more credible hypothesis that I intend to examine. First it is necessary to consider the provenance of the album.

Records from the John Rylands Library archives show that the album was acquired in 1901 by the library's founder Enriqueta Rylands in a sale of manuscripts from the library of the earls of Crawford.[52] It was one of approximately 6,000 Western, Middle Eastern, South Asian and Oriental manuscripts, purchased from the prestigious Bibliotheca Lindesiana for the sum of £150,000, which formed the cornerstone of the new collection.[53] Many of these, including Latin MS 14, were initially held at the Rylands family residence, Longford Hall, before being transferred to the newly built library after Enriqueta's death in 1908, where they remain today.

While there are few known references to this album before 1901, Hodgson, who has written extensively on the library of the earls of Crawford, has drawn my attention to an entry in the *Library Report* written by the 25th Earl, the art historian and prominent bibliophile Alexander Lindsay (1812–80), in 1861–65. This important entry, which appears to mark the first reference to the collection of cuttings, warrants quoting in full:

> I have a volume (as you may recollect) of ancient Italian miniatures, collected apparently by a German artist, one or two of which must be as old as the eleventh or twelfth century, while the majority appear to me to be from the hand of Fra Filippo Lippi, – a very rare and precious collection.[54]

While the attributions here are erroneous, this description does capture the stylistic profile of Latin MS 14. The miniatures ascribed to the eleventh or twelfth centuries can be matched to the handful from the thirteenth or fourteenth century; the majority thought to be by Lippi to the illuminations from the late fifteenth or early sixteenth centuries occupying all but one of the first thirty-two folios, a majority of which are by closely related Florentine illuminators, many from the same parent manuscripts.[55] How can this inaccuracy be explained? Lindsay's area of particular interest and expertise was early Italian painting, the work of the *primitivi*, and not illuminated manuscripts, and thus his knowledge was likely limited; after all, the art-historical study of manuscripts was still nascent in the 1860s.[56] As for the mention of Lippi, this is probably a (very) hopeful reading of works of recognisably Florentine hands, many of which share stylistic similarities, and one which looked to inflate the prestige of the collection. This is consistent with the way in which historians and collectors approached illumination in the period, through the lens of monumental painting.

What is most significant, however, is the mention of 'a German artist'. Given Ramboux's direct connection to and clear interest in two of the illuminations (both reproduced in the Städel sheets), it seems certain that this is a reference to Ramboux, whose profile as a prolific collector and dealer is well known. While scholarship has tended to focus on his important collection of Italian primitives, Christina Schulze has drawn attention to his ownership of a significant number of medieval and Renaissance codices as well as albums, individual manuscript leaves and framed and loose cuttings.[57] These formed over 250 lots, many comprising numerous items, at one of Ramboux's postmortem sales at J. M. Heberle in Cologne in 1867. Thirty of these – over 180 leaves and cuttings – were acquired for the Museum für Kunst und Industrie (now The MAK) in Vienna.[58] A cutting now at the J. Paul Getty Museum by Giovanni di Paolo (MS 29) was also in his collection; as were at least six at the Wallraf-Richartz Museum in Cologne, where he was curator between 1844 and 1866.[59]

If the cuttings in Latin MS 14 *were* initially 'collected' by Ramboux, as the entry claims, then this suggests that he played a greater role in their excision than previously thought. It would suggest that the illuminations were removed during or

immediately after Ramboux's study at San Pietro, and offers a *terminus ante quem* of 1835, after which he is attested in Assisi and then Rome and Tuscany.[60]

To return to Mazzatinti's theory, the *Library Report* entry raises serious questions as to its accuracy. While it is impossible to rule out Ranghiasci's ownership of any of the cuttings, at the very least, the entry proves that a portion of them left Gubbio with Ramboux well before the inventory or the sale. Given that Ramboux was a keen collector, and obviously thought Littifredi's work was important enough to record, the most likely explanation is that he purchased them from the monks – as Mazzatinti suggested of Ranghiasci – or removed them himself, took them from Gubbio and later sold them, some eventually making their way into the collection of Alexander Lindsay.

While the date Lindsay purchased the album (or indeed, whether all the cuttings were assembled by that time) is not clear, it has been contended that the apparent absence of records in the library's correspondence or accounts may be an indication that it was acquired on one of Lord Lindsay's many visits to Italy.[61] This is confirmed by two inscriptions on the album's spine which read 'MINIATURE ANTICHE' ('Ancient Miniatures') and 'J. SPITHÖVER. ROM'. The latter, especially significant, reveals the involvement of the bookseller, photographer and fellow German expatriate Josef Spithöver (1813–92), who was active in Rome c.1850–70 and was clearly responsible for the production of the album. Interestingly, Spithöver is known to have been involved with the Nazarenes, the Rome-based brotherhood of pious German artists of which Ramboux was a part.[62] Relatively little is known of his activity as a dealer of manuscripts; however, Rowan Watson has drawn attention to fifty leaves and cuttings bought from him by the Victoria and Albert Museum in 1860.[63]

Given that Ramboux is known to have returned to Germany in 1843, the most plausible explanation is that he sold the loose cuttings before his departure, that they were then acquired and bound by Spithöver, and that the album was subsequently purchased by Lindsay. This must have occurred over the course of a decade or two as we know that the album was in Britain by the early 1860s, when it is mentioned in the *Library Report*. Thus, the mostly likely period of acquisition is the 1850s. This is consistent with both Lindsay's movements (he writes a letter from Rome in May 1856, for example) and with his 'preoccupation' at this time with enhancing the Biblioteca Lindesiana.[64] The acquisition of an album of cuttings, then at the peak of its popularity among bibliophiles, would have been a necessity.

As for the movements of the Christie's initial 'P', now in a UK private collection, little is known of its provenance. The appearance of bald patches on its reverse, indicating the application and removal of an adhesive, suggests that it too may have once been pasted in an album. The provenance of the Berlin *Coronation* miniature likewise remains vague, although Alai has been able to trace it back to 1883 when it was acquired by the Kupferstichkabinett from the dealer H. G. Gutekunst in Stuttgart.[65] The whereabouts of the other initials or miniatures traced by Ramboux is not known at this time. It is certain, however, that they and other cuttings from

this manuscript – not to mention those from the other dismembered books from San Benedetto – were widely dispersed across Europe (and likely beyond). It is only with time and further research that these will come to light.

Further Potential Cuttings

One significant consequence of the identification of the three traced initials is that they shed light on five further initials, all previously attributed to Littifredi, whose provenance has remained a mystery (see **Table 1**).[66] While scholars have agreed that these cuttings are from the same manuscript or series of manuscripts, it has not been possible to tie them definitively to a particular commission.[67] Although unfortunately not traced by Ramboux, the striking similarities between these and the three traced initials lead me to believe that they too are from the San Benedetto manuscripts. Not only do they match the size profile of the first three, but the distinctive stylistic and compositional features discussed here (for example the hands, halos and initial form) can also be observed across all five.[68]

This conclusion is supported by a comparison of the reverses of the initials 'O', 'H' and 'T' with that of the traced initial 'P'. While the content alternates between lines of text and musical notation, the script is identical across the four. The text is approximately 18 mm tall; the four-line stave, 40 mm. Interestingly, the reverse of the initial 'H' reveals a section of rubric which appears to open an antiphon to be recited at vespers, confirming that Littifredi worked on an antiphonary.[69] Again, there is evidence that these were once pasted down. The initial 'S', which Freuler notes comes from a gradual, indicates that Littifredi worked on at least one other closely related book.[70] Much like the Christie's cutting, little is known of the provenance of these initials. It is possible that some or all may have been offered at the various sales of Ramboux's collection after his death, but the brief and vague lot descriptions make identification difficult.[71] The only information I have been able to find relates to two cuttings. The initial 'C' (**Figure 8**) was in France until

TABLE I
Further cuttings from San Benedetto by Littifredi.

Title	mm	Location
Initial 'C' with the Virgin and Apostles	85 × 82	London, Sotheby's, 8/12/2015, lot 19
Initial 'O' with St Laurence	86 × 83	London, Sotheby's, 5/7/2016, lot 32
Initial 'H' with St Bernard or St Benedict	90 × 95	London, Sotheby's, 5/7/2016, lot 32
Initial 'S' with Five Martyr Saints	97 × 95	Milan, private collection [see Freuler, *Italian Miniatures*, no. 102]
Initial 'T' with a Bishop Saint	83 × 86	Cologne, Wallraf-Richartz-Museum, M 186

2013, when it was sold to a private collector in the UK.[72] Records for the cutting now at the Wallraf-Richartz-Museum in Cologne, attributed to Littifredi by Alai, indicate that it was acquired from the vom Raff family in 1900.[73]

In addition to these five, I believe at least a further five initials, also contained within Latin MS 14 (see **Table 2**) – none of which have previously been attributed to Littifredi – can also be ascribed to this commission.[74] Their presence in an album with known ties to Ramboux and San Pietro in addition to the stylistic similarities to the initials mentioned above strengthens this hypothesis, as does a comparison of their reverse sides. Indeed, it has been possible to link the initials 'R' with John and 'A' with Peter and Paul to missing initials on folios 14 and 77 in the above mentioned Corale 50 (E) at the Archivio di Stato in Gubbio.[75] The initials, which again show figures in half-bust before a dark-grey ground, are in fact the most revealing of the thirteen discussed. Their figures not only display the first explicit iconographic evidence of their provenance – monks in the white Olivetan habit – but also reveal an even more profound link to contemporaneous monumental painting.[76]

Given the collaborative nature of book painting, it is possible that the physiognomic variation between the figures in these initials (cf. **Figures 9–10**) may indicate other hands, for example an assistant in Littifredi's workshop.[77] However, when considered in relation to Littifredi's other known work, which demonstrates his ability to innovatively deploy a range of different figure types, I argue that the initials here should be seen as the work of a single, adaptable hand. This is evidenced in the Siena Book of Hours (fos 50v, 51r) and the Vatican Book of Hours (fo. 1r). However, that is not to say there are no similarities between these and the other initials from Littifredi's San Benedetto commission. The hand supporting the book in the initial 'I' (**Figure 9**) is almost identical to the book-holding hand of St John in the initial 'R' (**Figure 10**), of God the Father in the Berlin miniature, and to the hand supporting the gridiron in the initial 'O' with St Laurence (see **Table 1**). The tonsured figure is also similar to the Dominican saints inhabiting the border roundels on the incipit page to the Vatican Book of Hours (fo. 1r). The martyr's palm and, again, the halo are also very close to those in the traced initial 'P'.

One interesting detail not seen in the other initials is the inclusion of a window or windows in the three initials in which Olivetan monks are depicted, creating the impression of a small monastic cell. This motif was almost certainly gleaned from contemporaneous panel painting. It appears frequently in the three-quarter length portraits of the Virgin and Child by artists such as Botticelli, Leonardo and Lorenzo di Credi: for example, in the *Madonna and Child with a Pomegranate* by the latter, now at the National Gallery of Art, Washington (**Figure 11**).[78] The composition of the initial 'I' also finds strong parallels in an earlier initial by Littifredi opening the Office of the Virgin on fo. 1r of the Vatican Book of Hours (**Figure 5**). Furthermore, instead of painting the body of the letter form, which would bisect the initial's central part, only its top and bottom parts are depicted, creating the

Figure 8 Littifredi Corbizzi, initial 'C' with the Virgin and Apostles, 1499–1503, 85 × 82 mm. UK private collection (photo: author).

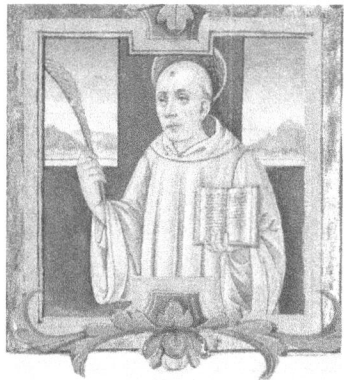

Figure 9 Littifredi Corbizzi, initial 'I' with an Olivetan martyr Saint, 1499–1503, 88 × 87 mm. Manchester, John Rylands Library, Latin MS 14, no. 8, fo. 7 (photo: © the University of Manchester).

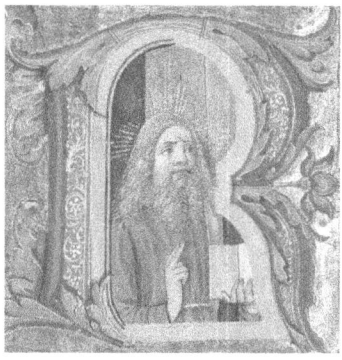

Figure 10 Littifredi Corbizzi, initial 'R' with St John, 1499–1503, 83 × 82 mm. Manchester, John Rylands Library, Latin MS 14, no. 9, fo. 8 (photo: © the University of Manchester).

TABLE II
Further cuttings from San Benedetto by Littifredi in Latin MS 14.

Title	mm	Shelfmark
Initial 'I' with an Olivetan martyr Saint	88 × 87	Latin MS 14, no. 8, fo. 7
Initial 'R' with St. John	83 × 82	Latin MS 14, no. 9, fo. 8
Initial 'O' with an Olivetan monk	87 × 82	Latin MS 14, no. 15, fo. 13
Initial 'A' with Sts. Peter and Paul	82 × 85	Latin MS 14, no. 16, fo. 14
Initial 'U' with an Olivetan monk praying	97 × 87	Latin MS 14, no. 30, fo. 26

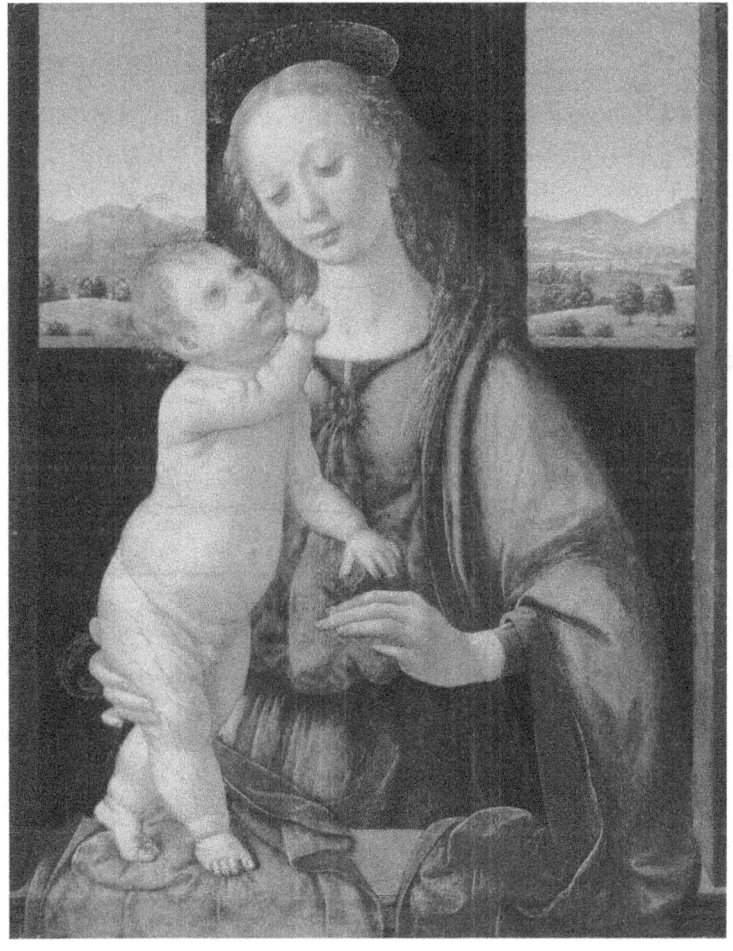

Figure 11 Lorenzo di Credi, *Madonna and Child with a Pomegranate*, 1475/80, 165 × 134 mm. Washington DC, National Gallery of Art, acc. no. 1952.5.65 (photo: Courtesy of the National Gallery of Art, Washington).

impression of the letter tucking behind the picture plane. These ingenious devices, which negate the physical constraints of the parchment, offer examples of the many inventive ways illuminators adapted traditional compositions and iconographies to meet the spatial requirements of the painted page.

Conclusion

The identification of the three initials traced by Ramboux in the mid-1830s offers an invaluable insight into Littifredi's work for the Olivetan monks of San Benedetto, Gubbio. These initials, the first to be linked definitively to this commission, in addition to the already identified Berlin miniature, not only help reconstruct this manuscript, which extensive dismemberment had almost entirely erased from history, but offer an important indication of Littifredi's style during his last known datable period of work.

A critical reassessment of the circumstances surrounding the dismemberment of this and the other manuscripts then held at San Pietro, in addition to the emergence of a key piece of evidence from the 1860s relating to Latin MS 14, indicates that Ramboux played a greater role in the excising and collection of the miniatures – Littifredi's included – than has previously been acknowledged. While the numerous tracings of illuminated manuscripts in the Städel sheets make clear his aesthetic and art-historical interest in the painted page, the revelation from the *Library Report* raises important questions about the extent to which this crossed over into an economic interest. Furthermore, it raises other issues. What are the implications of these conclusions for the rest of the cuttings in Latin MS 14? Were some of them also traced by Ramboux? Could some perhaps be from the other liturgical books decorated for San Benedetto?

Through a combination of stylistic, physical and iconographic analysis in addition, where possible, to an interrogation of provenance, I have argued that a further ten initials – five attributed to Littifredi before, and five also contained within Latin MS 14 – can now also be linked to this commission. These cuttings, executed with great skill and attention to detail, reveal an illuminator very much connected to the fluid artistic environment at the turn of the Quattrocento in Florence and Siena; they very much solidify Littifredi's position, as Garzelli has argued, as the 'most significant' illuminator in Attavante's circle.[79] Now totalling fourteen, these cuttings constitute a major addition to Littifredi's corpus. I hope that by drawing attention to this talented illuminator and this important yet largely uncharted period of work, this article will invite further study and, ultimately, encourage the emergence of further cuttings from this commission.

Acknowledgements

I am especially grateful to Hanna Vorholt, whose advice and support has been instrumental in the writing of this article. I would also like to thank Angela Dillon Bussi, Beatrice Alai, Ada Labriola, John Hodgson, Peter Kidd, Mary Pardo and

Jessica Richardson, as well as Anne Anderton and the John Rylands Library – which has recently digitised Latin MS 14 – for their help. I am thankful for the support of the Association for Manuscripts and Archives in Research Collections (AMARC) who generously provided a grant to cover research and publication costs.

Notes

1. For more on Ramboux's project, see Christina A. Schulze, '"Museum Ramboux" – Eine italienische Stilgeschichte in Kopien von Johann Anton Ramboux (1790–1866) an der Königlichen Kunstakademie Düsseldorf (1841–1918)' (PhD dissertation, University of Vienna, 2011); Uf Sölter (ed.), *Italien so nah. Johann Anton Ranboux (1790–1866)*, (Cologne: Wienand Verlag, 2016). The most recent publication on Ramboux is Dóra Sallay, '"Pratichissimo della scuola senese": Johann Anton Ramboux (1790–1866) conoscitore', in Francesco Caglioti, Andrea De Marchi and Alessandro Nova (eds), *I conoscitori tedeschi tra Otto e Novocento* (Rome: Officina Libraria, 2018). These publications focus on his copies or collection of paintings, rarely mentioning illuminations.
2. The likely dates for these stays are 1816–22, 1832 and 1833–42/43; see Dóra Sallay, 'The Sienese Paintings in Hungary: A History of Collecting, Conservation and Previous Research', in *Corpus of Sienese Paintings in Hungary* (Florence: Centro Di, 2015), pp. 13–24.
3. This quotation is extracted from the title page of the group of sheets at the Städel Museum, kindly translated from the German by Hanna Vorholt; see Frankfurt, Städel Museum, Bib. 2472 IX.
4. As Dóra Sallay notes, Rumohr 'stressed the importance of creating reliable reproductions of surviving medieval works of art, and recommended Ramboux as the most suitable talent'; see Sallay, 'Sienese Paintings', p. 15.
5. Sallay, 'Sienese Paintings', 15–17. See Christina A. Schulze, 'Johann Anton Ramboux und Italien', in Ulf Sölter (ed.), *Italien so nah. Johann Anton Ramboux (1790–1860)* (Cologne: Wienand, 2016), p. 21. See also the other articles in this volume.
6. Ramboux's description, cited in Schulze, 'Johann Anton Ramboux und Italien', p. 21. Although beyond the scope of this article, particularly important here is Ramboux's membership of the Nazarene brotherhood, a group of devout German artists and writers founded in 1809 by Johann Frederick Overbeck and Franz Pforr living in Rome. They saw the art of medieval and early Renaissance Italy as not only a model for a new German art, but as a blueprint for a revived, ideal Christian society in Germany. See Schulze, 'Johann Anton Ramboux und Italien', pp. 13–21; for the impact of the Nazarenes on Ramboux's project see Schulze, 'Museum Ramboux', 107–25. A useful overview of wider medievalism in early nineteenth-century Germany is Michaela Braesel, 'Medieval Elements in Nineteenth-Century German Illuminations: Contexts and Models', in Thomas Coomans and Jan De Maeyer (eds), *The Revival of Medieval*

Illumination. Renaissance se l'eluminure medieval (Leuven: Leuven University Press, 2007), esp. 138–40. See also other articles in this volume.

7 See Christina A. Schulze, 'Museum Ramboux', 100–25; Sallay, 'Sienese Paintings', p. 17.

8 Schulze, 'Johann Anton Ramboux und Italien', p. 22.

9 Littifredi was born in Florence in 1465. His career seems to have begun in the second half of the 1480s; c.1493 he moved to Siena, where he lived until his death, c.1515. The best general studies of the illuminator are Annarosa Garzelli, *Miniatura fiorentina del Rinascimento, 1440–1525: Un primo censimento*, vol. 1 (Florence: La Nuova Italia, 1985), pp. 333–4, 37–9; Diego Galizzi, 'Corbizzi, Littifredi (Litti)', in Milvia Bollati (ed.), *Dizionario biografico dei miniatori italiani: Secoli IX–XVI* (Milano: Sylvestre Bonnard, 2004), pp. 174–5.

10 Städel Museum, Bib. 2472 II 115A–D. I thank Beatrice Alai for drawing my attention to this series of tracings.

11 G. Mazzatinti, 'Storia delle arti a Gubbio', in M. Faloci Pulignani, M. Santoni and G. Mazzatinti (eds), *Archivio storico per le Marche e per l'Umbria* (Foligno: Presso la Direzione, 1884), p. 45. It is not clear from the entry how many books Littifredi worked on, but the inclusion of the word 'salmista', referring to the psalmist [i.e. King David], could suggest an antiphonary – a book containing the sung parts of the Divine Office – whose text borrowed heavily from the psalms. This seems to be supported by the text 'In d[omi]nicis/dieb[us] ad/v[espe]ras an[tiphona]' on the reverse of a cutting offered at Sotheby's (to which I return later), which I believe was originally from this manuscript; see London, Sotheby's, 5 July 2016, lot 32. However, the initial 'S' with five Martyr Saints discussed by Freuler is from a gradual, opening the Introit to the Second Mass for Several Martyrs.

12 *Ibid.*, 41–7. For the other individuals, see Elvio Lunghi, 'Le arti del Duecento a Gubbio: il mito di Orderisi da Gubbio tra miniatura e pittura', in Giordana Benazzi, Elvio Lunghi and Enrica Neri Lusanna (eds), *Gubbio al tempo di Giotto. Tesori d'arte nella terra di Oderisi* (Perugia: Fabrizio Fabbri Editore, 2018), p. 36. As far as I am aware, their work for San Benedetto also remains largely unstudied.

13 In 1860 the dismembered codices were transferred to the state archive in Gubbio: see Ada Labriola, 'Miniature rinascimentali riprodotte nel XIX secolo. Gaetano Milanesi, Carlo Pini e Giovanni Rosini: dai calchi grafici alle stampe di traduzione', *Rivista di storia della miniatura*, 20 (2016), 165, n. 9.

14 See note 5 above; see also Gaudenz Freuler, *Italian Miniatures: From the Twelfth to the Sixteenth Centuries*, vol. 2 (Milan: Silvana, 2013).

15 See Irene Hueck, 'Le copie di Johann Anton Ramboux da alcuni afferschi in Toscana ed in Umbria', *Prospettiva*, no. 23 (October 1980), 9, n. 6; Labriola, 'Miniature rinascimentali riprodotte nel XIX secolo', 165, n. 9; Beatrice Alai, *Le miniature italiane del Kupferstichkabinett di Berlino* (Firenze: Edizioni Polistampa, 2019), cat. 44, pp. 196–7.

16 This album contains fifty-four cuttings from the thirteenth to early sixteenth centuries (forty-two are Italian, the majority by Florentine illuminators, and date from the late fifteenth to early sixteenth century; there are several French cuttings, although there is

no time to discuss these here). One cutting (no. 42, fo. 37) bears a handwritten note indicating an attribution by Otto Pächt to Niccolò da Bologna. It has been fully digitised and is available to view online. See Alai, *Le miniature italiane*, pp. 196–7, and the JRL catalogue: M. R. James, *A Descriptive Catalogue of the Latin Manuscripts in the John Rylands Library at Manchester* (Manchester and London: University Press and Longmans, Green, 1921), pp. 38–41.

17 London, Christie's, 30 July 2020, lot 5; I thank Angela Dillon Bussi for the identification of these two Martyr Saints.

18 Manchester, John Rylands Library, Latin MS 14: 28, fo. 24 and 31, fo. 27.

19 An important volume in the field is Sandra Hindman et al., *Manuscript Illumination in the Modern Age* (Evanston, IL: Northwestern University, 2001).

20 Very little has been published on the album of medieval and Renaissance illuminated manuscript cuttings. This is acknowledged in a brief overview of the practice in Hindman, *Manuscript Illumination in the Modern Age*, 80–91. One of the (very) few recent discussions of the album is Beatrice Alai, '*Litterae deaurate et pictae*: Frammenti miniate della Cappella Sistina negli album della collezione von Nagler', *Rivista di Storia della Miniatura*, 23 (2019).

21 See for example Lisa Fagin Davis's (partial) virtual reconstruction of the Beauvais Missal.

22 *Fragmented Illuminations: Medieval and Renaissance Manuscript Cuttings at the V&A*, 8 September 2021–5 June 2022, curated by Catherine Yvard.

23 Sallay, 'Sienese Paintings', p. 17.

24 Another very similar signature to the one seen in **Figure 1** appears on the first sheet of tracings. See Städel Museum, Bib. 2472 II 115A.

25 See John W. Bradley, *A Dictionary of Miniaturists, Illuminators, Calligraphers, and Copyists*, vol. 1 (London: Bernard Quaritch, 1887), pp. 139, 254.

26 For more on the historiated initial in this period, see J. J. G. Alexander, *The Decorated Letter* (London: Thames & Hudson, 1978), pp. 18, 21.

27 Cf. an initial by Boccardino 'il Vecchio': New York, Christie's, 26 October 2016, lot 43.

28 Cf. the other initials within this book by other illuminators, for example, one by Mariano del Buono on fo. 195r. See Laura Cavazzini, 'Dipinti e sculture nelle chiese dell'Ospedale', in Lucia Sandri (ed.), *Gli innocenti e Firenze nei secoli: un ospedale, un archivio, una città* (Firenze: Studio per Edizioni Scelte, 1996), pp. 124–6.

29 Siena, Biblioteca Comunale degli Intronati, MS X.V.3, fos 1r, 13r, 50v, 51r, 114r.

30 For example, see the hands in Attavante's *Praeparatio ad missam* for Pope Leo X from 1520: New York, Pierpont Morgan Library, MS H.6, fo. 1v.

31 Of the 1102 illustrations in volume 2 of Garzelli's authoritative text, I could only identify approximately thirteen, other than Littifredi's, with this halo type.

32 One exception is the Missal of the Bishop of Dol (Lyon, Bibliothèque Municipale, MS 5123) where on occasion (fos 6v, 16v, 27v for example) similar though not identical halo forms appear.

33 See Garzelli, *Miniatura fiorentina*, 337–9; Freuler, *Italian Miniatures*, 860–3. Freuler has noted the influence of Botticelli in Littifredi's work.

34 See J. J. G. Alexander, *The Painted Book in Renaissance Italy: 1450–1600* (New Haven, CT: Yale University Press, 2016), 270. See an initial 'N' with the Birth of the Virgin from the workshop of Ghirlandaio (Copenhagen, SMK, Department of Prints and Drawings, inv. no. 1742), in Eleonora Mattia, 'Three Italian Illuminated Cuttings in the Royal Library of Copenhagen: The Master B. F., Attavante and the Master of Montepulciano Gradual I', *Fund og Forskning i Det Kongelige Biblioteks Samlinger*, 56 (2017), 9–11.

35 Again, this same solid halo is used for the Christ Child in the Innocenti antiphonary (fo. 13r).

36 Städel Museum, Bib. 2472 II 115D.

37 Writing of the Siena Book of Hours, Mirella Levi D'Ancona suggested that Littifredi had little imagination and simply 'copied' Attavante, see Mirella Levi D'Ancona, *Miniatura e miniatori a Firenze dal XIV al XVI secolo: documenti per la storia della miniatura* (Florence: Leo S. Olschki, 1962), 168; Angela Dillon Bussi and Giovanni M. Piazza, *Biblioteca Trivulziana: Milano* (Fiesole: Nardini, 1995), p. 192.

38 See no. 11, fo. 10 in James, *Descriptive Catalogue*, p. 38.

39 Garzelli, *Miniatura fiorentina*, 337–9; Jonathan J. G. Alexander, *Medieval Illuminators and Their Methods of Work* (New Haven, CT, and London: Yalue University Press, 1992), pp. 128–9.

40 Alai, *Le miniature italiane*, p. 196.

41 I thank Peter Kidd for his suggestions here.

42 For more on Celotti, see Anne-Marie Eze, 'Abbé Luigi Celotti and the Sistine Chapel Manuscripts', *Rivista di Storia della Miniatura*, 20 (2016), 139–54. See also Hindman, *Manuscript Illumination in the Modern Age*, 52–62, 93–101.

43 Noble or glamorous provenance still remains a major selling point for objects appearing on the art market today. One only has to look at the description of a leaf with a miniature of the *Mass of St Gregory* at Maggs Bros, London (stock code: 225283). Here a special subheading indicates that it is 'from the collection of the Marquess of Bute'.

44 Oderigi Lucarelli, *Memorie e guida storica di Gubbio* (Città di Castello: S. Lapi, 1888), p. 623.

45 See Labriola, 'Miniature rinascimentali riprodotte nel XIX secolo', 165, n. 9. These codices have been digitised.

46 See Gubbio, Sezione di Archivio di Stato di Gubbio, Corali del Convento di San Pietro, Corale 50 (E); the manuscripts have been digitised and are accessible through the website of the Archivio di Stato di Perugia.

47 Luisa Morozzi, 'Contributo alla ricostruzione delle miniature appartenenti ai corali di San Pietro a Gubbio', *Paragone*, 31 (1980), 54.

48 G. Mazzatinti, *Inventari dei manoscritti delle biblioteche d'Italia* (Forlì: L. Bordandini, 1890), 123.

49 *Ibid.* Gubbio, Luigi Bonfatti, 12–20 April 1882, lots 992–9.

50 Labriola, 'Miniature rinascimentali riprodotte nel XIX secolo', 165, n. 9. This entry from the inventory was published in Francesca Mambelli, 'Il museo disperso dei Ranghiasci nell'inventario del 1877: Premesse all'edizione critica', in Patrizia Castelli

and Salvatore Geruzzi (eds), *Il Museo di Gubbio memoria e identità civica 1909–2009 atti del Convegno di studio, Gubbio, 26–28 novembre 2009* (Pisa: F. Serra, 2012), p. 232.
51 *Ibid.*
52 Manchester, John Rylands Library Archive, JRL/6/1/7/14.
53 John R. Hodgson, '"Spoils of Many a Distant Land": The Earls of Crawford and the Collecting of Oriental Manuscripts in the Nineteenth Century', *Journal of Imperial and Commonwealth History*, 48:6 (2020), 1–4.
54 The *Library Report* has not been published, but this section is reproduced (although the connection to Ramboux not made) in Hugh Brigstocke, 'Lord Lindsay as a Collector', *Bulletin of the John Rylands Library* 64:2 (1982), 315. It is only 'tentatively' identified here as a reference to Latin MS 14; the fact the volume referred to matches so closely the stylistic profile and, indeed, is now known to contain initials traced by Ramboux confirms this.
55 See James, *Descriptive Catalogue*, pp. 38–41.
56 See Alan N. L. Munby, *Connoisseurs and Medieval Miniatures, 1750–1850* (Oxford: Clarendon Press, 1972), p. 11.
57 Schulze, 'Museum Ramboux', 80, n. 566.
58 *Ibid.* Cologne, J. M. Heberle, 27 December 1867, lots 687–724 and 882–1097; unfortunately, records of the sale were destroyed during the Second World War. For the leaves and cuttings now at the MAK, see KI 1541–1604. I thank Peter Klinger at the MAK for his assistance in tracking these down.
59 See inv. nos M 5, M 7, M 10, M 18, M 20, M 23.
60 See Sallay, 'Sienese Paintings', pp. 16–19.
61 This has been convincingly suggested to me by John Hodgson.
62 See Elvira Ofenbach, *Josef Spithöver. Ein westfälischer Buchhändler, Kunsthändler und Mäzen in Rom des 19. Jahrhunderts* (Regensburg: Schnell & Steiner, 1997), pp. 60–1.
63 Acc. nos 1487–1537; see Rowan Watson, 'Educators, Collectors, Fragments, and the "Illuminations": Collections at the Victoria and Albert Museum in the Nineteenth Century', in *Interpreting and Collecting Fragments of Medieval Books*, ed. Linda L. Brownrigg and Margaret M. Smith (London: Red Gull Press, 2000), pp. 28, 36. Here he is referred to as 'Spithower'. He clearly had an interest in medieval manuscripts as his press, the *Libreria Spithöver*, also published works on medieval manuscripts by contemporary scholars.
64 Brigstocke, 'Lord Lindsay as a Collector', 308.
65 Alai, *Le miniature italiane*, 196.
66 For more on these initials, see *ibid.*, 196–7.
67 See the auction catalogue entries for the first three initials listed in Table 1.
68 There appear to be other cuttings within Latin MS 14 from the same book or series of books as Littifredi's, but worked on by other hands. Further research is needed here.
69 See note 11 above.
70 Freuler, *Italian Miniatures*, 860.
71 See note 64 above.

72 Paris, Beaussant Lefèvre, 5 April 2013, lot 52. A label on the back of its frame identifies the framer as Frédéric Petit of 95 Rue Ampère in Paris, who appears to have been active at the end of the nineteenth century.
73 Cologne, Wallraf-Richartz-Museum Archiv, Kartei_M_186; see Alai, *Le miniature italiane*, 96, fig. 10.
74 See the entries in James, *Descriptive Catalogue*, 38–9.
75 This is the result of research at the Archivio di Stato in July 2022. There is not time to discuss my additional findings here; however, it has been possible to link other cuttings now in Latin MS to missing initials in this choirbook. I plan to present this research in another article.
76 Parallels can be drawn with a tracing in Ramboux's sheets from San Pietro, which shows a group of monks crowded round a large open book on a lectern, see Städel Museum, Bib. 2472 II 115A.
77 There is no time to discuss the workshop practices of illuminators, but for more on this topic, see Alexander, *Medieval Illuminators and Their Methods of Work*.
78 Freuler also draws parallels between the composition of the initial 'D' in the Vatican codex and a tondo, *The Madonna and Child with Two Angels*, from the studio of Botticelli offered at Christie's New York on 28 January 2009, lot 8.
79 Garzelli, *Miniatura fiorentina*, 337.

Manchester University Press

Incunabula at the Manchester Grammar School

R. M. CLEMINSON, UNIVERSITY OF OXFORD

Abstract
The article describes copies of three early-printed books at the Manchester Grammar School, which have not previously been noted in the bibliographies. These are the *Missale Romanum* (Venice, 1494), *De Re Militari* (Rome, 1494), and Aquinas, *Summa contra Gentiles* (Cologne, 1501). Two of the books have Hungarian connections, as is shown by inscriptions in them. They appear to have been at the grammar school since the late nineteenth or early twentieth century, but their detailed provenance remains obscure.

Keywords: incunabula; early printing; Manchester Grammar School; Hungarian libraries

In memoriam Eszter Ojtozi,
1935–2006

The presence of incunabula in Manchester is far from unexpected: the John Rylands Library possesses one of the world's great collections, with up to 3,500 items (including duplicates), and there are smaller but still significant collections at Chetham's Library and the Central Library (98 and 33 titles respectively). However, it has not been known until recently that the Manchester Grammar School possessed any such material. I first became aware of it from a brief notice of the school's 1494 Missal in a privately circulated brochure produced as part of the celebrations of the school's 500th anniversary in 2015.[1] On making direct enquiries at the school, I was surprised to discover that the handlist of the antiquarian book collection (about 250 items), prepared by a commercial valuer and incorporated in Carol Ray's unpublished *Report to the Governing Body on the Antiquarian Book Collection* (November 2012), lists no fewer than three incunabula; these copies were at that time unknown to bibliography.[2]

The first of these is the aforementioned missal. The second is a collection of ancient writings on military matters edited by Giovanni Sulpizio da Verola and published in Rome in the same year. The third volume, despite having a perfectly preserved colophon, is incorrectly identified in the handlist as an edition of Thomas Aquinas's *Summa contra Gentiles* published in Cologne in 1500. This edition is a ghost: all references to it are apparently derived from a note following Hain's entry for the 1497 edition, where he remarks 'Ed. ejusd. impressoris a. 1500 valde dubia mihi videtur', as well it might.[3] The book at Manchester Grammar School was in fact published in 1501, but it is no less interesting for that. None of the three books has a current shelfmark.

Formal notices of the three copies follow:

1. Missale Romanum. Venice, Johann Emerich of Speyer for Lucantonio Giunta, 13 VIII 1494.
ISTC im00709300
Lacks the first nine leaves (i.e. all the preliminaries and a1) and also o6.
Binding: worn blind-tooled brown leather on wooden boards (16th century?) with remains of two clasps. Modern spine and flyleaves.
Inscriptions: *last leaf*, Frater Michael Chircorasij [?]
inside front cover, on last leaf verso, and inside back cover, mass propers for St Sophia, St Ladislas, St Stephen, St Imre and the Three Kings
on modern flyleaf at front, MGS bookplate and inscription: Repaired 1.iii.31, G.S. Thompson M.A., Librarian
*f.*II 1494-bŏl

2. Johannes Sulpitius Verulanus (ed.), Scriptores rei militaris. Rome, Eucharius Silber, 1494.
ISTC is00344000
Binding: 18th-century worn brown leather on card, with 19th-century buckram spine. Two flyleaves at each end, the outer one and pastedown evidently contemporary with the spine, the inner one older.
Inscriptions: 19th-century bibliographical notes on the inner flyleaves.
Snippet from printed sale catalogue (?) pasted inside front cover.
Stamps on the first leaf: Manchester Grammar School Thompson Library; Manchester Grammar School Heywood Foundation. (The second of these is also on the last leaf.)

3. Thomas Aquinas, Summa contra Gentiles. Cologne, Heinrich Quentell, 31 VIII 1501.
VD16 T 1020
Sewn on three tawed bands; contemporary limp vellum cover.
Inscriptions: *front flyleaf*, Conuẽtus Budẽs(is)
title page (i) Andreæ Monozlij & Am[...] |Datus à Pp̃mo õm õño N[...] | Telegdino Ep̃po qqecclen[...] | pr̃mo gratioso [...] | 27. Maj 1580 | Dñe labia mea aperies et os | mea Annunciabit laudem tuam.
(ii) Cap̃li Posoniensis | 1633 Lit. T.

The first of these volumes is the rarest of the three – the Incunabula Short Title Catalogue lists eleven other copies, none of them in England – so the Manchester Grammar School copy, though imperfect, is of some significance. It is also interesting because for certain parts of the mass it gives the chant as well as the words, so that it is an early, and quite a fine, specimen of printed music.[4]

Before the Council of Trent imposed uniformity on most of the Roman Catholic world, the mass was usually celebrated according to a local use – in England, for example, the use of Salisbury, in Hungary, that of Esztergom, and so on. The Franciscans, however, were from the beginning very energetic in propagating the use of the Roman rite (*Missale secundum consuetudinem Romanae curiae*) wherever they were. In this they were followed by other religious orders, which were similarly international in character, and who essentially adopted the Franciscan use

with minor modifications. It is clear that the 1494 Missale Romanum was printed for use by religious communities: a number of the rubrics state that an action is to be performed by 'a brother' (*frater*). The inclusion, among the *propria sanctorum*, of saints of particular relevance to the Augustinian order – St Augustine himself, his mother St Monica, St Simplician, who was instrumental in his conversion, St William of Maleval, the founder of an order of hermits later partly merged with the Augustinians, and St Nicholas of Tolentino, an Augustinian friar – suggests that the book was printed with this order in mind. It may also be noted that the rite for admitting young people into the order (*Ad induendum puerum vel puellam habitum*, beginning on f. CCXXIV) prescribes *postea dicat prior orationem sancti augustini v⟨e⟩l sancti francisci: ac orationem s. monice vel s. clare*.

Though there is nothing in the book that allows us to trace its history in any detail, the fact that the additional manuscript material on the pastedowns and flyleaves includes the three Hungarian royal saints – Stephen, Ladislas and Imre – indicates that it was in use in Hungary at an early period in its existence, and the pencil inscription on the first extant leaf, '1494-ből', shows that it was still there in modern times. There is, however, no indication of how it left or how it came to Manchester, though it was certainly at the Manchester Grammar School by 1931, as the inscription on the front flyleaf proves.

The title of the second volume, 'Scriptores rei militaris', is an invention of modern bibliographers: the book itself has no overall title, and the title on the first leaf, 'Vegetius de re militari', refers only to the first of the texts that it contains. It is a collection, edited by the humanist Giovanni Sulpizio da Veroli (Io. Sulpitius Verulanus), of classical writings on military matters.[5] He first issued his collection in 1487, also printed at Rome by Eucharius Silber, with a dedication to his former pupil Pierpaolo Conti, who was, according to the epistle dedicatory, at that time embarking on a military career under the command of his brother-in-law, the celebrated condottiere Niccolò Orsini (1442–1510), who had married Elena Conti in 1467. The first work that it contains, the *De re militari* by P. Vegetius Renatus, who lived in the late fourth and early fifth centuries AD, was perhaps the most influential work on the subject up to this period.[6] This is followed by the *Strategematicon* of Sextus Julius Frontinus (c.35–103, for whom see the introduction to the Loeb edition of his works).[7] Next comes Pseudo-Modestus's *De re militari*, a short work which is in fact an epitome of parts of Vegetius.[8] The 1487 volume concludes with *De instruendis aciebus* by Aelianus Tacticus, who wrote in Greek in the second century, in a Renaissance translation by Theodore Gaza (Θεόδωρος Γαζῆς, c.1398–c.1475).[9]

For the second edition, Sulpitius reissued all the above texts with the addition at the end of *De optimo imperatori* by Onosander (first century) – the *editio princeps* of this work – translated from the Greek by Nicolaus Sagundinus (Νικόλαος Σεκουνδινός, 1402–64).[10] In this edition, the one at the Manchester Grammar School, the first two works (Vegetius and Frontinus) have separate colophons, dated 'M.cccc.xciiii die xxiiii Octobris' and 'M.cccc.xciiii die tertio nouembris' respectively; the remaining sections of the book have no colophons or dates. It is not,

therefore, absolutely certain that the printing of the whole book was completed in 1494. It is not a particularly rare book – the Incunabula Short Title Catalogue lists over a hundred copies – but the Manchester Grammar School copy is in an exceptionally fine state of preservation.

Alfred Mumford's statement that the school library possessed a copy of 'Vegetus' (*sic*) in the time of William Barrow, who was High Master from 1677 to 1720,[11] if it has any basis in fact, cannot refer to this volume. It is contradicted by the manuscript and printed additions on the endpapers, which indicate that the book was still in commercial circulation in the nineteenth century. It is also telling that the book was evidently not present when the school library was reorganised and effectively re-founded in the 1840s and 1850s, largely thanks to the efforts of Richard Thompson (1811–62), Second Master.[12] A handlist of the books in the library, of which there were then about six hundred, was printed in about 1856. No copy seems to survive at the school, but it formed the basis for an article on 'The Manchester Free Grammar School Library' in the *Manchester Guardian*, 19 August 1856. This is essentially a survey of those books in the library that were of antiquarian interest; the fact that the writer (whom Mumford identifies as the Manchester journalist and antiquary John Harland (1806–68), though the article is unsigned) makes no mention of what would have been the oldest book in the collection is a strong indication that it was not yet there.

The stamps on the first leaf provide better information. The first of these refers to Mr Thompson, whose own collection, amounting to 1,900 volumes, was presented to the school in 1876. The second refers to Oliver Heywood (1825–92), chairman of the governors from 1876 until his death, who gave £1,000 to the library in 1882.[13] Absolute certainty in these matters is not possible, as library administration in the nineteenth century seems to have been somewhat haphazard, depending on the enthusiasm of individual masters. However, if we assume that the Thompson Library stamp does not refer exclusively to Mr Thompson's own books (otherwise the Heywood stamp in the same book would be hard to account for), but that his name was applied to the entire collection of which his bequest had formed the nucleus, and if we assume that the Heywood stamp was applied correctly, then it provides a *terminus post quem* of 1882 for the acquisition of the book. Since it is mentioned by Mumford, it was certainly in the library by the time he was collecting material for his book at the beginning of the twentieth century. It is thus highly probable that the book came to the Manchester Grammar School at the end of the nineteenth century or the beginning of the twentieth.

The third book is the well-known *Summa contra Gentiles* of Thomas Aquinas, in the edition of Theoderic of Susteren, a Dominican of Cologne who edited several of Aquinas's works. This book too is in excellent condition, and is notable for its limp vellum cover which may well be its original binding. Its early history is easier to determine than its subsequent fate. The inscription on the flyleaf, 'Conventus Budensis', indicates that it first belonged to a religious house of one of the mendicant orders at Buda, most probably the Dominican convent of St Nicholas, though the Franciscan friary in the Budavár is also a possibility. Later, in 1580,

as indicated by the inscriptions on the title page, it was given by Miklós Telegdy (1535–86), Bishop of Pécs, to András Monoszlóy (1552–1601), afterwards Bishop of Veszprém.[14] Together with the majority of his books, it passed after his death to his brother Gábor, Canon of Pozsony (Bratislava), and subsequently to the chapter library there, as attested by the second of the inscriptions. The chapter library survives to this day (nearly four thousand volumes, now in the Slovak National Archive), and it is impossible to tell when this volume was lost to it.

It is, however, remarkable that two of the three oldest books at the Manchester Grammar School both have Hungarian connections. It seems improbable that this is pure coincidence, but in the absence of any information about when they were acquired, one can only speculate about when their association began. One at least was at the school by 1931; neither is mentioned by Mumford or any earlier source. The disruption occasioned by the First World War certainly brought about the displacement of many rare books, and it is possible that both came into the possession of an individual who decided to present them to the school during the following decade. More than that it is, at present, impossible to say.

Notes

1. Zoey Ward (ed.), *Pass it on, Boys: MGS at 500* [Manchester, 2015], pp. 48–9.
2. I have since informed the editors of the Incunabula Short Title Catalogue at the British Library, and they are now included.
3. Ludwig Hain, *Repertorium Bibliographicum, in quo libri omnes ab arte typographica inventa usque ad annum MD. typis expressi, ordine alphabetico vel simpliciter enumerantur vel adcuratius recensentur*, vol. I, pars I (Stuttgart – Tübingen: J. G. Cotta, 1826), no. 1390.
4. For the history of music printing at this period, see Mary Kay Duggan, *Italian Music Incunabula: Printers and Type* (Berkeley: University of California Press, 1992); this edition is described on p. 242.
5. On Verulanus, see Peter G. Bietenholz and Thomas B. Deutscher (eds), *Contemporaries of Erasmus: A Biographical Register of the Renaissance and Reformation*, 3 vols (Toronto: University of Toronto Press, 1985–87), vol. III, p. 300.
6. Christopher Allmand, *The* De Re Militari *of Vegetius: The Reception, Transmission and Legacy of a Roman Text in the Middle Ages* (Cambridge: Cambridge University Press, 2011); see in particular pp. 239–48 for early printed editions.
7. Frontinus, *Stratagems. Aqueducts of Rome*, trans. C. E. Bennett, ed. Mary B. McElwain (Cambridge, MA: Harvard University Press, 1925).
8. M. D. Reeve, 'Modestus, scriptor rei militaris', in Pierre Lardet (ed.), *La Tradition vive: mélanges d'histoire des textes en l'honneur de Louis Holtz* (Turnhout: Brepols, 2003), pp. 417–32.
9. Bietenholz and Deutscher (eds), *Contemporaries of Erasmus*, vol. II, p. 81.
10. On Sagundinus see Π. Δ. Μαστροδημήτρης, Νικόλαος Σεκουνδινός (1402–1464): βίος καὶ ἔργον (ἐν Ἀθῆναις, 1970).

11 Alfred A. Mumford, *The Manchester Grammar School, 1515–1915* (London: Longmans, 1919), p. 129.
12 *Ibid.*, pp. 282, 307.
13 *Ibid.*, p. 371.
14 For both of these see the relevant articles in Szinnyei József, *Magyar írók, élete és munkái* (Budapest: Hornyánszky, 1891–1914).

David Lloyd Roberts (1834–1920), Physician and Gynaecologist: His Collection of Rare Books and Art Treasures

PETER MOHR, UNIVERSITY OF MANCHESTER

Abstract

David Lloyd Roberts MRCS LSA MD FRCP FRS.Edin (1834–1920) was a successful Manchester doctor who made significant contributions to the advancement of gynaecology and obstetrics. His career was closely linked to the Manchester St Mary's Hospital for Women and Children, 1858–1920. He lectured on midwifery at Owens College and the University of Manchester and was gynaecological surgeon to Manchester Royal Infirmary. He had many interests outside medicine, including a large collection of rare books, paintings and antiques. He produced an edition of Thomas Browne's *Religio Medici* (1898) and a paper, *The Scientific Knowledge of Dante* (1914). He donated his books to the John Rylands Library and the London Royal College of Physician, his paintings to the Manchester Art Gallery, and he left a large endowment to Bangor College, Wales. This article reviews his medical work alongside his legacy to literature, the arts and education.

Keywords: gynaecology; obstetrics; St Mary's Hospital; John Rylands Library; Royal College of Physicians; Dante; Thomas Browne; Manchester Art Gallery

Dr David Lloyd Roberts was a well-known and charismatic Manchester obstetrician and gynaecologist, with a career that spanned sixty years (**Figure 1**). He was a wealthy man who spent a fortune collecting rare books, artworks and antiques, which he generously bequeathed to various institutions. However, his medical work and his collections have faded from memory. This article first provides a summary of his medical career, followed by an account of his collections and bequests to the John Rylands Library, Manchester City Art Gallery, London Royal College of Physicians and the University of Bangor. Roberts's book collection provides an example of a professional man's late Victorian and Edwardian library; unlike those of most other medical men, his collection was not confined to medicine and covered a diversity of subjects, authors and publishers. It is this breadth and scope of his library that makes it a valuable source for scholars, worthy of comparison with other large collections.

Roberts's medical education and his subsequent work as an obstetrician provide a good example of the career of a hospital consultant during the second half of the nineteenth century. His successful career and wealth certainly provided him with the means to indulge his obsessive collecting, and the main focus of this article is not 'Dr Roberts the obstetric physician', but 'Roberts the collector' and his thousands of books, paintings and antiques. The combination of his book

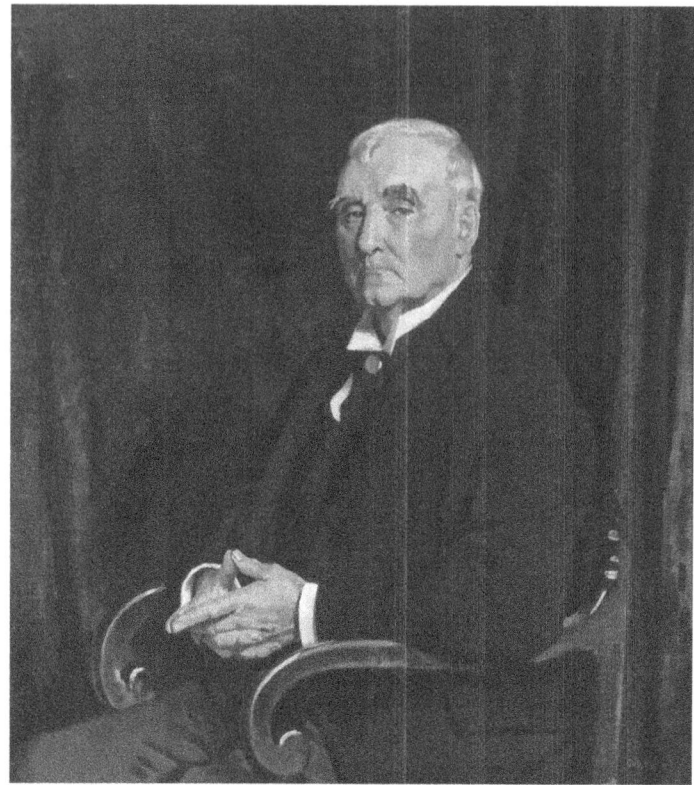

Figure 1 Portrait of Lloyd Roberts (1923). Copy made for the Royal College of the Physicians of the original portrait (1915) by William Orpen for St Mary's Hospital, now in Manchester Art Gallery (image courtesy of Art UK and RCP).

collecting alongside antiques and artworks is unusual, and places him in an elite group of eclectic and compulsive collectors. The classification of his books, how they were acquired and the reasons for his obsessive accumulation of artefacts are discussed and compared with other collectors in further sections. He could not have read all the volumes, but he was nevertheless knowledgeable about their literary worth: for example, he used them in the preparation of his published works on Thomas Browne and Dante. Towards the end of his life, he took great care in organising the dispersion of his estate and endowments; he was aware that his collections were valuable cultural assets, and after careful consideration he decided on the John Rylands Library and the London Royal College of Physicians as the final repositories for his books, and the Manchester City Art Gallery as the most suitable institution for his pictures and antiques.

Early Life and Entry to the Medical Profession 1834–58

David Lloyd Roberts was born on 28 October 1834 and baptised on 16 November that year.[1] When he died in 1920 he had no surviving relatives, and the narrative of

his obituaries and biographical notes is based mainly on memoirs from his friends, which focus on his medical career and are vague about his early life. They state that he was born in Stockport in 'humble circumstances . . . the son of Martha and Robert Roberts', and that as a young child he had to work as a messenger for a chemist's shop; he preferred to be called 'Lloyd Roberts' and spoke with a Lancashire accent. They mention that later, his circumstances somehow improved, and he attended Making Place Academy in Calderdale.[2]

Fortunately, previously uncatalogued correspondence by his friend and executor Albert Blackburn (1863–1945), recently discovered in the University of Bangor archives, has provided more detail. Mr Blackburn was a wholesale pharmacist who supplied Roberts's private practice; his letters record that Roberts was born in Stockport, but his mother died shortly after the birth and he was brought up by his grandmother in Denbigh until he was 7, when he was reunited his father, who had remarried, to Martha Redfern in 1838. Roberts had described his stepmother as 'one of the best of women', and after his father's death (c.1849), he and his stepmother moved to Cheetham Hill in Manchester, where he worked for a time in a chemist shop owned by Edward Brown, nearby on Bury New Road. His stepmother, 'Martha Roberts', is entered in the 1861 census as his 'mother'; the name of his birth mother remains to be discovered.[3]

An alternative account by a medical student in 1937 claimed that David Lloyd Roberts was born in 1840 in Mold, Wales, was orphaned at the age of 3 and was brought up with his uncle's family in Earlestown, Lancashire, where he worked for a local chemist. It is difficult to reconcile this account by 'persons variously related to him', which is probably based on misinformed family legend (or possibly a completely different 'Lloyd Roberts').[4] It vaguely hints that Lloyd Roberts wanted to hide some family scandal, and it is true that he never revealed much about his childhood; however, it is more likely that he just did not remember much of his early life or did not want to recall those difficult years.

In 1851 he was indentured to William Smith (1817–75), surgeon at the Manchester Royal Infirmary (MRI), Lecturer in Anatomy at the Manchester Royal School of Medicine (MRSM) on Pine Street, and Professor of Anatomy at Owens College. Smith was a role model for Roberts – a good surgeon with a large private practice.[5] Roberts studied surgery at the MRI and attended the MRSM for lectures and dissection under surgeon Thomas Turner (1793–1873), who had founded the MRSM in 1825.[6] The Apothecaries Act (1815) required medical practitioners to hold a licence from the Society of Apothecaries (LSA) and the Royal College of Surgeons (MRCS); Roberts qualified LSA and MRCS in 1857 and later gained an MD by examination from the University of St Andrew's in 1859.[7]

In 1872, the MRSM joined Owens College and relocated to the new Manchester Medical School on Coupland Street. 'Owens' became the Manchester Victoria University in 1880 and conferred medical degrees (MB ChB) from 1883; these institutions played an important part in Roberts's later career.[8]

Lloyd Roberts and St Mary's Hospital for Women and Children, 1858–1920

The development of Manchester as a wealthy industrial city was an attraction for young doctors, and when Roberts qualified he was following a well-trodden path.[9] He set up in general practice and was living with his stepmother at 23 St John Street; within a year he was appointed as 'surgeon-in-ordinary' to St Mary's Hospital for Women and Children, nearby on Quay Street.[10] In 1864 he married Martha Occleshaw (1842–1911), the daughter of William Occleshaw (1774–1849), a wealthy Manchester lead merchant and property owner. The wedding took place at Manchester Cathedral, and they set up house at Kersal Towers, Bury New Road.[11]

The history of St Mary's Hospital is well documented.[12] It was founded as the 'Lying-in Charity for the Delivery of Poor Women' near Salford Bridge in 1790 by 'man-midwife' Charles White (1728–1813).[13] The charity was renamed the 'Lying-in Hospital', and in 1840 moved to South Parade, opposite St Mary's Church on Parsonage Green. In 1854 it was again renamed 'St Mary's Hospital and Dispensary for Diseases Peculiar to Women and Diseases of Children' to signal that it was a hospital not just for childbirth but also for women's diseases.[14] The midwives assisted at home births, while the medical officers, 'man-midwives', dealt with difficult cases (the term 'man-midwife' was replaced in 1828 with 'surgeon-in-ordinary').[15] Thomas Radford (1793–1881) had joined as man-midwife in 1818 and became a consulting physician in 1841; he played an important role in establishing a new St Mary's Hospital, which opened on Quay Street in 1856.[16] Roberts was appointed as a surgeon-in-ordinary in 1858; Radford, an expert in the use of obstetric forceps and Caesarean section, was the main influence upon Roberts's surgical training, and they were also neighbours on Bury New Road.[17] The new hospital included a children's ward, vaccination service, operating theatre and gynaecological surgical ward.

Roberts was interested in the surgical treatment of uterine tumours and ovarian cysts, and set up a women's cancer ward in 1863.[18] Charles Clay (1801–93), who had joined the staff in 1858, was a pioneer of 'ovariotomy', a dangerous intra-abdominal operation, performed to remove large cysts or tumours of the ovary.[19] Roberts published a paper in the *Lancet* (1870) on the safety of ovariotomy, in which he described the technique in detail, and later reported twelve cases, again in the *Lancet*.[20] Before the 1870s, both caesarean section and ovariotomy were controversial operations with a high mortality and only performed *in extremis*; indeed, even general surgeons regarded abdominal surgery as 'new territory', and for a time it was mainly the preserve of gynaecological surgeons.[21] Roberts was regarded as a good surgeon, responsible for most of the abdominal operations during the 1860s–1870s, and it was said that 'he kept the flag flying for ovariotomy'.[22]

Medical apprentices had witnessed deliveries since the 1790s and had received lectures on midwifery from 1820. Roberts thought that the teaching of obstetrics and gynaecology should be increased and based on physiological principles.[23] John Thorburn (1834–85), gynaecologist at the Southern Hospital for Women and

Children (a rival to St Mary's), was appointed as the first Professor of Obstetrics and Gynaecology at Owens College in 1873, and Lloyd Roberts and Charles Cullingworth (1841–1908), both from St Mary's, were subsequently appointed as lecturers in midwifery in 1883.[24] Medical professors and lecturers were employed part time and expected to fit in their teaching sessions alongside their private practice. Lectures were given at the college, and clinical teaching was organised in the hospital. Roberts, inspired by his mentor Professor Smith, hoped to inherit the Chair of Obstetrics; he had regularly taught students, and his well-written and illustrated *Student's Guide to the Practice of Midwifery* was a popular textbook.[25] Nevertheless, when Thorburn died in 1885, Cullingworth was appointed as professor. When he moved to St Thomas' Hospital in London in 1888, Roberts assumed that he would replace him; however, the chair was awarded to William Japp Sinclair (1846–1912) from the Southern Hospital.[26] An archive note suggests that this was the reason why Roberts left no endowment to the university, and it is also noteworthy that he made no mention of Professor Sinclair in his historical essay on the 'Manchester School of Obstetrics and Gynaecology' in the *British Medical Journal* (1902).[27]

Dr Roberts was wealthy; he had a successful private practice (his patients, in their carriages, lined up along St John Street), and an additional income from investments and properties.[28] His wife also came from a wealthy family that owned houses in the Plymouth Grove area.[29] A cartoon from 1908 depicts him as a short stocky man, wearing a top hat, in which he kept his papers and his monaural stethoscope (**Figures 2 and 3**).[30] Although he projected an image of a Victorian doctor (he always travelled by coach and horse, and never owned a motor car) he kept up to date with medical science; in his long career he witnessed the introduction of anaesthetics, antisepsis and bacteriology, and was quick to adopt surgical advances, including wearing an operating gown, mask and gloves. He was part of the period of transition from 'man-midwife' to the profession of obstetrics and gynaecology, yet although a gynaecological surgeon, he described himself as a 'general physician with an interest in women'.[31]

Roberts was an active member of the Manchester Medical Society, the North of England Obstetrical and Gynaecological Society, the Royal Society of Medicine, the London Medical Society and the Royal Society of Edinburgh. He also played a leading role on the committee planning a new St Mary's Maternity Hospital on Whitworth Street, which opened in 1904.[32] After some delay, a second St Mary's Hospital building for gynaecological cases opened on the corner of Oxford Road and High Street in 1911.[33] Roberts gave up major surgery in 1895, and Mrs Roberts died on 24 January 1911. Nevertheless, he continued to see patients at St John Street, attend medical meetings and act as chairman of St Mary's Hospital until a month before his death on 27 September 1920.

Figure 2 Anonymous cartoon of Lloyd Roberts, *Manchester Medical Students Gazette* (1908) (Image courtesy of University of Manchester).

Figure 3 Lloyd Roberts' monaural stethoscope, 7'' (Image by University of Manchester Museum of Medicine and Health).

The Collections and Legacy of David Lloyd Roberts

Lloyd Roberts's friend, Dr William Fothergill (1865–1926), provided some details of Roberts's daily routine: on his way to work he would stop at an antique shop to add to his collection of Jacobean silver, and when away attending a medical meeting, he would explore the shops for rare books and artworks. His collection of blue and white china, which he bought in London, was said to value £10,000, and Mr Joseph Hughes, from Sherratt & Hughes bookshop, visited weekly to advise him on rare books.[34] Around 1885–86 Roberts moved to a larger house, Ravenswood on Old Hall Road, mainly to accommodate his collection of nearly 5,000 books, pictures and antiques; the house was lit by candles rather than gas in order to protect the pictures, and the collection was so large that it was described in the *British Medical Journal* as a 'miniature Wallace Collection'.[35]

Roberts's estate was valued at £125,677 7s 9d. He had no surviving relatives, but he made generous endowments to his domestic staff, hospitals and other institutions.[36] His cook, coachman and other staff received legacies of between £100 and

£500, and an endowment of £2,000 to St David's Church for Welsh Anglicans on Lime Grove went towards a stipend for the minister.[37] He also left endowments for annual 'Lloyd Roberts Lectures' in Manchester and London on a topic of scientific or medical interest.[38] The following list summarises his wishes for the disposal of his estate:

> Collection of bound books: John Rylands Library.
> Medical books and manuscripts: Royal College of Physicians.
> Paintings, mezzotints, carpets, antiques: Manchester Corporation Art Gallery.
> Endowment to the Royal College of Physicians: £3,000.
> Three executors: £1,000 each.
> Accountant: £250.
> Joseph Hughes: £250 for supervising the book collection.
> St David's Church, Lime Grove, Chorlton on Medlock: £2000.
> St Mary's Hospital: £5,000, and £500 for Lloyd Roberts Lectures.
> Manchester Royal Infirmary: £3,000, and £500 for Lloyd Roberts Lectures.
> Royal Society of Medicine: £5,000, and £500 for Lloyd Roberts Lectures.
> Medical Society London: £2,000, and £500 for Lloyd Roberts Lectures.
> St David's College Lampeter, West Wales: £4,000.
> Bangor College, North Wales: £5,000 for a 'Lloyd Roberts Professorship'.
> Bangor College, North Wales: residual estate, about £20,000.

A note in the Manchester University archives states that 'he left the bulk of his fortune to the Welsh School of Medicine, ignoring the University of Manchester in his will'. This was incorrect; he had made no mention in his will of the Cardiff University Medical School or the Welsh National School of Medicine.[39] He bequeathed instead £4,000 to St David's College at Lampeter, founded in 1822 in west Wales, which had no medical school but was renowned for its Founder's Library and collection of rare books.[40]

In 1908, Roberts had donated several thousand pounds to the University College of North Wales towards the cost of the new Main Building at Bangor University; he was subsequently elected Vice-President of the College, 1914–19, and later a bronze memorial plaque was hung in the main hall in 1930. In his will he bequeathed the residue of his estate, about £20,000, to the college and also left a further £5,000 to endow a Lloyd Roberts Chair; as there was no medical school at that time, a Chair of Zoology was established.[41] Why did he make these endowments? His grandparents lived in Denbigh and there may have been other family links, but he had no special connection to Bangor. He may have wanted to open a medical school, or just generally support Welsh education; certainly, he understood the value of a good education as an escape from poverty. However, Mr Blackburn, his executor, thought that Roberts's interest in Bangor was mainly encouraged by his association with Lord Tyrell-Kenyon (1864–1927), President of University College of North Wales, and Sir Henry Reichel (1856–1931), the first Principal of the College, whom he would have met at the time of the appeal for the new Main Building.[42] The fact is that in 1912 he added a codicil to his will about his residual estate, which concluded 'to pay the ultimate residue to the University

College at Bangor, North Wales' and £5,000 'for a professorial Chair on any subject the College may think fit'.

Lloyd Roberts's Collection of Books in the John Rylands Library

Roberts's collection of rare books was his main interest outside of his medical work, and he gave considerable thought to its future location. He had decided not to bequeath anything to the University of Manchester, partly because he had been passed over for the professorship, and also because he did not think the University Library, including the Medical School Library, would take proper care of the volumes.[43] He decided to split his collection: his rare medical books and manuscripts would go to the Royal College of Physicians (RCP) and his general collection of bound books was left to the John Rylands Library (JRL). The librarian Henry Guppy (1861–1948) wrote in 1924:

> The most important bequest of all was that of the late Dr Lloyd Roberts who had taken a great interest in the library from its inauguration and under his will he gave the librarian authority to select from his large collection of books whatever he considered would be of interest in the building up of our collection. As a result, the library was enriched by some five thousand volumes.[44]

The Royal College of Physicians recorded its donation as 1,857 medical books, so it is probable that Guppy's figure of '5,000' included Roberts's medical books before their dispersal to the RCP.[45] The John Rylands Library Accession Register records over 2,900 books donated by Lloyd Roberts, of which 1,035 volumes, dating from the fifteenth to the nineteenth century, are listed in the online University Library catalogue, linked with his name as 'previous owner' (the registered volumes not listed in the catalogue are mainly duplicate editions); an additional thirty-one volumes are listed in the catalogue of the Aldine Press, and two volumes are in the Incunable Collection.[46] The catalogued titles cover a wide range of subjects written in English, Latin, French, Italian and other languages.

A few of Roberts's books in the John Rylands Library are loosely related to 'medicine', such as Mead's *Pharmacopoeia Meadiana* (1781) and Sir Samuel Garth's satirical poem *The Dispensary* (1699).[47] Guppy also noted that the collection included examples of the 'great modern binders' and others of 'great historic interest', previously owed by famous personages. The majority of the titles relate to literature, theology and the arts, for example *Absalom and Achitophel: A poem* (1708) by John Dryden (1631–1700) and *Examples of the Art of Book-Illumination During the Middle Ages,* published by Bernard Quaritch (1819–99) and bound by Zaehnsdorf.[48] There are catalogues of exhibitions and book collections, dictionaries and domestic handbooks, such as *Delights for ladies: to adorne their persons, tables, closets, and distillatories* (1632) by Hugh Plat (1552–1608).[49] The two volumes from before 1500 are the *Scriptores rei rusticae* edited by Filippo Beroaldo (1499) and Antonio Rampegolo's *Compendium morale* (not after 1473).[50]

The Lloyd Roberts Lectures helped to keep his memory alive and always mentioned his book collection, but after they ceased in the 1950s any awareness of the collection declined. The collection is a valuable resource and is mentioned in the *Cambridge History of Libraries in Britain and Ireland* (2006), but it is difficult to know just how much it has been used.[51] Indeed, a search of the British Library Catalogue and the *Bulletin of the John Rylands Library* reveals only a single article that refers to one of Roberts's volumes. The article by Dr Cordelia Warr describes an eighteenth-century manuscript, 'A series of fifty-four clever drawings on vellum: monstrous births', from the library of Edward Davenport (1778–1847) and later owned by Lloyd Roberts. The manuscript describes a range of 'monstrosities' from conjoined twins to more fanciful images, such as a pig with a human head.[52] This interesting article, a contribution to understanding the historical role of monstrosities in art, provides an excellent example of the potential of Roberts's collection for historical research in both the humanities and medicine.

Roberts did not let his collection stand idle and put it to use to pursue his own research into the physician and scholar Sir Thomas Browne AB AM MD FRCP (1605–82). In 1892 Roberts published a revised edition of Browne's *Religio Medici*, followed by further editions in 1898 and 1902. His introduction includes a list of nineteen earlier editions (1642–1881) in his private collection, which he used in preparing his revised version. He also included a brief biography of Thomas Browne, presenting him as a cultured, well-educated man who combined a life as a successful physician with literary scholarship (perhaps a lifestyle that Roberts aspired to).[53] Roberts explains that he decided to edit a new version of *Religio Medici* to correct errors that had crept into earlier editions. Browne had started to write *Religio Medici* around 1635 in support of the Anglican church and, as a discussion of his theological beliefs, the afterlife and the nature of the spiritual world.[54] His first authentic edition in 1643 was published to correct unauthorised and anonymous copies of his manuscript that had appeared in print earlier that year. Over the years many errors crept into later editions, so in 1835 Simon Wilkin (1790–1862) decided to include the 1643 edition in his collection of *Sir Thomas Browne's Works* (1835).[55] Roberts also regarded the original 1643 version as the most authoritative and used it in his revised edition with some corrections of spelling and printing errors. He also included in the same volume Browne's *Christian Morals* (1756), regarded as a continuation of *Religio Medici*; *Letter to a Friend*, a discussion of mortality based on the death of a friend from tuberculosis; and *Hydriotaphia (Urn Burial)* (1658), a history of cremation.[56] Browne's short essay *On Dreams* was later added to Roberts's 1898 edition.[57] This nicely printed, small volume provided an easy-to-read collection of Thomas Browne's best-known publications. Copies of Roberts's three editions, and all the titles mentioned in this section, are in the JRL.

Lloyd Roberts was also an admirer of Dante Alighieri (c.1265–1321), an interest that probably dated from his 'grand tour' of Florence, Genoa and Corona in 1883.[58] He was a founding member of the Manchester Dante Society (1906) and delivered a published lecture to the Society on the *Scientific Knowledge of Dante* in 1914.[59] At that time, there was a large and well-established Italian community in

Manchester, and a general interest in Italian art and architecture.[60] He owned four editions of the *Divine Comedy*, and there was a collection of Dante material in the JRL.[61]

Roberts's choice of topic, 'the scientific knowledge of Dante', is interesting. Dante's essays and poems had been studied for centuries, so he declared that he had not 'presumed to discuss [Dante's] intellectual gifts', but 'science' still left him a broad canvas and was a popular topic for a Manchester audience.[62] This was an important landmark in his life; he was 79 and still working, and this was an opportunity to demonstrate that he was not 'just a doctor' but also man of scholarly interests (again, perhaps in the style of Thomas Browne).

In his lecture, Roberts discussed Edward Moore's (1835–1916) account of Dante's knowledge of astronomy and geography, and argued that Dante would have received a broad education at Bologna University, where he may have attended lectures on anatomy and physic.[63] Roberts highlighted a dozen examples of medical and scientific references in the *Divine Comedy*, *Convivio* and *La Vita Nuova* covering physiology, reproduction, zoology and botany – Dante's references to quartan malarial fever and epilepsy are striking examples. Roberts was one of the first to emphasise Dante's use of medical similes, and while more recent articles have also drawn attention to references in Dante's works to cardiac and neurological disorders, they make no reference to Roberts's published lecture.[64] He concluded that Dante was well educated in the sciences of his time, and familiar with the works of Aristotle, Galen and Hippocrates. He acknowledged Dante's skill in using this knowledge in his poetic similes, and described them as 'fragments of science, like gorgeous-hued inlays of mosaic, [that] form lustrous stars, irradiating with intrinsic beauty, pregnant with hidden meaning'.[65]

Lloyd Roberts's Collection of Books in the Royal College of Physicians

Roberts bequeathed his rare medical books and manuscripts to the RCP because he thought that the University Medical Library would not be able to look after the collection properly. At the time of his death, the Medical Library was located in the University Medical School on Coupland Street, but the books were still the property of the Manchester Medical Society; the library was running out of space, and there was a continual tension between the Manchester Medical Society and the university over the funding of the books and journals.[66] There is some confusion over the number of books sent to the RCP; the obituary of Roberts in *Munk's Role* states that he donated 'his valuable library of 3,000 books', but that number may have been confused with his £3,000 donation to the college.[67] The RCP librarian's report of 1921 records the donation of 1,850 'rare and interesting books', including fifty volumes published before 1500, which 'filled the library shelves, and the overflow was put in the bookstore' in the RCP building (then at Pall Mall East).[68]

All of Roberts's books in the RCP have been catalogued, but only about 200 appear in its online catalogue as 'donated by Roberts'; these were considered the 'most important volumes'. The others, which are identified by his book plate, were

catalogued as if they were 'ordinary', less rare books.[69] Many are editions of classical anatomical and surgical manuals, pharmacopeia, and texts on healthy living. Two examples of the rarer books are *Medicine libri octo noviter emendati et impressi* (1516) by Cornelius Celsus (*c*.25BC–50AD) and *The pisse-prophet or certaine pisse-pot lectures: Wherein are newly discovered the old fallacies, deceit, and jugling of the pisse-pot science* (1637) by Thomas Brian.[70] The college also holds twenty-six manuscripts donated by Roberts, including an anonymous copy of Celsus's *De medicina libri octo* (1451) and Sarah Wigges's collection of medical receipts, *Hir booke. Live wel, dye never. Dye wel, live ever* (1616).[71] Thirty of the RCP books were transferred to the Welsh National School of Medicine before the College relocated in 1964 to its new building at Regent's Park. A comparison of these books with the RCP catalogue confirms that they are duplicate editions from between about 1600 and 1750, such as *The magnetick cure of wounds* (1649) by Jean Baptiste van Helmont (1577–1644).[72]

Lloyd Roberts's Collection of Art and Antiques in the Manchester Art Gallery

In Roberts's original will (1912) he left his mezzotints, watercolours and antique carpets to the Whitworth Institute and his valuable collection of china plate, furniture and other 'objects of art' to the Manchester Art Gallery. Although the Whitworth had opened a new gallery in 1908, Roberts expressed in his will doubts about the quality of care of the pictures, and in 1918 he revoked the bequest and left his whole collection of art works and antiques to the Manchester City Art Gallery.

An exhibition of some of Roberts's pictures at the Manchester Art Gallery in 1921 included an engraving by William Miller of Turner's painting of the *Grand Canal in Venice*; Edward Landseer's painting, *Bolton Abbey*; and a watercolour, *Sunset*, also by Turner.[73] These pictures can be traced in the Manchester Art Gallery catalogue, which records 42 mezzotints, 348 prints, 57 paintings, 76 watercolours and hundreds of pieces of ceramics, glassware and silver antiques. Roberts was especially interested in mezzotints, and one engraved by Valentine Green (1739–1813), *A Philosopher Shewing an Experiment on the Air Pump*, is on permanent display in the Manchester Art Gallery along with a painting of a shipwreck, *Last of the Crew*, by Clarkson Stanfield (1793–1867). Among Roberts's large collection in the art gallery store, one might highlight William Frith's (1819–1909) painting of the *Squire's Boxing Lesson* (1860), based on an incident in Oliver Goldsmith's novel, *The Vicar of Wakefield*; a pair of rare eighteenth century Kangxi blue and white vases; and the watercolour by D. G. Rossetti (1828–82), *Dante Meeting Beatrice* (**Figure 4**).[74] Even an eighteenth-century wineglass, illustrated in the Gallery Catalogue (1982), is noteworthy for the detail of its engraving.[75]

Why did Lloyd Roberts Collect?

The literature on collecting and collectors is extensive; however, it is mainly focused on museum collections and acquiring 'objects', whereas the hobby of

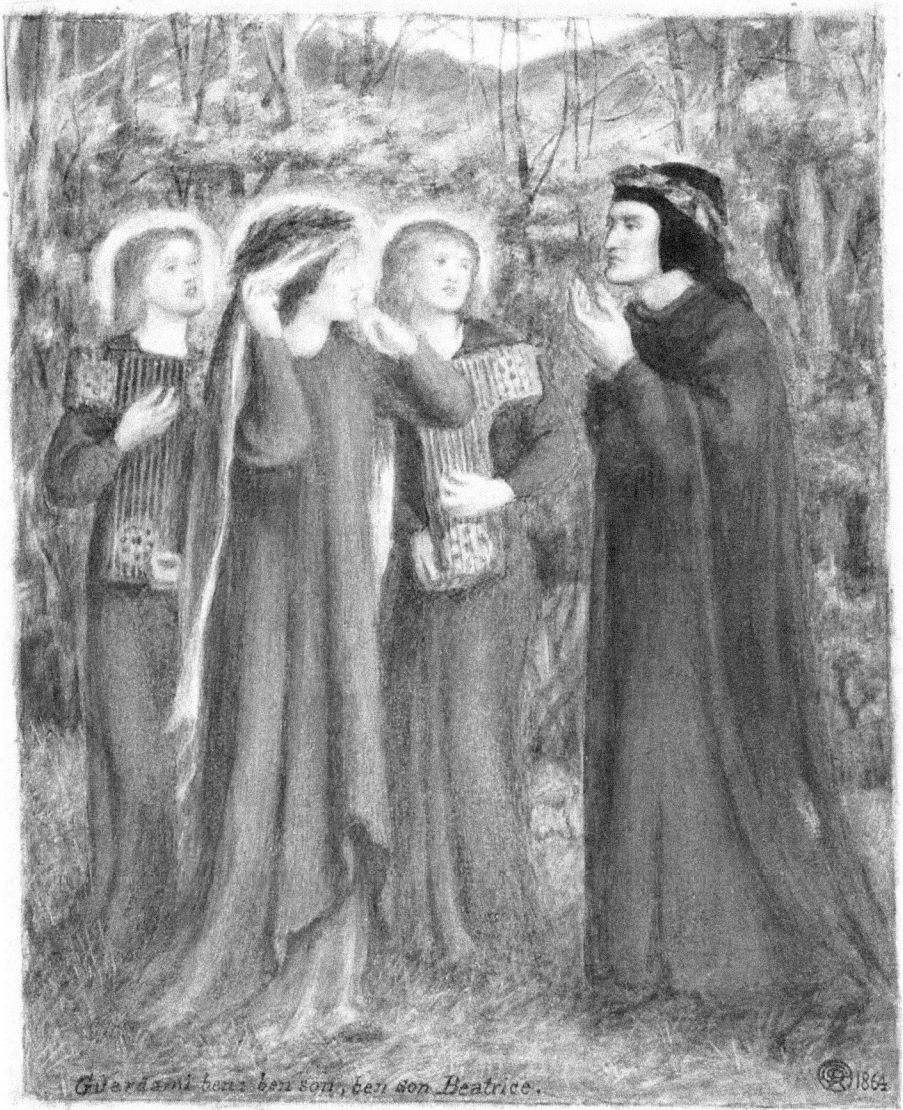

Figure 4 Watercolour, *Beatrice meeting Dante* (1853) by D. G. Rossetti (Image courtesy of Manchester Art Gallery, CC BY-SA 4.0).

book-collecting is rarely included and tends to be treated as a separate topic.[76] Even medical historian John Pickstone (1944–2014), who in *Ways of Knowing* argued that cabinets of curiosity, private collections and museums were the foundation of scientific knowledge, only briefly discussed libraries and made no mention of private book collections.[77]

David Pearson has provided a detailed analysis of the multifarious motivations of book collectors: they collect books on account of their rarity or because they see

a value in them, which may be monetary, emotional or historical. Other bibliophiles might focus on specific topics, first editions, special bindings, illustrations or previous owners.[78] William McIntosh and Brandon Schmeichel have made a study of the social and psychological motivations behind collecting; for some it is just an enjoyable hobby or a source of information and education, while others might regard their collections as an investment or a sign of wealth and social status; for a few it can become a serious obsession, 'bibliomania'.[79] Most bibliophiles only collect books or even just a specific type of book or manuscript. Roberts was a bibliophile and also an obsessive collector of antiques and pictures. He was interested in medical books, but most of his book collection was an eclectic mix in several languages, covering a wide range of subjects. He enjoyed buying books, visiting antiques shops and adding to his collection, but he may also have regarded his collections as an investment and status symbol, perhaps even a rampart against memories of his childhood poverty, and eventually as his memorial.

Roberts's eclectic collection of books and objects can be contrasted with that of his colleague, Dr Thomas Radford, whose manuscripts, books, illustrations (the 'Radford Library') and obstetric forceps were entirely devoted to the subject of obstetrics and gynaecology and used for teaching at St Mary's. The Radford Library was donated to the University of Manchester in 1927 and Radford's collection of historical obstetric forceps was transferred to the university's Museum of Medicine and Health (MMH) in 1991.[80] Dr John Wilkinson (1897–1998), a haematologist at the MRI, exemplifies the specialist collector; he built a unique collection of over 600 Delftware drug jars, now in the Thackray Medical Museum in Leeds, and although related to pharmacy, his motive for collecting was for their value as a rare type of ceramic, not for any link to his medical work.[81] Anne Hull Grundy (1926–84), a wealthy art historian, is an example of an obsessive collector who amassed a huge collection of jewellery, *netsuke*, decorative art, Martinware pottery, pictures, silver, books and medals. During the 1970s–1980s, she and her artist husband, John Hull Grundy (1907–84), dispersed the collection to several museums including the British Museum, and a selection of medically related silver antiques, medals, pictures and books were also gifted to MMH. Like Roberts, the Hull Grundys' intention was in part to find a safe home for the objects and also to memorialise their name – Anne's donations were always conditional on a printed catalogue and display signage: 'The Hull Grundy Collection'.[82]

Pearson included Lloyd Roberts in his discussion of collectors who donated their books to learned institutions and national libraries. Roberts's book collection was wide-ranging; his donation to the RCP was not focused on gynaecology and covered all aspects of medical science, herbalism and healthcare. He can be compared with other contemporary collectors: for example, John Williams (1840–1926), Professor of Obstetrics at University College, London, who donated 25,000 volumes on general topics related to Wales, to the National Library of Wales; whereas William Osler (1849–1919), Professor of Medicine at Oxford, gave 8,000 volumes devoted to the history of medicine to McGill University, Canada.[83] Perhaps the best comparison can be made with Robert Edward Hart (1878–1946), not a

medical man, but a successful Lancashire rope manufacturer who collected rare coins, manuscripts and books. His bequest to the Blackburn Library, Museum and Art Gallery in 1946 included medieval manuscripts, incunabula, books printed before 1801 and 8,000 ancient coins.[84] Few can compete with the pharmaceutical manufacturer, Sir Henry Wellcome (1853–1936), who acquired over 120,000 books for the Wellcome Library.[85] Nor should we not forget Enriqueta Rylands's generous acquisition for the JRL of thousands of books and manuscripts from the Spencer Library in 1890 and the Crawford Collection in 1901.[86] A common factor that unites these collections is 'wealth'. The great book collections of the landed gentry were amassed over generations, but when some of those families fell on hard times, they were forced to sell their libraries to wealthy collectors of the business and professional classes such as Roberts and Hart. Their libraries reflected their wealth and social status, and the content was an indication of their education and cultural interests. Each of these private libraries was unique, an eclectic mix of titles and subjects; when they were finally bequeathed to a professional library, they were in a way 'liberated', and become a valuable resource for information and research, available to everyone.

Lloyd Roberts's life was in two parts, one as a doctor and the other as a bibliophile and collector; he wanted to be remembered, but his medical work has faded, and the Lloyd Roberts Lectures ceased as the endowments were exhausted. Nevertheless, he should be celebrated for his bequest of rare books and manuscripts, a repository of knowledge for the study of the humanities and medicine.

Acknowledgements

I owe thanks to the staff of the University of Manchester Library; Anthea Darlington, St Paul's Church, Kersal; Stephanie Seville, heritage officer, University Museum of Medicine and Health; Hannah Williamson, curator of fine art, Manchester Art Gallery; and Professor Stephen Milner. Also, I am grateful to the following for help with archives and catalogues: Christine Stahl, bibliographical assistant, JRL; Katie Birkwood, librarian, RCP; Karen Pierce, librarian, Cardiff University Library; Sarah Philips, archivist, Cardiff University; Nicky Hammond, archivist, St David's, Lampeter; and Lynette Williams, archivist, Bangor University Archives.

Notes

1 Roberts is buried with his wife at St Paul's Church in Kersal, Salford. His gravestone is inscribed 'Born 28 October 1834 – died 27 September 1920'.

2 W. Brockbank, 'David Lloyd Roberts', *Honorary Medical Staff of the Manchester Royal Infirmary, 1830–1948* (Manchester: Manchester University Press, 1965), pp. 91–8; Royal College of Physicians (RCP), 'Roberts, David Lloyd', *Munk's Roll, 1826–1925*, vol. 4 (London: RCP, 1955), pp. 259–60; W. E. Fothergill, 'Obituary', *Lancet*, 9 October (1920), 766–7; Anonymous obituary, *British Medical Journal*, 2 (1920), 569; University

of Manchester Archives (UoM), GB 133 MMC/2/Roberts D/1; Obituary, *Manchester Guardian*, 29 September 1920.

3 University of Bangor Archives, 'Lloyd Roberts bequest', box 1. Two letters, 19 September and 11 October 1922, from Albert Edward Henry ('A. E. H.') Blackburn of Mottershead Chemist, 7 Exchange Street, Manchester to Major W. P. Wheldon (1897–1961), Secretary and Registrar of Bangor University.

4 T. G. B., 'David Lloyd Roberts', *Manchester University Medical Students Gazette*, 16 (1937), 104. 'T. G. B.' was Thomas Geoffrey Barlow BSc MB ChB (1939) FRCS (1915–75), consultant orthopaedic surgeon for Salford Hospitals from 1957. He had social connections in North Wales but was not related to Roberts.

5 W. Brockbank, 'Professor William Smith LSA FRCS', *Honorary Medical Staff*, note 2, pp. 29–30.

6 E. M. Brockbank, *The Foundation of Provincial Medical Education in England* (Manchester: Manchester University Press, 1936); Anonymous, *Memoir of Thomas Turner FRCS* (Manchester: J. E. Cornish, 1875).

7 V. Nutton and R. Porter (eds), *The History of Medical Education in Britain* (Amsterdam: Rodopi, 1995), pp. 229–49.

8 W. H. Challoner, *The Movement for the Extension of Owens College, 1863–73* (Manchester: Manchester University Press, 1973), pp. 1–23.

9 J. V. Pickstone, *Medicine and Industrial Society* (Manchester: Manchester University Press, 1985), pp. 10–22.

10 *Medical Directory*, 1859, Dr Roberts was living at 88, Elizabeth Street, Cheetham Hill; *Census 1861*, Roberts and his stepmother Martha Roberts, were living at 23 St John Street. Martha Roberts was entered as 'mother' and 'property owner'. He saw his private patients at no. 23 until 1882, when he moved his consulting rooms to 11 St John Street.

11 Ancestry.com, 2021, 'Selected Marriages, England', marriage certificate, 12 October 1864.

12 J. H. Young, *St Mary's Hospitals, Manchester, 1790–1963* (Edinburgh: Livingstone Ltd, 1964); J. W. Bride, *A Short History of St Mary's Hospitals, Manchester, 1790–1922* (Manchester: Sherratt & Hughes, 1922); D. L. Roberts, 'The Manchester School of Obstetrics and Gynaecology', *British Medical Journal*, 2 (1902), 377–82.

13 E. M. Brockbank, 'Charles White FRS', *Sketches of the Lives and Work of the Honorary Medical Staff of the Manchester Infirmary* (Manchester: Manchester University Press, 1904), pp. 27–65.

14 W. Page (ed.), *Victoria History of the Counties of England, Lancashire*, vol. 4 (London: University of London, 1966), p. 248. St Mary's Church, Parsonage Green, was founded in 1756 and closed in 1890.

15 Young, *St Mary's*, pp. 28–45, note 12.

16 C. W. Sutton and O. Moscucci, 'Thomas Radford LSA MRCS', *Oxford Dictionary of National Biography* (2004); UoM Archives, 133 MMM/14, 'Thomas Radford'.

17 T. Radford, *Observations on the Caesarean Section, Craniotomy, and on other Obstetric Operations* (London: Churchill, 1865 and 1880); *Census 1881*, Roberts lived at 185 Bury

New Road and Dr Radford at 187. Both men are buried at St Paul's Church in Kersal, Salford.
18 Young, *St Mary's*, p. 55, note 12.
19 P. D. Mohr, 'Charles Clay', *Oxford Dictionary of National Biography* (2004).
20 D. L. Roberts, 'On Points to be Observed in Ovariotomy', *Lancet*, 95 (1870), 190–1; D. L. Roberts, 'Twelve Cases of Ovariotomy', *Lancet*, 101 and 102 (1873), 168, 237–8, 593, 770, 416–7.
21 J. H. Young, *Caesarean Section: History and Development* (London: H. K. Lewis, 1944), pp. 81–92.
22 J. W. Bride, 'Some Manchester Pioneers in Obstetrics and Gynaecology', *Journal of Obstetrics and Gynaecology of the British Empire*, 61 (1954), 69–80.
23 D. L. Roberts, 'Preface to the first edition', *Student's Guide to the Practice of Midwifery* (London: Churchill, 1876).
24 W. Brockbank, 'Prof. Sir William Thorburn KBE MD FRCS', pp. 103–6, note 2; UoM Archives, GB 133 MMC/9/11/Southern Hospital; Mohr, 'Charles James Cullingworth LSA MRCS MD', *Oxford Dictionary of National Biography* (2004). The Southern Hospital had branches on Upper Brook Street and Clifford Street, founded 1866.
25 Roberts, *Student's Guide*, note 23 (1876, 1879, 1884).
26 Bride, 'Sir William Japp Sinclair', note 22; UoM Archives, 133 MMC/2/SinclairW. He did not join St Mary's until it had merged with the Southern Hospital in 1906.
27 UoM Archives, 133 MMC/2/RobertsDL/2/13, anonymous 'Biographical note on D. L. Roberts'; Roberts, 'The Manchester School of Obstetrics and Gynaecology', note 12.
28 Brockbank, 'David Lloyd Roberts', note 2; University of Bangor Archives, 'Lloyd Roberts bequest', box 2, lists of his shares and rents from houses he owned in Lancashire.
29 T. McGrath, '84 Plymouth Grove', *Manchester Regional History Review*, 1 (2016), 14–6; D. Duffy, 'Gaskell House blog', https://elizabethgaskellhouse.co.uk/and-weve-got-a-house-yes-we-really-have/. William Occleshaw lived at 42 Plymouth Grove and owned twenty-five houses in the area, including Gaskell House.
30 Anonymous cartoon, 'Aye Lad!', *Manchester Medical Students Gazette*, 8 (1908), 70. His monaural stethoscope is in the University of Manchester Museum of Medicine and Health (MMH).
31 Fothergill, 'Obituary', note 2.
32 'St Mary's Hospital: the proposed new buildings', *Manchester Guardian*, 7 April 1891. The building of the new hospital started in 1901 on 'Gloucester Street', which was renamed 'Whitworth Street' in 1904.
33 For details of the two new St Mary's hospitals, see Young, *St Mary's*, note 12, pp. 66–88. 'High Street' was renamed 'Hathersage Road'. Both hospitals were replaced in 1970 by a new building along Hathersage Road, which in turn was demolished and replaced in 2009 by the present St Mary's Hospital, part of the Manchester University NHS Foundation Trust hospitals complex.
34 Fothergill, 'Obituary', note 2; W. Brockbank, 'David Lloyd Roberts', note 2, pp. 96–7. William Fothergill MA BSc MB CM MD, Manchester Professor of Gynaecology & Obstetrics (1920–26).

35 Anonymous 'Obituary', note 2.
36 Probate Registry, 'Will of David Lloyd Roberts', 31 January 1921.
37 Manchester Archives Local Studies, M496, Parish records, 1889–1954. St David's was founded in 1898 on Lime Grove, near to the Medical School on Coupland Street. During the 1950s the church building was part of the Students Union, until it was demolished c.1960.
38 UoM Archives, GB 133 MMC/6/1. The Lloyd Roberts Lectures were held in various medical institutions and hospitals in Manchester and London during 1921–53 and were usually published in one of the medical journals.
39 Anonymous, 'Lloyd Roberts: A Retrospect', *Lancet*, 258 (1951), 1172–3. In 1921, the Cardiff University Medical School became the Welsh National School of Medicine.
40 University of Wales Lampeter Archives, GB 1953 UWL; N. Hammond, archivist, Trinity St David's, personal communication, 1 June 2021. Ms Hammond noted that Roberts made two donations of £2,000 to fund scholarships c.1920. The college is now Trinity St David's and joined the University of Wales in 1971.
41 Mr David Roberts, former registrar of Bangor University, personal communication, 9 May 2021. The amount donated in 1908 is not recorded. Mr Roberts estimated the total endowment at £26,000, but this might be confused with the residual estate; L. Williams, archivist, Bangor University, personal communication, 14 May 2021, thought the residual estate was about £20,000.
42 University of Bangor Archives, 'Lloyd Roberts bequest', note 3.
43 UoM Archives, MMC/2/RobertsDL/1/13, biographical note.
44 H. Guppy, *The John Rylands Library: A Record of its History, 1899–1924* (Manchester: The University Press, Manchester, 1924), p. 116; F. Taylor and W. G. Simpson, *The John Rylands University Library* (Manchester: booklet, University of Manchester, 1982). Henry Guppy MA DPhil was librarian for 48 years. The JRL merged with the University Library in 1972.
45 UoM archives, MMC/2/RobertsDL/1/25, N. Moore, 'Report of the RCP Library Committee', 4 July 1921. The report gives the number of books as '1,850', corrected by hand to '1,857'.
46 JRL Accession Register 952, pp. 50–264; C. Stahl, Bibliographical Assistant, JRL, personal communication, 6 June 2021.
47 R. Mead, *Pharmacopoeia Meadiana: faithfully gathered from original prescriptions, containing the most elegant methods of cure in diseases. To which are annexed, useful observations upon each prescription* (London: printed for John Hinton, at the King's-Arms, in Newgate-street, 1756 (Manchester, JRL, R51450.5)); S. Garth, *The Dispensary: A poem* (London: printed and sold by John Nutt, near Stationers-Hall, 1699 (Manchester, JRL R51023)).
48 J. Dryden, *Absalom and Achitophel: A poem* (London: printed by H. Hills, in Blackfryars, near the Water-side, for the benefit of the poor, 1708 (Manchester, JRL, R51030.5)); B. Quaritch, *Examples of the Art of Book-Illumination during the Middle Ages: Reproduced in Facsimile* (London: Bernard Quaritch, Piccadilly, 1889–92 (Manchester, JRL, R51696)).

49 H. Plat, *Delights for ladies: to adorne their persons, tables, closets, and distillatories with beauties, banquets, perfumes, and waters* (London: Printed by R. Young, sold by James Boler, 1632 (Manchester, JRL, R49742.1))).

50 *Scriptores rei rusticae*, ed. Philippus Beroaldus (Reggio Emilia: Franciscus de Mazalibus, 20 November 1499), ISTC is00350000; GW M41062 (Manchester, JRL, R51626); Antonius Rampegolus, *Compendium morale* (Augsburg: SS Ulrich and Afra, not after 1473), ISTC ir00022000; GW M36990 (Manchester, JRL, R51625).

51 D. Pearson, 'Private Libraries and Collecting Instinct', in A. Black and P. Hoare (eds), *Cambridge History of Libraries in Britain and Ireland*, vol. 3 (Cambridge: Cambridge University Press, 2006), pp. 180–202.

52 C. Warr, 'A Series of Fifty-Four Clever Drawings on Vellum: Monstrous Births in Italian MS 63', *Bulletin of the John Rylands Library*, 91 (2015), 57–80.

53 T. Browne, *Religio Medici and other essays*, edited by D. Lloyd Roberts (London: David Stott, 1892); revised editions (London: Smith Elder & Co., 1898) and (Manchester: Sherratt and Hughes, 1902). For Browne's short biography, see 1898 edition, pp. ix–xxv and list of older editions, p. xxxvi.

54 A. B. Shaw, 'Sir Thomas Browne: The Man and the Physician', *British Medical Journal*, 285 (1982), 40–2; F. L. Huntley, ' "Well Sir Thomas?": Oration to Commemorate the Tercentenary of the Death of Sir Thomas Browne', *British Medical Journal*, 285 (1982), 43–7.

55 S. Wilkin (ed.), *T. Brown, Sir Thomas Browne's Works: Including his Life and Correspondence* (London: W. Pickering, 1835).

56 T. Browne, *Christian Morals*, with a life of the author by Samuel Johnson (London: printed by Richard Hett, Pater-Noster Row, 1756); T. Browne and H. Gardiner (ed.), *Religio Medici: together with a letter to a friend on the death of his intimate friend and Christian morals* (London: William Pickering, 1845); T. Browne, *Hydriotaphia, Urneburiall: A discourse of the sepulchrall urnes lately found in Norfolk* (London: printed for Hen. Brome at the signe of the Gun in Ivy-lane, 1658).

57 S. Wilkin, 'T. Brown', note 55. *On Dreams* (undated) by Browne was a manuscript in the Sloane Collection 174, fos 112–20, first published by Wilkin in 1835.

58 UoM Archives, MMC/2/RobertsDL/1/4, 5 and 6. Three postcards to his wife from Florence, Cortona and Genoa, September 1883.

59 D. L. Roberts, *The Scientific Knowledge of Dante. A lecture delivered at the University of Manchester before the members of the Manchester Dante Society* (Manchester: University Press, 1914).

60 S. J. Milner, 'Manufacturing the Renaissance: Modern Princes and the Origins of the Manchester Dante Society', in J. Wolff and M. Savage (eds), *Culture in Manchester: Institutions and Urban Change since 1850* (Manchester: Manchester University Press, 2013), pp. 61–94; S. J. Milner, personal communication, 27 July 2021.

61 Roberts's copies were: D. Alighieri, *La Divina commedia*, 2 vols (London: W. Pickering, 1822–23); *La Comedie de Dante, De L'enfer, du Purgatoire et Paradis* (Paris: Jehan Gesselin, 1597); *La Comedia di Dante Aligieri con la noua epositione di Alessandro Vellutello* (Venice: Francesco Marcolini, 1544), two copies.

62 P. Bondanella, 'Introduction and notes', in D. Alighieri, *The Inferno*, translated by H. W. Longfellow (New York: Barnes & Noble Classics, 2003); D. Alighieri, *The Divine Comedy*, translated by C. H. Sisson, with an introduction and notes by D. H. Higgins (Oxford: Oxford University Press, 1998).

63 E. Moore, *Studies in Dante*, 3rd series (Oxford: Clarendon Press, 1903) pp. 1–143; P. Fughelli, 'Bolognese Medicine During the Time of Dante', *Medicina Historica*, 1 (2017), 77–83; for Dante's education, see A. Barbero, translated and edited by A. Cameron, *Dante* (London: Profile Books, 2021), pp. 95–104.

64 M. A. Riva, L. Cambioli et al., 'Dante and Cardiology: Physiopathology and Clinical Features of Cardiovascular Disease in the Middle Ages', *International Journal of Cardiology*, 181 (2015), 317–19; M. A. Riva, I. Bellani et al., 'The Neurologist in Dante's *Inferno*', *European Neurology*, 73 (2015), 278–82; L. Roffi, 'Dante's Medical Knowledge: The Case of the *Inferno* Canto XXX', *Advances in Historical Studies*, 7 (2018), 15–21.

65 Roberts, *Scientific Knowledge*, note 59, p. 28.

66 I. Isherwood and P. D. Mohr, *Medical Men and Medical Science: History of the Library of the Manchester Medical Society 1834–1998* (Manchester: Portico Library Monograph 22, 2000). The MMS transferred ownership of the medical books to the university in 1930. The Coupland Street Medical School Library was run down 1968–77; the books were transferred to the main University Library, the Stopford Medical Library and the JRL.

67 Royal College of Physicians, 'Roberts, David Lloyd', *Munk's Roll*, 4 (1955), pp. 259–60.

68 N. Moore, 'Report of the RCP Library Committee', 4 July 1921, note 45.

69 K. Birkwood, RCP special collections librarian, personal communication, 11 May 2021; G. Davenport, I. McDonald, C. Moss-Gibbons (eds), *Royal College of Physicians and its Collections* (London: James & James, 2001). p. 77.

70 A. Cornelius Celsus, *Medicine libri octo noviter emendati* (Lyon: S. Bevelaqua, 1516), RCP, shelf-mark D2/60-h-12; Thomas Brian, *The pisse-prophet or certaine pisse-pot lectures: Wherein are newly discovered the old fallacies, deceit, and jugling of the pisse-pot science, used by all those (whether quacks and empiricks, or other methodicall physicians) who pretend knowledge of diseases, by the urine, in giving judgement of the same* (London: printed by E. Purslowe for R. Thrale, 1637), RCP, shelf-mark D2/60-d-13.

71 Royal College of Physicians, MS 45 (*De medicina libri octo* of Aurelianus Cornelius Celsus, dated 1451); MS 654, Sarah Wigges, *Hir booke. Live wel, dye never. Dye wel, live ever* (dated 1616).

72 K. Pearce, cataloguing librarian, University of Cardiff Library, personal communications, 7 June and 28 June 2021; J. B. van Helmont, *A ternary of paradoxes: The magnetick cure of wounds. Nativity of tartar in wine. Image of God in man* (London: printed by James Flesher for William Lee, Fleet Street, at the sign of the Turk's head, 1649).

73 UoM Archives, 133 MMC/2/RobertsLD/1/26, J. P. Todd and H. Lawrence, Report, 'City of Manchester Art Gallery, paintings and drawings in David Lloyd Roberts bequest', Autumn 1921.

74 H. Williamson, curator of fine arts, Manchester Art Gallery, personal communication, 17 March 2021. I am grateful to Hannah Williamson for a digital copy of Roberts'

objects in the Gallery's catalogue, 1920.158 to 1920.1353, and a tour of the items in store.

75 *A Century of Collecting, 1882–1982: Manchester City Art Galleries* (1982), 'Lloyd Roberts bequest' engraved wine glass (*c*.1775), p. 84.

76 For example, J. Elsner and R. Cardinal, *The Culture of Collecting* (London: Reaktion Books, 1994); S. M. Pearce, *On Collecting* (Oxford: Routledge, 2003); A. Shelton (ed.), *Collectors* (London: Horniman Museum, 2001); S. J. M. M. Alberti, 'Shaping Scientific Instrument Collections', *Journal of the History of Collections*, 31 (2019), 445–52.

77 J. V. Pickstone, *Ways of Knowing* (Manchester: Manchester University Press, 2000), pp. 79, 127–8.

78 Pearson, 'Private Libraries', note 51.

79 W. D. McIntosh and B. Schmeichel, 'Collectors and Collecting: A Social Psychological Perspective', *Leisure Sciences*, 26 (2004), 85–97.

80 P. D. Mohr and W. Jackson, 'University of Manchester Medical School Museum', *Bulletin of the John Rylands Library*, 87 (2005), 209–23.

81 B. Hudson, *English Delftware Drug Jars* (London: Pharmaceutical Press, 2006), pp. 17, 22, 30, 34; Royal College of Physicians, 'John F. Wilkinson MD FRCP DSc', *Munk's Roll*, 11 (1998), 623.

82 P. D. Mohr and S. Seville, 'The Hull Grundy Collection in the Museum of Medicine and Health, University of Manchester', *Journal of the History of Collections*, 33 (2021), 287–96.

83 Pearson, 'Private Libraries', note 51, pp. 191–2.

84 C. Johnston (ed.), *A British Book Collector, Rare Books and Manuscripts in the R. E. Hart Collection* (London: University of London Press, 2021), pp. 1–21.

85 R. R. James, *Henry Wellcome* (London: Hodder & Stoughton, 1994), pp. 363–4, 383–4.

86 D. A. Farnie, 'Enriqueta Augustina Rylands (1843–1908), Founder of the John Rylands Library', *Bulletin of the John Rylands Library*, 71 (1989), 3–38.

'Manchester Men?'

EMILY JONES, UNIVERSITY OF MANCHESTER

Caroline M. Barron and Joel T. Rosenthal, eds, *Thomas Frederick Tout (1855–1929): Refashioning History for the Twentieth Century* (London: University of London Press, 2019)

D. W. Hayton, *Conservative Revolutionary: The Lives of Lewis Namier* (Manchester: Manchester University Press, 2019)

One of the first research seminars I ever attended, as a fresh-faced Masters student working on the posthumous reception of Edmund Burke, was on the framing of the then-latest volume of the History of Parliament, which took the project from the Great Reform Act of 1832 to the aftermath of the Second Reform Act and the commencement of Gladstone's first administration in 1868. I was new to Oxford, having arrived straight from my undergraduate degree at Manchester and a history degree there that, I would learn, had long since renounced the sort of political and constitutional history that still lingered in the 'British' papers of my new institutional home. It was also at this seminar that I first encountered the legacy of that bygone leading light of the Manchester History Department, Lewis Namier (1888–1960). Namier was a figure who would lurk in the background of my thesis (eventually my first book) as a kind of anti-history in the story of Burke's transformation into the 'founder of modern conservatism' in the 150 years after his death in 1797. In retaining its focus on individual biographies, why, the speaker was pressed, was the framing of the History of Parliament still proceeding along 'Namierite' lines?

Most thinker-adjectives are highly reductive, and 'Namierite' is no exception; suggesting a distinctive approach to politics that focuses on the worlds of elite individuals, in which ideas and principles are unimportant if our task is to understand the motives and actions of these principal actors. As David Hayton's evocative biography attests, one of Namier's chief targets in his work on eighteenth-century politics was indeed to unseat the unscholarly 'whig' history that looked romantically to earlier periods to identify clear party differences based on principles and connections, or nefarious monarchical intentions based on evidence such as Burke's political writings – an attack that even extended to the writing of other critics of the whig interpretation such as Herbert Butterfield, who would prove to be a lifelong 'enemy'.[1] But Namier's approach was more nuanced than the popular characterisation would suggest, and Hayton variously demonstrates the ways in which his writing on European affairs and history adopted a rather different tone

and argument, in which the ideas of intellectuals or even 'public opinion' could indeed be realised.[2] At the same time, however, we see how Namier himself was no stranger to so-called 'whig' thinking, whether we see this in terms of his veneration of the British or 'English' constitutional and political system, or in the more general terms that Butterfield would later use to define it (i.e. as present-minded, such as in his later work on Germany, the rise of the Nazis, and his long-standing Zionism and keenness to draw 'lessons from history').[3]

T. F. Tout (1855–1929), meanwhile, was obliquely familiar to me, thanks to the undergraduate prize bearing his name. The edited collection presented by Caroline Barron and Joel Rosenthal, which cleverly places both modern and medieval historians in conversation alongside the more personal recollections of Tout's grandson, reveals similar concerns with regards to Tout's historical work, this time with regard to his portrayal of the reigns of the first three Edwards and the relevance of a framework of two-party politics to this period.[4] The supposed 'whiggism' of Tout becomes – to the contributors in sections 2 and 3 of the volume in particular – a central focus for his rescue or condemnation. As the 'heir' of the great late-nineteenth-century constitutional historian Bishop William Stubbs, Tout's work was often caricatured as being overly simplistic in its interpretation of, for example, the role and character of the nobility or his theory of the existence of a 'middle' party.[5] Tout met his 'Namier', however, in the form of K. B. McFarlane, whose scholarship, combined with that of McFarlane's pupils, sought to explode the evolutionary constitutionalism of earlier histories, as well as the approach (associated with Tout) to medieval administrative history that took nineteenth-century bureaucracy and the modern civil service as its model.[6] But Tout, as Seymour Phillips's chapter argues, was nonetheless a great scholar who suffered the misfortune of going out of fashion.[7] Although Tout's reputation was thus subsumed within a broader 'whig' tradition by later historians, rather than earning his own moniker (Toutite?), he and Namier perhaps share a claim to being less often read than cited.[8] Indeed, the final, excellent, chapter of Hayton's biography charts the rapid descent of Namier's reputation in the years following his death as historians of seventeenth- and eighteenth-century Britain reaffirmed the importance of party based on 'connections' and, more broadly, the power of ideas and principles to act as motive forces in politics. It was at this point that the negative implications of the verb 'to Namierise' were most stark, and the term 'Namierite' became pejorative.[9] 'Who now reads Bolingbroke?' Burke once asked in his *Reflections on the Revolution in France* (1790), 'who ever read him through?'

This gets us back to that first seminar in Oxford. In fact, taking both volumes together revealed the strong and lifelong connections to Oxford (and Balliol College in particular) that both Namier and Tout shared, as well as to historical institutions that were establishing themselves on firmer ground over the first half of the twentieth century, such as the Institute for Historical Research, the British Academy, and the Dictionary of National Biography (DNB). In Namier's case, this is also a story of institutional anti-Semitism.[10] The great merit of these studies, however, is the skill and care taken in guiding the reader through the forest of thorns now

grown around their respective sleeping beauties. The seemingly boundless energy of each historian detailed vividly in each account also demonstrates that their period of slumber was at least very well deserved: in addition to institutional and, for Namier, political commitments, their individual literary output was phenomenal. In Tout's first year at Manchester in 1891, for instance, he produced fourteen biographies for the DNB, a textbook for Macmillan and two reviews – one for the newly founded *English Historical Review*, the other for the *Manchester Guardian*.[11] It took 130 people to revise or replace Tout's entries, written in his spare time between 1885 and 1900, for the 2004 edition of the DNB.[12] A cash-strapped Namier, in the winter of 1920–21, could be found teaching as many as forty-five tutorial pupils, but he was similarly overburdened later in life when his position was more secure: the litany of reviews, second editions, History of Parliament biographies, and other promised projects plagued Namier in his final years.[13] Both complained of the strain of their written work, although while Tout's prose was considered graceless in comparison to his predecessors, especially the constitutional histories of F. W. Maitland, Namier's style was widely admired for its vibrance and ferocity.[14] His fearless reviews, in particular, attracted a great deal of attention both positive and negative, some of which would come back to haunt him.[15]

In a more localised setting, Tout and Namier are now lauded as former titans of the Manchester History Department, to which I returned as a lecturer in 2018. Yet their relationship with both the city and the university could not have been more different. For Tout, inspired by the philosophical idealism associated with T. H. Green, Benjamin Jowett and late nineteenth-century Balliol more broadly, the move to Manchester entailed a much fuller immersion in the intellectual and social life of the city. It followed teaching posts at other budding civic colleges, such as St David's, Lampeter, where Tout taught a broad range of topics – history, English literature, political economy – and developed significant and long-lasting friendships in a manner that mirrored many of his Balliol contemporaries who went on to significant roles in other fledgling civic universities, such as C. E. Vaughan, who moved from Cardiff, to Newcastle, to Leeds, and retired to Tout's Manchester to complete his work on Rousseau and the history of Romanticism.[16]

Tout's life in Manchester was no less embedded than in Lampeter, where he served as an alderman.[17] He was committed to adult education, most notably in his work for the Workers' Educational Association (WEA) and the Historical Association, as well as social work and efforts to connect the university to the city via the Manchester University Settlement in Ancoats. His efforts within the university were also expansive, and not confined to the workings of the History Department alone: founding and chairing Manchester University Press, for example, and in the fight for an independent university charter.[18] As Stuart Jones's chapter demonstrates, Tout's vision helped to establish the notion of a civic university with a civic mission; not merely 'a university *in* Manchester' but '*the* University *of* Manchester' – 'the embodiment and representative of the intellectual life of that city'.[19] The Touts took this responsibility seriously and established themselves as an impressively academic (and historically minded) family: Tout's wife, Mary, was a

former student who wrote for the DNB and her sister, Hilda Johnstone, was another Manchester historian. A daughter, Margaret, made what now may seem an unusual move in choosing her father as a PhD supervisor, and went on to work at the Queen Mary University of London and at Bristol.[20] Margaret's son, in turn, went down to Oxford to read for his History BA in 1951.[21]

Tout's role in 'fashioning' the Manchester History Department as distinctive in its focus on research, in contrast to the ancient universities of Oxford and Cambridge, is well known.[22] What emerges from essays on Tout's teaching, his idea of a university, and his relationships with staff and students is a more holistic presentation of Tout's History Department. As a teacher, he believed the 'special subject' and historical research training helped students of all abilities develop 'principles of research and criticism', while overturning what he felt to be a false dichotomy between teaching general historical knowledge and training in historical research methods – 'knowledge', therefore, as opposed to cramming or 'memory work'.[23] As a colleague, Tout was significantly involved in departmental administration, and insisted on women students and staff having the same opportunities as men.[24] Promoting the advancement of women was a notable product of his presidency of the Royal Historical Society, and Tout had previously criticised Cambridge for its treatment of female scholars.[25] Publications such the 1902 volume *Historical Essays by Members of the Owens College, Manchester*, co-edited by Tout and James Tait, trumpeted the achievements of both editors in 'combining the scholarship of Manchester veterans with that of Manchester students ... becoming research historians'.[26] Despite, therefore, a personal reputation for being cautious and measured, his affection for and sincere relationships with his students were demonstrated in particular through the letters from students that Tout received during the First World War which, as Chris Godden's chapter reveals, convey the 'enormous respect they had for their teacher' and the emotional and practical support Tout provided for students away from home.[27] His leading role in completing Mark Hovell's work on Chartism – a topic far beyond Tout's usual remit – after Hovell died in combat in August 1916 provides a further example. Tout's moving memoir of Hovell, included in the final published text, expressed Tout's sense of loss for not only a promising historical talent, but a good friend.[28]

In contrast, Namier was always searching for an 'escape' from Manchester, where he never permanently settled – preferably to Oxford, despite the prejudice and rejection he had encountered in certain quarters.[29] London, or the country houses of his many aristocratic friends (most importantly his close friend and long-term ally Blanche 'Baffy' Dugdale, a fellow Zionist and Balfour's niece), were also good alternatives even if they did not come with a university position attached.[30] Manchester, to Namier, was a dull, dark city – moist, not rainy.[31] The History Department was less hierarchical than in Tout's day, though still proud of the distinctive reputation he had earned for it. Namier joined a department which, in 1937, boasted seven lecturers, of which the 'assistant lecturers' acted as 'literally the professor's assistant'. Namier thus took it upon himself to mentor his junior, a young A. J. P. Taylor, by encouraging him to write consistently and

introducing Taylor to a publisher and his contacts at the *Manchester Guardian*.[32] This personal mentorship was indeed admirable, and was both genuine and extended to many other younger historians whom he treated as intellectual equals, yet Taylor would eventually paint Namier as a sort of nightmare colleague who taught only subjects he was familiar with, had no time for first years, and shirked necessary administration including marking.[33] This would later become a classic Oxford view of Namier: 'a tyrannical monomaniac who neglected undergraduates in pursuit of his own ambition'.[34] Hayton, however, argues that the records of Manchester Faculty meetings suggest that a more nuanced interpretation is needed. Accordingly, though Namier did indeed have both a healthy dislike of routine university administration and an unusual teaching philosophy, which centred on the brightest who could be 'trained in the techniques of research', and perhaps self-indulgently pushed students into topics that he was himself concerned with, he nonetheless taught a broad range of subjects and participated in undergraduate examinations – albeit in a characteristically idiosyncratic and bombastic manner; a load which only increased as time went on, thanks to growing student numbers following the end of the war in 1945.[35]

Yet even Hayton admits that, by the late 1940s, Namier 'did very little administration, taught none of the labour-intensive first year courses, and in his second-year survey lectures and third-year special subject taught what he liked, and what he knew'.[36] Likewise, while Namier's sights often lay further abroad – to Israel, Palestine, Germany, Poland and the rest of eastern Europe – at least initially, he threw himself into Manchester's social and intellectual life, attending university seminars, speaking to regional historical societies, and dining with local notables. Eventually, Namier's Manchester life combined his work and international interests, encompassing a range of activities for Manchester's numerous Jewish associations and acting as president of the university students' Zionist society.[37]

In fact, despite the university's apparent pride in 'not being Oxford or Cambridge' identified by Taylor, when we take these two studies together a significant connection emerges between Manchester and Oxford beyond Tout and Namier alone.[38] Far more lecturers and chairs, at least in the History Department, seem to have come from Oxford than any other institution, and promising students and researchers were in turn sent for lectureships and other positions at Oxford, including two Tout-trained regius professors (F. M. Powicke and V. H. Galbraith). The early chapters of the Tout volume also make frequent comparisons with his former Balliol colleague and latterly regius professor at Oxford, C. H. Firth.[39] There was snobbery at play here, of course – for Hugh Trevor-Roper, the research-focused approach of the Manchester History school was 'boring'.[40] Meanwhile, to Taylor the PhD was 'provincial' and unnecessary, a sentiment that lasted well into the twentieth century.[41] As my own DPhil supervisor can attest, the lack of a completed doctoral thesis was no bar to a permanent position in early 1980s Oxford, nor in many other UK universities at that time.

Although Tout's 'Manchester school' emphasised administrative history and research training in a way that the Oxford History Faculty did not, the centrality of constitutional and political history to the major historical protagonists of the first half of the twentieth century is also undeniable. We need to look elsewhere, however, to get more of a feel for the growth of the economic and social history – Toynbee, Tawney, the Hammonds – that challenged the primacy of constitutional and political history. These were not mutually exclusive endeavours, however, as seen in G. M. Young's British Academy lecture on Burke, published in 1943, which advocated for the wider application of Namier's fine-grained research method to less obviously political historical topics. Young, another Balliol product whose wildly successful *Victorian England: Portrait of an Age* (1936) had argued that the true turning point in nineteenth-century history was the 1847 Factory Act, told his audience how, fifteen years earlier, Namier 'showed us, or reminded us, how little we really knew of the minute anatomy of political England in the days when the Burkes were speculating in East India Stock'.[42] What was still missing, however, was 'an equally exact analysis of that unknown world east of Temple Bar. As we go from Westminster to the City, the air grows thicker and murkier. What are the names we faintly read above the counting houses, and what dark gigantic transactions are conducted within them?'[43]

Both Hayton's brilliantly readable, impressively comprehensive biography and Barron and Rosenthal's inclusive, ambitious volume significantly advance our understanding of the lives of two often misremembered 'Manchester [History] men'. Biographical approaches that centre leading professors, then, take us so far. But that really depends on what questions we are asking and who or what we think matters in writing university histories, or indeed histories of history. Immersive studies into famous and significant male professors – particularly when read together – can challenge common caricatures or simplifications of each figure's work and immerse the reader in the complexity of intellectual and institutional lives, as well as the relationship between universities and the outside world. The individual or biographical approach helps us to see, for instance, how fundamental research and support was provided to Tout by his family, his students, and junior colleagues: Dorothy Broome, for example, who set aside much of her own work to help bring the *Chapters of Administrative History* to completion; his wife, Mary, together with James Tait and Hilda Johnstone, also helped to complete *Chapters* after Tout's death in 1929.[44] Towards the end of his life Namier, too, realised that collaboration and group work would be essential to realising the vastness of historical research in need of urgent attention.[45] The help and guidance of 'Baffy' Dugdale, as well as his second wife Julia, were equally significant intellectual, financial and personal pillars in Namier's life and afterlife.[46]

But we catch only glimpses of other aspects of university life that deserve to be more fully explored: the gendered experiences of staff and students, for example, support networks such as those discussed here, or university life in general. Mary Tout, for example, founded the Manchester Women's Union in 1900, which sought to bring past and present alumna together, including faculty wives.[47] One

Manchester History Society social event in 1906 saw the women making dinner for their male peers.[48] If (T. F.) Tout had asked 'what is a university for?', others, as Emily Rutherford's recent work shows, were increasingly posing a slightly different question, a question which resonates with us today living and working in the context of the marketisation of higher education and debates over student fees and the university 'experience': what did it mean to be a student? As I read each book, there were still flashes of recognition for people like myself who have shifted variously between Manchester and Oxford, especially as both a student and a lecturer: expectations, snobberies, pressures, and prejudices. One 'lesson' I will certainly be taking from Namier in particular, however, is that I, too, shall be thanking all future hosts with copies of my own book about Burke.[49]

Notes

1 D. W. Hayton, *Conservative Revolutionary: The Lives of Lewis Namier* (Manchester: Manchester University Press, 2019), pp. 63, 134, 366–75. For a concise definition of Whig history, see P. R. Ghosh, 'Whig Interpretation of History', in K. Boyd (ed.), *Encyclopedia of Historians and Historical Writing* (New York: Routledge, 1999).
2 Hayton, *Namier*, pp. 105, 178, 194, 257, 284–5.
3 *Ibid.*, pp. 282, 287, 292.
4 See the chapters by Phillips, Hamilton, Dryburgh, Raven, Barratt, McEwan and Biggs in Caroline M. Barron and Joel T. Rosenthal (eds), *Thomas Frederick Tout (1855–1929): Refashioning History for the Twentieth Century* (London: University of London Press, 2019).
5 Henry Summerson, 'T. F. Tout and the Dictionary of National Biography', in Barron and Rosenthal (eds), *Tout*, p. 242.
6 Matt Raven, 'Tout and the Higher Nobility Under the Three Edwards', in Barron and Rosenthal (eds), *Tout*, p. 164; Elizabeth Biggs, 'Tout's Administrators: The Case of William Moulsoe', in Barron and Rosenthal (eds), *Tout*, pp. 200, 211. For more on Stubbs and Victorian constitutional histories, the classic text is J. W. Burrow, *A Liberal Descent: Victorian Historians and the English Past* (Cambridge: Cambridge University Press, 1981), which the more recent work by James Kirby, *Historians and the Church of England: Religion and Historical Scholarship, 1870–1920* (Oxford: Oxford University Press, 2016) challenges and builds upon.
7 Seymour Phillips, 'Tout and the Reign of Edward II', in Barron and Rosenthal (eds), *Tout*, p. 121.
8 Raven, 'Tout and the Higher Nobility', p. 153.
9 Hayton, *Namier*, pp. 396, 398.
10 *Ibid.*, pp. 31–2.
11 John D. Milner and Dorothy Clayton, 'Tout's Work as a Reviewer', in Barron and Rosenthal (eds), *Tout*, p. 250.
12 Summerson, 'Tout and the *DNB*', p. 232.
13 Hayton, *Namier*, p. 135.

14 Phillips, 'Tout and Edward II', pp. 117–18; Summerson, 'Tout and the *DNB*', p. 235.
15 Hayton, *Namier*, p. 294.
16 Ralph Griffiths, 'The Early Years and Wales's History', in Barron and Rosenthal (eds), *Tout*, pp. 12, 14. For more on Vaughan, see E. Jones, *Edmund Burke and the Invention of Modern Conservatism, 1830–1914: An Intellectual History* (Oxford: Oxford University Press, 2017), pp. 198–9, 205–6, 216–17.
17 William Gibson, 'Thomas Frederick Tout at Lampeter: the Making of a Historian', in Barron and Rosenthal (eds), *Tout*, p. 37.
18 Dorothy Clayton, 'Tout and Manchester University Press', in Barron and Rosenthal (eds), *Tout*, p. 57; H. S. Jones, 'T. F. Tout and the Idea of the University', in Barron and Rosenthal (eds), *Tout*, pp. 81–3.
19 Jones, 'Tout and the Idea of the University', p. 83.
20 Joel Rosenthal, 'The Homage Volume of 1925 – Looking Back and Looking Forward', in Barron and Rosenthal (eds), *Tout*, p. 277; Tom Sharp, 'Reflections on my Grandfather, the Historian T. F. Tout', in Barron and Rosenthal (eds), *Tout*, pp. 297, 303–5.
21 Sharp, 'Reflections on my Grandfather', p. 297.
22 Peter Slee, *Learning and a Liberal Education: The Study of Modern History in the Universities of Oxford, Cambridge and Manchester, 1800–1914* (Manchester: Manchester University Press, 1986); William Whyte, *Redbrick: A Social and Architectural History of Britain's Civic Universities* (Oxford: Oxford University Press, 2015).
23 Peter Slee, 'The Manchester School of History: Tout's Contribution to the Pedagogy of Academic History, in Barron and Rosenthal (eds), *Tout*, pp. 48, 51–2.
24 Sharp, 'Reflection on my Grandfather', p. 303.
25 Ian d'Alton, 'Institutionalizing History: T. F. Tout's Involvement with the Royal Historical Society and the Historical Association', in Barron and Rosenthal (eds), *Tout*, p. 224; Milner and Clayton, 'Tout's Work as a Reviewer', p. 254.
26 Rosenthal, 'The Homage Volume of 1925', p. 284.
27 Slee, 'The Manchester School of History', p. 49; Christopher Godden, ' "Dear Professor Tout . . .": Letters from Tout's Students during the First World War', in Barron and Rosenthal (eds), *Tout*, pp. 98, 101–2.
28 Clayton, 'Tout and Manchester University Press', p. 65. See also the special issue on Hovell's life and work: *Bulletin of the John Rylands Library*, 94 (2018).
29 Hayton, *Namier*, pp. 232, 293–5, 309, 365.
30 *Ibid.*, p. 333.
31 *Ibid.*, p. 210.
32 *Ibid.*, p. 213.
33 *Ibid.*, pp. 309–10.
34 *Ibid.*, p. 309.
35 *Ibid.*, pp. 216, 215, 293.
36 *Ibid.*, p. 309.
37 *Ibid.*, p. 216.
38 *Ibid.*, p. 212.

39 Slee, 'The Manchester School of History', pp. 41, 49; Jones, 'Tout and the Idea of the University', p. 76.
40 d'Alton, 'Institutionalizing History', p. 228.
41 Clayton, 'Tout and Manchester University Press', p. 69.
42 G. M. Young, *Victorian England: Portrait of an Age*, 2nd edn (Oxford: Oxford University Press, 1953), p. 47.
43 G. M. Young, *Burke: British Academy Annual Lecture on a Master Mind* (Oxford: Oxford University Press, 1943), pp. 14–15.
44 Biggs, 'Tout's Administrators', p. 201. See also d'Alton, 'Institutionalizing History', p. 227, for Johnstone's collaborative work with Tout; she 'in fact did the bulk of the work' on *State Trials of the Reign of Edward I, 1289–93* (London, 1906).
45 Hayton, *Namier*, pp. 220, 334–5.
46 *Ibid.*, pp. 149, 161–2, 194–5, 393–4.
47 E. Rutherford, 'The Politics and Culture of Gender in British Universities, 1860–1935' (unpublished PhD dissertation, Columbia University, 2020), p. 164.
48 Rutherford, 'Gender in British Universities', p. 179.
49 Hayton, *Namier*, p. 333.

The Mammal Thing: Jeff Nuttall and Visceral Intelligence

TIMOTHY EMLYN JONES, BURREN COLLEGE OF ART

Abstract
Celebrated as a leader of London's 'Underground' in the 1960–70s, and a leading British poet and performance artist of his time, Jeff Nuttall found fame through his critique of post-nuclear culture, *Bomb Culture*, which provided an influential rationale for artistic practice through absurdism but lost that recognition a decade or so later. Less well recognised, and with greater influence, is the distinctively visceral sensibility underlying much of his creative work, notably his poetry that draws on Dylan Thomas and the Beat Movement, his graphic drawing and luscious painting styles, and his pioneering performance art. This article argues that it is through these artistic expressions of visceral intelligence that Jeff Nuttall's art and its long-term influence can now best be understood. It is intended to complement the Jeff Nuttall Papers in the Special Collections of The John Rylands Research Institute and Library, University of Manchester, deposited by the gallerist and poetry publisher Robert Bank (1941–2015), to whose memory this article is dedicated. Further papers have been added by Nuttall's friends and relatives.

Keywords: visceral intelligence; Underground; counterculture; Dylan Thomas; William Burroughs; Beat Movement

I hate and renounce as a coward every being who separates what he calls his body from what he calls his consciousness or his thought. (Antonin Artaud, quoted by Jeff Nuttall)[1]

Gut reaction – the viscera as a source of intelligence for an artist – is the basis of the expression 'first thought = best thought' that characterised creative process for the Beat Movement. Together with Charles Olson's earlier emphasis on the breath, this raising of intuition and spontaneity to first principle honours the *soma* as a source of poetic intelligence, contrary to the then dominant view of poetry as governed by the constraints of syntax and metre.[2] This primary source of artistic intelligence underpinned the art of Jeff Nuttall: poet, painter, performance artist, novelist, cultural commentator, teacher, actor and friend of this writer. In taking a fresh view of this once famous but now largely forgotten polymath, it would be contradictory to honour just one of his disciplines. His oeuvre is best seen as a matrixial whole, the many strands being unified not only by Nuttall's inimitable personality but also his faith in the intelligence of the gut – the aesthetic principle of visceral intelligence in artistic production – for which he became the chief advocate in the United Kingdom.

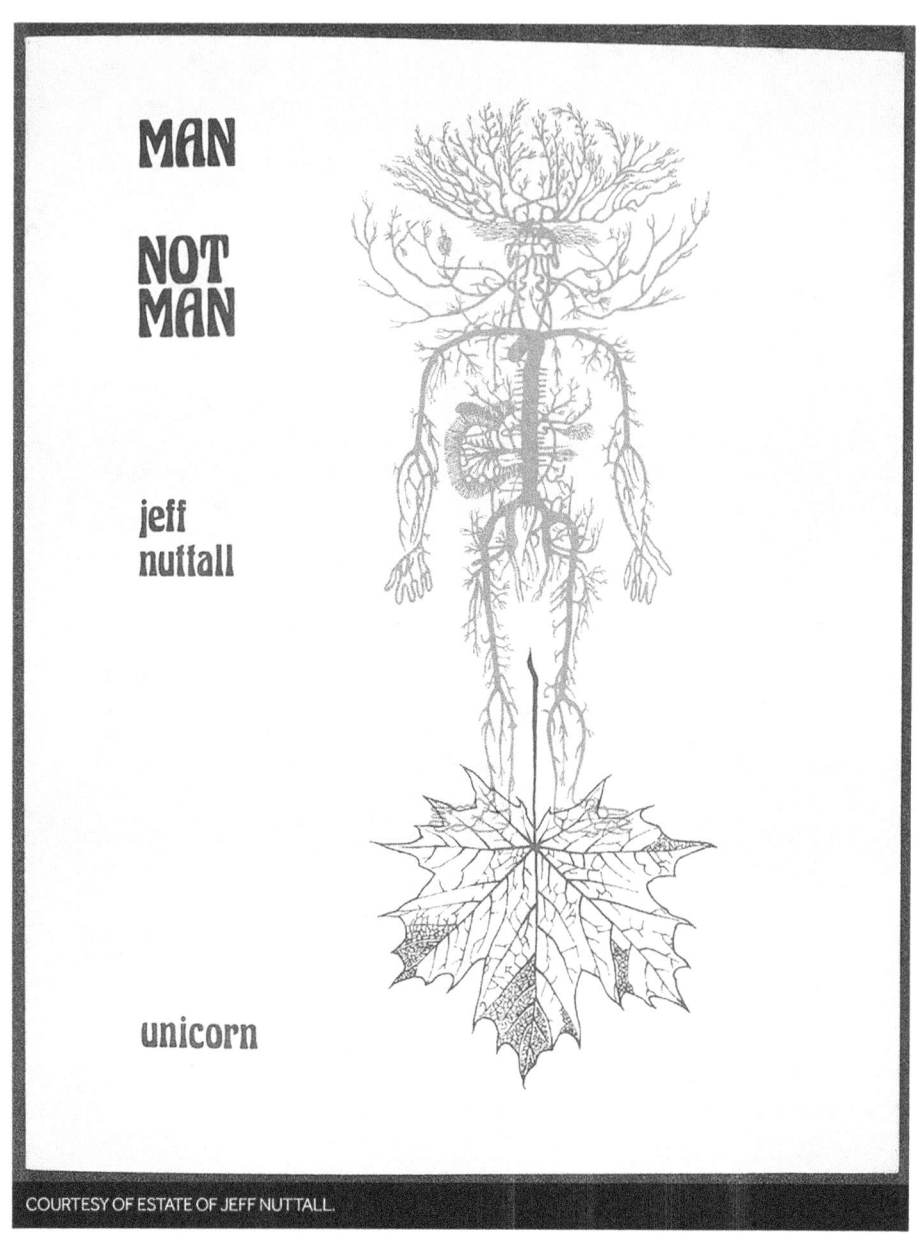

Figure 1 Drawing from the front cover of Jeff Nuttall's *Man Not Man*, 1975.[3] Private collection. © Jeff Nuttall.

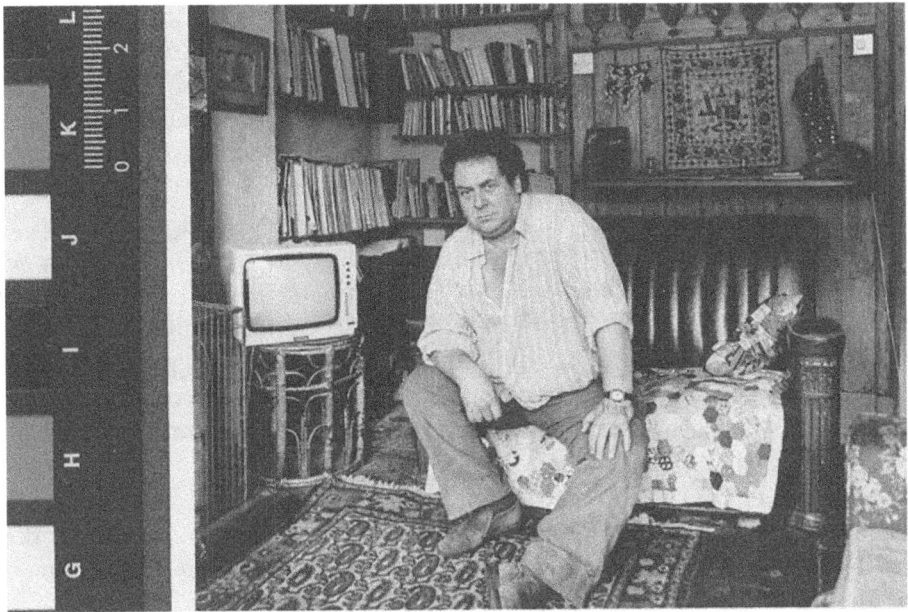

Figure 2 Photographic portrait of Jeff Nuttall, taken by Timothy Emlyn Jones at Nuttall's home in Lumb Butts, Todmorden in 1981. © Timothy Emlyn Jones.

Jeff Nuttall referred to visceral intelligence as 'the mammal thing', and he made it his own, both as a perspective and a creative strategy.[4] Several decades later, it can be seen how Nuttall set precedents for how visceral intelligence has become a contemporary issue in the arts, as well as in other aspects of culture. A new wave of interest in Nuttall has resulted recently in a significant exhibition and the re-publication of several of his major works, with a biography of him about to go to press, and the time has come for a fresh look at his contributions to contemporary culture. Any reappraisal of his strengths and weaknesses, such as this article, has to deal with the view of him as a contentious character as much as a pioneer in poetry and art, for it is in the difficulties as well as in the pleasures of this man's art that its worth may be found.

Nuttall bought into the Beat Movement, one strand of American Modernism, when it was new, and he amplified and extended it in the United Kingdom. He was a follower and advocate of his friend William Burroughs, collaging text and writing with a long-breath style that owed much to Charlie Parker and free jazz, as well as to Charles Olson and Allen Ginsberg. His poetry and prose remain distinctive, and his paintings continue to delight and contribute to our understanding of their time. Even so, he remained principally and primarily Anglo-Welsh, like the greatest influence on his art, Dylan Thomas, who had earlier been an influence on those Americans, who in their own turn influenced Nuttall, who, like Thomas, is also enjoying a critical reappraisal.

Jeff Nuttall became a major cultural figure in 1960s Britain and, together with his friends and associates Michael Horovitz, Alexander Trocchi, Bob Cobbing, and his mentor William Burroughs, he became one of the central members of the Beat Movement in the United Kingdom, known as The Underground (subsequently evolving into the British Poetry Revival) in its reaction to cultural conservatism then epitomised by those English poets of the 1950s known as 'The Movement'. Nuttall was as much an intellectual, cultural commentator and academic as he was an engagé, enragé, artist, poet and performer, and thus, unlike some associated with the counterculture. Nuttall did not take Kerouac and Ginsberg's call to spontaneity as a premise for anti-intellectualism. Rather, he took the call as it was intended, as an intrinsically intelligent artistic strategy that was then seemingly new, although it is as old as the Romantic movement itself.[5] Those who were distracted by his flamboyant love of transgression, and who did not recognise Nuttall as a deeply serious and intelligent artist who liked to clown around some of the time, missed an opportunity to consider his full worth. He remains a more significant figure than the self-appointed 'mainstream' of culture – and poetry in particular – once thought of themselves, even though he remains under-acknowledged.

In addition to taking visceral spontaneity as a central strategy in his poetic and artistic production, Jeff Nuttall also celebrated the viscera in the content and form of his work from the 1960s onwards. In this respect he shared common ground with only a proportion of the Beats, in particular with Michael McClure, whom he admired. In citing Artaud in one of his four books of cultural theory and commentary,[6] Nuttall was in accord with Dylan Thomas's valuing of the visceral, as expressed in his 1933 letter to Pamela Hansford Johnson:

> All thoughts and actions emanate from the body. Every idea, intuitive or intellectual, can be imagined or translated in terms of the body, its flesh, skin, bones, sinews, veins, glands, organs, cells or senses.[7]

As with Thomas, this was central to Nuttall's aesthetics, but for him it went further as a crucial element of creative process, as evidenced by his paintings, sculptures and poetry, and more controversially at the time, by his performance art.

Adopting the argument against a mind/body duality first advanced by Gilbert Ryle in 1948 was an important step in the formation of Nuttall's art, not just as a perspective on meaning, but also as a precedent for the embodiment of knowledge as it can now be found in contemporary theory.[8] Neurology was also an influence in discussing intelligence as being dependent on complex relationships of bodily systems within an expanded concept of mental process, rather than on a concept of brain that is somehow independent of the central nervous system as a whole.[9] Nuttall too took a position in which the intelligence of the viscera is real – not just a metaphor – and something that may be theorised, just as the principle of embodied knowledge has become central in contemporary culture. John Goodby's radical reappraisal of Dylan Thomas, written to mark Thomas's centenary in 2014, applies contemporary theory to make much of bodily intelligence and reposition

Thomas as the central figure of mid-twentieth century English poetry that many of poetry's conservatives – proponents of Auden – sought to deny him.[10] In presenting this fresh view of Thomas in relation to so-called 'mainstream' poetry, Goodby reveals equally fresh perceptions of the mainstream's conservatism, and this perspective also sheds new light on Nuttall's under-appreciated contributions to British culture.

While Ryle discussed operational knowledge, or know-how, as distinct from factual or propositional knowledge, the idea of multiple forms of intelligence (or 'intelligences') became well established through the work of Howard Gardner a decade or so after Nuttall.[11] Also, in the 1980s, ideas of bodily intelligence re-emerged as a central trope in feminist theory through Julia Kristeva and Luce Irigaray among others.[12] These and related developments continue to contribute to an emerging epistemology of art practice (a term which I use to embrace all the arts: visual, poetic, dramatic and so on) notably through the idea of art as a process of enquiry in which visceral intelligence partners mental and emotional intelligence as part of the larger picture of the intelligence of doing:[13] thus Nuttall set precedents that remain relevant both to the disciplines within which he practised, and to the wider cultural context in which his influence, and that of others such as Thomas, has gone largely unrecognised until recently.

Under the shadow of Maurice Merleau-Ponty,[14] whom he told me he admired, Nuttall drew together the physical and the theoretical in the mission to resist dualities and to unite apparent opposites – experience and the body, language and non-linguistic communication – in Merleau-Ponty's case through 'carnal formulae' as an alternative to the hegemony of text, and in Nuttall's case through a union of personal experience, visual art and poetry. He wrote of 'the seemingly contradictory directions' in his work, and he also asserted that 'the pastoral and romantic ... have the same meaning as the absurdist and bawdy'.[15] The connectedness of the visual and literary are discussed in the next section of this article. Also, like Merleau-Ponty, Nuttall can be criticised from the feminist perspective expressed by Elizabeth Grosz for envisioning bodily knowledge in relation to a specifically male body.[16] Nuttall was aware of this apparent shortcoming at the time, explaining in conversation with this author that as a male person he felt he had no alternative since he had no other body, and asserting until the last decade of his life that he saw his mission as fraternal with that of feminism in this respect. In particular, in his short novel *The Patriarchs* (1978), he takes on patriarchy as endemic to the post-industrial landscape and culture of northern England – for many years his homeland – that had been the scene of systemic economic exploitation, and its poet, a thinly disguised Ted Hughes, as 'the shaman of the patriarchs pleading resignation'.[17] In his last ten years, however, he seemed to despair of any prospect of fellow feeling from those feminists he had earlier spoken of as fellow travellers.

Nuttall's focus on the visceral establishes him as a precedent for cultural theory in the early twenty-first century as much as it saw him as a popular figure in his own period, the Cold War, which he definitively represented in his first book of

cultural theory, *Bomb Culture*.[18] In that book he argues that the only rational response to the prospect of nuclear apocalypse is to be irrational, that also being the heart of any creative endeavour, and thus he turns despair into positivity. In matching one absurdity with another, he perhaps provides insight into how we may best respond to the defining absurdities of our own historical period – the fake truths and alternative facts of a self-serving reality feeding the financial interests of the super-rich.

In envisioning art and literature holistically, it was not sufficient for Nuttall to be an artist or a poet, but necessary to be both, each the essence of the other. Jeff Nuttall's approach appears synaesthetic, as in his own words, 'I paint poems, sing sculptures, draw novels.'[19] In this respect, his outlook was similar to Wallace Stevens's vision of the commonality of poetry and painting:

> there seems to exist a corpus of remarks in respect to painting, most often the remarks of painters themselves, which are as significant to poets as to painters. All of these details, to the extent that they have meaning for poets as well as for painters, are specific instances of relations between poetry and painting.[20]

Despite Nuttall's 1967 account of his multi-disciplinary output, quoted here, several decades later a more partial view was expressed in the cover note for his last publication, *Selected Poems*, probably written by himself, albeit in the third person:

> He has been busy across a broad range of creative disciplines but it is in his poetry that his inimitable concerns are most clearly seen.[21]

Whatever his retrospective self-assessment, there is much evidence throughout his career that he saw the arts as a unified field of creative endeavour, and that he saw the human body and all its distinguishing features, both sensuous and abject, as essential to the intelligence of art.

Although commonly portrayed as two separate modes of engagement with the world, art and literature can be seen as two dimensions of the one mode and mission: the visualisation of human consciousness. Rooted in aesthetic knowledge – the world taken in through the eyes and ears and nose, tongue and skin, and responded to in the gut as much as in the heart and the head, whether expressed by the tongue or the hand – these are mammalian ways of understanding the world and creating meaning from it and about it. Visceral intelligence may be considered as a mode of consciousness as far beyond emotional intelligence as emotional intelligence is beyond mental intelligence,[22] and Jeff Nuttall was one of the twentieth century's champions of it, along with others that he told me he admired: Maurice Merleau-Ponty, Georges Bataille, Martin Heidegger, Michael McClure, Hermann Nitsch, Günter Brus and others.

As with William Blake – who, like so many of his generation, Nuttall celebrated as the highest example of creative impulse – Nuttall's attainment in art is often

overshadowed by his attainment in poetry. Any reconciliation of these two dimensions of creative energy, however partial, is likely to shed light on the foundations of creative process.

In considering Jeff Nuttall's contribution to the visual arts, one is drawn as much to comparisons with writers as with artists. It is difficult to think of Nuttall's contribution to understanding without reference to Dylan Thomas. There was a time when Nuttall was often thought of as Thomas's successor in the Neo-Romantic lusciousness of his writing, and not just because of the outward similarity of two once pretty, curly-headed boozers gone fat, making inspirational chaos in London's artistic and literary milieux. There is similarity too in their treatment of words as if they were physical material in the crafting of visualisation, in their use of collage, as well as in their exploration of childhood memories as a source of inspiration in remaking consciousness. In Thomas's case the innocence and happiness of the child is romanticised, albeit from the retrospective perspective of adulthood, while in Nuttall's case the puerile is celebrated, the abject welcomed, and the neurotic energy undressed. As a result, Thomas emerged as an honorific figure in America (and later in Wales), having been cast in England as a marginal figure in the shadow of Auden by the movement for decades, until John Goodby's recent work shed new light on his achievements.[23] Nuttall too has been seen as problematic, though mainly in England, and perhaps a reappraisal of him in the light of the contemporary theory that he helped shape may also follow, as has been the case for Thomas. What Nuttall and Thomas shared was the universalisation of the particular, both within the shadow of James Joyce.

Although born in Lancashire, Jeffrey Nuttall was brought up at Orcop, Herefordshire, on the border of England and Wales, and this bi-cultural location was formative in his aesthetic sensibility. He represented and celebrated this bucolic world in visual and literary forms that associate with the body, in images redolent of Graham Sutherland, John Piper and Ceri Richards – painters just one generation older than Nuttall – and that of their predecessor and inspiration Samuel Palmer, a contemporary and follower of William Blake. For many generations of artists, the landscape has been redolent of the body, and this idiom remained with Nuttall throughout his life, throughout his alliances with Surrealism, Neo-Romanticism, the Beat Movement, Situationism, Assemblage and Neo-Expressionism.

In Nuttall's landscape drawings and paintings there is a visceral engagement with the anthropomorphic potency of the land and natural forms such as trees, rocks and ancient buildings that take on, reflect, and sometimes merge with the human viscera of guts, spume and pudenda. A numinous feeling suffuses the imagery of many of his drawings and paintings, and that of many of his poems, in which landscape and farming references are intermingled with those of the body and sexuality, and it is always present in his painterly handling of words. These qualities are exemplified by a poem inspired by the Sheela-na-gig on the Romanesque church at Kilpeck, near his childhood home:

> Who'd couple with foetus, with handful of sore yell wet, with its jelly eyes staring/Clamped around the grunt-root sucking it up to a rash/... the entire spring season ploughed her in her eldritch luminous paralysis.[24]

Despite his self-identification as a Modernist, and his central position in 1960s British radicalism, the CND (Campaign for Nuclear Disarmament) and The Underground, Nuttall also remained stylistically a Neo-Romantic in his visual art. This appears contradictory since, in his role as chair of the UK's National Poetry Society in the mid-1970s, he identified as a Modernist standing against the Neo-Georgians. Neo-Romanticism is also contradictory of his espousal of collage (or as his mentor William Burroughs described it, 'cut-up') that seems quintessentially Modernist. His dual position as a Pre-Modernist and a Modernist was not Nuttall's only contradiction. Despite his later atheism and iconoclasm, Nuttall's 1960s exhibition catalogue note reveals him taking his early artistic inspiration from Christianity (following the precedent of the visionary painter Samuel Palmer), albeit with the visceral emergent:

> All my paintings are religious. I believe that the face of God is visible in nature. I paint landscape in such a way as to emphasise the God in it. The presence of God is strongest in those potent shapes and colours which our warped society holds to be obscene. Society calls it obscene and shuns it in order to protect itself from the truth.[25]

This early religious outlook soon gave way to Nuttall's better-known atheist absurdism of the world of 'nuclear suicide', for which he became for a time the principal spokesperson through his book *Bomb Culture*[26] and his co-founding of the theatre group *People Show*.[27] However, traces of this early inspiration reappeared in his later years. His transition from religious to secular outlook is illustrated by the following entry in *My Own Mag*, written in a faux childish script partly replicated below, with misspellings retained:

> Dear God, You didn't listen and the prime minister didn't listen nither, nor Father XMAS and MuMY AND daddy were busy anb I Kept on asking. I DON'T THINK YOUR THARE ANY MORE I think you gone to the pictures wel When you get back you'll be sorry cos I hurt ... (finally the handwriting becomes illegible before disappearing into the charred chaos of the burnt page).[28]

After a career teaching in secondary schools in the south of England, Jeff Nuttall was able to progress into teaching in higher education as a result of the recognition he achieved through the outstanding success of *Bomb Culture*, and he spoke of the book opening doors for him. He took up a senior lectureship in the art school in Bradford and then in Leeds, before his final academic position as Head of Fine Art at Liverpool School of Art. Nuttall's move to the Pennine Hills of the north of England took him to a hard-edged industrial world, with a frugal economy far removed from the bucolic, Celtic rurality of the Welsh borders at Herefordshire

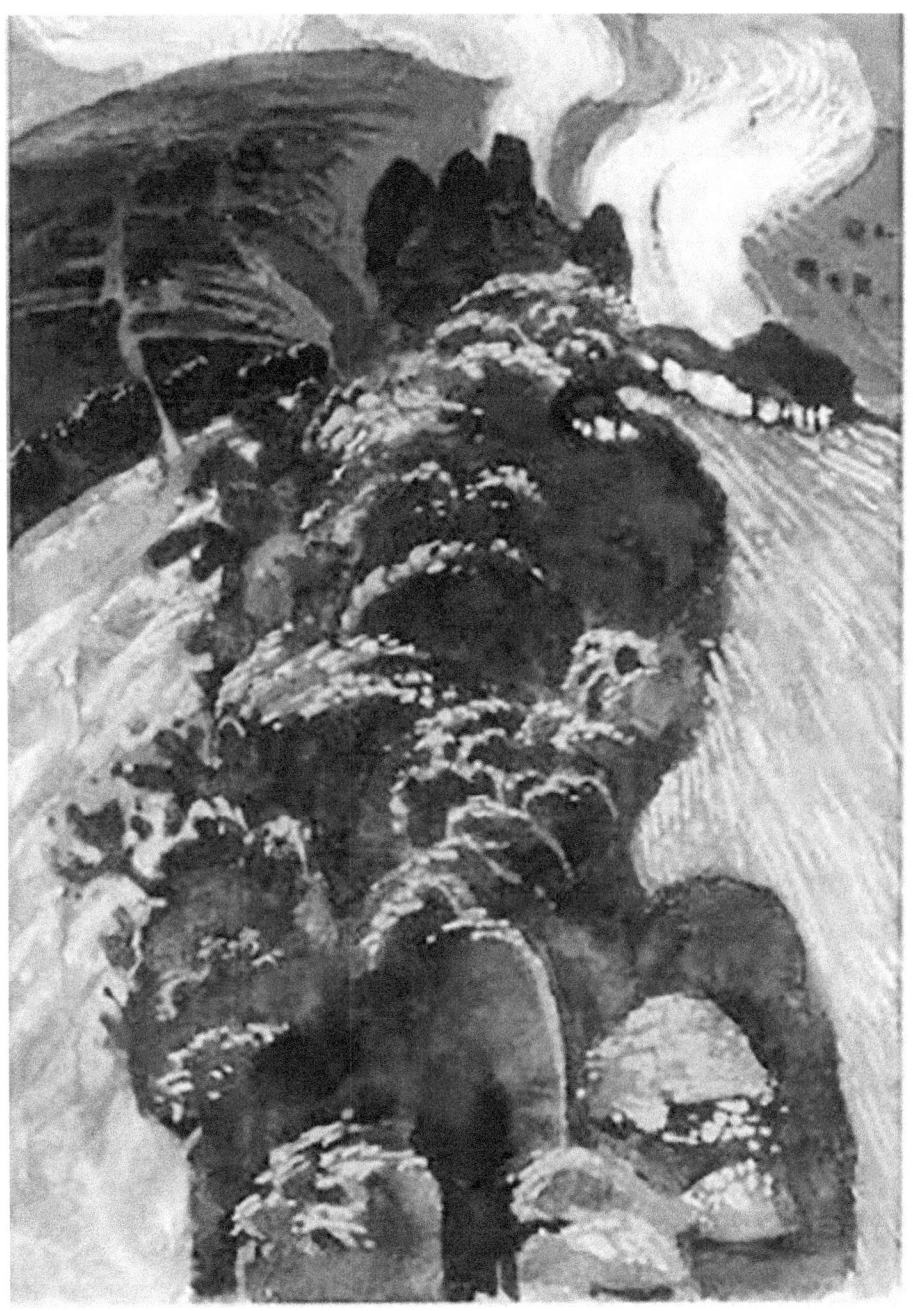

Figure 3 'Wooded Ridge', Gouache, 2003. See 'The Life and Works of Jeff Nuttall,' http://jeff-nuttall.co.uk/html/landscape_images.html. © Jeff Nuttall.

in which he had grown up. Here, among the bleak hills and snug industrialised valleys of 'The North', he found a visceral landscape unlike that of Herefordshire, one marked by industry:

> the tripes, the guts, the root bodily functions are in the industrial North. It is an endearing characteristic of the nation that it is frank with its functioning. The plumbing shows, a rash of railways, cheap terrace housing, arrogant chimneys, mills and sweat shops, stations and wreckage yards, warehouses and sewerage beds, cover most of Lancashire and half of Yorkshire, an ostentatious defilement of the landscape, where the boss was a face not a trademark, and the extent of his wealth was to be gauged by the length of his factory's excretory chimney. The nation's digestive system, its anal tract, is coiled across the Pennines, and dredges down across the desolate plain of West Lancashire to the Irish Sea.[29]

Here was a people openly proud to be blunt, self-consciously and defiantly remote from the soft and effete world of 'The South', albeit by only a small number of miles. Nuttall made the quirks and postures of 'The North' his own, with emblematic cloth cap and plaid scarf worn attitudinously above a proud belly and loud persona that had been out of place in southern England. His northern persona was an ironic, amiable, often comic posture that was sometimes taken at face value, notably by some members of the women's movement who saw in this figure the unreconstructed misogynist bigot then quintessentially represented by the northern comedian Bernard Manning. Indeed, Nuttall celebrated the 'subculture of urban life, particularly in the North of England'[30] for its authenticity and emphasis on shared experience, but much as he sought participation he remained more an ethnologist than a common man. Despite his espousal of northern culture, his accent was distinctively southern and 'posh'. In *Common Factors/Vulgar Factions*, he declared his belief that the 'language of the commonplace, often call [sic] 'bad taste', may reveal far more about the true nature of modern society than the consciously styled structures through which the age of technology attempts to create an identity'.[31] This perspective may have seemed to Nuttall justification for his phallocentric iconography and apparently misogynistic attitude. He described his motivation as 'a gravitational concern with the way in which physical love must transform the repellent without euphemising or diluting its Swiftian character', but that sophistication often went unnoticed, with his apparent crudeness being taken at face value.[32] Later in life he made his living as an character actor in a number of feature films and several TV series, often portraying unsympathetic characters, and that may have reinforced the impression of Nuttall as a male chauvinist.

This fundamental misunderstanding of his identity, which he permitted, worked badly against Nuttall. His Blakean faith in the universal value of personal experience was in fraternal compact with the feminist principle of the personal being political, and he acknowledged his admiration of the work of Germaine Greer personally and somewhat conditionally in print.[33] The effect of this misunderstanding was to rob him of the credibility and fashionable kudos he had gained as a key figure of The Underground in 1960s London. It also diminished his standing as a

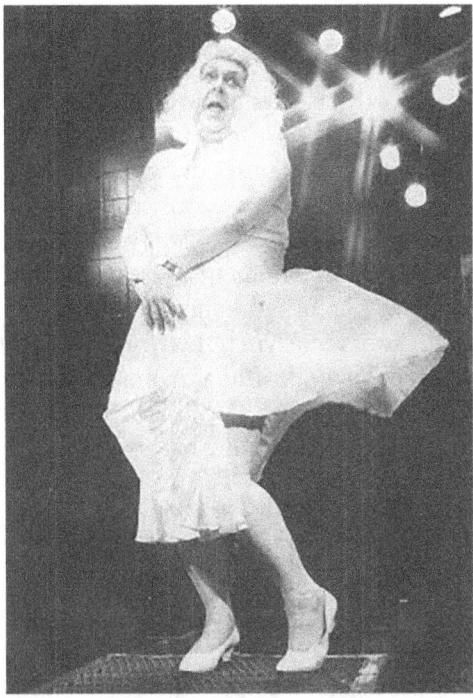

Figure 4 Jeff Nuttall as Marilyn Monroe, Happening, late 1980s. See *The Life and Works of Jeff Nuttall*, http://jeff-nuttall.co.uk/html/happenings_images.html. © Jeff Nuttall.

socially relevant artist and cultural commentator, a potential and valuable role to which his several theoretical books, his critical writings for *The Guardian*, and his occasional television appearances such as those on the BBC2's *The Late Show*, were testimony. Jeff Nuttall could have done more to help himself.

In discussing this problem with me, he regretted it as being one of generational misunderstanding, although I felt the problem also to be one of a clash of locational cultures. Either way, his often self-consciously transgressive manner, much ahead of its time, did not invite empathy from those who could otherwise have become his allies.

This original, visceral and intellectual artist was a man of the world, but in preferring to go about it in the guise of a 'bloke', he lost the recognition he deserved. Nuttall's Rabelaisian celebration of the gut extended from poetic trope to the flaunting of a Falstaffian belly that ran counter to his artistic mission. He liked to play the clown, but the Swiftian gist of his satire was sometimes missed. It is sadly ironic that those who dismissed Jeff Nuttall as a pig missed the self-awareness represented by one of his early and most important prose-poetical books, *Pig*:

> I celebrate myself to the glory of Pig ... I rise in the world like a surfacing island from the original loam and there shall be Pig moving in the mists of the forests and there shall be Pig moving around the cooking fires of the habitats and there

shall be a mountainous shadow of Pig against the glory of noon and humanity shall sweat once again with a fine free flow of baconjuice. / Le Pig c'est moi.[34]

While the impact of the northern sensibility on his artistic work was most evident in his performance art and theatre, of which his own account is the best, the northern impact also became evident in his drawing.[35] Nuttall was one of the first in the UK to transform the comic from a specifically working-class northern cultural form – exemplified by *The Beano* and *Dandy* – into an autonomous fine art medium (although comparable developments were taking place at that time in Pop Art in the USA, Lichtenstein's paintings being most notable).

Nuttall's *My Own Mag*, in its idiosyncratic hybrid verbal-visual format, incorporated the comic strip as early as 1964 in a manner equally drawn from popular culture and the radical literary tradition.[36] In this he was originator, writer and editor; his contributors including William Burroughs (who also wrote a preface for *Pig*).

Nuttall's influence was strongly felt in the United Kingdom where *Viz* adopted his energetic linear style in 1979, itself becoming an influential publication.[37] Nuttall was delighted by the early editions of *Viz*, which prompted him to devise *Knuckleduster Funnies*,[38] a part-return to *My Own Mag*, being a series of comic books drawn by Nuttall and others (myself included in one edition) and co-edited and designed by Nuttall with Robert Bank at the Arrowspire Press, Colne in England – a small independent press notable for having been established to publish Eric Mottram's *The Book of Herne*, Bank having been a student of Mottram at King's College, London.

Arrowspire also published Nuttall's *The Pleasures of Necessity* and further poetry by Eric Mottram.[39] Eric Mottram once told me he held Nuttall in the highest esteem, and he proofread many of Nuttall's books prior to publication. In these crypto-comic books, Nuttall unified the visual and the verbal in ways significantly different from those of his contemporaries.

Contemporaneously, Ian Hamilton-Finlay pioneered the integration of the visual and the verbal through concrete poetry in the Scottish Lowlands, as did John Furnival and Dom Sylvester Houédard in Gloucestershire; and Nuttall knew them all, yet there was a fundamental difference of style. The concrete poets were aesthetic practitioners in a manner that Nuttall declined to adopt. Here, perhaps, we see the anti-effete stance of the English North.

Jeff Nuttall's connection with the Beat Movement was direct. William Burroughs took up the precociously gifted and outstandingly sociable young poet's invitations to publish in several editions of *My Own Mag*, and he made Nuttall a protégé as well as a means for disseminating his own literary ideas in the United Kingdom. All successful artists need followers and Nuttall proved a willing disciple of Burroughs, although he never lacked critical distance. Jeff once told me that he thought the principle of the 'cut-up' had limited creative potential. Burroughs had been artistically successful, he argued, not because of his innovations in literary structure and method, but because of his innate feel for language: 'he was just

Figure 5 Portrait of Robert Bank, drawn by Jeff Nuttall sometime in the 1990s. Private Collection. © Jeff Nuttall.

such a bloody good writer', Nuttall told me. Jeff Nuttall adopted the method of the cut-up in his own work, notably in *Pig*, thus disseminating and popularising Burroughs's ideas and becoming a leading influence in The Underground for a younger generation of collagists that included David Bowie and Brian Eno among others.

Figure 6 Knuckleduster Funnies 1–4, 1985–86, litho and photocopier. See *The Life and Works of Jeff Nuttall*, http://jeff-nuttall.co.uk/html/culture_images.html. © Jeff Nuttall.

While Burroughs credited Brion Gysin as the originator of the 'cut-up', it originated several decades earlier in Dada and Surrealism, with Tristan Tzara's pulling words from a hat to compose a poem being sometimes cited as an origin. Cut-up of a sort also appears evident in the poetry of Dylan Thomas, who was informally

associated with Surrealism in England, though in his case it may have been the cut-and-paste of his own text rather than anything truly aleatory. There is evidence to support the view that this kind of cut-up was one of Dylan Thomas's writing methods, long before Burroughs and Gysin.[40] Thomas was a crucial influence on the Beat Movement, becoming hugely influential in America at exactly the moment so many UK writers turned their back on him. The lineage of influence is simple and important: Thomas's 'Do Not Go Gentle Into That Good Night' on Rexroth's 'They Are Killing All the Young Men', on Allen Ginsberg's *Howl*, on Nuttall's *Pig*. This lineage apart, direct Thomas influences on Nuttall are equally clear, especially in the texture and strategic deployment of language. Nuttall's adaptation of Beat methods suggests he should be better appreciated than he is currently, and maybe this will come.

One element working against Jeff Nuttall, I suspect, is once again the formative influence of location. What if he had adopted the Bay Area in lieu of the English North? It was probably his connection with William Burroughs that helped him get published in San Francisco in *City Lights Journal No. 3* in 1966 (with the prose fragment, 'Boy with Face of Sour Apples'), in *Ole'*, edited by Douglas Blazek (though not published in San Francisco until issue 5, only four years after Nuttall began writing poetry), and in *San Francisco Earthquake No. 5*, only three years later.[41] In writing much of this article in San Francisco, a visit to the City Lights Bookstore proved enlightening. Looking for references on the shelves I found none to Jeff Nuttall, though I found nostalgic mentions of Jeff's friend Michael Horovitz in several books. Nuttall's impact at *City Lights* seems eclipsed by his connection with Burroughs, since when Nuttall sent Lawrence Ferlinghetti a copy of *My Own Mag* he received a postcard in return asking for twenty copies of 'the William Burroughs edition', but no others;[42] in fact, Burroughs's contributions to *My Own Mag* were spread over many editions, though it is probably the Tangier issue that Ferlinghetti had in mind. This orientation to Burroughs also figures in Jed Birmingham's extensive account of *My Own Mag* at Reality Studio.[43]

Nuttall's standing as a visual artist in the United Kingdom is reflected in his representation in the 1970s–1980s by what was then one of London's most innovatory art galleries, the Angela Flowers Gallery (now trading as Flowers Gallery), as well as by his appointment as the head of the Fine Art Department at Liverpool School of Art. The soft sculptures he exhibited with Angela Flowers demonstrate a figurative viscerality, as disturbing, recognisably human forms fill cheap cardboard suitcases, alluding both to the bodies of murder victims famously dumped in railway left-luggage facilities in news stories of the 1970s, and to the assemblage tradition represented by Kienholz and others. Here we see the abject aspect of the human form, simultaneously close to – yet remote from – the sensuous dimension celebrated elsewhere in Nuttall's oeuvre.

In this, as in the work of some of his contemporaries such as Stuart Brisley, Günter Brus and other Viennese actionists,[44] we see the abject presented not merely in its disgusting form, but in what is intrinsically an enquiry into the depths of humanity, a decade before Kristeva wrote on abjection.[45] Here we can see the effect

Figure 7 'Interiors', 1964, suitcase soft sculpture. See *The Life and Works of Jeff Nuttall*, http://jeff-nuttall.co.uk/html/body_images.html. © Jeff Nuttall.

of what Viktor Shklovsky called *ostranenie* or 'enstrangement', sometimes referred to as 'defamiliarisation',[46] later developed into Berthold Brecht's strategy of 'alienation', sometimes referred to as 'distancing effect'.[47] The viewer is distanced from the spectacle rather than encouraged to identify with it, a strategy that can be seen throughout Nuttall's work: as he explained, 'disaffiliation is a prerequisite of protest', a principle found throughout Nuttall's oeuvre.[48] These sculptures bring the viewer to question their own existence, through the union of attraction and repulsion, whether exhibited in the Flowers gallery or in the Situationist spirit deposited by Nuttall in public left-luggage facilities for strangers to discover.[49] Here we see Nuttall's characteristic union of opposites, absurdist humour and tragic repulsion, resolved – or not – within the engagement of the audience. At its best this strategy can be powerful in the generation of Nuttall's meaning, but in some cases it alienated the viewer or the reader not only from the subject of his art, but also from himself as a personality when taken to be repulsive.

Following his retirement from teaching in 1984, Nuttall took his new young family to Portugal and enjoyed a prolific period of painting in watercolours and oils, making bucolic Palmeresque landscapes reminiscent of the countryside of his early Welsh borders childhood. The oils he produced in this period are notable for the succulence of his paint, demonstrating a more relaxed viscerality than that of his earlier work.

His Portuguese period was followed by a period in Barnes, London, before a return to the English-Welsh border of his early childhood, but this time on the Welsh side in Abergavenny, and subsequently in Crickhowell. Here the apparently

Figure 8 'Cloud Shadows, Algarve 1', oil on canvas. See *The Life and Works of Jeff Nuttall*, http://jeff-nuttall.co.uk/html/landscape_images.html. © Jeff Nuttall.

visceral dimension of his sensibility re-emerged in his paintings and reliefs, and he wrote of it.

> My Black Mountain reliefs... are, indeed, landscape; not viscera, not pornography and not wrestling pythons, but they do emphasise that geological and vegetable forms share shapes and parallel processes with animal (and human) digestion, gestation and reproduction, in a turbulence of decay, erosion and rebirth. My work is intended as a celebratory prayer about these things.[50]

It was at this time that he edited his *Selected Poems*, and the cover note that is probably by his own hand re-emphasises the mammalian dimension of his aesthetics:

> An elegiac mood prevails behind the scatology and verbal clowning... The content always reverts to a gravitational concern with the way in which physical love must transform the repellent without euphemising or diluting its Swiftian character.[51]

Nuttall's 'gravitational concern' can be seen in his constant return to the physical in the inspiration of his poetry and art, in its content and in its form, whether in the jazz-informed long-breathed rhythms of his poetry, the corporeality of his sculpture, or the material juiciness of his oil paint. But his focus on the bodily and

the spontaneous, free from inhibition, does not imply any lack of rigour: he was contemporary with the hippy generation, but he never joined it.

'Freedom is the hardest discipline', this son of a schoolteacher once told me, and this take on rigour is the key to understanding his achievement. He was prolific in all he undertook, and it was his huge capacity to focus energy that empowered him, and his capacity to direct his energy that shaped his creative achievements. The principle of freedom from the constraints of the conscious mind that underpins 'first thought = best thought' may be thought by some as an easy alternative to creative strategy and craft: laziness. As Nuttall told me, however, the discipline of freedom is not so much freedom from constraint as freedom of opportunity.

In writing of creative process, Mihály Csíkszentmihályi points to the importance of mental states and contextual factors to clarify how creativity is not so much a matter of creative thinking as a matter of diverse intelligences, including bodily intelligence alongside the cerebral.[52] For self-expression to be spontaneous, for the gut reaction to be certain and true, yielding the new rather than the ubiquitous, quotidian and predictable – the unexpected rather than the formulaic – the artist must be bodily engaged and grounded in the experience of the present moment, free from the inhibiting mental clutter and chatter of everyday concerns.

There are many ways to achieve this openness to intuition and inner knowing, many of which are described by Helen Palmer in *Inner Knowing*.[53] Best known perhaps are the methods associated with Surrealism, automatic writing being the pre-eminent creative method. Coleridge claimed laudanum as a way to imagination, Yeats found creativity in spiritual trance, and Artaud found it in madness of a kind. For Allen Ginsberg, the state of mind was achieved through long and repeated periods of meditation. For Jack Kerouac, the potency of emptiness was attained through meditation, alcohol and drugs. For Nuttall, the path is neither well defined nor documented, but there is evidence in the form and content of his work of his capacity to put cerebral control aside for intuition to emerge and become embodied. He knew how to get out of his own way, as all creative persons must. Anyone who knew him would recognise his copious drinking in the tradition of which Dylan Thomas was taken to be the landmark figure, and maybe that did contribute to his creative work. While over the years I saw Nuttall drunk on a number of occasions – and by that means variously inspired and inspiring, or sometimes belligerent and even anti-social on occasion – I never saw him bereft of wit nor beyond self-control. He once told me of the hurt he felt at having been described as alcoholic. His frequent drinking, he told me, was not through dependence on alcohol, but through his passionate need for company and his profound discomfort on being alone. Drinking was part and parcel of conviviality in Nuttall's milieu, and conviviality – in the sense advocated by Ivan Illich – was the core of his creative spirit.[54] For the social Nuttall, conviviality opened an internal door, enabling the poet to pass through the doors of constraint.

In *Art and the Degradation of Awareness*, Nuttall returned to Illich in criticising the vacuity of culture at the turn of the millennium for its lack of conviviality,

caring and creativity.[55] Within that aesthetic, which he saw epitomised by the Millennium Dome, in contradistinction to Coleridge's pleasure dome, there seemed no place for committed and personally immersive creative process, and therefore no place for Nuttall.[56] For Nuttall, the visceral source of inspiration was crucial, however he tapped into it – whether through booze or through sheer emotional and mental discipline in the knowledge that language alone is insufficient for poetry, whether the poetry of language or that of the painterly image or the performed event. The core of his art was mammalian experience, and essential to that was openness to one's own experience, the experience of experience rather than the idea of it – conviviality in Illich's terminology. In Nuttall, viscerality is combined with a formidable command of language and materiality as the distinctive discipline that he brought to the tradition of Romantic literature and art. While *Art and the Degradation of Awareness* is put forward as a critique of contemporary culture, Nuttall's real argument is embodied in his works of art, arising from and embodied in the viscera.

Jeff Nuttall was aware of his contradictions. He refers to them in *The Pleasures of Necessity*, and he spoke of them personally. I have a distinct memory of Roland Miller, one of Nuttall's earliest collaborators, telling me that Jeff had told him that the disparate pattern of his creativity would be seen in time to be unified within the larger pattern of his personal identity and mission; within his personality. Nuttall remains a figure of contradictions. He is a contrary figure too, unwilling to be readily understood, having been curious of where his curiosity might take him. Wilful and given to the moment, spontaneous as a matter of principle – at the level of rigorous discipline – he was a foreigner to the categories and labels that came to be used to section, package and sell artistic radicalism as commodity in the early twenty-first century. It is as if he wished to situate himself at the coincidence of contraries.[57]

Nuttall was a man of many parts, a soul in pursuit of unity and disparity in the one moment, seeking to lay the ghost of dualism through a deeply personal engagement in love, lusciousness and the abject: a modernist in a postmodern world. In his later years he seemed tired, as if his mission was unresolved and out of time. The lack of public recognition following a period of huge popularity may have been due to unsympathetic attitudes to this problematic man, or to the complexity and diversity of artistic achievements too difficult to summarise succinctly or to place as marketable product, or to both. Eventually, he spoke to friends of wanting to go, and eventually he settled for the three score years and ten of scripture, as if self-consciously returning to his Christian roots.

It is almost two decades since his death, and as concepts of art as embodiment and the intelligence of the visceral are becoming mainstream artistic concerns – as is the absurdism he advocated in *Bomb Culture* – and with the performance art he pioneered becoming commonplace, his artistic efforts and achievements may be perceived to have been not against the cultural tide as he feared, but in front of it. He has much to teach us about our own time and how we might best respond to

it. As an artist, Jeff Nuttall was a pioneer of visceral intelligence in the spirit of Antonin Artaud. In this respect, we may find unity in his artistic diversity through this aesthetic principle, more than through his distinctive and extravagant personality alone.

There remains more work to be done in coming to understand this artist's contribution to culture,[58] and it is to be hoped that the several recent initiatives of Douglas Field and Jay Jeff Jones, including the exhibition *Off Beat: Jeff Nuttall and the International Underground* at the John Rylands Library, Manchester, the simultaneous reissue of five of his short novels which they edited, and the 50th anniversary re-publication of *Bomb Culture* also edited by them, may provide examples and stimulate further interest in this largely forgotten but once celebrated figure.[59] It is to be hoped too that the renaissance in Dylan Thomas studies led by John Goodby will have the effect of shedding new light on Nuttall as Thomas's principal follower, just as Thomas gains recognition as the central figure that his work warrants rather than as the marginal figure promoted by Britain's more conservative poets and scholars.[60] Goodby has already followed through on some of the implications of this reappraisal of Thomas in a groundbreaking surveying of innovative Welsh poetry in the English language in *The Edge of Necessary: An Anthology of Welsh Innovative Poetry*, finding Nuttall a significant figure.[61] Having examined the influence of the Movement's efforts to marginalise Dylan Thomas's reputation in *The Poetry of Dylan Thomas: Under the Spelling Wall*,[62] in this anthology Goodby maps how the inheritors of the Movement's legacy attempted the marginalisation of subsequent Welsh innovators in their own mission to dominate English language poetry, saying:

> The poetry presented in *The Edge of Necessary* cannot be thought of as some kind of tributary to the central flow of 'Welsh poetry', tolerated, sanctioned and accommodated by something bigger. Rather, it is now the bigger thing – broader, deeper, more dynamic, internationalist in scope and action, and as such the best literary vehicle for reconnecting Wales to a cultural worldscape.[63]

This fresh approach to Dylan Thomas's heritage, in which Jeff Nuttall is a significant figure, is not restricted to Wales but belongs to the international horizon of innovatory writing. New perceptions of Thomas and Nuttall lead by implication to similarly new readings of their context: the essentialist, conservative poetic heritage of post-war British writing once led by the Movement. This leads inevitably to a better understanding of the many poetic movements in the English language, and to recognition that the claims of any one movement to the position of 'mainstream' in a diversified, egalitarian and inclusive culture have to be beyond credibility.

An understanding of visceral intelligence seen as one of the many streams of international post-war twentieth-century culture will benefit from a rigorous understanding of Jeff Nuttall and his associates. It is in Nuttall's largely unacknowledged contributions to this imaginative and innovative base of poetry, painting, and performance art – and by extension, wider English language culture in all its many and diverse streams – that his significance lies.

Acknowledgements

The gallerist and poetry publisher Robert Bank (1941–2015) suggested to me shortly after Jeff Nuttall's death that I should write an account of the work of our mutual friend, at a time when there were none. Robert Bank's long-standing and tireless championing of Jeff Nuttall did much towards ensuring that Nuttall's memory stays in the public sphere. As well as publishing him at Arrowspire Press and exhibiting him at Gallery By The Park, Barrowford, in his lifetime, Bank continued to promote Jeff Nuttall's reputation after his death by organising exhibitions, setting up the Jeff Nuttall website (jeff-nuttall.co.uk), persuading the John Rylands Library, Manchester to take in some of the Nuttall archive, and arranging for various public art collections to take Nuttall paintings, so it is a pleasure to dedicate this article to him. Robert and I were friends from 1980 until his death, and he exhibited my work at The Gallery By The Park and published some of my work at the Arrowspire Press.

I am also grateful to Stephen Mossman and Cordelia Warr at the University of Manchester for publishing this article; to the reviewers Gillian Whiteley and Douglas Field, who were kind enough to disclose their identities, for their helpful comments on it; and to Jay Jeff Jones for his comments on an earlier draft. An exchange of emails with Professor John Goodby on the Dylan Thomas connection was invaluable.

I first met Jeff Nuttall in 1973 when Ian Breakwell asked me to stand in for him in *Jack*, a novel of Jeff's to be improvised in Trafalgar Square and in nearby London streets (we got thrown out of the Café Royal), and then in the Oval Theatre Club.[64] We became colleagues at the Open University and Rochdale College of Art; he invited me to contribute a suite of drawings to *Knuckleduster Funnies*, and subsequently we were close neighbours and friends for many years until shortly before his death. Parts of this article are based on our conversations.[65]

Notes

1 Jeff Nuttall, *The Pleasures of Necessity* (Colne: Arrowspire, 1988), p. 2.
2 The authorship of the expression 'first thought = best thought' has been attributed both to Jack Kerouac and to Allen Ginsberg, but it has not been possible to determine which might be the earlier use of the phrase. The body-centric approach to poetry did not of course begin with the Beats, and Charles Olson's celebration of breath as fundamental to what he called 'projective verse' is an important precedent. Not only is Olson's influence on Allen Ginsberg and the Beat Movement well established, but the relationship of syllable-breath-line of which he writes in *Projective Verse* (1950) is evident throughout Nuttall's poetry, and is referred to as 'Nuttall's long line' in the cover note of his *Selected Poems*, for which see note 22 below. Olson's essay can be viewed at http://writing.upenn.edu/~taransky/Projective_Verse.pdf (accessed 6 May 2022), and a discussion of it found in Kate North, 'Charles Olson's Projective Verse:

The Breath and The Line', in Nigel McLoughlin (ed.), *The Portable Poetry Workshop* (London: Palgrave 2017), pp. 201–7.

3 Jeff Nuttall, *Man Not Man* (Greensboro, NC: Unicorn Press, 1975), front cover. The drawing is a simplified transcription of Figure 1, 'Anatomie, Les Arteries', in Diderot & Alembert, *Encyclopédie* (1762). See https://artflsrv03.uchicago.edu/images/encyclopedie/V18/plate_18_4_12.jpeg (accessed 30 April 2022).

4 Jeff Nuttall used the term 'the mammal thing' several times in conversation with me. The precedents in visceral intelligence that Jeff Nuttall set are touched on at several points in this article, being most notable in the new research culture of arts practice as well as in feminism, psychology (especially popular psychology) and the biological sciences, also discussed in this note. The practice of the arts has been particularly affected since the early 1990s by the development of so called 'practice-based' doctorates in arts education which have led to increased rigour in ideas about art practice. That many poets and artists have been dependent on income from an educational practice is well known, though often unacknowledged. Historically, a teaching practice did not often affect an art practice, though for some artists such as Joseph Beuys, art and education have been inextricably related, as for this author too. However, the move of once-independent art schools into universities in the 1990s led to university-led research culture significantly affecting the ethos of art education, notably in the development of doctorates based on the ways that artists enquire into the nature of reality. Just as physicists enquire into the working of the world and biologists enquire into the working of living organisms, so artists can be seen to enquire into consciousness. The epistemology of art has become an explicit concern in this new educational culture. As artists develop explicit accounts of the intelligence of art practice, as distinct from the epistemology of other disciplines, so the visceral intelligence of which Nuttall was a pioneer has become of particular interest. See Timothy Emlyn Jones, 'The PhD in Studio Art Revisited', in James Elkins (ed.), *Artists With PhDs* (Washington DC: Academia Press, 2014), with all the other twenty-five chapters also relevant. The place of visceral intelligence in feminism can be seen in the pioneering work of Julia Kristeva and Luce Irigaray (see note 13), as well as in Elizabeth Grosz's *Volatile Bodies: Towards a Corporeal Feminism* (Bloomington: Indiana University Press, 1994). In this perspective, much discussion of the human body is shown to have been centred on the specifically male body and thereby of limited relevance. In psychology, the place of the intelligence of the body including the viscera is discussed in Risa F. Kaparo, *Awakening Somatic Intelligence* (Berkeley: North Atlantic Books, 2012). In the biological sciences, the intelligence of the viscera is discussed by Robert Martone, 'The Neuroscience of the Gut', in *Scientific American*, 19 April 2011, and proprioception is discussed by John C. Tuthill and Eiman Azim, 'Proprioception', in *Current Biology*, 28 (2018), R194–R20.

5 Throughout this article I draw on personal memories of things Jeff Nuttall said or did, and where a point is not referenced it is based on my personal experience of the man. Nuttall pointed out to me that the themes of stream of spontaneity and stream of consciousness writing can be traced back to Laurence Sterne's *Tristram Shandy* and Coleridge's preface to *Kubla Khan*, in his response to my suggestion of some possible revisions to a late draft of his novel *Always Waiting*. While accepting the credibility of

my (invited) comments, he stated it would be contradictory of his creative method in fiction for him to revise in that way. However, when at a later date he invited me to read an early draft of *Art and The Degradation of Awareness* following the death of Eric Mottram, who had been his regular reader, he was happy to revise this scholarly work in response to my comments.

6. Nuttall, *Bomb Culture*; Jeff Nuttall and Rodick Carmichael, *Common Factors/Vulgar Factions* (London: Routledge, 1977); Nuttall, *The Pleasures of Necessity* (Colne, Arrowspire Press, 1988); Jeff Nuttall, *Art and the Degradation of Awareness* (London: Calder Publications, 2001).
7. Dylan Thomas, *Poems Selected by Derek Mahon* (London: Faber & Faber, 2004), p. viii.
8. Gilbert Ryle, *The Concept of Mind* (Harmondsworth: Penguin, 1949; republished with an introduction by Daniel C. Dennett in 2000).
9. Paul D. MacLean, *A Triune Concept of the Brain and Behavior* (Toronto: University of Toronto Press, 1973), and Paul D. MacLean, *The Triune Brain in Evolution: Role in Paleocerebral Functions* (New York: Plenum, 1990).
10. John Goodby, *The Poetry of Dylan Thomas: Under The Spelling Wall* (Liverpool: Liverpool University Press, 2013).
11. See Howard Gardner, *Frames of Mind* (New York: Basic Books, 1983) and *Intelligence Reframed: Multiple Intelligences for the 21st Century* (New York: Basic Books, 1999).
12. Julia Kristeva, *Powers of Horror: An Essay on Abjection* (New York: Columbia University Press, 1982); Luce Irigaray, *Ethique de la différence sexuelle* (Paris: Minuit, 1984).
13. Michael Biggs and Henrik Karlsson, *The Routledge Companion to Research in the Arts* (London: Routledge, 2010); Daniel Goleman, *Emotional Intelligence* (New York: Bantam Books, 1995); see also www.eiconsortium.org/.
14. Maurice Merleau-Ponty, *Phenomenology of Perception* (London: Routledge, 1945; trans. Colin Smith, 2005).
15. Nuttall, *Pleasures of Necessity*, back cover.
16. Elizabeth Grosz, *Volatile Bodies: Towards a Corporeal Feminism* (Bloomington: Indiana University Press, 1994).
17. Jeff Nuttall, *The Patriarchs: An Early Summer Landscape* (London: The Beau and Aloes Arc Association, 1978); reissued in Jeff Nuttall, *An Aesthetic of Obscenity: Five Novels*, D. Field and J. J. Jones (eds) (Singapore: Verbivoracious Press, 2016).
18. Jeff Nuttall, *Bomb Culture* (London: MacGibbon & Kee, 1968), republished to celebrate its 50th anniversary as Jeff Nuttall, with D. Field and J. J. Jones. (eds), I. Sinclair (foreword) and M. Fusco (afterword), *Bomb Culture: 50th Anniversary Edition* (London: Strange Attractor Press, 2018).
19. Jeff Nuttall, 'The People', in the *International Times*, 9 (1967), p. 10.
20. Wallace Stevens, 'The Relations between Poetry and Painting', in *The Necessary Angel* (London: Faber & Faber, 1960), p. 160.
21. Jeff Nuttall, *Selected Poems* (Cambridge: Salt Publishing, 2003).
22. For a treatment of the theory of multiple intelligences see Howard Gardner, *Multiple Intelligences: New Horizons in Theory and Practice* (New York: Basic Books, 1993 and 2006); see www.eiconsortium.org/.

23 Goodby, *The Poetry of Dylan Thomas*.
24 Jeff Nuttall, 'The Whore of Kilpeck', in *Penguin Modern Poets 12: Alan Jackson, Jeff Nuttall, William Wantling* (Harmondsworth: Penguin, 1968), p. 64. While this poem was included in the 1968 Penguin selection by which he then wanted to be represented, it was omitted from his 2003 *Selected Poems* (see note 23). This later omission could equally reflect either a change of attitude or the constraints of limited space felt by any prolific poet.
25 Jeff Nuttall (1960s): http://jeff-nuttall.co.uk/html/nuttall_on_paintings.html (accessed 6 May 2022).
26 Nuttall, *Bomb Culture*.
27 www.peopleshow.co.uk/archive (accessed 10 May 2022). Nuttall was one of five co-founders of People Show. A view that Nuttall was the primary instigator of People Show is supported by Lyn Gardner in *The Guardian* (30 November 2016), 'The first gig the group did, at the behest of Jeff Nuttall, was a "happening" created around a performance by a rising young band called Pink Floyd at the All Saints church hall in Notting Hill.' See www.theguardian.com/stage/theatreblog/2016/nov/30/people-show-theatre-50-years-toynbee-studios (accessed 10 May 2022). The website advises that early People Show performances were (unlike many later shows) scripted and included room for improvisation, without noting that those scripts were written by Jeff Nuttall.
28 Jeff Nuttall, *My Own Mag*, 4 (1964), p. 2; see http://realitystudio.org/images/bibliographic_bunker/jeff_nuttall/my_own_mag/my_own_mag.04.02.jpg (accessed 6 May 2022).
29 Jeff Nuttall, *Emperor of Lancashire*, BBC broadcast (1979); see http://jeff-nuttall.co.uk/html/nuttall_on_paintings.html (accessed 6 May 2022).
30 Nuttall and Carmichael, *Common Factors/Vulgar Factions*.
31 *Ibid.*, inside front dust cover.
32 Nuttall, *Selected Poems*, back cover.
33 Unconditionally in personal comment, but also conditionally in Nuttall, *Art and the Degradation of Awareness*, p. 62.
34 Jeff Nuttall, *Pig* (London: Fulcrum Press, 1969), pp. 30–1.
35 Jeff Nuttall, *Performance Art, Vol 1: Memoirs* (London: John Calder, 1979).
36 Jeff Nuttall, *My Own Mag* (1963–66). For the complete series see https://realitystudio.org/bibliographic-bunker/my-own-mag/ (accessed 6 May 2022). See also Jed Birmingham, *Yay!: A Moving Times Supplement (An In-Depth Examination of My Own Mag)*, 20 October 2008, at http://realitystudio.org/bibliographic-bunker/my-own-mag/yay-a-moving-times-supplement-an-in-depth-examination-of-my-own-mag/ (accessed 6 May 2022).
37 Initially published in 1979 in very small photocopy editions and distributed by hand by Chris Donald in Newcastle upon Tyne, *Viz* subsequently grew rapidly and became a bestseller by 1989, by which time it had changed ownership. Jeff discovered it in a specialist comic bookshop in Soho in 1980. See www.viz.co.uk.
38 Jeff Nuttall and Robert Bank, *Knuckleduster Funnies* (Colne: Arrowspire Press, 1985–86).

39 Eric Mottram, *The Book of Herne* (Colne: Arrowspire Press, 1981); Mottram was a friend of Allen Ginsberg, and a friend and biographer of Kenneth Rexroth.
40 The evidence is an account given to me by my former teaching colleague, the ceramicist Annie Banks, of her friend Aeronwy Thomas telling of being as a child sent to call her father from his garage workshop at Laugharne, and finding him arranging and rearranging many cut up strips of manuscript on the garage floor. That sounds like cut-up. I am grateful to Professor John Goodby for confirming that this was most likely a cut and paste of Thomas's own text, unlike some other practitioners of 'cut-up'.
41 Gillian Whiteley, 'Sewing the "Subversive Thread of Imagination": Jeff Nuttall, Bomb Culture and the Radical Potential of Affect', in *The Sixties*, 4 (2011), 109–33.
42 Postcard from Lawrence Ferlinghetti to Jeff Nuttall, asking for '20 copies of the William Burroughs edition', shown to me by Robert Bank when the Nuttall Archive was in his possession. Presumed to be in the John Rylands Library Archive, Manchester.
43 Birmingham, *Yay!: A Moving Times Supplement*.
44 For a survey of Viennese actionism and its legacy, see the catalogue of the exhibition *My Body Is The Event* (2015), at *Museum Moderner Kunst (Mumok)*, Foundation Ludwig, Vienna: www.mumok.at/sites/default/files/cms/wa_wandtext_presse.pdf (accessed 6 May 2022); the exhibition title was taken from Günter Brus, one of the main exhibitors.
45 Kristeva, *Powers of Horrors*.
46 Viktor Shklovsky, 'Art as Device' (1917), in Viktor Shklovsky, *Theory of Prose*, trans. B. Sher (London: Dalkey Archive Press, 1990).
47 Bertolt Brecht, 'The Modern Theatre Is the Epic Theatre' (1930), in John Willett (ed. and trans.), *Brecht on Theatre: The Development of an Aesthetic* (London: Methuen, 1964).
48 Nuttall, *Bomb Culture*, p. 35.
49 Examples of the suitcase sculptures can be seen on *The Life and Works of Jeff Nuttall* website, where they are/were offered together with other works of art to public collections: http://jeff-nuttall.co.uk/html/bequest_art.html (accessed 6 May 2022).
50 Jeff Nuttall, *A Catalogue Note*, exhibition at Abergavenny Museum, 1996; see http://jeff-nuttall.co.uk/html/nuttall_on_paintings.html (accessed 6 May 2022).
51 Nuttall, *Selected Poems*, back cover.
52 Mihály Csíkszentmihályi, *Flow* (Rider, 1992 and 2002); Mihály Csíkszentmihályi, *Creativity: Flow and the Psychology of Discovery and Invention* (New York: Harper Perennial, 1996).
53 Helen Palmer, *Inner Knowing: Consciousness, Creativity, Insight and Intuition* (New York: Jeremy P. Tarchner/Putnam, 1998).
54 Ivan Illich, *Celebration of Awareness: A Call for Institutional Reform* (London: Marion Boyars, 1971 and 2001).
55 Nuttall, *Art and the Degradation of Awareness*.
56 Samuel Taylor Coleridge, 'Kubla Khan, a Vision' (1816), in *The Complete Poems of Samuel Taylor Coleridge* (Harmondsworth: Penguin Classics, 1997).
57 Nicholas Cusanus, *De docta ignorantia* (1440) (London: Routledge, 1954).

58 The following might be worthwhile topics for research: Jeff Nuttall's contribution to the Neo-Romantic movement; the conflict of hegemonies between the Movement and the British Poetry Revival, and its effects on contemporary poetry; the role of the mammalian intelligence of the gut in the formation of art; the surrealist and visionary heritage represented by Artaud and Thomas and others in its impact on Nuttall's creative methods and imagery; Nuttall's trans-disciplinary use of language in which prose and poetry merge as what was then a new type of fiction; Nuttall's pioneering of the autobiographic voice within a scholarly discourse in cultural theory, exemplified by *Bomb Culture* and subsequent publications; Nuttall's use of language in which the improvisatory jazz idiom conflates with collage and painterly qualities; Nuttall's use of cut-up; Nuttall's advocacy of libertarianism and the bawdy in the face of absurdity in the Cold War as relevant to our contemporary period.

59 www.manchesterhive.com/view/journals/bjrl/93/1/article-p131.xml (accessed 10 May 2022); Nuttall, *An Aesthetic of Obscenity: Five Novels*; Nuttall, *Bomb Culture*.

60 Goodby, *The Poetry of Dylan Thomas*.

61 John Goodby and Lyndon Davies (eds), *The Edge of Necessary: An Anthology of Welsh Innovative Poetry, 1966–2018* (Powys: Aquifer, 2018).

62 Goodby, *The Poetry of Dylan Thomas*.

63 Goodby and Davies, *The Edge of Necessary*, p. 32.

64 This is described by Jeff Nuttall in Nuttall, *Performance Art, Vol. 1*, pp. 163–77.

65 In the preparation of this article I have further consulted Emily Beber (ed.), *The Bodies That Remain* (Earth: Punctum Books, 2018), at http://repository.londonmet.ac.uk/4574/7/Beber_The_Bodies_That_Remain_Excerpt.pdf p. 18 (accessed 6 May 2022); Francis Booth, *Amongst Those Left: The British Experimental Novel, 1940–80*, lulu.com (2012), 684; James Charnley, *Anything But Dull: The Life and Art of Jeff Nuttall* (London: Academica Press, 2022); Andrew Darlington, *Jeff Nuttall: Bombed Culture*, at https://andrewdarlington.blogspot.com/2014/03/jeff-nuttall-bombed-culture.html (accessed 6 May 2022) (20 March 2014); Gillian Whiteley, 'Carnival of Discord', in Geraldine Monk (ed.), *Recollections of Poetry in Transition* (Bristol: Shearsman Books, 2012).

EU authorised representative for GPSR:
Easy Access System Europe, Mustamäe tee 50,
10621 Tallinn, Estonia
gpsr.requests@easproject.com

www.ingramcontent.com/pod-product-compliance
Lightning Source LLC
Chambersburg PA
CBHW081154290426
44108CB00018B/2548